MECHADEMIA 2

Networks of Desire

Mechademia
An Annual Forum for Anime, Manga, and Fan Arts

FRENCHY LUNNING, EDITOR

Mechademia is a series of books, published by the University of Minnesota Press, devoted to creative and critical work on anime, manga, and the fan arts. Linked through their specific but complex aesthetic, anime, manga, and the fan arts have influenced a wide array of contemporary and historical culture through design, art, film, and gaming. This series seeks to examine, discuss, theorize, and reveal this unique style through its historic Japanese origins and its ubiquitous global presence and manifestation in popular and gallery culture. Each book is organized around a particular narrative aspect of anime and manga; these themes are sufficiently provocative and broad in interpretation to allow for creative and insightful investigations of this global artistic phenomenon.

MECHADEMIA 2

Networks of Desire

Frenchy Lunning, Editor

UNIVERSITY OF MINNESOTA PRESS MINNEAPOLIS • LONDON

http://www.mechademia.org

Spot illustrations by Rana Raeuchle

Published by the University of Minnesota Press
111 Third Avenue South, Suite 290
Minneapolis, MN 55401-2520
http://www.upress.umn.edu

ISSN: 1934-2489
ISBN-10: 0-8166-5266-X (pbk. : alk. paper)
ISBN-13: 978-0-8166-5266-2 (pbk. : alk. paper)

Printed in the United States of America on acid-free paper

The University of Minnesota is an equal-opportunity educator and employer.

12 11 10 09 08 07 10 9 8 7 6 5 4 3 2 1

Mechademia Editorial and Advisory Boards

Contents

希望 Horizons

Review and Commentary

トレンド Torendo

Introduction

FRENCHY LUNNING AND THOMAS LaMARRE

ART MECHO

Art Mecho. Apparently an encounter of Art Deco with mecha, but much, much more; an embrace of the false image of luxury, yes, but piloted like a bipedal robot; Art Mecho is the tactical armor in the graphic battle for new worlds of desire, in which we so-called consumers are finished with desire for something, some things. We embrace the infinitesimal variation that draws anger from the core of cute, from tiny animals, dolls, and an array of involuted styles that present us with desire in an ensemble, with desire in and of worlds. So don't tell us that our delight in false images makes us traffickers of the inscrutable Orient. Art Mecho takes on the mecha powers of the false, and the retro of Art Mecho is not that of the backward glance over the shoulder, of historical timeliness and fashion, of futurism and militarism, but of those little bits of history repeating. This is the retro of Retro Direct, a mechanism that allows different gearings when peddling backward, jerkily moving over the rubble of history.

GRRRL

少女

Shojo

DEBORAH SHAMOON

• • •

Revolutionary Romance: *The Rose of Versailles* and the Transformation of Shojo Manga

The Rose of Versailles (*Berusaiyu no bara*, or *Beru-bara*), the "shining master-piece of shojo manga," was an instant hit among teenage girls in Japan from the moment it first appeared in the manga magazine *Margaret* in 1972. At a time when shojo manga was just beginning to shift its demographic from elementary school students to high school students, *The Rose of Versailles* was part of a larger trend toward longer and more complex storytelling in comics for girls.[1] Fan response to *The Rose of Versailles* was immediate and unprecedented, sparking a "Beru-boom," a craze among teenage girls in the early 1970s for anything related to the manga, or for anything French. When the main character, Oscar, died well before the end of the series, teachers reportedly were forced to suspend classes because all the girl students were in tears, and one distraught fan mailed a letter containing a razor to author-artist Ikeda Riyoko.[2] How did this narrative-heavy account of the events leading to the French Revolution evoke such an impassioned response among Japanese girls? While the lush, rococo setting and sweeping epic scale certainly appealed to girls' sensibilities, I argue that what distinguishes *The Rose of Versailles* from other shojo manga of the time is the depiction of adult heterosexual romance between equals. The continued popularity of *The Rose of*

Versailles suggests that girls long for romance stories featuring a powerful female character, but the narrative compromises that Ikeda used to depict that romance suggest the extent to which equality in heterosexual romance remains a fantasy in shojo manga.

Although *The Rose of Versailles* depicts heterosexual romance, the narrative still operates within the genre of shojo manga, which tends to favor homosocial and homosexual relationships. This generic feature predates shojo manga of the 1970s and appears as far back as the 1920s in girls' literary magazines. Before doing a close reading of *The Rose of Versailles,* I first analyze the generic conventions that Ikeda drew on, both from prewar girls' magazines and from postwar girls' comics. Specifically, I discuss the difficulties the genre has in portraying heterosexual romance, relying instead on same-gender pairings. Contemporary shojo manga would not have existed without prewar girls' magazines, which developed a narrative and aesthetic idiom for the private discourse on girlhood. But with this legacy, shojo manga also inherited certain generic limitations from girls' magazines, in particular a reliance on sameness in romantic couples and difficulties in portraying realistic heterosexual romance narratives without sacrificing the social and sexual agency of the female character.

SAME-SEX ROMANCE IN GIRLS' MAGAZINES

Girls' literary magazines in the 1920s and 1930s, the *shōjo shōsetsu* (girls' novels) and accompanying illustrations serialized in them, developed a recognizable aesthetic and literary style. These magazines came be associated with the "authentic" representation of *shōjo bunka* (girls' culture), a discrete discourse premised on a private, closed world of girls that not only embraced close female friendships but avoided heterosexual romance. These relationships between girls were described in the language of romance and were sometimes sexual. It should not be inferred, however, that the girls were lesbians in the twenty-first-century sense of the term. Same-sex love in this context was neither an expression of a repressed inner self nor a subversion of a patriarchal system; rather, it was a socially acceptable means of delaying heterosexual courtship until girls had finished school and were available for marriage. To avoid confusion, I refer to these relationships by the term used to describe them in the 1920s, *dōseiai* (same-sex love).

Japanese prewar society condoned same-sex relationships between girls, but only within the context of a larger homosocial group, usually an all-girls' school, and only as long as both girls maintained a feminine appearance. Gregory Pflugfelder, Sabine Frühstück, and Jennifer Robertson, among others, all emphasize that in the 1920s and 1930s, sexologists and educators usually considered close relationships between girls to be normal.[3] *Dōseiai* relationships were premised on sameness (*dō*). It was a coupling not merely with someone of the same sex but with one who exhibited the same modes of dress, speech, and behavior. The girls' uniforms, usually some variation on the sailor suit with a blue pleated skirt, contributed to this ideal of sameness in that they promoted a similar appearance among schoolgirls. The *dōseiai* relationship celebrated in girls' magazines was between two girls who were not only feminine but dressed exactly alike.[4] The ideal of *dōseiai* encouraged sameness, loving the one who looks just like the self. Moreover, it was seen as a transitory relationship that teenage girls would eventually outgrow.

NEGOTIATING THE "LOVE TRAP" IN SHOJO MANGA

As the narrative and aesthetic heir to girls' magazines, shojo manga inherited a tendency to favor homosocial plot structures and an aesthetic reliance on uniformity in romantic pairs. While this generic reliance on older *dōseiai* conventions helped propel shojo manga to mainstream popularity among girls, it has had a limiting effect on the genre. Shojo manga still wrestles with the problem of female agency in heterosexual romance narratives.

The Rose of Versailles appeared just as shojo manga was undergoing a significant transformation. In the early 1970s a group of young women who became known as the *24 nen gumi* (literally, the Shōwa 24 group, so called because many of the women were born in or near Shōwa 24, or 1949) began to write shojo manga for teenage readers.[5] This group of artists, of whom Ikeda Riyoko is one, dealt openly with politics, sexuality, and with the psychological development and interiority of the characters. The pop culture critic Ōtsuka Eiji describes this change as analogous to the discovery of interiority in early Meiji fiction.[6] The manga scholar Takeuchi Osamu likewise writes that shojo manga in the 1970s went beyond simple entertainment to become a vehicle of self-expression for the author.[7] Although artists were innovators in many ways, they continued to employ many of the aesthetic and narrative features of prewar girls' magazines, including a tendency to make partners

in romantic couples resemble each other. Thus *dōseiai* continues to be the dominant mode of romance in shojo manga. The legacy of girls' magazines to shojo manga is not only a private space for discourse about the experience of female adolescence but also generic conventions that could not easily accommodate heterosexual or heterogender desire and romance.

Unlike prewar girls' magazines, shojo manga writers in the 1970s were not prohibited from depicting heterosexual courtship, or even heterosexual sex, but they found social reality as well as generic conventions stood in the way of granting agency to girl characters in heterosexual couples.[8] The shojo manga scholar Fujimoto Yukari points out that many shojo manga stories in the 1970s center on a girl who finds her identity and self-worth through a close emotional bond with a boy. The girl, who sees herself as unpopular, clumsy, and unattractive, eventually achieves happiness by completely subsuming her desires to the one boy who loves her despite her defects. Having made passivity a virtue, a girl can find true love only by sacrificing herself to her boy. Deprived of agency, the girl must rely solely on the "power of love" to achieve her goal. Fujimoto calls this the "love trap."[9] Although this type of Cinderella–Prince Charming story is clearly not unique to Japan, it was the dominant narrative of heterosexual romance in shojo manga in the 1970s and one that has not entirely disappeared even today.

To create truly assertive characters, the writers relied on *dōseiai* structures that had developed in prewar magazines. Although same-sex love among schoolgirls continued to appear, by the early 1970s, portrayals of sexual relationships between beautiful boys who resemble each other became more popular. *Dōseiai* allowed writers to create nonthreatening love stories, and by making the characters boys rather than girls, writers could infuse the stories with blatant eroticism, free from the dangers for girls inherent in heterosexual sex. Matsui Midori argues that the stories of *dōseiai* between boys stage the repressed desires of the female readers: "It was apparent that the boys were the girls' displaced selves; despite the effeminate looks that belied their identity, however, the fictitious boys were endowed with reason, eloquence and aggressive desire for the other, compensating for the lack of logos and sexuality in the conventional portraits of girls."[10] As Matsui suggests, the boy characters in these manga invite the girl readers to identify with them because of their feminine appearance, marked with ectomorphic bodies, huge eyes, and long, flowing hair. Although the characters are boys, these stories are essentially the same as the *dōseiai* stories found in prewar girls' magazines.

One of the seminal shojo manga stories featuring this kind of boy-love story is Hagio Moto's *Heart of Thomas* (*Tōma no shinzō*), which first appeared

in *Shōjo Comic* in 1974. Although all the characters are boys, they are all very feminine in appearance, with long, flowing hair and slender, graceful bodies. The story is set in a boys' boarding school in Germany in the early twentieth century. Like the girls in prewar girls' fiction, the boys in *Heart of Thomas* inhabit a private, homosocial world, and their primary concern is romantic entanglements with one another. The story is suffused with the sensibility of longing and nostalgia, with repeated emphasis on the purity of the boys' love for each other. While using male characters, as Matsui suggests, allowed Hagio to invest her characters with sexual agency, this freedom is limited to the homosocial world of adolescence.

Because boy-love comics are a form of escapist fantasy for girl readers, many stories feature foreign, historic, or fantastic settings, like early-twentieth-century Germany in *Heart of Thomas*. Mark McLelland, in a study of boy-love shojo manga, quotes from a fan: "[Boy-love] comics are an imaginary playground in which I can flee the realities of everyday life."[11] Matsui argues that transference of the girl reader's identity onto the boy character can be a powerful means for girls to access their sexual desires, but the leap of imagination required for such a reading can also be detrimental: "The Japanese boy-love comic, in its most imaginatively ambitious mode, is a remarkable amalgam of the feminine and the adolescent imagination. . . . Yet this transgressive play can easily slide into self-indulgence, an intellectual equivalent of drug-taking."[12] The popularity of boy-love comics among female readers, even now that heterosexual courtship and even sex are no longer taboo in shojo manga, suggests that the conventions of *dōseiai* still function as a fantasy version of a perfect romance.

HOMOGENDER ROMANCE IN *THE ROSE OF VERSAILLES*

It was within this genre that *The Rose of Versailles* first appeared, between April 1972 and December 1973. Ikeda Riyoko, like Hagio Moto and other shojo manga artists in the early 1970s, was experimenting with ways to expand the genre. Ikeda, who was just twenty-four years old at the time, encountered strong opposition when she first proposed the idea of a biography of Marie Antoinette to her editors. As a result of this opposition, Ikeda was dependent on fan feedback to ensure continued publication of her story.[13] The manga's artistic style and narrative focus changed significantly during its serialization, as the inexperienced Ikeda matured as a writer and artist, but also in

> READERS WHO WERE EXPECTING A FLUFFY ROMANTIC COMEDY, HOWEVER, WERE NO DOUBT SHOCKED BY THE SOCIAL AND GENDER CRITIQUES THAT EMERGE AS THE STORY BECOMES INCREASINGLY SERIOUS.

response to readers' feedback. The plot's development provides a unique opportunity to see how readers reacted to Ikeda's innovations. Chief among these was to make the main character a woman who dresses and behaves as a man. Readers responded positively to this story because Ikeda wrote in the idiom of earlier shojo manga and *shōjo shōsetsu*. At the same time, however, she attempted a compromise between the adolescent world of *dōseiai* and the adult world of heterosexual romance.

In its early chapters, *The Rose of Versailles* begins as a rather straightforward biography of Marie Antoinette. Ikeda drew most of her historical details from Stefan Zweig's 1933 book *Marie Antoinette: Portrait of an Average Woman,* which she had read in high school.[14] The first several chapters of *The Rose of Versailles* detail many real aspects of Antoinette's life, including her close relationship with her mother, Maria Theresa of Austria, her loveless marriage at the age of fourteen to Louis XVI, her early rivalry with Madame du Barry, her friendship with the Comtesse du Polignac, the Affair of the Necklace, and her lifelong romance with Hans Axel von Fersen, a Swedish count. Ikeda casts this historical story in terms of shojo manga: the teenage Antoinette is not much different from the lively, silly girls of shojo manga looking to be redeemed by love, in this case, her love for von Fersen. Antoinette's fights with Du Barry also take on the tone of schoolgirl rivalries. The exotic setting, elaborate costumes, and polite language appealed to girl readers who had long enjoyed this sort of fantasy. For example, Mizuno Hideko's 1963 manga *Pretty Cora* (*Suteki na Kōra*) (Figure 1) is visually similar in the shape of the eyes and hair, the flower motifs, and the cartooniness of the background characters.[15] Ikeda addressed her readers in an idiom that was familiar to them.

Readers who were expecting a fluffy romantic comedy, however, were no doubt shocked by the social and gender critiques that emerge as the story becomes increasingly serious. As the characters enter adulthood, Antoinette is eclipsed by the fictional Oscar François de Jarjayes, a cross-dressed woman and the captain of the Queen's Royal Guard (Figure 2).[16] Oscar begins the story as a supporting character, invented, Ikeda later revealed in interviews, because she felt unable to convincingly portray a male soldier.[17] Oscar is born the youngest daughter of General de Jarjayes, who, despairing of a male heir, raises her as a boy and a soldier. She proves to be an accomplished officer and a natural leader. Although she dresses and behaves as a man, however,

Oscar's sex is never a secret; the other characters all know that she is in fact a woman. Despite her masculine dress and bearing, she retains feminine features, specifically long hair and large eyes, as well as compassion and empathy. She is far more charismatic and complex than Antoinette, and it is easy to see why she takes over the narrative.

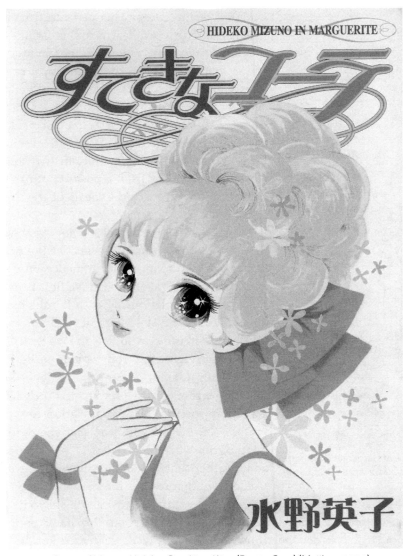

FIGURE 1. Cover of Mizuno Hideko, *Suteki na Kōra* (Pretty Cora) (Mujikan, 2000).

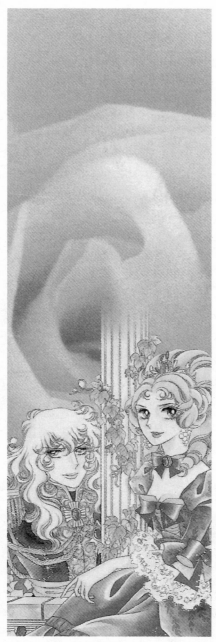

FIGURE 2. Bookmark of Oscar and Antoinette. Ikeda Riyoko, *Berusaiyu no bara* (The Rose of Versailles).

Through Oscar, the text radically questions the assumptions of both *dōseiai* and heterosexual romance and gender roles. As her narrative trajectory gains momentum, Oscar has two basic conflicts, the first in her career and politics, and the second in her romantic life. To summarize the first briefly, Oscar, as captain of the Royal Guard, gradually begins to realize that she is supporting a corrupt regime. Despite her personal friendship with Antoinette, Oscar learns to sympathize with the revolutionaries, renounces her aristocratic status, and takes on a new commission as captain of a regiment of commoners. She and her men eventually join with the revolutionaries in a series of events also loosely based on real incidents. Oscar herself is killed while leading her regiment in the storming of the Bastille. In her political career, Oscar moves from a position of privilege to learning to embrace the ideals of the French Revolution.[18]

Oscar's romantic conflicts, however, would have far more significance than her politics, in terms of fan response and influence on subsequent shojo manga. The narrative first pairs Oscar in a *dōseiai* relationship with Rosalie Lamorlière.[19] Rosalie is a stereotypical good girl, sweet, obedient, and timid, who falls in love with Oscar after Oscar rescues her from various perils. Rosalie's adoring admiration for Oscar is reminiscent of girl-girl romance in prewar girls' magazines, but Oscar does not allow the relationship to develop.[20] Oscar makes it clear that she desires a relationship with a man; that is, she desires an adult, rather than an adolescent, relationship. It would seem that readers too could not accept Oscar in a schoolgirl relationship. Ikeda has stated that she originally intended Rosalie to serve as a point of identification for girls, but the character proved unpopular.[21] Ever dependent on fan feedback, Ikeda decreased Rosalie's significance in the plot.

Having rejected Rosalie and *dōseiai,* Oscar then attempts a heterosexual relationship with Antoinette's lover, Fersen. Fearing that he does not see her as a woman, Oscar attempts to seduce him by donning a dress for the first (and only) time in her life and attending a ball in disguise as a foreign princess. Even this, however, is not enough to convince Fersen to see Oscar as anything more than a comrade.[22] Oscar's second foray into romance comes when her father arranges her marriage to the Comte de Girodel. Whereas Fersen saw her only as a man, Girodel sees Oscar only as a woman, which infuriates her. To spite both Girodel and her father, she appears at her engagement party in her military dress uniform and dances with women.[23] This ends her engagement and also highlights her inability to accept either a clearly masculine or a clearly feminine role.

> WHEN OSCAR FINALLY ACKNOWLEDGES HER OWN FEELINGS AND RETURNS HIS LOVE, SHE DESCRIBES ANDRE AS HER SHADOW AND COMPARES THE TWO OF THEM TO THE MYTHOLOGICAL TWINS CASTOR AND POLLUX.

At this point, Oscar finally realizes what the reader has already known for some time: her one true love is in fact Andre Grandier, who has been her faithful companion and sidekick since childhood. Andre first appears in the narrative as a background character, and Ikeda later admitted that she did not initially create him as a love interest.[24] But as Ikeda, in response to feedback from fans, made Oscar the main character over Antoinette, she also developed Andre more fully as a partner to Oscar. Significantly, however, Andre begins to emerge as a love interest after Oscar cuts his hair, which alters his appearance to more closely resemble her own. As the story progresses, they increasingly resemble each other, in the shape of the hair and eyes, and in the clothes they wear, usually military uniforms. When Oscar finally acknowledges her own feelings and returns his love, she describes Andre as her shadow and compares the two of them to the mythological twins Castor and Pollux.[25] This increasing physical resemblance does not occur with other characters; specifically, it does not occur between Antoinette and Fersen, both of whom retain clearly gender-differentiated appearances.

Andre becomes Oscar's ideal love interest not only because he physically resembles her but because his own masculine identity is somewhat compromised. First, he is of a lower social class, little more than a servant in the de Jarjayes household. For much of the story Oscar either gives him orders or ignores him. Second, and even more significantly, their romance begins to develop only after Andre loses an eye in the line of duty; in the latter half of the

story, he gradually loses his sight completely to sympathetic blindness. His disability enforces his subordinate, dependent position. By the time they finally consummate their relationship and pledge to marry, Andre has become completely blind, symbolizing his loss of masculinity.

Andre's suffering, both from Oscar's inattention to him and from the gradual loss of his sight, is highlighted in moments of melodramatic stasis, which further feminizes him. For instance, Andre decides to find out more about the republican politics that have so preoccupied Oscar by reading Rousseau. But rather than one of Rousseau's philosophical works, he reads the romance *La nouvelle Héloïse* and sees himself in the story of forbidden love between a noble lady and a commoner.[26] He reacts emotionally to the story (like a female reader of romance novels, or shojo manga), and his emotions and thoughts are portrayed visually. According to the conventions of shojo manga, extended interior monologues and pauses in the action to visually represent emotional anguish are usually reserved for the female characters, but in the second half of *The Rose of Versailles*, as Oscar wrestles with political issues, it is Andre who suffers the stereotypically female pain of unrequited love. In visually representing his inner thoughts, the narrative invites readers to identify with him. As Matsui suggests, reader identification in shojo manga does not necessarily follow gender lines; however, it is interesting that readers rejected Rosalie, the image of female suffering, as a point of identification, in favor of Andre.

Although Oscar and Andre's relationship is in a biological sense heterosexual, it is still configured within the story as homogender. As a masculine woman and an emasculated man, Oscar and Andre physically and symbolically resemble each other in a way that is not far removed from the aesthetic of *dōseiai* that pervades both prewar girls' magazines and boy-love shojo manga. Oscar represents a compelling, if fantastic, solution to Fujimoto's love trap. Oscar is able to give herself completely to Andre because he never asks her to compromise either her masculine or her feminine identities. Oscar remains popular among girl readers even thirty years after the story's initial publication not only because she displays masculine strength and agency without sacrificing her feminine beauty and empathy but because she finds true love without losing her identity to her partner.

Although Oscar emerges as the main character, her death (preceded by Andre) occurs well before the end of the story. Ikeda has said in interviews that after the deaths of Andre and Oscar, readership declined sharply and her editors pressured her to finish the story quickly, although she had wanted to continue.[27] The final chapters rush through many details of the Revolution,

with a focus on Fersen and Antoinette's doomed love. The story ends, as it must, with Antoinette's execution. Her character has evolved from a silly, flighty teen, not unlike many girl characters in less serious shojo manga, to a mature woman who recognizes her failures as a head of state and faces her death bravely. As a strong female character, however, she still pales in comparison with the more complex Oscar. The final page of the story recounts Fersen's own fate: in 1810 he was trampled to death by a mob in Stockholm, the victim of political rivalry among Swedish royal families. The final panel shows Fersen's broken corpse lying in the street, a far cry from the light, cheery tone that characterized the opening chapters.[28] Over the course of the series, in moving from these early, childish illustrations to the final gruesome image, we can see in Oscar's increasing importance as a character, and in the relative decline of Rosalie and Antoinette, the evolution of shojo manga from a genre for children to one for older readers. These brutal images, and the deaths of the main characters, shocked readers at the time but also led them to embrace more serious stories, and stories with political and social criticism.

TEXTUAL REPRODUCTION OF
THE ROSE OF VERSAILLES

The popularity of *The Rose of Versailles* has increased not only with the continual reprinting of the collected edition but also with its move to other genres, including an animated television series (1979–80), a live-action film (1979), and a stage version by the Takarazuka Revue (1974), which has enjoyed many revivals. The anime version is faithful to the original manga, but the film and stage versions differ. An analysis of how those versions differ sheds light on the strengths and appeal of the original story.

The film version of *The Rose of Versailles,* given the English title *Lady Oscar,* was produced by the Japanese cosmetics company Shiseidō, directed by Jacques Demy, and filmed on location at Versailles using a cast of mostly British B-list actors.[29] The film, which was not well received, distorts the original story, although its failures are instructive. Oscar, played by Catriona MacColl, is weak and feminine; she lacks the charisma and confidence of the original character. Takayama Hideo complains that MacColl's "feminine curves" are too visible in her uniform, which gives her an inappropriately sexualized appearance.[30] In the film, Oscar remains a woman in male drag; she never embodies both male and female attributes, as in the manga.

The most obvious difference between the manga and the film, however,

> THE ROSE OF VERSAILLES HELPED TRANSFORM SHOJO MANGA INTO A GENRE THAT COULD ENCOMPASS VAST EPICS, COMPLEX PSYCHOLOGICAL PORTRAITS, POLITICAL COMMENTARY, AND ADULT ROMANCE.

is in Oscar's relationship with Andre. In the film, Andre (Barry Stokes) is the stronger partner, and their conflict is not about Oscar's need for independence or her fear of losing herself in a relationship but about their class differences. Andre mockingly and smugly dictates Oscar's political awakening, but they never become social or romantic equals. More significant, his appearance does not change to resemble hers, nor does he lose his sight. The underlying discourse of homogender romance and the imagery of twins is completely gone. Oddly, the film ends with Andre's death, with the action cut off abruptly before Oscar's death. Perhaps the deaths of both characters would have been too tragic for a romance film, but instead of resolving the plot, the film ends with Oscar literally nowhere, searching the crowd for Andre, not knowing that he is already dead. Although the film uses the same characters, without the discourse of *dōseiai* that made the manga version compelling, the film lacks any coherence or resolution.

Perhaps the larger problem for the live-action film is that the mimetic style of mainstream cinema is simply not compatible with the melodramatic, fantastic mode of shojo manga. The Takarazuka Revue, with its all-female cast, and its roots in prewar girls' culture, can more easily stage the gender ambiguities of *The Rose of Versailles*. Although the Takarazuka version changes the plot somewhat, it remains true to the homogender nature of the romance between Oscar and Andre. While Ikeda did not originally write the story with the Takarazuka in mind,[31] shojo manga and the Takarazuka both have roots in prewar girls' culture and share an aesthetic of *dōseiai*. Takayama follows his complaint about MacColl's overly feminine performance by asserting that only a Takarazuka actress trained in playing male roles and schooled in the seventy-year history of *shōjo bunka* can play the role of Oscar appropriately.[32] By using female actresses to assume the roles of both men and women, the Takarazuka is uniquely compatible with shojo manga, which stages the desires of girls in a closed, private world of girls' culture. While Oscar seems to challenge traditional gender roles, she is still firmly embedded in a discourse of *dōseiai*.[33]

The Rose of Versailles helped transform shojo manga into a genre that could encompass vast epics, complex psychological portraits, political commentary, and adult romance. The "bed scene" featuring Oscar and Andre on the

eve of the Revolution had a profound impact on girl readers. Fujimoto writes, "From that scene, each of us decided, 'I want to have sex like Oscar and Andre.' For us junior and senior high school girls at the time, our concept of sex was fixed by that manga."[34] The perfect union between Oscar and Andre that Fujimoto recalls as so appealing is possible only because both characters have defied gender roles. Oscar can give herself to Andre without fear of losing her independence to him because he not only admires her masculine qualities but is emotionally and socially dependent on her. Ikeda avoids the love trap by inverting it. While the tough but compassionate Oscar, and her heterosexual, homogender romance with Andre, has proved enduringly popular with teenage girls, she is still the product of a narrative compromise. The persistence of gender switching and homogender romance tropes in shojo manga suggests that equality in heterosexual relationships remains a problem for both female writers and female readers.

..

Notes

An earlier version of this essay was presented as a paper at the 2005 annual meeting of the Association for Asian Studies in Chicago. I am grateful to the participants for their insightful comments.

　　1. Yokomori Rika, *Ren'ai wa shōjo manga de osowatta* [I learned about love from shojo manga] (Tokyo: Kuresutosha, 1995), 32.

　　2. *Berusaiyu no bara daijiten* [Big dictionary of *The Rose of Versailles*] (Tokyo: Shūeisha, 2002), 126.

　　3. Gregory Pflugfelder, *Cartographies of Desire: Male-Male Sexuality in Japanese Discourse, 1600–1950* (Berkeley: University of California Press, 1999), 287; Sabine Frühstück, *Colonizing Sex: Sexology and Social Control in Modern Japan* (Berkeley: University of California Press, 2003), 70; Jennifer Robertson, *Takarazuka: Sexual Politics and Popular Culture in Modern Japan* (Berkeley: University of California Press, 1998), 68.

　　4. For examples of girls' magazine illustration, see the Yayoi Museum Web site: http://www.yayoi-yumeji-museum.jp/exhibition/yayoi/0504.html. The museum displays work by girls' magazine artists including Yumeji Takashi, Takabatake Kashō, and Nakahara Jun'ichi.

　　5. Artists include Hagio Moto, Ōshima Yumiko, Yamagishi Kyōko, Ichijō Yukari, and Miuchi Suzue, among many others.

　　6. Ōtsuka Eiji, *Sengo manga no hyōgen kūkan: Kigōteki shintai no jubaku* [The space of expression in postwar comics: The enchantment of the symbolic body] (Tokyo: Hōzōkan, 1994), 65.

　　7. Takeuchi Osamu, *Sengo manga gojūnenshi* [A fifty-year history of postwar comics] (Tokyo: Chikuma Library, 1995), 139. However, singling out the shojo manga artists of the 1970s as a distinct group is historically and ideologically problematic. Rather than consider the manga of the 1970s as an isolated moment in time, it is perhaps more useful to

think of these "classic" manga as part of a continuing process of generic experimentation and innovation. For more on the early development of shojo manga, see Takahashi Mizuki, "Study of *Shōjo Manga:* Analysis of Representations and Discourses" (PhD diss., University of London, 1999).

8. According to Fujimoto Yukari, the first "bed scene" in shojo manga appeared in 1972 in *Rabu geemu* (Love game) by Ichijō Yukari. Fujimoto Yukari, *Watashi no ibasho wa doko ni aru no? Shōjo manga ga utsusu kokoro no katachi* [Where do I belong? The shape of the heart as reflected in girls' comics] (Tokyo: Gakuyō shobō, 1998), 46.

9. Ibid., 114.

10. Matsui Midori, "Little Girls Were Little Boys: Displaced Femininity in the Representation of Homosexuality in Japanese Girls' Comics," in *Feminism and the Politics of Difference,* ed. Sneja Gunew and Anna Yeatman (New South Wales, Australia: Allen and Unwin, 1993), 178.

11. Mark McLelland, "The Love between 'Beautiful Boys' in Japanese Women's Comics," *Journal of Gender Studies* 9 (2000): 7.

12. Matsui, "Little Girls Were Little Boys," 194. Self-indulgence does seem to have taken over the genre: the current trend in many boy-love comics favors endlessly repeating sex scenes over plot and character development, and parody or appropriation of existing texts over originality.

13. *Berusaiyu no bara daijiten,* 123.

14. Ibid., 122.

15. Mizuno Hideko, *Suteki na Kōra* [Pretty Cora] (Tokyo: Mujikan, 2000).

16. More images of the major characters, scanned from the original manga, can be found online at http://members.fortunecity.com/goldstep/ikeda.html, http://www.ladyoscar.com/, and http://www.interlog.com/~dgsimmns/RoV/RoV.gallery.html.

17. Nimiya Kazuko, *Takarazuka no kōki: Osukaru kara posutofeminizumu e* [The sweet smell of Takarazuka: From Oscar to postfeminism] (Tokyo: Kōsaidō, 1995), 228.

18. Ikeda describes the events leading to the Revolution in great detail, which in 1972 would have resonated with the student protests of the New Left.

19. Rosalie Lamorlière was the name of the servant who attended Antoinette in prison before her execution, but Ikeda elaborated on her character and wrote her into the story from the beginning. *Berusaiyu no bara sono nazo to shinjitsu* [The Rose of Versailles, its mysteries and the truth] (Tokyo: JTB, 2003), 149.

20. Oscar tells Rosalie, "I think of you as a younger sister . . . don't forget, I am a woman." Ikeda Riyoko, *Berusaiyu no bara* (Tokyo: Shūeisha, 1994), 2:115.

21. *Berusaiyu no bara daijiten,* 30.

22. Ikeda, *Berusaiyu no bara,* 3:80–81.

23. Ibid., 3:291–92.

24. *Berusaiyu no bara daijiten,* 29.

25. Ikeda, *Berusaiyu no bara,* 4:292.

26. Ibid., 3:306–7.

27. *Berusaiyu no bara sono nazo to shinjitsu,* 114–15.

28. Ikeda, *Berusaiyu no bara,* 5:233.

29. *Lady Oscar* was never released in the United States, although it played in Europe. I have heard anecdotally that *The Rose of Versailles* manga and TV anime versions, in

translation, were very popular in France in the 1970s and 1980s. It would be interesting to examine French reaction to this shojo manga–style retelling of French history.

30. Takayama Hideo, "*Beru-bara* shōjo no nijū-nen" [Twenty years of *Beru-bara* girls], in *Takarazuka no yūwaku: Osukaru no akai kuchibeni* [The allure of the Takarazuka: Oscar's red lipstick], ed. Kawasaki Takako and Watanabe Miwako (Tokyo: Seiyūsha, 1991), 301.

31. Nimiya, *Takarazuka no kōki,* 228.

32. Takayama, "*Beru-bara* shōjo," 301.

33. For further discussion of the Takarazuka version of *The Rose of Versailles,* see Robertson, *Takarazuka,* 74–77. Robertson views Oscar as emblematic of the *otokoyaku,* or actress assigned to male roles, in that she highlights the performative nature of gender.

34. Fujimoto, *Watashi no ibasho,* 47–48.

MASAMI TOKU

• • •

Shojo Manga! Girls' Comics! A Mirror of Girls' Dreams

Historically, many great comic books have existed in cultures all over the world. It may be, however, that in Japan the popularity of manga (comics) and its impact on visual popular culture and society are more significant than in any other culture. In contrast to the United States, where comic books are only for children or collectors, in Japan manga influences all of Japanese society, from preschoolers to adults. Its influence appears throughout Japan in commercials on TV, in advertisements, on billboards, and even in school textbooks.[1] But Japanese manga is no longer just a phenomenon of visual pop culture in Japan. At the beginning of the twenty-first century the popularity of Japanese manga has spread worldwide through comic books, animation, and merchandise. But despite manga's popularity, not many people really understand its significance, its worldwide popularity, its appeal for children, and its difference from American comics. One of the major characteristics of manga is that it has split into boys' (*shōnen*) and girls' (*shōjo*) comics. Regardless of the subject depicted in the story, the main theme of boys' manga is how the heroes become men by protecting women, family, country, or the earth from enemies. The theme of girls' manga is how love triumphs by overcoming obstacles. These generalizations are true to a certain extent; however,

19

the theme of girls' manga has been changing in response to the changing roles of women in the still male-dominated Japanese society.

A TOURING EXHIBITION OF SHOJO MANGA

Since World War II, the role and the value of shojo manga have become significant in Japan, reflecting girls' and women's desires and dreams. In its subjects and expressions, manga reflects female aesthetics and fulfills female dreams. To explore the role of visual pop culture that impacts U.S. society through the phenomenon of manga in Japan, I created a touring exhibition in the United States to introduce manga's value and contribution to visual culture and society with a special emphasis on shojo manga.

The exhibition Girls' Power! Shojo Manga! has two purposes: to examine the worldwide phenomenon of Japanese comics and to develop the media and visual literacy of teachers, students, and the community. These purposes will be accomplished through this touring exhibition and symposia on the cultural and historical backgrounds of this Japanese visual popular culture that exerts such an influence on U.S. society. The exhibition's goal is to examine the treatment of gender roles in shojo manga and to examine how *shōjo mangaka* (girls' manga artists) have contributed to the development of a unique style of visual expression in their narratives, a contribution seldom discussed in the world of Japanese comics. This is the first touring exhibition of girls' comics that includes a discussion of gender issues in manga. The exhibition is intended to open minds to the value of visual popular culture.

> IN ITS SUBJECTS AND EXPRESSIONS, MANGA REFLECTS FEMALE AESTHETICS AND FULFILLS FEMALE DREAMS.

More than two hundred artworks created by twenty-three renowned *shōjo mangaka* are introduced chronologically in three major generations over the last sixty years: the dawn of modern shojo manga (postwar–1960s), the development of modern shojo manga (1960s–1980s), and the new generation of modern shojo manga (1980s–present). The medium reflects the evolution of the social roles of Japanese girls and women during this period. The exhibition also documents how the visual composition of manga mirrors developments in Japanese aesthetics.[2]

FIGURE 1. Exhibition catalog of *Girl Power! Shojo Manga!* Image from *Versailles no bara* (The Rose of Versailles).

THE DAWN OF MODERN SHOJO MANGA

In general, *shōjo mangaka* create manga for girls and women; however, these comic artists are not always female. Most shojo manga in the 1930s and 1940s were created by male *mangaka*. Four of them (Tezuka Osamu, Chiba Tetsuya, Ishinomori Shōtarō, and Matsumoto Leiji) were major contributors to the development of contemporary shojo manga in this early period, although they are now well known for their hit manga and animation for boys and men.[3] The most notable among them is Tezuka Osamu (1928–1989), who is often called the father of modern Japanese manga.

A versatile artist, he wrote both boys' and girls' manga and was the most important early influence on shojo manga artists. Tezuka changed the concept of manga in Japan by creating a new style of expression influenced by narrative film. He took the prevalent comic strip form and expanded the concept by creating story manga. In turn, his influence has gone beyond manga and can be seen in literature and film. One of his well-known shojo manga is *Ribbon no kishi* (Ribbon knight, 1953–56/1963–66), which depicts the story of Princess Sapphire, who, through an angel's mischief, was born a girl with both a male and female spirit. In the story, she transforms into a knight to defeat the conspiracy to take over the throne of Silver Land Kingdom. The story's main theme is Sapphire's identity struggle: to be a boy and rule the kingdom or to be a girl and marry a prince, Frantz Charming. The story ends happily ever after with Sapphire marrying the prince. Tezuka's most famous shojo manga story indicates the situation of female life in Japan at that time, when women had to choose between limited careers in the business world or marriage.

> IN MOST CASES IN THE EARLY 1950S MALE *MANGAKA* STARTED THEIR CAREERS AS GIRLS' *MANGAKA* AND THEN SWITCHED TO BOYS' MANGA AFTER ESTABLISHING THEIR CAREERS.

In most cases in the early 1950s male *mangaka* started their careers as girls' *mangaka* and then switched to boys' manga after establishing their careers. For example, Chiba and Matsumoto started their careers as *shōjo mangaka* during the 1950s because the *shōnen* manga society was already dominated by senior male *mangaka*. They found opportunities to pursue careers in the world of shojo manga even though they did not know much about girls' desires and expectations. Chiba admits that he asked his wife about girls' feelings and aspirations. Matsumoto reluctantly started his career as a *shōjo mangaka* by negotiating the subjects in shojo manga and coming up

with a story of friendship between his favorite animals and girls' heroines. Because women in Japan were not allowed careers except for limited jobs such as schoolteachers, manga society was not open to female comic artists.

Thus the world of shojo manga was a place for young male *mangaka,* but not for female *mangaka,* to develop their careers before going into boys' manga. Nevertheless, there are many great stories of strong-willed heroines who never gave up hope despite the tragic destinies created for them by male artists. Shojo manga captured girls' hearts and kept on giving them hope to survive and even find happiness in the harsh postwar world. There is no doubt that it was limited in reflecting girls' desires and expectations, since it was created by male *mangaka.* With the growth of the economy in Japan, many Japanese female *mangaka* who were originally influenced by these male *mangaka,* especially by Tezuka, started to depict their own desires and dreams from their own points of view as women in the 1950s. This ushered in the true

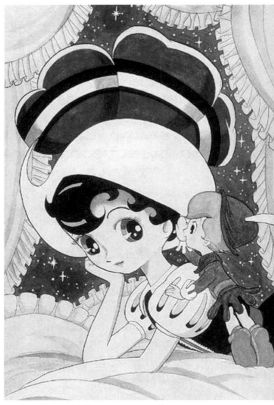

FIGURE 2. Tezuka Osamu, *Ribbon Knight,* 1953–1956, 1963–1966. Copyright Tezuka Production.

dawn of modern shojo manga in Japan, when female artists who shared the same desires and dreams with girls created shojo manga for them.

Watanabe Masako, Maki Miyako, and Mizuno Hideko are the most successful female *shōjo mangaka* of this period. The major topic of girls' manga then was how girls grow up under severe circumstances, fight obstacles, and finally achieve happiness. These female *mangaka* successfully depicted girls' dreams with diverse and entertaining themes. One favorite subject was the story of looking for true love of mother (or family members). For example, Watanabe often created stories about the reunion of twin sisters who grow up separately or are accidentally switched at birth: one in a wealthy family and one in poverty (e.g., *Shōkōshi* in 1953 and *Glass Castle,* 1969–70). The main theme depicted in Watanabe's stories is of family members separated by uncontrollable destiny and finally meeting after a long journey. Maki, in contrast, created a story of a relationship struggle between a mother as a successful ballet dancer and a daughter abandoned by the mother in pursuit of success. The heroine eventually gets both her mother's love and success as

a ballet dancer (*Hahakoi Waltz*, 1960). Separation, forced or voluntary, reflects the reality of postwar Japan. Reunion also reflects women's desires under the postwar circumstances. The themes created by female *mangaka*, the pioneers of modern shojo manga, clearly represent their own desires to both find love and pursue careers.

In this period, the heroines are often depicted as cute, innocent, and patient girls, but with strong wills to change their tough lives to be happy or successful. The heroine's image idealizes girls' figures and styles.[4] The backgrounds are always decorated with beautiful flowers and Western-style houses with gorgeous furniture to emphasize an ideal life that most Japanese girls had never seen at the time. The themes and images of an ideal Western world in those days made it easier for Japanese girls to live in the harsh postwar world. Both Watanabe and Maki created stories for themselves with images of things that they wanted but never had.[5] As ideal expressions of their own dreams, their shojo manga were full of colorful images that attracted Japanese girls.

With these women, the world of shojo manga depicted by men was replaced by the vision of female *mangaka*. These women were the precursors of the following female *mangaka* in contemporary manga, but at the same time they are also vital artists who continue to develop their interests in their own visual worlds, exploring new areas such as suspense and erotic manga.

THE DEVELOPMENT OF MODERN SHOJO MANGA

Contemporary Japanese manga developed under the strong influence of American pop culture, including American comics and Disney animation, after World War II. In those days, manga was only inexpensive children's entertainment that made it easier to live in the devastated postwar society in Japan. Thus manga started as a way for children to buoy up their dreams. It gradually developed from simple caricatures to complicated stories in response to readers' demands and expectations. The first boys' weekly magazine, *Shōnen Magazine*, was published by Kōdansha in 1959, and the first girls' weekly magazine, *Shōjo Friend*, was published by Kōdansha in 1963. The children who supported the manga market were born between 1947 and 1950.

When the first girls' weekly magazine was published, these children were becoming teenagers. Before this period, children had stopped buying and reading manga after elementary school. However, this generation did not stop even after high school, finding manga more attractive than other media, such as TV and movies. As a result, the number of magazines published grew in response to readers' diverse expectations, so that the age of manga readers spread from children to adults during the 1960s. After the 1960s, diverse manga were developed for different ages and genders and addressed favorite themes and subjects. One example is the development of *gekiga* ("visual novels"), more serious and realistic story manga with diverse fiction and nonfiction themes, mainly in adolescent male manga magazines. Subjects like sex and violence were no longer taboo in manga from that point.

The influence of *gekiga* appeared in female manga magazines as "ladies' comics" in the mid-1970s in response to older female desires. These manga depicted the realities and obstacles of life after marriage, unlike shojo manga, which concentrated on finding true love. For example, as her interests have matured and changed with age, Maki, who started as a girls' *mangaka* with sweet stories for young girls in the 1950s, has targeted the older audience of ladies' manga, creating artwork that is more personally relevant and interesting to her.[6] Maki is the first female *mangaka* to use the *gekiga* style and develop ladies' comics to depict the realities of women her age in response to mature women's expectations. After 1979 Watanabe also started to create comics aimed at women in their twenties and thirties. In depicting the human drama of women's lives, she included graphic sex scenes, saying that sex was a part of the human condition and that it was necessary to include it as a part of the drama of everyday life. At the same time, she has published many manga of her own interpretations of great literature, including the nineteenth-century Chinese erotic novel *Kinpeibai*, which is still banned in China.[7]

THE 1970S COULD BE CALLED THE GOLDEN ERA OF SHOJO MANGA.

The 1970s could be called the golden era of shojo manga. Many *shōjo mangaka* were recruited and developed through the manga correspondence schools of girls' manga magazines.[8] Satonaka Machiko, Ikeda Riyoko, Miuchi Suzue, and Ichijō Yukari are the most successful and greatest contributors to shojo manga in this era.[9] Each artist has a different character, but they all share their high quality and skill as storytellers regardless of the genre, such as drama, horror, suspense, history, comedy, and adventure. Human drama continues to attract readers of all ages.

FIGURE 3. Watanabe Masako, *Kinpeibai, 1995–present*. Courtesy of Watamabe Masako.

Another significant group of *shōjo mangaka* who contributed to the development of sensitive and intellectual shojo manga is the *24 nen gumi* (the "Magnificent 24s": female *mangaka* who were born around 1949, which is Shōwa 24 according to the Japanese calendar). With the arrival of the *24 nen gumi* (Takemiya Keiko, Hagio Moto, Yamagishi Ryōko, and Ōshima Yumiko), the world of girls' manga flourished with diverse subgenres of sci-fi, love, history, adventure, and so on, becoming more and more visually inventive.

This group is especially famous for introducing the theme of homosexuality. Sensational at the time, it led to the creation in the next generation of a major subgenre, "boys' love," in shojo manga. In 1976 Takemiya wrote the first commercially published boys' love story, the masterpiece *Kaze to ki no uta* (*Poem of Wind and Trees*), about a French boys' school, which caused a sensation for its depiction of the love–hate and openly sexual relationships among three males. At that time, this type of manga was mainly published in *dōjinshi* (fanzines), but after the publication of *Kaze to ki no uta* in shojo manga, the contents of shojo manga (which had no depictions of sexual love between men and women) changed. The success of this story prompted the development of the genre of boys' love within the shojo manga world. The "boys" that Takemiya creates are neither real-life boys nor dream-princes for the girls in the story but boys with independent minds and beautiful bodies whom girl readers simply adore. These boys are the symbols of girls' wishes to be independent and pure, and not objects with which to fall in love.

Another significant development in shojo manga of this period was the boom in "otometic" stories, stories about love and the coming-of-age experiences of teenage girls. Since most female readers could identify with the stories, it became a major subgenre.[10]

Since the 1960s, manga has been developing to meet mature readers' expectations. In other words, the themes in manga reflect changes in Japanese social and cultural conditions. In the mid-1970s, shojo manga also split into girls' comics and ladies' comics in response to the aging of readers. These female *mangaka* continue to depict and develop manga in response to readers' expectations and the art-

FIGURE 4. Takemiya Keiko, *Poem of Wind and Trees*, 1976–1984. Courtesy of Takemiya Keiko.

ists' own aesthetics as graphic novelists. In female manga, especially ladies' comics, the voiceless voices reflected Japanese females' real feelings toward their life and destiny, which were limited by social roles and values in Japan. At the same time, manga was renamed "graphic novels" because of the quality and the diversity.

THE NEW GENERATION OF MODERN SHOJO MANGA

A major trend in shojo manga in the 1980s was the influence of *mangaka* from the comic markets. Comic markets (known also as Comiket or Co-mike), which started as places for amateur comic artists to sell their original manga, have become a worldwide phenomenon, appearing not only in Japan and other Asian countries but also in the United States. The original Tokyo comic market, which started in 1975, has become a biannual event with twenty-five thousand *dōjinshi* groups and five hundred thousand participants over three days in 2005. CLAMP (the group of four female *mangaka*, Igarashi Satsuki, Ōkawa Ageha, Nekoi Tsubaki, and Mokona) might be the most successful *mangaka* who have been able to cross over from the amateur comic market into the world of professional manga. They attract vast audiences of diverse age groups with their megahit manga, several of which have been animated for TV and film, as well as used for multimedia products and merchandise.[11] The process that these four manga artists use to create and develop each story is more complex than that of any other shojo manga where artists in general create a story by themselves, although they may use assistants. The role each *mangaka* of CLAMP takes in developing each story depends on the story's subject, since each artist has her own unique talents. The four members collaboratively develop the scenario and then divide the work and bring the parts together at the end. As their roles vary with each project, their visual style can be dramatically different from project to project.

> "WHY ARE THE COUPLES DESCRIBED IN YAOI MALES? ONE OF THE REASONS IS TO ELIMINATE POWER STRUCTURES BETWEEN COUPLES OF DIFFERENT GENDERS."

One significant phenomenon of comic markets is the genre of homosexual boys' love parodies in manga and novels called "yaoi" and "boy's love," which are depicted by female manga fans.[12] While groups of university students created *dōjinshi* with original characters and plots, at the same time manga and anime fan clubs produced parodies of characters from commercial manga and animated cartoons. The term *yaoi* is an acronym of three phrases: *yama nashi, ochi nashi,* and *imi nashi* (no climax, no point, no meaning).[13] In the eighties *yaoi* became synonymous with M/M—parodies of popular manga and animation characters in what appear to be gay relationships in which explicit and sometimes violent sex is shown. "Boys' love," termed *shōnen ai* in Japanese, refers to *dōjinshi* about highly romantic, gentle, loving, and cuddly male-male

relationships in which explicit sex is seldom suggested. Both *yaoi* and boys' love are, according to their creators and consumers, forms of love "superior" to heterosexual varieties. There are many interpretations of why female amateur *mangaka* (*dōjinshi* creators) are interested in boys' love as their favorite theme. Yoko Nagakubo says, "Why are the couples described in Yaoi males? One of the reasons is to eliminate power structures between couples of different genders. In heterosexual love relationships, it is extremely difficult to exclude the normal power structures in which men are strong and women are weak. Using male couples makes it possible to describe a more equal relationship between two individuals."[14] Yoshinaga Fumi, one of the major boys' love *mangaka* originally from the

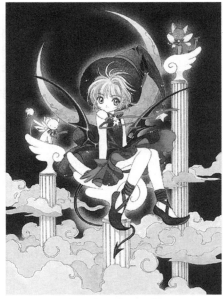

FIGURE 5. CLAMP, *Card Captor Sakura*, 1996–2000. Copyright CLAMP.

comic markets, explained the reason she creates a story: "I want to depict people who try very hard but don't make it. In boys' magazines people who try hard always win. That is not what I want. I want to show the people who didn't win, whose dreams didn't come true. It is not possible for everybody to get first

FIGURE 6. Yoshinaga Fumi, *Western Antique Pastry Shop*, 1999–2000. Copyright fumi yoshinaga/ shinshokan.

prize. I want my readers to understand the happiness that people can get from trying hard, going through the process, and being frustrated. The job I got was with a boys' love magazine, so I decided to show my philosophy through boys' love. Boy's love stories deal with minorities. I show the pains of gays who can't fit in. Minorities have to deal with society before they can achieve happiness."[15]

When this phenomenon appeared in the 1980s, major publications totally ignored its popularity. But the genre of boys' love has become a major part of the world of shojo and ladies' manga, and it has begun to appear in mainstream Japanese visual culture (such as TV series) today.

THE FUTURE OF SHOJO MANGA
IN THE UNITED STATES

The influence of the manga movement continues to spread with translated comics, animation, and other merchandise. Shojo manga also continues to diversify in response to readers' demands. Shojo manga has been hugely popular in Asian and European countries since the 1990s. The same phenomenon is just beginning in the United States. In June 2005 the monthly shojo manga anthology *Shojo Beat* began publication in the United States, two years after a monthly shōnen manga anthology, *Shonen Jump,* began publication. The *New York Times* has said that shojo manga has "become one of the hottest markets in the book business" and that two publishers, Viz Media and Tokyopop, "have been the leaders in the American manga market, which has more than

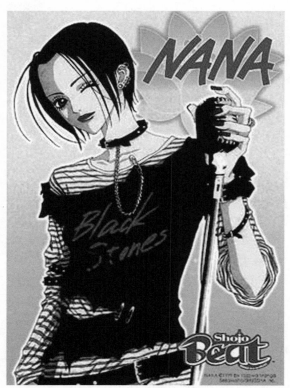

doubled since 2002, helped along by a $5 billion [global] business in related animated films, TV series, and licensed products like dolls and action figures."[16] Boys' love is a big phenomenon not only in Japan but also in the United States. The *New York Times* also mentions that the topic of boys' love has become significantly popular even in commercial publications in the United States. In Japan the topic of shojo manga seems to have no limitations, and love between women has started to appear.[17] As the original theme of shojo manga is "love," the eternal theme of shojo manga is still "love," regardless of the subjects in diverse styles such as drama, sci-fi, or suspense.

Shojo manga is said to be a mirror of Japanese girls' and women's desires and expectations. In its subjects and expressions, manga reflects female aesthetics and fulfills female

FIGURE 7. *NANA* postcard. Copyright 1999 Yazawa Manga Seisakusho/Shueisha Inc.

dreams. But manga not only reflects social aesthetics and values throughout Japan, it influences them. It will be interesting to see how this taste of shojo

manga will affect visual cultural society in the United States and whether it will lead to a renaissance of girls' comics in the United States that will reflect and influence U.S. audiences' desires and expectations as well.

Notes

1. In 1998 the Ministry of Education decided that the issue of visual popular culture, including anime and manga, should be adapted into the national art educational curricula, especially for eighth and ninth grades. Anime and manga became part of the curriculum in 2002.

2. Masami Toku, "Visual Cultural Research in Art and Education," Shojo Manga Web site, http://www.csuchico.edu/~mtoku/vc.

3. For example, Tezuka Osamu's *Tetsuwan Atom* [Astro boy], Chiba Tetsuya's *Ashita no Jō* [Tomorrow's Joe], Ishinomori Shōtarō's *Kamen Rider* [Mask rider], and Matsumoto Leiji's *Ginga tetsudō 999* [Galaxy Express 999].

4. It is well known that Maki's heroines are used to represent ideal Japanese girls, the best example being Licca-chan, a kind of Japanese Barbie doll made by the Takara Toy Company starting in 1967, which became a megahit that continues to sell forty years later. See Licca-chan Web site at http://web-japan.org/kidsweb/cool/01-10-12/licca.html.

5. In personal interviews, both Watanabe (July 9, 2005) and Maki (August 10, 2005) mentioned the motivation for their creation of shojo manga.

6. In 1968 she published the serial manga *Mashūkobanka* [Mashūko Lake elegy] through the ladies' magazine *Josei Seven* (Women Seven). Since then she has published many manga in the *gekiga* style in both male and female manga magazines.

7. While other *mangaka* tailor their work to readers' demands, Watanabe has always followed her own path of discovery, and that search has kept her active as a prolific artist for over fifty years. Her manga, based on universal human themes, has weathered time well and continues to attract new readers.

8. In Japan, most young people who want to be *mangaka* tend to apply for manga competitions, which are biannually organized by the weekly and monthly manga magazines. This system is beneficial not only for participants (amateur *mangaka*) to get opportunities to debut as professional *mangaka* but also for publication companies to find and recruit talented artists for their companies.

9. See, for example, Satonaka's story of the first female emperor of Jitō, *Tenjō no niji* [Rainbow in heaven, 1983–], Ikeda's spectacle that revolves around a love story set during the French Revolution, *Versailles no bara* [Rose of Versailles, 1972–74], and Miuchi's ongoing serial *Garasu no kamen* [Mask of glass, 1976], the story of one girl's rise to fame in the theater.

10. Mutsu A-ko, Iwadate Mariko, and Kuramochi Fusako are representative artists of this genre.

11. Their most recent successes are the animated film XXXHOLiC, released in 2005, and the Japanese Public Television (NHK) animated series *Tsubasa—RESERVoir CHRoNi-CLE* (Wings—RESERVoir CHRoNiCLE).

12. Brent Wilson and Masami Toku, "'Boys' Love,' Yaoi, and Art Education: Issues of Power and Pedagogy," in *Semiotics and Art/Visual Culture*, ed. Deborah Lee Smith-Shank (Reston, Va.: National Art Education Association Press, 2003), 94–103.

13. The term *yaoi* was coined in the late seventies by Kanazawa region *dōjinshi* artists, including Sakata Yasuko and Hatsu Rinko. *Yaoi* is an ironic subversion of a traditional Japanese narrative structure consisting of an introduction, development, transition, and conclusion (Natsume, interview with author, June 6, 2002).

14. Yoko Nagakubo, "Yaoi Novels and Shojo Manga" (Girls' Comics)," in *Shojo Manga! Girl Power!* ed. Masami Toku (Chico, Calif.: Flume Press, 2005), 17.

15. Yoshinaga, interview with author, July 14, 2005.

16. Sarah Glazer, "Manga for Girls," *New York Times,* September 18, 2005, http://www.nytimes.com/2005/09/18/books/review/18glazer.html.

17. Fujimoto Yukari mentions that "although boys' love was popular in the 1990s, the issue of lesbianism was practically taboo. Still, even in the 1990s, positive depictions of lesbians started to appear. Originally, the theme of shojo manga was women falling in love with men, but the trend has been to include a wider range of women's experiences, showing women how to live. Love is not seen as everything, but is rather one part of life. Things like friendship between women can be more important than love, as in *Bishojo Senshi Sailor Moon* (1992–1997) and *Shojo Kakumei Utena* (1996–1998)" ("A Life-Size Mirror: Women's Self Representation in Girls' Comics," in Toku, *Shojo Manga! Girl Power!* 16).

MEREDITH SUZANNE HAHN AQUILA

Ranma ½ Fan Fiction Writers: New Narrative Themes or the Same Old Story?

We have a new public sphere. It is everywhere and nowhere. It includes everyone, yet it holds no clear identity for anyone. It is both terrifying and exhilarating. It is new media: a jumble of contradictions and desire, all nervous predictions and all shining potential. It is the latest thing, and it is the same old story. Looking at media studies and communication research, we can see conflicting perceptions of new technology such as blogs, Web rings, live journals, and ensuing human-media interactions.

Scholars such as Charles H. Cooley have warned against homogenization through globalization as they watched the world modernize into a mass society following industrialization and urbanization.[1] The changes to society led many to denounce media technology from fear, ignorance, or anecdotal evidence. We can occasionally find evidence that such "technophobia" remains a concern today. With the possibility of the loss of individual or group identity to mass culture, is it any wonder that many scholars have previously treated media audiences as homogenized groups and occasionally continue to do so?

These fears are completely valid in light of the fact that media, to a certain extent, *do* homogenize, if only by treating us all the same way. At the

very least, media hope for an idealized audience, which for commercial purposes *is* a homogenized one. For mass media to be usable, they must, by nature, be somewhat universal. A television commercial, for example, must be accessible to all viewers in the range of its broadcast in order to have any significant economic impact. This commercial pressure necessitates a certain amount of oversimplification of media messages, a sort of appeal to the lowest common denominator, if you will. However, simply because a medium demands simple, unified messages and constructs such messages with generalized audiences in mind is no reason for us to believe (as scholars once did) that audiences treat messages identically. Indeed, such a practice is seen less and less as we look at communication research throughout its history.

Over time, "hypodermic needle" theories of homogenous media effects upon passive, easily influenced audiences have given way to theories of selective attention, modeling factors, opinion leaders, social networks, and spirals of silence, all of which suggest that audiences are composed of individuals who perceive and respond to media in different ways depending upon social cues and environment, past and present.

Rather than focus wholly on the media and their messages, researchers in the recent past began looking at the consumers of media and the psychological, sociological, cognitive, relational, and contextual influences on media effects. Audiences were seen as having unique perspectives that caused them to act in unique ways, or perhaps not to act at all. Shearon A. Lowery and Melvin L. DeFleur refer to this phenomenon as "the theory of selective influence based on individual differences."[2]

The primary similarity among all of these theories is their practice of rejecting earlier media effects theories. The dominant theories of the last few decades have moved toward a view of audiences as active, socially bound individuals who vary in their uses and treatments of media messages. These discoveries were important and useful, but they still did not go far enough. Viewers were still seen as either aware or passive, but not truly *active*. More recently, scholars have taken that next step. Whereas we once saw audiences as passive absorbers of mediated messages and later as selective interpreters of media, we now see them as active participants in meaning formation.

Raymond A. Bauer, for example, stated that previous works did not give audiences enough credit as thinking human beings but instead dehumanized them into robots or animals guided only by instincts and reflexive responses. He believed, however, that although it was rational and had self-control, "the audience [was] not wholly a free agent; it must select from what is offered."[3] Today we know that audiences can not only choose *not* to choose

(they do not have to select from what is offered), but beyond that they can create new choices for themselves that better meet their needs and desires for mass media.

Based on the works of Michel de Certeau and Pierre Bourdieu, Henry Jenkins's theory of participatory fandom places individuals in a position of power in relation to media. Not only can they select media content and process it, but they can influence it as well. In his book *Textual Poachers: Television Fans and Participatory Culture,* Jenkins examines how audiences can actively engage media content to change media consumption from a passive process to a creative, thoughtful process that he refers to as "textual poaching."[4]

Textual poaching is the act of taking preexisting work (a television show, a movie, etc.) and making it one's own either through such actions as writing fan fiction based on the original text, writing original songs based on existing characters, publishing newsletters or Web sites devoted to the material, or even writing to the creators to make suggestions or demands about a favored text.

In some cases, these actions can be subversive: writing a story that changes the ending of an existing television episode, for example, or rewriting a movie script to include a homosexual romance rather than a conventional heterosexual love story. In other cases, the "poachers" work hard to stay true to their favorite materials and merely build upon existing works to extend the material and enhance their media experience. In a few instances, such poaching has led to writing jobs for fans.

Jenkins defines his view of the nature of media audiences as a "participatory culture." Rather than look at how individuals are affected by media, he examines how individuals affect media. He does not confine his attentions to media producers, either. He places power in the hands of viewers who may in turn become secondary producers through textual poaching. Under previous paradigms, society rejected fans for engaging too closely the media they enjoyed. This was often seen as antisocial and unhealthy or, at best, a little odd. Much as children are often feared to be vulnerable to media, fans were often seen as "cultural dupes" unable to tell fantasy from reality.

Today we are pressured to question whether these "fan-atics" are really the ones who are missing something. They use mass media as a starting point to create elaborate materials to meet their own needs and desires, they connect socially to other fans in a culture of tastes, and they actively engage mass media when they feel strongly about what they are being shown. Contemporary scholars are now pondering the possibility that it is everyone else who is missing something.

Jenkins treats "fans as active producers and manipulators of meanings."[5] Not only can fans reject the choices offered by media and work to change what is available, but, under Jenkins's view, they have the ability to reject society as

HENRY JENKINS'S THEORY OF PARTICIPATORY FANDOM PLACES INDIVIDUALS IN A POSITION OF POWER IN RELATION TO MEDIA.

well by subverting reality within their own creations. Through new technology (Web sites, chat groups, mailing lists, etc.) fans find others who share even their most unconventional tastes and habits, and they unite. Over time, these "countercultures" grow and attract the attention of the mainstream until they gain at least a measure of acceptance and become subcultures of society. In some ways, this refutes Elisabeth Noelle-Neumann's "spiral of silence" concept by empowering minority voices within the majority culture.[6] Still, today's theories of truly active viewing, media citizens, and participatory fandom are not wholly without their problems.

This chapter addresses both positive and negative views of new media technology to show where they blend and where they clash. More specifically, it looks through the lens of anime fan activity in order to expound upon the complexities of the relationship between media, fans, and narrative. To this end, I focus on the work of Henry Jenkins, a longtime scholar of fan culture.

Jenkins's work provides a strong foundation from which to observe how new media such as the Internet, blogs, live journals, and so forth affect narrative, genre, and myth. I attempt to pick apart Jenkins's argument using the specific example of *Ranma ½* (a manga series originally published in Japan from 1987 to 1996) and the perspectives of various other authors in order to better understand its strengths and weaknesses in helping us understand the ties between media and storytelling.

FAN-FICTION CLASSIFICATIONS AND JENKINS'S CONCEPTUALIZATION OF TEXTUAL POACHING

Japanese animation, or "anime," is quickly gaining a large fan base in the United States. What began as a cult following based upon pirated films has blossomed into an enormous fan community, as anime becomes increasingly accessible worldwide. Numerous activities catering to fan demands—conventions, fan magazines, anime clubs—have become widely available. Most interesting, however, is the bond that has developed between writers and readers of anime fan fiction ("fan fics") on the Internet.

These writers and their readers have carved out a niche for themselves as a fan culture, despite the fact that they generally never meet in person. Even though Jenkins could probably have never envisioned such communities when he wrote about participatory fandom in his book, these fan writers support his proposal that fans are "active producers and manipulators of meaning" rather than passive "cultural dupes, social misfits, and mindless consumers."[7] Fan fiction writers follow many of the patterns that Jenkins delineates. They are a close-knit group that works to expand their favorite series, fill in the gaps left by the original producers, and create depth where there previously was little or none for the characters. From Jenkins's perspective, it can be said that these writers do this primarily through the manipulation of mythic structure and genre within new media.

An entire library could be written about anime and its related fan literature, but for simplicity's sake I examine *Ranma ½* because it is widely known (it has been available in anime and manga form since the early 1990s) and fairly representative of most anime fan communities. *Ranma ½* tells the story of a teenage martial artist named Saotome Ranma. During a trip to a training ground in China, Ranma-kun fell into an ancient, cursed spring. Now, whenever he is splashed with cold water, he transforms into a teenage girl (Ranma-chan). Hot water reverses the effect, but only until the next dunking. Being a proud young man, Ranma is understandably mortified and eager to regain his full masculinity. However, he is forced to put his plans on hold when his father, Saotome Genma, reveals that long ago he betrothed Ranma to the daughter of an old friend, Tendō Sōun. Now that Ranma is fifteen, it is time for him to meet his fiancée. On the day of the meeting it is raining hard, but Genma insistently drags a loudly protesting Ranma-chan to the Tendō Dōjō. Once there, they discover that Sōun's late wife had not one but three daughters—Kasumi (age nineteen), Nabiki (age seventeen), and Akane (age fifteen). Initially, the girls (who were wary of their father's matchmaking) are very pleased to see that Saotome Genma has a daughter. However, once they learn of the curse, they realize that they are not free from the bridal contract, and one of them must marry Ranma as ordered by their father. Akane is immediately elected because she is the same age as Ranma, and she hates men (and Ranma is only half a man). Thus begins a bitter engagement between two unwilling partners.

Many types of fan fiction have been written around this show. Some of the most common fan-created genre titles (and these are used for other shows besides *Ranma ½*) are WAFF stories, angst-fics, lemons, crossovers, self-insertions, and alternate universe fics. Although these do not match

Jenkins's terminology perfectly, they are all very similar if not identical to his definitions of fan genres.

MANY TYPES OF FAN FICTION HAVE BEEN WRITTEN AROUND RANMA 1/2.

"Warm and Fuzzy Feeling," or WAFF stories, are those that focus on romance. In the case of *Ranma ½* that typically means a story in which Ranma finally admits to Akane how he feels about her, though it can also involve other characters from the show. Angst-fics are darker tales often involving drama, violence, and adult issues; for example, Ranma becomes depressed over his unrequited love for Akane and turns to drugs or suicide. WAFF stories fall under Jenkins's classification of emotional intensification; hints of romantic or friendly motivations are brought to the surface and allowed to take flight in the narrative.[8] Angst-fics have a similar intensifying function, although they tend to center on antagonistic, depressive, or malevolent emotions.

Lemon is the term used to describe sexually explicit portrayals of anime characters. This category has various degrees from "limes," which have only implicit sexual content, to "lemon-scented" or "lemonade" fics that have small smatterings of explicit sex, to all-out *hentai* fics. *Hentai* is the Japanese word for pervert. This genre is characterized by explicit and graphic descriptions of sex, and stories often include unconventional sexual activity. In a category that often lies beside or within lemons and *hentai,* we find "yaoi-fics." *Yaoi* can loosely be translated as "slash" fiction, a type of story generally involving romantic homosexual encounters (e.g., "Kirk/Spock" or "Batman/Robin"). A *yaoi* Ranma fic might involve Ranma and Ryōga (another male character who has a friendly rivalry with Ranma and who some say should end up with Akane). This type of story could have any amount of sexual content, but generally it would be expected to have explicit intercourse between the two male characters. Lemons and *yaoi* can easily be compared to Jenkins's definition of an "eroticisation" fan fiction.[9]

Crossover stories—and this is the same category title used by Jenkins—mix characters or settings from two or more of the author's favorite series, while self-insertions, or "personalization" as Jenkins called them, allow the author to place himself or herself into the narrative.[10] Alternate universe stories (A.U. fics) are flexible in their definition. Such a story may place a favored character in a new setting, for example, outer space or the ancient past. Other A.U. fics will simply change the events of the series into a sort of parallel universe of the original. An example of this would be a story that answers the question, what if Ranma had never been cursed? Or what if Ranma had been engaged to Nabiki instead of Akane? These styles can be compared to Jenkins's "character dislocation" category.[11]

FAN ACTIVITIES AND MEDIA EFFECTS
UPON MYTH AND GENRE

Examining the above fan-fiction classifications, either in Jenkins's terms or in the commonly used jargon of the fan-writing community, shows the effects that media may have upon myth and genre. As anime material crosses from one medium into another, the "rules" of narrative become hazy and breakable. Mainstream values and expected norms that apply to the mass media of television and film (which are mostly commercially controlled and traditionally associated with passive viewing) cease to be gospel, and the sky becomes the limit. When anime fans poach characters and settings from television shows, films, and manga and bring them to Internet chat forums, Web rings, blogs, and personal home pages, they take on the power of the commercial producer. They can change endings, alter personalities, substitute genres, and even break out of the mainstream entirely. These new media allow for the accessibility of content, making it seem less untouchable and more malleable.

As Jenkins points out, fans are not passive viewers of commercially produced materials. They do not fit neatly into Stuart Hall's models of encoding and decoding.[12] They are active, critical participants in meaning production. The activity can come in the form of fan letters and script submissions, but more often, it is seen in the form of underground poaching of copyrighted material for personal entertainment and interpersonal circulation. The resulting texts claim the original material and transform it into something that better reflects a fan's own values, expectations, and desires.

Through fan writing, characters such as Ranma can discard their child archetype personas and become weak, vulnerable, or corrupt. Quests are forgotten, sacrifices are denied by those who would normally rush to be martyrs, and historically common perceptions of time, space, nature, and gender are all subverted. Unrequited love need not remain that way, and villains need not lose.

Everything that is familiar, everything that is expected, everything that is "normal" in narrative is no longer taken for granted when fans get their hands on a text. By bringing together small groups of people whose preferences and desires do not fit into the mainstream, taste cultures are created and allowed to grow online. The ability of fans to circulate widely the products of their taste cultures on the Internet means that characters and story lines that could never exist in the popular media may flourish. Genre may also be explored and warped. Favorite characters can be (and are) placed into

new genres (such as Ranma lemon fics—Takahashi Rumiko's work is considered by most to be appropriate for young teens), and within genres, rules are also broken. Fans often break cyclical patterns common to the romantic-comedy genre (such as Ranma and Akane's tendency to fall in and out of love at the drop of a hat). This may come in the form of an angst-fic that motivates Ranma to give in to his frustrations and just kill Akane. It might also come in the form of a WAFF fic that ends with a martial arts–themed wedding.

Commercially minded production companies create films and television programs based upon centuries-old mythic structures and formulaic genre patterns, then send them out into the world where fans pick them up, dust them off, and repossess their content to create something new and individual. As Barbara Stafford puts it, "Indifferent or fleeting cast-offs—like vanishing sensations—are alchemically metamorphosed into cherished, enduring objects for every man and woman."[13] To put it more simply, fans take mass-produced cultural products and mark the material as their own through fan activities that alter the traditional original form and turn it into something unique and personal. They subvert mainstream media to meet their own individual needs and desires.

TEXTUAL POACHING THROUGH NEW MEDIA AND THE SUBVERSION OF GENRE: SOME CAVEATS

It is true that the change from traditional mass media (television, radio, and film) to newer, more audience-centered media (niche-based cable programming, Web rings, specialty Web sites, etc.) seems to allow for a certain amount of creativity, but we must be careful to avoid technological determinism or overeager assumptions. The opportunity to influence narrative has been available since before written stories even existed.

Storytellers have shaped and reshaped popular tales throughout history. Jenkins himself admits that various fan magazines have circulated ever since the invention of ditto sheets. Even if they could never reach as many people as the modern Internet, they were present, and they were in some ways subversive from the popular communication perspective of passive media usage at the time. Not only has the opportunity always been present, the opportunity has been regularly rejected by fanatics and nonfanatics alike.

What Jenkins seems to ignore is the fact that the possibility/increased ease of subversion and change does not *guarantee* any degree of subversion or change. Most fans are rather hesitant to handle their idolized materials.

> THE MAJORITY OF FAN READERS AND WRITERS DO NOT APPROVE OF STORIES THAT GO TOO FAR IN REBELLING AGAINST THE ORIGINAL INTENTIONS OF THE SERIES' CREATORS.

Jenkins unknowingly reports this when he describes commonly held societal beliefs that fan activities are somehow freakish or inappropriate. Getting too close to one's favorite material is often frowned upon, especially if that material is something that is not popular among the larger culture (Jenkins's primary example was *Star Trek*). As I show in a moment, even within active, participatory fan groups, many fans are outright resistant to any sort of drastic change. Furthermore, when fans *do* engage in subversive activities through taste cultures, we often find that in time, their actions gain notice, gain imitators, and, eventually, gain at least some degree of mainstream acceptance sometimes to the point of popularization and commercialization. Shefrin shows us how fans can even become valuable contributors to Hollywood offerings such as *The Lord of the Rings* by attracting the attention of mainstream directors who actually solicit their advice.[14]

We must always remember: although technology may make all things possible, it does not make all things probable. It is true that the Internet and related, customizable media make it easier to create, circulate, and locate subversive fan material. However, it is also true that the new media fabricate, disperse, and pinpoint these subversions while under the control of human hands and minds—hands and minds that are not always eager to subvert. Thus it is that fans, more often than not, seem to feel most comfortable when their expectations are fulfilled, and things continue to run in the same way or, at least, in a similar way to what has come before. We can see this when we examine which fan genres are the most widely accepted.

Recontextualization, expansion, refocalization, and emotional intensification are generally the norm among anime fan writers.[15] Members of this community generally seek to expand upon existing knowledge of a show, explain character motivations with fabricated backgrounds, bring minor characters into the spotlight, and magnify existing emotions. As Jenkins noted, however, there are also those (and they are generally less popular) who prefer personalization (referred to as "self-insertion" by this community), character-dislocation (A.U. fics), and crossovers. These formats allow fans to truly enter the universe of their favorite characters (much to their readers' chagrin) and mix characters from various favored series (often changing personalities and alignments in the process) in an infinite number of settings. Some consider this blasphemy and "scrutinize for any signs of autobiographical intent" as they read.[16]

Although anime fans show examples of all of Jenkins's methods of

textual poaching, some activities are clearly more widely accepted than others. We learn this from looking at which authors are the most popular and which stories are most commonly chosen for ridicule, either through flaming or through "MSTing." A flame is a negative critique of a fic without constructive criticism. A reader would be "flaming" a writer if he or she said something to the effect of "this story stinks and the writer should be shot." Flaming is universally frowned upon, but it does occur. MST sites (named after Mystery Science Theater 3000, a show that spoofs old B movies) are a commonly accepted form of critique that devote themselves to laughing at notoriously poorly written fics by posting sarcastic comments and parodies (an activity known as "MSTing"). In MST pages, criticism is strictly regulated. You may make fun of poor-quality work in a clever and amusing manner, but it is not acceptable to explicitly insult or flame another writer's work. This is the primary way that the community regulates and censors itself. When one reads a few sites and looks at the MSTings, flames, and rankings of favored fics, it quickly becomes clear to new writers what will and will not be accepted by the larger community. Many people who post links to fic pages on their own home pages explicitly refuse to endorse lemons or self-insertions. Meanwhile, the fics that end up on MST pages most often are lemons, self-insertions, and sloppy crossovers. Once again, we see that it is possible to subvert the mainstream, but those that do are punished by their peers.

More specifically, the majority of fan readers and writers do not approve of stories that go too far in rebelling against the original intentions of the series' creators. Although anime fans poach freely, we can see from their discussions that they still maintain a high degree of respect for the writers of their favorite shows and disapprove of any action that defiles their work. Subversion is always possible, but a safe, familiar status quo is generally preferred.

There is a definite hierarchy and a clear set of patterns that exist among individual fan writers. It is true that some writers drastically change the characters and settings of their favorite shows (*hentai, yaoi,* self-insertion, etc.), but it becomes clear when we examine fan forums that the larger majority does not appreciate this behavior. There is a great deal of respect for the original creators, and it seems to be unacceptable to stray too far from a show's original intent. In the hierarchy of fan writers, those who go against the original genre and narrative designs of the creators are somewhere near the bottom. Many of them write for their own sakes, knowing that only their friends and others who enjoy the same, more subversive styles will read their work. They are not treated as badly as those writers without any talent, but they do not gain the same respect that is common to more conventional fic writers.

The least popular stories are generally lemons that include sex for sex's sake with little regard to characters or original background (these are often abhorred for playing too loosely with beloved characters—no pun intended here). The *hentai* category is especially disapproved of by many for the often risqué treatment of characters (examples include bondage, fetishes, and other less conventional sexual themes). Even *hentai* writers tend to place disclaimers before their stories so that people under eighteen and those who dislike this genre can avoid it. From this tendency, we see that the writers have come to expect a certain amount of backlash for their efforts.

The most popular stories to read and to write are clearly those that work within the original universe of the series. Even self-insertions can gain some acceptance if they focus mainly on a show's original characters rather than the fan-author. These true-to-format examples are the stories that get awards from readers and are often mentioned on many sites as must-reads. They are also less likely to be found on MST pages. As one peruses various sites, certain names regularly pop up. Krista Fisk (formerly Krista Perry) is one name that appears on almost every fan-fic Web page. She has won such fan awards as the 1997 Taleswapper Fanfic of the Year Award and the 1999 Ranma Fanfiction "Best Continuing Series" award. Not only does she have an extensive *Ranma ½* story expansion (which is well respected for maintaining the integrity of the original story and characters), but she has also made a name for herself by creating her own comic strip that is in the Japanese style and updated weekly. Most critiques comment on her ability to stay true to the original styles while taking them in a creative new direction (Figure 1). Other writers, such as Joseph Palmer, who writes short stories about Akane and Ranma, gain popularity for similar reasons. He has won the Animefest Best of Show Fanfic Award and a Taleswapper award.

The most highly respected of the fan-fiction writing community seems to be those who maintain the purity of the characters, genres, and narrative/mythic structures they poach; write in an interesting and creative manner without relying on shocking movements away from the mainstream, far-fetched plotlines, or self-satisfying schemes; avoid excessive lemon writing (the most popular rarely have higher than a "lime" rating, and even that amount of sexual activity is generally kept to a minimum); and bring characters closer together.

So we can see that stories that work hard to break narrative norms are generally not as common or as well received as stories that do not. The majority of fan writers tend to obey certain mores and maintain their work within the main boundaries created by the shows' writers and the mainstream mass

media. As a whole, anime fans seem content to expand upon existing works rather than twist or shape them into something completely new. This can be further seen in the feedback and popularity surrounding various works within the community.

Although fans often disagree about favorite characters and approaches to fan-fiction writing, within the writers' community it is accepted that certain formats are preferable to others. As Matt Hills shows us in his book *Fan Cultures*,[17] there is a definite hierarchy among fans. This is why writers like Krista Fisk are mentioned on many pages, but writers who go against the grain and, say, pair up Ranma with Kuno (a young man whom Ranma despises) may gain appreciation among a small subgroup of fans, but not among the community as a whole. Such subversive writers may even find themselves critiqued on MST pages—generally the greatest dishonor a fan writer may earn. Even in this world of countercreativity where the work of popular writers is twisted and turned upside down, a certain respect for the writers is maintained, as well as a fairly strict code of behavior for fan writers. Despite Jenkins's view of fans as being commonly subversive toward media, it is clear from their behavior that such transgression is the work of small-taste cultures, not the larger community as a whole.

FIGURE 1. Illustration of *Hearts of Ice* by Krista Fisk: Ranma, Akane, Yuki-onna, the Shadowcat, and Masakazu the Tengu.

Lev Manovich seems to make the same mistake as Jenkins in assuming that with the advent of new technology, media identity will *inevitably* change.[18] This is an attitude that is common, but perhaps at risk for overstatement. Manovich sees digital technology as the start of something historically different, something intensely significant. In truth, however, this blending of cinema and still art, of reality and fiction, is really no different from the blending of genres and mythic structures that has occurred for decades in the form of textual poaching, and this poaching (and Manovich's blending) is

not inevitable but actually somewhat uncommon. Technology may facilitate distribution and even encourage fan activities by bringing people with similar tastes together, but the spirit of the act, the desire, has always been there, and that spirit is not so subversive as some would have us believe.

In fact, because of new media that make even the smallest preference-based group more accessible, it is a great deal easier for taste cultures to gain attention within the larger society and, in time, perhaps go mainstream. We can see this in fan-fiction databases. Although certain types of fics are generally unpopular among fans, as was mentioned above, fic databases that collect links to various stories published online (often filed by fan genre or by original series) still tend to maintain headings for such genres as slash, self-insertion, and lemon. Database creators are well aware of the smaller taste cultures and allow room for them, even if they still insist upon marking these genres with warnings or disclaimers. From this, we get the sense that the more subversive genres have gained at least some grudging acceptance. Furthermore, some mainstream anime writers can even be seen poking fun at the slash genre and occasionally joking about lemon sensibilities within the dialogue of popular shows, a sure sign that these less popular genres have made it onto the common radar and been acknowledged, if not fully appreciated. Not only have new media *not* turned old genre structures completely upside down, they have made it possible for mainstream society to be slowly, gently, introduced to subcultures of unconventional tastes while still maintaining the status quo.

CONCLUDING THOUGHTS ON MEDIA AND NARRATIVE

We can certainly see evidence within *Ranma ½* fan-writing communities of the active fan persona that Jenkins first described. However, Jenkins's stance that fan activity is inherently subversive toward the mainstream powers that be is simply not supported. Although there is potential for genre and myth to be warped beyond recognition, for the most part, they remain intact with a few simple additions and tradition-appropriate changes here and there. Scholars, including Jenkins, assume too much when they associate new media with change and fans with subversion. In some cases, new media actually encourage the popularization of so-called subversive sensibilities, thus rendering them no longer subversive.

It is dangerous and inaccurate to assume that technology will bring about anything other than a digitized humanity. Although there are exceptions to

narrative rules, these tend to be rare and are generally overshadowed by more widely accepted, mainstream cultural tastes. Behind the screen, we are still the same human race that we have always been—our preferences, our concepts of normality, our desires, and our traditions do not change when we move from one medium to another.

..

Notes

1. Tara M. Emmers-Sommer and Mike Allen, "Surveying the Effect of Media Effects: A Meta-analytic Summary of the Media Effects Research," *Human Communication Research* 25 (1999): 478–97.

2. Shearon A. Lowery and Melvin L. DeFleur, *Milestones in Mass Communication* (New York: Longman, 1983).

3. Raymond A. Bauer, "The Obstinate Audience: The Influence Process from the Point of View of Social Communication," in *The Process and Effects of Mass Communication,* ed. Wilbur Schramm and Donald F. Roberts (Urbana: University of Illinois Press, 1971), 326–46.

4. Henry Jenkins, *Textual Poachers: Television Fans and Participatory Culture* (New York: Routledge, 1992).

5. Ibid., 23.

6. Elisabeth Noelle-Neumann, "The Theory of Public Opinion: The Concept of the Spiral of Silence," in *Communication Yearbook 14,* ed. James A. Anderson (Chicago: Sage, 1984), 256–87.

7. Jenkins, *Textual Poachers,* 23.

8. Ibid., 174–75.

9. Ibid., 175–77.

10. Ibid., 171–72.

11. Ibid., 171.

12. Stuart Hall, "Encoding/Decoding," in *Culture, Media, Language: Working Papers in Cultural Studies,* ed. Stuart Hall, Dorothy Hobson, Andrew Lowe, and Paul Willis (London: Hutchinson, 1980), 128–38.

13. Barbara Stafford, "What's Magic Got to Do with It?" in *The Imagination of the Body and the History of Bodily Experience,* ed. Kuriyama Shigehisa (Kyoto: International Research Center for Japanese Studies, 2000), 249–60.

14. Elena Shefrin, "Lord of the Rings, Star Wars, and Participatory Fandom: Mapping New Congruencies between the Internet and Media Entertainment Culture," *Critical Studies in Media Communication* 21 (2004): 261–81.

15. Jenkins, *Textual Poachers,* 162–77.

16. Ibid., 171.

17. Matt Hills, *Fan Cultures* (New York: Routledge, 2002).

18. Lev Manovich, "What Is Digital Cinema?" in *The Digital Dialectic: New Essays on New Media,* ed. Peter Lunenfeld (Cambridge, Mass.: MIT Press, 1999), 173–92.

MARI KOTANI

Translated by Thomas LaMarre

Doll Beauties and Cosplay

A DOLL'S HOUSE

It was not so long ago that being described as a "dolled-up woman" or a "doll-like woman" would not have been seen as a particularly good thing. This is probably still true today. To think of a woman as a doll gives the impression of someone pretty as can be yet totally scatterbrained, without a thought in her head. It's not far from this to the idea that the doll beauty just "wants to be human" in the adorable manner of Pinocchio.

In 1972, when the American writer Ira Levin published *The Stepford Wives*, the women's liberation movement, begun in the early 1960s, had already had an enormous impact on society. Even in the world of science fiction, things were such that looking at a woman as a doll was completely inadmissible. Women were autonomous human beings, ones who thought for themselves (put another way, as Ursula K. Le Guin has written, feminists are rational beings). Attitudes have changed, however, and the trend of looking at women as dolls has become so pronounced that we cannot ignore it any longer.

To give an example, albeit one that may not be entirely representative, when the American science fiction critic Marleen S. Barr, in the first chapter

of her book *Lost in Space: Probing Feminist Science Fiction and Beyond* (1993), discusses Ridley Scott's *Thelma and Louise* (1991), she compares the circumstances of the heroine's sidekick Thelma to that of the Stepford wives:

> Thelma, no longer a Stepford wife (Ira Levin's term), and Louise, no longer a servile meal server, proclaim that women are not components of a mindless female herd that men shepherd, that women are not electric sheep who follow automatically whenever patriarchy plugs in sexist master narratives.[1]

We might go back even further in time than Barr and compare Thelma to Nora in Henrik Ibsen's play *A Doll's House* (1879); at that time as well, it is striking the extent to which metaphors of the robot, the pet, the doll, or alien entity were used to speak of the social position of women, to describe their confinement within a patriarchal system.

The doll is just another metaphor for death. This becomes perfectly clear in *Thelma and Louise*. After all, the two women who strive to escape from their plight decide in the end to drive their car over a cliff. It all boils down to a desperate choice: choosing death or resigning yourself to life as a doll, pet, or robot.

The film version of *The Stepford Wives* (1975) appeared some three years after Levin's novel and, interestingly enough, at the very height of the women's movement in America; its heroine undergoes an experience that is like traveling back in time to a past that is the complete opposite of women's liberation. For all that we know, this return to an anachronistic past is done just for the sake of horror, since there is something seriously scary about this film. Even now, there is something scary about it.

DOLL HOUSE REDUX

But the situation was rather different some thirty years later, with the remake of *The Stepford Wives* (2004). The most dramatic change concerned horror: that is, was there any? Thirty years earlier there was something serious, even absolute, about horror. Placing a woman in a situation in which she risked complete annihilation was a ruthless gesture. Subsequently, as the rhetoric of horror became at once more popular and diverse, the line between horror and comedy became finer. Today we are likely to burst into laughter, for gruesome transformations and harrowing chases feel somehow artificial. I suspect that these shifts in attitude are related to advances in film technologies.

While I am not sure that he is entirely responsible, I find it significant that the director of the remake was Frank Oz, renowned for his work as a "Muppeteer." He is clearly a fantasy fan. After all, he was also one of the directors of *The Dark Crystal* (1982), a film that brought to life a thoroughly fantastical other world.

The Dark Crystal gained renown as a fantasy film that presented another world made entirely from scratch. It presents a stage prior to something like Peter Jackson's *Lord of the Rings* trilogy (2001–3), with its series of fantasy scenes that transformed the natural world of New Zealand to let us wander through an ancient European world. Indeed, watching *The Lord of the Rings,* I really sensed how much Jackson had learned from *The Dark Crystal.* Moreover, the directors of *The Dark Crystal,* Jim Henson and Frank Oz, are both known for their work with Muppets. Even today there is something remarkable about the way in which *The Dark Crystal* uses dolls to play major roles in its fantasy world.

As an aside, I do not think it was entirely a coincidence that, in one scene in *The Stepford Wives,* a T-shirt with a picture of Viggo Mortensen (a.k.a. Lord Aragorn in *The Lord of the Rings*) turns up in the trash. I am probably not the only one who enjoyed an insider's laugh at the director's nod to historical transformations in the fantasy film (and it's wonderful when you get the feeling that the director shares your opinions!).

When you watch the "making of" feature on *The Dark Crystal* DVD, you get a good look at Oz merrily constructing the fantasy world. He is especially attentive to getting the doll characters right. Once an artist is able to use magic to have dolls display the same emotion as humans and to construct a fantasy world in which dolls coexist with humans and imaginary creatures, then it should be possible to construct a world in which humans in turn appear as automatons.

This is precisely what the recent *Stepford Wives* made possible. It offered a world in which the world of dolls and that of humans meshed seamlessly, with humans acting like dolls and dolls like humans. As such, rather than a tale of the horror of becoming a doll, its filmic space enabled a tale centered on the delight of becoming a doll.

This is why the remake of the *Stepford Wives* is worth another look.

> ONCE AN ARTIST IS ABLE TO USE MAGIC TO HAVE DOLLS DISPLAY THE SAME EMOTION AS HUMANS AND TO CONSTRUCT A FANTASY WORLD IN WHICH DOLLS COEXIST WITH HUMANS AND IMAGINARY CREATURES, THEN IT SHOULD BE POSSIBLE TO CONSTRUCT A WORLD IN WHICH HUMANS IN TURN APPEAR AS AUTOMATONS.

Nicole Kidman plays the heroine, Joanna Eberhard, a female television producer in Manhattan who is consistently able to score top ratings with her shows. Beautiful, competitive, and, above all, greedy, Joanna produces a show ("I Can Do Better!") that is fairly harsh for a country that believes itself moral, a show in which perfect couples are tested by separating them for a week, putting them in the company of a host of male or female lovers, and then reuniting the couple to see if their marriage can survive. Above all, the program suggests that there are other, more pleasurable ways to live than as a couple, and many of its perfect couples actually end up breaking apart.

The show is very much "in your face," which is probably an effective way to target mass audiences. Nonetheless, even though the show's overt aim is, in principle, to liberate wives sexually, such an extreme method can only produce an extreme backlash. One man, infuriated over his wife's betrayal, kills his wife and her lovers and then forces his way into the TV station with a gun, in an attempt to murder Joanna.

After Joanna and her husband, Walter, both lose their jobs (actually Walter resigns in sympathy), Joanna has a nervous breakdown, and the family moves to Stepford, Connecticut, to rebuild their lives.

Everything in Stepford is impeccably beautiful, every house, every person. It is like a theme park dedicated to the spirit of the suburban America of the 1950s (albeit with a contemporary McMansion feel)—the pinnacle of the culture of the nuclear family. Especially impeccable are the women and homes, while the men who live there do not appear to be anything special. Not long after she arrives in Stepford, Joanna meets Bobbie Markowitz, a woman writer who is not yet integrated into these surroundings, and a gay man, Roger Bannister. The scenery of Stepford looks like something out of a fashion magazine or a house and garden journal; it is so deliberately impeccable that it almost feels suspicious. Sometimes it appears so artificially resplendent that it borders on camp. The scenery is so beautiful that it feels as if something were eerily out of place.

This is where the hand of Oz, the puppeteer of *The Dark Crystal*, really shows: if you have ever played with dollhouses and figurines, you will feel yourself drawn into this elaborately constructed toy land.

Even as the beauty of its artificiality bedazzles you, you will understand why it is only Joanna, Bobbie, and Roger who see through the falseness of Stepford. Joanna and Bobbie both know a lot about the world of fiction: Joanna lived in the world of television where fact and fiction become confused, and Bobbie is an author who thinks day and night about producing distinctions between truth and falsehood. Insofar as Roger is a gay man who veers

toward drag, he has a very refined, open-ended relation to reality. The three of them band together, sensing that there is something fishy about all this, and by the time the truth finally comes out, they are already participating in the doll "cosplay" of this playland.

SICKNESS UNTO BARBIE

The interest of the remake, then, does not lie in its horror but in its shift toward cosplay and figurines: toward a sort of playland of dolls. As a result, what truly holds the spectator's attention is how Joanna, a typical New York career woman who bustles about in business attire, will play the stereotypical role of the Stepford wife.

The film booklet and all the magazine reviews called attention to how Kidman had decided to play a role that conformed to our stereotypes about doll-like women. For instance, Watanabe Maki, a film critic, wrote, "Nicole Kidman's Barbie doll act is terrific." The outstanding moments of Barbie cosplay were surely Kidman dressed in an evening gown for the ball and Kidman in the supermarket in a tea dress pushing a shopping cart, which was especially eerie precisely because of the supermarket. Rather than a contemporary supermarket, this one evoked the strength and glamour of the American 1950s. It evoked an America that, in the wake of its World War II victories, became an industrial power, hammering out its automobiles. It evoked a time when everyone and everything glowed with the strength and beauty associated with being white, full of dreams of large-scale production and consumption.

Barbie first appeared in 1959, the product of a then small California toy company (Mattel). Soon, carried on the winds of commercialism (the power of advertising and the new children's market), Barbie developed a huge commercial base, making it almost synonymous with the American dream of the 1950s. Kidman is a vintage Barbie doll as she strolls along pushing her shopping cart, casting chilly sidelong glances.

But what sort of Barbie is this exactly?

This is where I would like to express my gratitude to those who made the casting choices. Kidman's Barbie cosplay takes the familiar transformation into a Stepford wife and gives it an ironic twist. Kidman's transformation into a Barbie imparts a totally different feeling from heroine turned "housewife" in the 1975 *Stepford Wives*.

As M. G. Lord points out in *Forever Barbie: The Unauthorized Biography of*

a Real Doll (1994), the prototype for Barbie was Lilli, a comic character created by Reinhard Beuthien for the *Bild-Zeitung*. A company had constructed a flaxen-haired womanly doll based on the cartoon character, but this was not a doll for children: "She was a pornographic caricature, a gag gift for men."[2] Ruth Handler of Mattel Inc. saw the doll, changed it in various ways, and marketed it as a dress-up doll for children. At first Barbie closely resembled Lilli. Until Barbie came along, dolls were baby dolls, soft and cuddly, something for children to hug. Although children soon grew accustomed to her, Barbie was completely different with her grown-up fashions, offering children a glimpse of the adult world.

In her detailed introduction to the twists and turns of Barbie's emergence, Lord offers this analysis of her femininity: "Barbie . . . may be, for some gay arbiters, the apotheosis of female beauty. The doll is built like a transvestite."[3] In this respect, Barbie is not so much the image of an adult woman as a gynoid alien, the very essence of a cosplay body.

PUPPETEER MAMA

The way in which the movie ends makes it perfectly clear that Kidman is playing Joanna as a kind of Barbie. It makes sense that people in the 1970s would see the film as a tale of the evil plot by husbands to force their wives to become housewives. For young people of the 1970s, the typical 1950s woman of the house belonged to their mother's generation.

> THE MORE WOMEN ARE DEPICTED AS ARTIFICIAL FABRICATIONS, THE MORE THE ALLURING AND SEDUCTIVE OTHERWORLDLINESS THAT SURROUNDS THE DOLL ENHANCES THE ATTRACTIVENESS OF THE CULTURE OF FEMININITY.

In the remake, women enjoy social success and stand alongside (or even above) men, yet as a compromise to the classic view of women, it turns out that it is Claire Wellington, a former robotics professor (played by Glenn Close), who is constructing the Stepford wives. In other words, the men are not responsible: rather, a woman is the ringleader, and she is depicted as a crazy mother who dresses up her daughters like dolls.

Still, this development makes clear that a double standard was in operation for mothers who in the late 1950s bought the newly born Barbie for their daughters. During the crisis of World War II, it was only natural that, as a matter of national policy, women would enter society to work alongside

men and participate in the war. When the war was over, it was thought natural for women then to become housewives. This became reality for housebound American women in the 1950s. The flip side of American prosperity was the growing rage of dissatisfied women, and in this context, I think that we would do well to consider something that comes prior to Betty Friedan's propaganda campaign: housewives providing their daughters with that independent adult cosplay doll, Barbie. Barbie, who did not play the role of housewife, whetted the consumer appetite of many girls. Above all, the doll fanned girls' desires to wear lots of different clothes.

Behind the overt and dominant wisdom—"be a lovely bride"—was a message about being economically independent, "be a working woman." This wretched double standard, with all its contradictory implications, was passed on to the young women who would soon participate in the women's liberation movement of the 1970s. And although nothing but a doll, a fabrication without independent existence, Barbie's very body was inscribed with a message of liberation, which ironically gave rise to a structure of ambivalence.

Thus Dr. Wellington, a mother creator for the new century, suggests a reading other than simply that of a woman who feeds Barbie-doll dreams to her girls. On the one hand, there is the message that "women can achieve a status higher than men," yet, on the other, there is a sense that "something seems to be missing." Basically, what Claire Wellington wishes to retrieve is the fantasy of "cute little feminine me." In order to reconstruct the classic femininity that she had been missing all her life, she transforms Stepford into a playland of ideal femininity. It is Claire more than any other woman who dresses elegantly and skillfully and "cosplays" the perfect wife for her husband, Mike. Yet the actual state for this ideal is nothing other than "figurine mania," that is, mechanically produced, high-functioning robots. The return to classic femininity has no need for men; it perfectly embodies the techno-feminist nation. The real shock comes of the fact that Claire, a woman far more capable than any man, embraces the sugary candy sweetness associated with girls' tastes.

There is no doubt that this is trite. Yet the beautiful realm of Stepford says a great deal about girls' taste for artificiality and monstrosity. The more women are depicted as artificial fabrications, the more the alluring and seductive otherworldliness that surrounds the doll enhances the attractiveness of the culture of femininity.

That is what interests me most. For women who adopt a feminist stance, the culture that revels in femininity becomes a truly complex object. While

it is sometimes treated as taboo, or simply ignored, or viewed as a sort of untouchable realm, it still possesses an allure that is derived from its aura of otherworldliness.

The wives of Stepford are originally figures of importance, business executives, lawyers, and such. Which means that society has accepted the skills of these women. Of course, this happens within a world of masculine values. Women's skills are evaluated only within this world of value. That Claire Wellington privately despairs of her husband (and wants a strong man to lead the way) shows that classic sexual discrimination still reigns in this world. This is precisely why it would not do simply to laugh at the trivial nature of the girlish tastes and girlish sentiment that lie behind Wellington's Stepford playland.

Maybe we can pose the problem another way. Why do Sarah Sunderson, played by Faith Hill, and the other successful women (even Bette Midler) all seem so happy when they are playing along with this playland, acting as dolls, and cosplaying femininity? Why does the cosplay turn into a world of Barbies, overflowing with a seemingly boundless excess of beauty that somehow goes beyond the limited dreams of men? Why does this fantasy world in which women possess a culture of femininity seem to do more than simply restore the "charm" that would heal Joanna after the traumatic loss of her successful career?

Such questions suggest that intelligent women today do their best to avoid looking squarely at femininity, to tend to laugh it off and turn away. And while they have broken its social continuity, there is a "certain something" of femininity that can be a source of satisfaction, if only in the form of game, as play. What did the Stepford wives gain through their cosplay transformation into dolls? What did they lose?

In the end, the riddle of the Stepford wives' disturbing and alluring sexuality is dispelled, and daily life returns. It is in the context of their lolling around the house in their pajamas that the fantastical quality of Stepford becomes self-reflective. Such scenes feel oddly like those of the Tyrannosaurus strutting around inside Jurassic Park.

The force of this fantasy is not unlike that of the femme fatale, whose sexuality once turned the head of the modern juvenile. The legacy of the evil woman, once styled as a "femme fatale" or an "icy beauty," does not so much linger on in the pure and inexperienced modern youths whom she seduced as it lingers in the defenseless heart of the crisp and efficient career woman of the twenty-first century who has attained such a high degree of knowledge.

GIRL FASHIONS FOR GIRLS

Now I come to a Japanese cosplay film that stands quite well alongside the Hollywood remake of *The Stepford Wives*—the 2004 film *Shimotsuma mo-nogatari* (Tale of Shimotsuma, released in North America as *Kamikaze Girls*). Adapted from Takemoto Nobara's novel of the same name, the film tells of the friendship that arises between two girls, Ryūgasaki Momoko, a fan of "Lolita" fashions,[4] and Shirayuri Ichigo, a member of a female motorcycle gang.

What first comes to mind with respect to the heroines' fashions and gender differentiation is how much like Takarazuka theater they are.[5] Ichigo, played by Tsuchiya Anna, adopts the male role, and the female role falls to Momoko, played by Fukada Kyōko. Naturally, the male role apparently serves as the protagonist, yet Momoko narrates the tale. Ultimately, the story tends to focus on Momoko and her cute little Lolita act.

Is there something odd about a girl sporting such girlie fashions? Surely there are viewers who see the film in this way. Actually, if Momoko's fashions make her look like a doll, it is because they are over-the-top gorgeous in the manner of European Bisque dolls. The almost suffocating excess of lace and frills and embroidery makes your eyes glaze over.

If we think shojo or "girl" conceptually, shojo refers to a juvenile existence prior to the adult female, that is, prior to the adoption of adult femininity.[6] Within the system circumscribed by patriarchy, insofar as it secures future femininity, shojo is a period when girls are protected and indulged, handled like dolls.

While the culture of prizing "girlhood" or "girliness" (*shōjo-sei*) arose in nineteenth-century England, especially among male writers like Lewis Carroll, it was in Japanese soil that it proliferated so incredibly. At the root of the shojo culture shaped by Shibusawa Tatsuhiko, Kaneko Kuniyoshi, Yagawa Sumiko, Honda Kazuko, and Mori Mari was above all the class consciousness of the prewar period, and it is evident that a certain economic prosperity and a certain culturalism or cult of cultivation provided the necessary ground for cultivating shojo.

The patriarchy provided a necessary guarantee within the system that gave rise to the shojo as nurtured within prewar schools for women. In other words, the shojo had economic and social status, or class. Yet in the shojo admired by so many intellectuals was a certain aggressiveness, which, while formed within the system, insofar as it was cultivated surreptitiously, ended up paradoxically possessing an aesthetic and sexual magic that shook the system.

In this respect, it is interesting that, even though you might think that

Momoko is a girl of the upper classes, it turns out not to be the case at all. This Momoko who aspires to the finest in Lolita fashions is not the daughter of an average middle-class family, protected by mom and pop. In fact, it is the opposite. Her father, a yakuza underling from Amagasaki, and her mother, a barmaid, got married on a whim; while pregnant with Momoko, her mother had a fling with her obstetrician, which led to the parents divorcing while Momoko was in elementary school. The home where she ends up living with her father and grandmother is in the quiet and uneventful countryside, in a realm far removed from cultivation, economic power, and the life of the mind.

Especially interesting is the geopolitics of clothing as Momoko describes them. She sees Amagasaki, where she was born, and Shimotsuma, where she lives in her grandmother's house, as places that demand a compulsory uniform of Western-style clothing. The dress for everyone in Amagasaki is loose-fitting jerseys and jogging suits, while in Shimotsuma mass-produced clothes have carried the day. These are worlds of cheap durable clothing, easy to move in and work in. Of course, the inhabitants of these places do not see these as uniforms. On the contrary, the viewer realizes that these are worlds fixed in advance only when Momoko, so removed from this world with her alien sophistication, first appears in her cute little "Loli" styles.

But what kind of identity informs the Lolita fashions worn by Momoko, which are so difficult to move or work in, so expensive and easy to soil?

FAKE DOLLS AND FAKE GIRLS

Utterly enchanted with Western clothing from a store (with a line of clothing) called "Baby the Stars Shine Bright," Momoko travels over two hours one way on her shopping sprees at Daikan'yama in Tokyo. True to the "baby" in the "Baby the Stars Shine Bright," Momoko's clothes are Lolita fashions, evoking Lolita in the sense of a preteen. The point of Lolita fashions is that they are the opposite of jerseys and jogging suits.

In brief, Lolita clothes entail a preteen look geared to teenage girls. Momoko's Loli-dress is girlie at first glance, but if you look at it a bit more carefully, it seems more suited to an artificially pieced together "nowhere girl." The lovely apparel serves as a device to produce the fantasy of shojo.

Yet, has not girliness or shojo-ness always been something exceedingly artificial? I recall one scene particularly well from *Interview with the Vampire* (1994). Because Claudia, a girl vampire played by Kirsten Dunst, became a vampire at a very young age, she is eternally barred from developing a mature

woman's body. Each year on the anniversary of the day that she became a vampire, Lestat, who lives with her in New Orleans, presents her with a Bisque doll from France. Year after year the luxurious dolls continue to pile up. This girl of the New World who could never afford a single Bisque doll plays with a rag doll that her mother made for her.

An old woman despite the fact that her body remains that of a child, Claudia is secretly angry with Lestat for treating her like a doll, and one day she murders a beautiful prostitute and hides her body in the huge pile of dolls.

These European imports, the Bisque dolls, were dolls for girls that looked like young girls. How telling it is that a beautiful girl vampire of great age possesses so many of them. For the likes of Lestat, and for Americans, the Bisque doll surely evoked the beloved land of Europe (especially France) and European culture. As Lestat strives to make Claudia into a sort of Bisque doll, he is at the same time reconstructing the culture of his homeland, Europe.

The crucial point is that girliness is the mediator of the relations between the Bisque doll, Claudia, and Lestat, yet, even though Claudia herself acts the part of a beautiful doll, her relations with the Bisque doll and Lestat expose the fact that this shojo-ness is an artificial construct, a fake. (Later, after Claudia tries to destroy Lestat, she travels to France, home of Bisque dolls.)

It is likewise with the relations between men who entertain an imperialist fantasy of what a girl should be, women who lend a hand in this fantastic scenario, and girls of the proper age who play the role with their bodies. As their common creation, shojo-ness, as fantasy, emerges as a fake. In this respect, it is at once doll and structure. The power of shojo-ness as fantasy releases the most powerful magical force, resulting in a rupture with the cultural subjugation that would make the shojo system into something axiomatic. Cultural hegemony renews itself through those who are directly in touch with this subjugated world. Those people need to take back their complexes. It is high time to perform shojo-ness differently.

> SHOJO IS NOT SOMETHING THAT IS SIMPLY OUT THERE. RATHER IT IS SOMETHING PERFORMED, AND THE SENSE OF PERFORMANCE IS CRUCIAL TO ITS CONSTRUCTION.

Both the "shojo fantasy" of Claudia and Lestat and that of Momoko in *Shimotsuma monogatari* are presented as fakes.

In the case of *Shimotsuma monogatari,* the shojo fantasy begins with the culture of the bourgeois daughters of downtown Tokyo who took the imported culture of Europe and America and made it their own; it then entered into the postwar world where it was popularized and thoroughly saturated

with capitalist development; it was finally reconstructed as a culture that demanded a certain degree of literacy. It was then that the ability to appreciate its aesthetic qualities gained high esteem.

Simply put, shojo-ness is not a condition or result of being born or raised; it is the ability to understand culture that is the condition for becoming "shojo." Shojo is not something that is simply out there. Rather it is something performed, and the sense of performance is crucial to its construction. When it has this sense, shojo perceives itself as an angel fallen from heaven, cut off from the heavens as it came into this world. The advanced perception of shojo is light years from the debased rule-constricted prefab world, but sometimes you catch a glimpse of the head-on collision of shojo and this world, so alien to one another.

GIRLS' WEAR AS CAMP

If one agrees that shojo is not something that exists out there as "natural" but is something brought to life via shojo culture, then, in the physical space of media, it does not matter whether there is really any shojo or not. Should male intellectuals and writers ever speak in such terms, people would surely leap for joy and better appreciate the shojo-ness latent in their works.

Still, because girls and shojo-ness are clearly not at odds with one another, there is a certain risk in girls tailoring the shojo fantasy to their bodies, much as women run a risk adopting femininity. A gap between girls and their shojo-ness must be inscribed somewhere. Otherwise we will be drawn into a hegemonic structure that simply makes girls into girls.

Today shojo has become a form of cosplay that anyone can adopt, yet, when actual girls take back this look, it is surely incumbent upon us to recognize that different forms of dress function rather like uniforms in the world and to assert that what these girls are performing is obviously cosplay.

In *Shimotsuma monogatari,* Momoko wears clothes that are so gaudy and frivolous that she stands out like a sore thumb, much like Nicole Kidman dressed as a Barbie doll in *The Stepford Wives.* There is an excessiveness about it that recalls the campiness of a drag queen performance.

In fact, the clothes that Momoko so loves draw their inspiration from eighteenth-century French rococo, often deemed ridiculous within art history. The excessiveness of rococo earned it a reputation for "foolishness" in relation to the realities of this world, from the perspective of the Age of Reason. It also found an application in the costumes of American drag queens,

which has been theorized in terms of "camp." With respect to these "foolish" practices of dressing, I would venture to say that those who take it as entirely foolish are simply discriminating against it. In this most "foolish" behavior, I see the sharpest and keenest "reason." For this reason, I think that the foolish adoption of costumes has immeasurable potential for girls. Seriously. It is entirely reasonable that Western clothes full of frills and frivolity should become strategic dress for girls today.

> THE GREAT THEATER OF OPERATIONS FOR GIVING REBIRTH TO SHOJO ITSELF (BY STAGING THE TRANSFORMATION OF GIRLS INTO DOLLS) COULD ALSO BE SEEN AS A GOTHIC ROMANCE THAT USES WESTERN CLOTHES TO ALLOW ABANDONED GIRLS TO "REGENERATE" THEMSELVES.

Of course, Momoko, born and raised under patriarchy, truly understands that girls' struggles are always makeshift. It is precisely her weak behavior that serves as a mask to conceal her strength. For Momoko who coolly ignores her parents, Lolita fashion is a suit of armor that protects her. Still, the meaning of Momoko's Loli-dress does not stop there. To protect oneself is also to protect one's world, including its future. Loli-dress is the trigger that sparks the creativity needed to write her world. Her environment as a child and a girl probably did not allow for a narrative in keeping with social norms, of development into an "ordinary girl." Because at an early age Momoko had to become independent of her mother and thus of "woman," she went from looking like an ordinary schoolchild to gradually entering the world of Loli-dress.

By wrapping herself in clothes bearing the name "Baby" and by working to transform herself into a doll, she was apparently able to produce her own rebirth. The babyish Loli-dress was the costume that enabled her independence. Still, conceivably, for women, this is what is given, and thus what is ignored: is this not precisely why it communicates to women who have become defenseless and without resistance?

In this respect, it is no coincidence that Ichigo, who appears in the male role, begins working part-time as a car mechanic just as she makes her debut as a model wearing Baby clothes. To become independent, she too must be reborn via Loli-dress. The great theater of operations for giving rebirth to shojo itself (by staging the transformation of girls into dolls) could also be seen as a gothic romance that uses Western clothes to allow abandoned girls to "regenerate" themselves. Therein lies the real pleasure of *Shimotsuma monogatari,* which its resonance with the remake of *The Stepford Wives* helps bring to the fore.

Notes

Translator's note: This text is a translation of "Bishōjo ningyō/cosupurei," which appears as chapter 16 of Kotani Mari's *Tekuno-goshikku* (2005), with some minor additions and alterations done for the sake of clarity and precision and with the author's permission. The term *cosupurei,* or cosplay, is an abbreviation of "costume play," which has become a blanket term that refers to dressing up or wearing disguises. Cosplay sometimes refers more specifically to dressing up as manga or anime characters in the context of conventions and fairs, although it frequently extends far beyond those contexts into daily practices. All subsequent notes and references were added by the translator.

1. Marleen Barr, *Lost in Space: Probing Feminist Science Fiction and Beyond* (Chapel Hill: University of North Carolina Press, 1993), 23.

2. M. G. Lord, *Forever Barbie: The Unauthorized Biography of a Real Doll* (New York: Walker and Company, 1994), 25–26.

3. Ibid., 213.

4. While there is something called *rori-con,* or "Lolita complex" in Japan (referring to a male fascination with young girls), most Japanese commentators claim that the girls who adopt so-called Lolita fashions or "Loli-dress" (*rori-fuku*) do not do so with the intent of attracting the sexual attention of adult men or adolescents. In other words, we are supposed to assume a certain sexual innocence or indifference in the girls who dress Lolita style.

5. Takarazuka theater, which began in the early twentieth century, involves all-female troupes, with actresses specializing in male or female roles, aimed largely at female audiences.

6. Until this point, I translated the Japanese terms into English (*shōjo* as girl, *shōjo-teki* as girlie, and *shōjo-sei* as girliness). I here start sometimes to use the Japanese terms *shōjo* and *shōjo-sei* in contrast to girl and girliness, depending on the context, because the author is now making more specific arguments about Japan. Of course, part of the point of the essay is that shojo culture is not limited to Japan but transformed and in a sense refined there; thus analysis of shojo culture need not limit itself to Japan or essentialize the Japaneseness of shojo.

A Japanese Electra
and Her Queer Progeny

Mori Mari's 1961 novella "Koibitotachi no mori" ("A Lovers' Forest") is the first story of a trilogy she wrote about passionate and doomed love affairs between older men and beautiful young boys.[1] Mari's work is invariably cited by Japanese scholars as the antecedent of a genre of manga and popular novels written by women for women about male-male love that began to emerge in the 1970s and remains extremely popular today.[2] While there are many terms to refer to the manga and fiction that followed Mari's lead (and many debates over generic classifications), for brevity's sake I use the term *yaoi* here to refer to the whole genre. *Yaoi* is an ironically self-deprecating acronym that is said to mean "no climax" (*yama nashi*), "no punch line" (*ochi nashi*), and "no meaning" (*imi nashi*).[3] Crucially, the term is used interchangeably as a signifier both for the genre of male-male comics written by and for women, and for the women themselves. Thus to write or read *yaoi* is also to be "a *yaoi* girl." In the early 1990s, the slippage this suggests between *what you read* and *who you are* sparked an intense and still ongoing debate over sexuality and identity that I discuss in the latter half of this essay. But first I would like to turn to Mari's early work to make some preliminary observations about the kind of psychic function this genre may be serving and how it is related to the question of literary style.

"A LOVERS' FOREST"

Mori Mari was already fifty-seven when she wrote "A Lovers' Forest." Until then, her writing had focused mostly on her famous and much-beloved father, Mori Ōgai, a towering figure in modern Japanese literature who played a major role in introducing European literature and medicine to Japan in the late nineteenth and early twentieth centuries. Ōgai died in 1922 when Mari was nineteen, and she was devastated by his death. It has become a commonplace in the criticism about her that she spent the rest of her life, as Tomoko Aoyama puts it, trying to "bring the past and her father back to life through her writing."[4] In "A Lovers' Forest," I argue, Mari is not only bringing her father back to life but also creating a space of pleasure in which her own (and perhaps our own) "maturation" into heteronormative adulthood can be deferred indefinitely. It is this insistence on pleasure, along with her *refusal to grow up,* that makes Mari the first (and still one of the best) practitioners of what would later be called *yaoi.*

> MARI'S WORK IS INVARIABLY CITED BY JAPANESE SCHOLARS AS THE ANTECEDENT OF A GENRE OF MANGA AND POPULAR NOVELS WRITTEN BY WOMEN FOR WOMEN ABOUT MALE-MALE LOVE THAT BEGAN TO EMERGE IN THE 1970S AND REMAINS EXTREMELY POPULAR TODAY.

"A Lovers' Forest" tells the story of a thirty-eight-year-old man named "Gidou" and his younger lover "Paulo." Gidou is an independently wealthy professor of French literature at Tokyo University. His mother was the daughter of a Japanese diplomat based in Paris, and his father was a wealthy Frenchman with the aristocratic-sounding name of Antoine de Guiche. Paulo's actual name is Kamiya Keiri, but Gidou rechristens him Paulo, and this is how he is referred to throughout the novel. Both of these Europeanized names are written phonetically in ornate Chinese characters in a fashion that mimics the way Mari's father named all of his children, including "Mari" herself.[5] (She had two brothers named Furitsu [Fritz] and Oto [Otto] and a sister named Annu [Ann].) In the beginning of the story we are told that Paulo is "seventeen or eighteen" but "not yet nineteen."[6] Nineteen, of course, is the age Mari was when her father died. After a passionate love affair with Paulo that lasts only a single year, Gidou is shot by a jealous former lover when she finds out that Gidou has left her for Paulo. Thus, as the story ends, Paulo finds himself in a situation not unlike the one in which Mari found herself at nineteen.

Gidou meets Paulo in a gay bar called "Mari," the name of which is written, interestingly enough, with the same characters as Mari's own. It is love

at first sight for the two men, and as they leave the bar (after a three-page cruising session worthy of Proust), Gidou invites Paulo home with him. "Why don't you come to my place tomorrow? We'll have martinis and cheese. Then we'll go and have some clothes made for you."[7] Gidou immediately takes to spoiling Paulo, whose unreal beauty is described obsessively throughout the story. Part of Paulo's beauty stems from the fact that he does not look Japanese. His hair, we are told over and over, is "streaked with brown" and his eyes are gray.[8] He has delicate features, luscious lips, and wide eyes, and he is variously compared to a fish, a sapling, a cat, a doe, a monkey, and finally a "poisonous little poppy."[9] We will get to his poisonous nature later, but for now it will suffice to note that he "appears not to have much willpower except when it comes to his own pleasure or desire."[10]

Paulo and Gidou are surrounded by the most luxurious objects one could imagine having in Japan in the early 1960s, all described to extravagant excess. Gidou is a man who "gave off an atmosphere of luxury and waste" wherever he went.[11] They eat caviar by the jar, and Paulo is outfitted with "pale lavender translucent creams for his skin," "Parisian brilliantine," "Roger Garet Soap," and "4711 Eau de Cologne."[12] He eats ham and bread, and drinks milk and coffee. Paulo puts his cigarettes out by pressing down hard on them after he has smoked less than half—a wasteful habit he picked up from Gidou and that reminds one of nothing more than the way Lord Henry Wotton languorously smoked his "innumerable cigarettes" in Oscar Wilde's *Dorian Gray*. Paulo has double eyelids (a coveted mark of Western-ness), his eyes seem to emit "pale lavender flames," and he is always lounging around with his head propped on his palm, looking up coquettishly at Gidou.[13] Anyone who has ever read Japanese girls' comics will recognize these features as belonging to a long-established type of wide-eyed hero, a type that might well be traced back to Paulo. Here is how Mari describes Paulo's face: "His eyes, fitted beneath the shadow of the bridge of his slightly arched, diminutive nose, were like precious stones inlaid in the sharply faceted piece of handwork that was his soft, young, and beautiful face."[14] The reference to Paulo's face as a "sharply faceted piece of handiwork" could just as well be a description of Mari's writing style. Like Jane Austen working away on her "little bit (two inches wide) of Ivory,"[15] Mari focused lovingly on the details. Mishima Yukio, one of Mari's most ardent fans, wrote gushingly of her use of language: "These are words you can't buy in the department store. They are available only *chez* Mori Mari."[16] Even Mari's punctuation is precious. In Japanese, the verb comes at the end of the sentence, and Mari has an idiosyncratic way of inserting a comma just before the verb that lends her sentences a kind of breathless, campily dramatic

effect. Mari's commas are not there to clarify the meaning but to add to the atmosphere. Here is the final sentence of our initial introduction to Paulo:

> His appearance was not such that one would imagine him with a companion of his own age, but rather by the side of an older woman striking a languorous recumbent pose or a man who would caress him for hours. That's how he seemed. . . . And that's the kind of boy he [comma] was.[17]

The closest thing to this style in English is to be found in British gothic novels like those of Ann Radcliffe, where commas abound, separating virtually every clause whether dependent or independent, as if the writer never wanted the sentence to end. Given that most gothic novels end in marriage (Radcliffe's *Mysteries of Udolpho* ends with a double one!) this reluctance to bring sentences to an end mirrors the heroine's desire to delay the very heteronormative closure she otherwise so ardently desires—to remain suspended in the romantic lead-up to marriage and adulthood. As Catherine Morland in Austen's *Northanger Abbey* says of *Udolpho,* "I should like to spend my whole life in reading it."[18] But at some point the novel must end, and the genre demands that the girl must marry.

Such an ending is made conveniently impossible in "A Lovers' Forest," thanks to the fact that the parties in question are both men. Yet despite this fact, and despite the ambivalence toward heteronormativity that it seems to share with gothic fiction, "A Lover's Forest" can hardly be read as a "gay" love story. Such a reading comes up lacking on any number of points. First and most obvious is the fact that both Gidou and Paulo have female lovers as well. While Gidou has currently left his woman lover because she has gotten too old and flabby, Paulo sleeps with his girlfriend, Nashie, with Gidou's blessing in a hotel room that Gidou has rented for the purpose. Gidou is not in the least jealous of Nashie, and Paulo thinks of her as a "little mother" because of her constant attentions.[19] Then there are the utterly unreal aspects of the story that put us squarely in the realm of fairy tale and fantasy, such as Gidou's fabulous wealth, his (pink!) Rolls Royce, and the inexhaustible paternal benevolence that he lavishes on Paulo. Finally, while rumors do fly that Paulo is Gidou's kept boy and Gidou is careful to keep their relationship discreet, there is never any sense in the text that the two are "in the closet" or would like to get out.

But perhaps the most striking aspect in which this text does not read like a "gay love story" (or perhaps I should say a "gay affirmative" love story) is that when Gidou is shot by his jealous (female) lover, Paulo is not particularly upset. He comes home to find Gidou's dead body in the living room, but in

> HOWEVER WE READ "A LOVERS' FOREST," THERE IS NO QUESTION THAT IT IS A TEXT IN WHICH SEXUALITY AND IDENTITY SEEM TO FLOAT FREE FROM THEIR OEDIPAL ANCHORS AND INTO THE OPEN SEAS OF FANTASY.

his initial shock all the beautiful boy can think of are the many beautiful objects that surround it. Paulo first notices how the light glances off the glass face of Gidou's Swiss watch as Gidou lies in his own blood. Then Paulo wanders through the rooms of the house gazing at the books, the mahogany bookshelves, the high-ball glasses purchased in Munich, the glass cat that Paulo had given him. His gaze lingers longest on the manuscript in French that Gidou had been writing, "in the clear and neat hand he had learned from French nuns."[20]

After wandering about like this for a while, Paulo leaves the house and walks to a park. Unbeknownst to him, he is being followed by a man who we know has been waiting in the wings all along. His name is Numada Reimon ("Raymond"), and, like Gidou, he is half French and half Japanese, although in his case it is his mother who is French. His name is rendered in Chinese characters like Gidou's. But he is older and darker—so dark that the narrator wonders aloud at one point whether he might be part black as well.[21] Gidou has been insanely jealous of Reimon for the whole story, but his jealousy—as is often the case—only heightened his passion for Paulo.[22] And now Reimon is waiting, knowing that Paulo is his for the taking. If Paulo has murdered Gidou, Reimon tells himself, he is willing to defend him.[23]

Luckily for Reimon, Paulo has already started to forget about Gidou. As someone who "never bothered himself much with morality," Paulo is relieved to have "come back to himself" and gotten over the "sentimental hysteria" that characterized his love for the late Gidou.[24] The story ends with Paulo walking through the park whistling a tune that Gidou had taught him. "With the eyes of someone who has come back alive from a faraway place, Paulo looked in all four directions and then up to the sky. There was still a darkness in his eyes, like a child who has just been punished."[25]

Whatever nausea the reader might have experienced in reading the sticky sweet descriptions of Gidou and Paulo's love affair is more than cured by this ending, where we see emerge the "cold flame" that burned in Paulo's eyes from the start. When I first read this story several years ago I was upset that Mari had chosen to depict yet another psychotic male homosexual unable to love anyone. But looking back at it this time through the lens of her imaginary relationship to her father, I find something more provocative and interesting in Paulo's heartlessness. As he prepares to exchange one love object for another—to *decathect* and *recathect,* as Freud would say—there does not

appear to be much trauma, just a continuing desire to enjoy the life to which he has been accustomed. When it comes to pleasure, remember, Paulo has plenty of willpower.

Given what we have seen so far, it would perhaps not be too much of a stretch to argue that in "A Lover's Forest" Mari has indulged herself in the fantasy of an incestuous homosexual love affair where Gidou plays the role of her father and Paulo plays Mari. The fact that the couple first meet in a gay bar called "Mari" and that the story's title itself plays on Mari's family name (which means forest) further suggests that the whole affair is taking place under the aegis of Mari's fantasies about her father and her younger self. The bar "Mari" was not much in reality, we read, but Gidou had something about him that made his corner of it seem fabulous.[26] If the murder of Gidou is an allusion to the death of Mari's father, Paulo's quick recovery might be read as a fantasized inversion of Mari's protracted mourning. At the same time, we might read the character of Gidou's jealous lover as another side of Mari herself who personifies and gratifies the patricidal urge (be it brought on by guilt or by anger) that likely accompanied her intense love of her father. But however we read "A Lovers' Forest," there is no question that it is a text in which sexuality and identity seem to float free from their oedipal anchors and into the open seas of fantasy. To call it a "gay" love story would not only render it vulnerable to the (anachronistic) criticism of being not "gay positive" but also reduce its rich perversities to the constraining coordinates of "identity." Mari's extraordinary attention to the materiality of language and the sumptuous object world she describes suggests a superabundant libido that refuses to be localized in any one person or thing. "A Lovers' Forest" is a text that bubbles over with pleasures and drives that are happily oblivious to the boundaries of character and personhood, as if Mari and her father themselves had been blown to bits and scattered throughout the text.

THE DEBATES ON YAOI

There was something in Mari's fantasy world that would capture the imagination of a whole new generation of women beginning in the 1970s for whom marriage and heteronormative adulthood was looking less and less attractive. At the same time, small numbers of gay-identified men in Japan were beginning to imagine a life outside marriage, but despite this historical coincidence, until quite recently Mari's successors wrote and circulated their work in virtual isolation from Japan's gay male community. As that community

reached a critical mass in the early nineties, more and more gay-identified men began to look to the media for representations of their own lives. In what remains of this essay I discuss a debate that arose when one such man lost his patience with the fact that the vast majority of representations in the market of what he considered his own sexuality were produced by and for women who seemed blissfully unaware of his and other gays' existence. Like Mori Mari before them, these women were writing about men who love men, but they had no interest in "gay identity" at all.

The debate began when the gay activist Satō Masaki published an inflammatory open letter to readers of *yaoi* in a small feminist journal (or *minikomi*) called *Choisir* in May of 1992. In his letter Satō complained that the gay men represented in *yaoi* comics and fiction had nothing to do with "real gay men." They were all like Mari's Paulo and Gidou: unspeakably beautiful, well educated, and wealthy. For the vast majority of gay men who did not fit this description, Satō wrote, these characters were impossible to identify with and, moreover, had little or no trouble accepting their own sexuality. What trouble they did have with their own or others' homophobia was evoked only as a narrative device to emphasize the purity and intensity of their love for each other. It was, in other words, strong and pure enough to overcome the accumulated force of heteronormative pressures. For Satō, "*yaoi* girls" were unfairly co-opting the "reality" of gay men and selfishly transforming it into their own masturbatory fantasy. As long as these misleading and unrealistic representations vastly outnumbered representations created by gay men themselves, such texts would constitute a major stumbling block for gay men trying to find their way out of the closet. Satō wrote,

> The more confused images of gay men circulate among the general public the harder it is for gay men to reconcile these images with their own lives and the more extreme their oppression becomes. Those among them who are able to live by their genitals alone might be all right. But the truth is that they are far outnumbered by gays who live their whole lives without ever having sex with another man. For gays like these, *yaoi* and *okoge* [fag hags] are a real nuisance, people they'd rather see dead. Gay sex is looked upon by men with disgust and by women with curiosity. When you're spying on gay sex, girls, take a look at yourself in the mirror. Just look at the expression on your faces! You can all go to hell for all I care.[27]

Satō's letter was the opening salvo of a fascinating and still-unresolved debate about how we define fantasy and its relation to politics, how we

understand the relation between identification and desire, and how we conceive of the mutual determinations between sexuality and identity. This debate was perhaps most significant in that it highlighted both the crucial need for and the difficulty of theoretical and political alliances between feminism and queer theory. Satō's letter seems to have come as something of a shock to the readers of *Choisir*, most of whom were fans or even writers of *yaoi* fiction. Many of them responded by saying that *yaoi* representations of male-male romance were never meant to have anything to do with "real" gay men but were simply projections of women's fantasies onto male bodies. Takamatsu Hisako, a *yaoi* fan and amateur writer, was Satō's most vocal interlocutor in the early years of what would eventually become known as the "*yaoi* debates" (*yaoi ronsō*). Takamatsu argued that her own discomfort with being the object

of the male gaze along with her disgust at the female body made it impossible for her to imagine romance or sex from the perspective of a biological woman. As a result, she explained that at a certain point she "gave up" being a woman and found that her sexuality centered exclusively on fantasies of boy love. In June of 1992 she wrote,

> SATŌ'S LETTER WAS THE OPENING SALVO OF A FASCINATING AND STILL-UNRESOLVED DEBATE ABOUT HOW WE DEFINE FANTASY AND ITS RELATION TO POLITICS, HOW WE UNDERSTAND THE RELATION BETWEEN IDENTIFICATION AND DESIRE, AND HOW WE CONCEIVE OF THE MUTUAL DETERMINATIONS BETWEEN SEXUALITY AND IDENTITY.

For my own reasons I get pleasure out of certain things and there is nothing I can do to change this fact. . . . There was a time when giving up these fantasies (*mōsō*) would have killed me and even now I know that I need them (although it's not as extreme as it was). But all of this is not to say that my need for these fantasies is enough to justify them. At the very least now that someone completely unknown to me has come forward and said "What you're doing hurts me" I have seen the face of the other for the first time. As a result, the pleasures that I have enjoyed until now have changed ever so slightly and I have no choice but to take another look at them.[28]

Over the next five years the pages of *Choisir* were almost entirely monopolized by impassioned arguments about the meaning of *yaoi*, almost all of which recapitulated in one form or another the basic positions originally articulated by Satō and Takamatsu. From Satō's perspective, *yaoi* was not only an unfair co-optation of gay sexuality by women but also a rejection of

female (not to mention "feminist") subjectivity. As a sexual fantasy, it was both politically regressive and self-defeating. Those in Takamatsu's camp, on the other hand, sought to salvage a space for their own fantasies outside political exigencies. They saw *yaoi* as a space of refuge from a misogynist culture in which women were made to be always the objects and never the subjects of desire. While they generally recognized that *yaoi* might constitute a form of violence against gay men, they insisted that to proscribe it as a rejection of womanhood or feminist subjectivity was to militate an equally repressive vision of female sexuality as one that must always culminate in heterosexual sex and sexual fantasies. In essence, then, they were arguing that the gay critique of *yaoi* was itself a form of heterosexism.

But this did nothing to convince those in the debate who identified most strongly as feminists. The translator and writer Kurihara Chiyo narrated her own conversion from a "fag hag" into a feminist in an article published in her coedited compendium to gay literature. After her conversion, Kurihara wrote,

> The whole reason behind my taking refuge in gay novels became clear and at that instant I realized I was a woman and that was OK. I realized that what I had to do was find a way to live and love as the woman that I am. And from then on the gay novels I loved so much and the interest I had in gays just vanished like a lie exposed to the truth. It literally just burned itself out. I understood that fans of "aesthetic" novels were unable to grasp their own psychology. I realized that once you accept your own femininity you will lose interest in "aesthetic" novels.[29]

Although she does not specify exactly how she went about it, Kurihara insists in a later article published in *Choisir* that she achieved this conversion through her own proactive efforts: "I wrote that as soon as I realized my interest in gays was a form of escapism my interest in gay novels burned itself out. But it didn't just disappear on its own. I incinerated it with the flame-thrower of reason, because I could not permit myself to indulge in something so embarrassing. I cannot accept contradictions in myself."[30]

Kurihara's flamethrower conversion is offered as a response to Takamatsu's insistence that sexual fantasy, by its very nature, is something outside one's control and therefore cannot be expected to follow the needs of any political agenda, even one's own. While Takamatsu also recognizes that her love of *yaoi* is a kind of symptom of her own internalized misogyny, she emphasizes that there is no reason why one's biological gender should predetermine the gendering of either the subject or object of one's desire.

Takamatsu's position is very much in agreement with the critique of identity offered by recent work in queer theory, a critique that places the emphasis on the processes of identification through which identities are formed rather than on identity as an ontological given. As Diana Fuss writes in the introduction to her *Identification Papers,* "As sites of erotic investiture continually open to the sway of fantasy, the meaning of a particular identification critically exceeds the limits of its social, historical and political determinations."[31] If this is indeed the case, Kurihara's insistence on using the "flame-thrower of reason" to control one's identification and fantasy would appear as a kind of rearguard effort to shore up a "feminist" subject position against the subversive effects of a too promiscuous process of identification. For Kurihara and Satō in the passages quoted earlier, a stable identity is a necessary precondition for action in the political realm. From a "queer" perspective, on the other hand, it is not identity but *identification* that enables radical political commitment. Takamatsu herself stops short of claiming that *yaoi* might help open up a space for queer politics, characterizing it instead as a refuge from misogynist representations of women. But other participants in the *yaoi* debate do make this argument. The critic Fujimoto Yukari in particular argues that *yaoi* functions as a means, even if only in fantasy, of overcoming and critiquing heterosexist gender norms.[32]

Yet, as Jonathan Mark Hall has argued, the kind of identification with gay men seen in *yaoi* and other forms of "okoge" (fag-hag) culture can all too easily function as what he calls a "spectacle, lure, and displacement [to young women]."[33] While a fascination with male homosexuality might appear in some sense as a critique of heterosexist patriarchy, Hall argues that the "escape" offered by phenomena like *yaoi* also "removes positions for resistance by substituting a commoditized form of opposition that in function underwrites the binds of virginity, male pleasure, and male dominance."[34] The quasi-queer critique of gender ideology that Fujimoto and others see in *yaoi* is, moreover, seriously undermined by the fact that although *yaoi* narratives always involve two men falling in love with each other, they almost invariably mimic the most conventionally heterosexual romance.

Let me cite one piece of *yaoi* fiction that should help make this point clear. In Minakami Rui's extraordinarily titled *yaoi* novel "I Want to Rape You in the Closet,"[35] for example, the story's heroes may be two men, but they are clearly marked with male and female genders. The beautiful younger boy, Natsuki, wants nothing more than to be loved by a "prince" (*ōjisama*) who will both love him and recognize his abilities as a fashion designer. What he does not realize at the beginning is that just such a prince has been spying

> A STORY LIKE "I WANT TO RAPE YOU IN THE CLOSET" MAKES IT POSSIBLE TO IMAGINE WHAT IT WOULD BE LIKE TO ENJOY ALL OF THE PRIVILEGES OF MASCULINITY WITHOUT BEING TIED DOWN BY THE CONSTRAINTS OF SOCIALLY MANDATED FEMALE GENDER NORMS.

on him from a bar across the street from his office as he works late into the night. From the outset then, the younger, feminized partner is represented as the passive object of a male gaze. This "prince," Rihito, is, predictably enough, a slightly older, taller, darker version of Natsuki and is copresident of one of Japan's most successful fashion houses. He uses the masculine first-person pronoun "ore" in contrast with the slightly more childish "boku" used by Natsuki—the same "boku" invariably used by Mori Mari's pretty boys. Rihito speaks English and French fluently, drives a Jaguar, and lives in an enormous mansion inherited from his dead parents. The mansion is so big, we are told, that it only intensifies poor Rihito's feeling of loneliness. Rihito scouts Natsuki to work in his own company, giving him the chance to become a famous designer. It is the older man who seduces Natsuki, and when they have sex, Rihito is always the top. Rihito plans the whole seduction from the beginning, and Natsuki is completely innocent and ignorant of Rihito's desire until the very end. The only thing that differentiates this and most other *yaoi* narratives from a conventional heterosexual romance is that since both heroes are men, they are both able to pursue their careers while fulfilling their romantic desires at the same time.

For women readers able to identify with Natsuki or Rihito (or both), a story like "I Want to Rape You in the Closet" makes it possible to imagine what it would be like to enjoy all of the privileges of masculinity without being tied down by the constraints of socially mandated female gender norms. So far, so good. But even though the choice of "gay" characters as protagonists might function as a critique of heterosexism, the novel's complete lack of concern for or even awareness of the reality of homophobia seriously blunts the force of this critique. While the older Rihito closes his self-introduction in the beginning of the novel with the impossibly casual footnote, "And I'm gay" (*Soshite, ore wa gei desu*), this little fact is otherwise represented as entirely irrelevant to his personality (except to the extent that it makes him more "interesting"—*koseiteki*—and exotic). In what seems an almost perverse recognition of the text's total disavowal of the reality of homophobic oppression for gay men, the central leitmotif of the novel is that of the "closet." It is the "walk-in closet" of Natsuki's (now-dead) parents where he first develops his love for fashion. And the spacious closet of Rihito's fashion house, stocked

full of highest quality haute couture, is where many of the romantic encounters between the couple take place. To the extent that the closet exists here, then, it is a very pleasant place to be. Rihito makes a point of saying that he and his business partner Seiji are "out" to their employees and that they have no problem with it: "Nowadays [being gay] is not such a rare preference," he says, "and they just tacitly recognize it as a form of individuality [*kosei*]."[36] But the depth of this (already questionable) acceptance is put even further into question in a later passage when he comments that,

> People think that the fashion industry is full of gays but actually that's not true. There are lots of guys who go around coming out because they think being gay is an expression of individuality or just because it's fashionable. The fact that the other designers were able to accept Seiji's and my comings out so easily is probably because they thought we were like those other guys. I'm sure they don't really believe that we actually like men.[37]

Never has a double bind seemed so convenient. Indeed, perhaps the most serious problem with this and other *yaoi* texts like it is that, in order to make the privileges of being a man accessible to women readers as fantasy, it makes gay men the ultimate beneficiaries of the heterosexist, patriarchal order. Completely unburdened by the constraints of reproductive sexuality, they simply luxuriate in a universe of privilege and play. If there is a subversive cross-gender identification taking place here or a possibility for gay identification, it comes at the price of the total effacement of the realities of misogyny and homophobic oppression.

Unfortunately, as Biddy Martin has argued in her critique of a similar tendency in some overly utopian strains of queer theory, this can make the situation even worse for women: "Having accepted the claim that interiorities and core gender identities are effects of normalizing, disciplinary mechanisms," she writes,

> many queer theorists seem to think that gender identities are therefore only constraining, and can be overridden by the greater mobility of queer desires. Predictably enough, gender of the constraining sort gets coded implicitly, when not explicitly, as female while sexuality takes on the universality of man. . . . Queer or perverse desires do not seem very transformative if the claims made in their name rely on conceptions of gender and psychic life as either so fluid as to be irrelevant or so fixed and punitive that they have to be escaped.[38]

While Martin's critique can certainly be applied to the *yaoi* phenomenon, I hesitate to close my argument completely on the side of its critics. The issues raised by the debate over *yaoi* have been extremely productive of critique from both a feminist and a queer perspective. Indeed they have forced a thoroughgoing rethinking of the complex relations between the two and have begun to forge new and productive alliances. Satō Masaki, who "threw the first stone" in the debate, reminisced a few years later that when he first wrote that *yaoi* could "go to hell" he was not interested in the situation of women at all. But when he read Takamatsu-san's response he realized that he needed to understand women's position in order to continue the debate. As a result, he became interested in feminism for the first time. In the process he discovered that the feminist perspective was quite useful for thinking about gay issues. In addition, he writes, "If I had never gotten involved in this debate I would never have started [my own *minikomi*] 'Kick Out.'"[39]

> IN THE END IT IS CRUCIAL TO REMEMBER THAT *YAOI* IS FIRST AND FOREMOST A FORM OF FANTASY. AND "EVERY SINGLE PHANTASY," AS FREUD WROTE, "IS THE FULFILLMENT OF A WISH, A CORRECTION OF UNSATISFYING REALITY."

Satō's *minikomi* was one of the first journals to emerge from within Japan's gay community that seriously engaged with issues of gay representation and homophobia. Its founding is thus an excellent example of the unpredictable ways in which promiscuous identifications spawn never-before-imagined forms of identity and coalition. Kurihara Chiyo "graduated" from her fascination with gays to write heterosexual pornography for women, while other participants in the debate like Takamatsu and Tanigawa Tamae have worked to theorize *yaoi* identity from the perspective of pre-oedipal sexuality and women's relation with their parents in ways that echo what we saw going on in Mori Mari's work.[40] Akiko Mizoguchi is working on a fascinating dissertation exploring the way her subjectivity as a lesbian was influenced by her reading of *yaoi*.[41] And writers of *yaoi* itself have begun, as Takamatsu intimated in the passage quoted above, to hear the voice of "real gays," which is slowly making their wholesale co-optation of gay representations less tenable, even as fantasy.

But in the end it is crucial to remember that *yaoi* is first and foremost a form of fantasy. And "every single phantasy," as Freud wrote, "is the fulfillment of a wish, a correction of unsatisfying reality."[42] While children are allowed their fantasies (in the form of play), Freud went on to write, "the adult . . . is ashamed of his phantasies and hides them from other people."[43] But the

fans and authors of *yaoi,* like Mori Mari before them, indulge their fantasies in public. In this, they have refused to grow up and accommodate themselves to an "unsatisfying reality." It is precisely this juvenile intransigence that constitutes the radical value of *yaoi*—a value that is at least different from if not superior to that of the "positive" images of homosexuality that Satō called for in his original letter.

Mori Mari wrote that she always felt that her father was too good for this earth. There was something in his goodness that made him vulnerable, and she felt it her duty to protect him. In 1960 she wrote, "Once a nightmare disturbed me and woke me in a cold sweat; it was about some men approaching my father working at his desk and attacking him from behind."[44] Any reader of Mori Ōgai (including most likely Mari herself) would be reminded by her dream of a passage in his 1909 novel *Vita Sexualis.* The protagonist of this ironically autobiographical novel (a text that is so sex-phobic that one of my students once called it *Vita Asexualis*) is terrified of homosexuals and takes a dagger with him to bed in his boarding school to defend himself against the older students who he believes are out to rape him.[45] In Mori Mari's stories and the *yaoi* works they spawned, homosexuality may not be out and proud, but it is not nearly as scary and violent as it was in her father's novel. Mari will take the place of that dagger to defend her father against attacks from the rear, but she will do so by making him queer. In the context of modern Japanese literature, where Ōgai is a towering masculine presence, this is no mean feat.

...

Notes

1. Mari Mori, "Koibitotachi no mori," in *Mori Mari zenshū* (Tokyo: Chikuma shobō, 1993). The other two are "Nichiyōbi ni boku wa ikanai" ["I Don't Go on Sundays"] (1961) and "Kareha no nedoko" ["The Bed of Dead Leaves"] (1962), both included in *Mori Mari Zenshū,* vol. 2.

2. In this essay I follow Tomoko Aoyama in referring to Mori Mari by her given name, "Mari," which she also used as a pen name.

3. Another often-cited etymology would have it mean "***Ya****mete!* ***O****shiri ga* ***i****tai!*" or "Stop! My Ass Hurts!"

4. Tomoko Aoyama, "A Room Sweet as Honey: Father-Daughter Love in Mori Mari," in *The Father-Daughter Plot* (Honolulu: University of Hawai'i, 2001), 171.

5. In fact Mari switches to a phonetic katakana rendering of these names early on in the story, citing the difficulty of the Chinese characters she has chosen for her characters' names. Incidentally, they are 巴羅 (Paulo) and 義童 (Gidou).

6. Mori, "Koibitotachi no mori," 65. All following translations are mine.

7. Ibid., 76.

8. Ibid., 74, 77, 81, 91.

9. Ibid., 65, 81, 84, 90, 91, 105.

10. Ibid., 66.

11. Ibid., 67.

12. Ibid.

13. Ibid., 66-67.

14. Ibid., 67.

15. Jane Austen and Deirdre Le Faye, *Jane Austen's Letters,* 3rd ed. (Oxford: Oxford University Press, 1995), 323.

16. Mishima Yukio, "Mori Mari," in *Mishima Yukio hyōron zenshū dai-ikkan,* ed. Miyoko Tanaka (Tokyo: Shinchōsha, 1989), 348.

17. Mori, "Koibitotachi no mori," 64–65.

18. Jane Austen, *Northanger Abbey, Lady Susan, The Watsons, Sanditon* (Oxford: Oxford University Press, 2003), 25.

19. Mori, "Koibitotachi no mori," 98.

20. Ibid., 121.

21. Ibid., 96.

22. The surge of jealousy that Gidou feels for Reimon only adds spice to his passion for the younger boy, "like a tropical curry on his tongue" (83).

23. Ibid., 123.

24. Ibid., 124.

25. Ibid., 125.

26. Ibid., 73.

27. Satō Masaki, "Yaoi nante shinde shimaeba ii," *Choisir* 20, no. 5 (1992): 9. All following translations are mine.

28. Hisako Takamatsu, "'Teki/mikataron no kanata e' 2: Miyō to suru koto, miete kuru koto," *Choisir* 21, no. 6 (1992): 8.

29. Chiyo Kurihara, "Tanbi shōsetsu to wa nani ka," in *Tanbi shōsetsu, gei bungaku gaido,* ed. Eiko Kakinuma and Kurihara Chiyo (Tokyo: Byakuya shobō, 1993), 333. "Aesthetic," or "*tanbi,*" is a related term that refers to what I have been calling "*yaoi.*"

30. Kurihara Chiyo, "Shikaru beki hanron no tame no hanron," *Choisir* 30, no. 9 (1993): 18.

31. Diana Fuss, *Identification Papers* (New York: Routledge, 1995), 8.

32. Fujimoto Yukari, "Shōjo manga ni okeru 'shōnen'ai' no imi," *New Feminism Review* 2 (May 1991): 280–84.

33. Jonathan Mark Hall, "Japan's Progressive Sex: Male Homosexuality, National Competition, and the Cinema," *Journal of Homosexuality* 39, nos. 3–4 (2000): 43.

34. Ibid., 66.

35. Rui Minakami, *Kurōzetto de ubaitai/In the Closet* (Tokyo: Leaf Novels, 2000).

36. Ibid., 87.

37. Ibid., 120.

38. Biddy Martin, "Extraordinary Homosexuals and the Fear of Being Ordinary," in *Feminism Meets Queer Theory,* ed. Elizabeth Weed and Naomi Schor (Bloomington: Indiana University Press, 1997), 112.

39. Masaki Satō, "Takamatsu-san e no tegami," *Choisir* 34, no. 4 (1994): 25.

40. See Tamikawa Tamae, "Josei no shōnen'ai shikō ni tsuite 3: 'Yaoi ronsō' kara," *Joseigaku nenpō* 16, no. 10 (1995): 36–51. For a more recent account of the debates about and history of "*yaoi*," see Mizuma Midori, *In'yu toshite no shōnen'ai: Josei no shōnen'ai to iu genshō* (Osaka: Sōgensha, 2005).

41. See Akiko Mizoguchi, "Homofobikku na homo, ai yue no reipu, soshite kuia na rezubian: Saikin no yaoi tekisuto wo bunseki suru," in *YAOI no hōsoku: Law of Desire,* ed. Mayumi Shinoda, Kakinuma Eiko, and Mizoguchi Akiko (Tokyo: Ryokuyōsha, 2001).

42. Sigmund Freud, "Creative Writers and Day-Dreaming," in *The Standard Edition of the Complete Psychological Works of Sigmund Freud,* ed. James Strachey (London: Hogarth, 1959), 9:146.

43. Ibid., 9:145.

44. Quoted in Aoyama, "Room Sweet as Honey," 173.

45. My use of the term *homosexuals* is admittedly anachronistic here. In Ōgai's novel he uses the term *kōha* (or "tough crowd") to refer to what we might today call homosexuals. The fact that the *kōha* are represented in Ōgai's novel as more "masculine," less fashionable, and far less hygienic than the "*nanpa*" (the girl-loving, "soft crowd") stands as a reminder of the extraordinary historical malleability of categories of sexual identity and practice. See Ōgai Mori, *Vita Sexualis,* trans. Kazuji Ninomiya and Sanford Goldstein (Tokyo: Tuttle, 1972).

時 間 性
Powers of Time

D A I S U K E M I Y A O

• • •

Thieves of Baghdad: Transnational Networks of Cinema and Anime in the 1920s

FROM *WAXWORKS* TO *THE THIEF OF BAGDAD*

Although cinema has been a transnational cultural form from the very beginning of its history, it has often emerged as a national cinema, formed by specific discourses on nationalism and modernization. This essay examines both the transnational and the national aspects of the 1926 Japanese animated film *Bagudajō no tōzoku (The Thief of Baguda Castle)* by Ōfuji Noburō. As the film's title indicates, Ōfuji's work was based on *The Thief of Bagdad,* the 1924 American feature film by Raoul Walsh, which was in turn inspired by Paul Leni's German film *Waxworks* that was released in the same year. According to the film scholar Miriam Hansen, "To write the international history of classical American cinema . . . is a matter of tracing not just its mechanisms of standardization and hegemony but also the diversity of ways in which this cinema was translated and reconfigured in both local and translocal contexts of reception."[1] This essay is one such attempt to write "both local and translocal" history of cinema on how narratives cross national, cultural, and generic frontiers and how they are received and appropriated. Comparing the Japanese and American versions reveals some significant similarities between the two

contexts. The similarities have to do with the pressures that nationalisms exert on tales that are overtly marked as foreign. The two versions are parallel instances of a shared cinematic nationalism but in different national contexts.

First, how could *The Thief of Bagdad* be located in the context of cinematic nationalism in the United States? The Walsh film partook of "Americanization" discourses of the 1920s. When *The Thief of Bagdad* was released in the United States, the renowned American poet and popular lecturer during the temperance movement, Vachel Lindsay—who was also a radical critic of white supremacy, even though it was commonly assumed that his view about race relations in America was too naive—expressed his excitement about the Americanization of the Arabian fairy tale by Douglas Fairbanks: "As he [Fairbanks] mounts his horse and rides across the plains, throwing sand and so calling up men from the ground, it is surely the Douglas Fairbanks gesture of triumph carried back into the days of the dream world of the Arabian Nights, and he is indeed a fairy tale hero, as fairy tales are read by American boys under the shadow of the Star Spangled Banner. . . . This is the American Art."[2]

Americanization was in fact a significant issue in the production of *The Thief of Bagdad*. In the 1920s, there was a boom in Hollywood to produce films set in the exotic Middle East or Asia and to build oriental-style movie palaces. This orientalist trend, however, was not meant to provide any subversive messages to the American film viewers, especially on the issues of race and sexuality. Instead, after the scandal of the silent comedy star Roscoe "Fatty" Arbuckle, Hollywood was in the middle of various attempts to acquire cultural legitimacy for middle-class audiences.

Under these conditions, *Waxworks* was excellent material for making another orientalist film, but it also was too foreign to be simply remade in Hollywood.[3] *Waxworks* is composed of three episodes. A young poet visits a wax museum and writes a story about each of the wax figures. The first episode is about Caliph Haroun al-Raschid in Baghdad, who does not believe in monogamy and loves a different woman every day.[4] He sneaks out of his castle to seduce a young baker's wife who is not satisfied with her life in poverty. The baker cuts off the caliph's hand and steals his magic ring to accommodate his wife's wish. Eventually, it turns out that the hand the baker cut off is that of the caliph's wax figure. In the end, the caliph gives her up and becomes a guardian of the young couple.

The seduction of other men's wives by the "Fatty"-looking caliph, despite being played by the renowned actor Emil Jannings; the murder attempt out of greed (or, the symbolic castration attempt out of jealousy) by the young hero; and the depiction of his wife as a femme fatale: all of these issues in the

first episode in *Waxworks* needed to be recon-
figured when it was remade as a star vehicle
for Douglas Fairbanks Sr. in the sociopolitical
contexts in Hollywood at that time. In 1929 *Va-
riety* reviewed the film and noted that its con-
tent was "very doubtful for standard policies and exhibs [*sic*]."[5]

AMERICANIZATION WAS IN FACT A SIGNIFICANT ISSUE IN THE PRODUCTION OF *THE THIEF OF BAGDAD*.

Hollywood's film industry pursued legitimatization and institutionaliza-
tion of cinema in response to the middle-class "Americanization" movement
of the period. The word *Americanization* was originally used during the an-
tebellum nativist controversies in the mid-nineteenth century, when many
Irish Catholic immigrants arrived in the United States, and referred to the
immigrants' assimilation into American principles and customs.[6] Basically,
Americanization was Anglo conformity: from the eighteenth century on,
the white Anglo-Saxon Protestants (WASPs) had been viewed as the domi-
nant ethnic majority and touted as a people distinguished by their desirable
qualities without being changed themselves. From the 1890s, as a result of
rapid industrialization, urbanization, and increase of immigrants, reorga-
nization of the social order became debated, especially among middle-class
Americans. They began to feel that the United States would require a higher
level of homogeneity and close conformity to the cultural majority (WASP)
in language, religion, and manners and that a more active policy of purpose-
ful Americanization was necessary. Xenophobia set off in the United States
by the outbreak of war in Europe in 1914 marked the opening of a far more
intense phase of the Americanization movement.[7] By the 1920s, the move-
ment came to mean exclusion of people on ethnic or racial basis. Increasingly
popular among middle-class audiences, motion pictures institutionally sup-
ported the Americanization movement.

Americanization was also a feasible strategy for studios to make the im-
ages of their stars heroic and sympathetic enough for middle-class audiences.
The Thief of Bagdad makes Fairbanks's character heroic, effectively using the
motif of a racial hierarchy that supports the ideas of white supremacy and
Anglo conformity. The film utilizes racist stereotypes such as "Muslims as
agile thieves, fat, lazy, and spineless princes, or superstitious princesses; Af-
ricans as sword carriers; and Asians (Mongols) as diabolical, amoral, and cun-
ning criminals" in order to clarify its melodramatic structure between good
and evil.[8] A renowned actor in Japan's *shingeki undō* (theater modernization
movement) named Kamiyama Sōjin plays the antagonist villain, a Mongolian
prince, who plans to take over Baghdad by marrying the princess, played by a
white actress named Julanne Johnston (fear of miscegenation). The Chinese

American actress Anna May Wong plays a Mongol slave. The Mongolian race, "authentically" played by Asian actors, is distinguished as conspiring and villainous, in opposition to sympathetic Arabs played by white actors including Fairbanks and Johnston. Kamiyama's makeup includes the notorious Fu Manchu–like whiskers, and Wong's costume primitively and erotically reveals much of her torso and legs. *Variety* does not question the film's racism but praises its effective use of nonwhite actors: "So-jim [*sic*] in the role of Mongolian Prince, a really fine characterization. Anna May Wong as the little slave girl who is a spy for the Mongolian Prince, proved herself a fine actress."[9] However, many Chinese Americans thought Wong's part was demeaning, and Kamiyama hid his Japanese nationality so as not to offend Japanese Americans.[10]

In addition to the racial stereotypes, *The Thief of Bagdad* uses the structure of a melodramatic chivalry tale and a bildungsroman to distinguish Fairbanks from the other Arabian characters as well as from the villainous Asian ones. It is a story of Fairbanks's growing up from a child to a man, which is juxtaposed as his development from savagery to civilization. In the beginning, Fairbanks's Arabian thief is depicted as a primitive savage who plans to abduct the princess. He is "bronzed and naked to his waist line" and shows his "dexterity and agility."[11] Yet, as the narrative develops, Fairbanks's character turns into a hero who protects a heroine and the order of the society from other nonwhite people. In the early twentieth century many reform theories about boys that were aligned with popularized notions of Social Darwinism juxtaposed a boy child with a racial "savage."[12] The *New York Times* stated, "He [Fairbanks's character] is actually a young man in search of his birthright— true manhood and power over men—who has discovered that happiness cannot be stolen."[13] The ostensible moral of the tale, given at the beginning and the end of the film, "Happiness must be earned," delivers the real lesson in America in a sugarcoated manner that "even the lowliest person on the social ladder can make something of himself . . . and move up the socioeconomic scale."[14] Fairbanks's transformation of identity, from a primitive thief masquerading as a prince to a more civilized, or Americanized, citizen, makes his character more sympathetic and heroic than other nonwhite characters.

THE THIEF OF BAGUDA CASTLE AND "MEDIATED" JAPAN

Despite its strong inclination to the ideology of Americanization, the success of *The Thief of Bagdad* was not limited to the U.S. domestic market. This

spectacular film was received very well internationally and impressed numerous critics and artists in Japan. *The Thief of Bagdad* was released there in 1925 and selected as the best "entertaining film of excellence" of the year by *Kinema junpō,* a popular Japanese film journal. Right after the film's release in Japan, a reviewer at the film journal *Eiga ōrai* highly valued the film's artistic and technical as well as financial achievement:

> The dreamy scene, composed of the splendid background, the dazzling light, and the movement of people, is undoubtedly filled with unique rhythm of beauty. In particular, the picturesque artistic value in the background cannot be missed. The magnificent castle in Baghdad, the extremely grotesque valley of fire, the fascinatingly misty court of moon, the mysterious court in the ocean, and the architecture of huge statue of Buddha are the display of the essence of technical craftsmanship. . . . When I see this film, or this type of films, I understand the artistic value and the exhibition value coexist in cinema. In this film, *The Thief of Bagdad,* in fact, aesthetically and pictorially, the artistic value and the exhibition value stand side by side.[15]

It is noteworthy that in Japan, in addition to such admiration of the film's technical aspects, *The Thief of Bagdad* was praised for the appearance of a renowned Japanese actor in the film. Despite his villainous role, Kamiyama Sōjin was highly valued in Japanese film magazines.[16] *Katsudō zasshi* listed excerpts from six reviews of *The Thief of Bagdad* in U.S. newspapers and magazines, all of which acclaimed Kamiyama's acting. Ushihara Kiyohiko, a film director who had studied in the United States, wrote in 1926, "Hurray, Mr. and Mrs. Kamiyama Sōjin! I cannot think without tears about the brave soldier in the Hollywood film industry who explores his unique skills and struggles alone."[17] Tamura Yukihiko of *Kinema junpō* also wrote, "[Kamiyama] is doing his best for the good of the Japanese people."[18]

This issue of nationalism in the reception of *The Thief of Bagdad* is significant especially when we turn our attention to its Japanese remake. In 1926 Ōfuji Noburō, a pioneer animator specializing in cut-paper (*kirie*) animation, remade *The Thief of Bagdad* into a thirty-eight-minute animated film, *The Thief of Baguda Castle,* using *chiyogami,* Japanese papers with handprinted color patterns, by which "girls traditionally made dolls to play with."[19] Even though *The Thief of Baguda Castle* basically follows the narrative of *The Thief of Bagdad*—the exciting adventures of a thief who falls in love with a princess and becomes her dream prince/savior after slaying a dragon and finding treasures including a flying horse—it was not a simple remake of the American

counterpart at all. On its surface, the film does not appear to be based on a foreign film. The viewers who are not familiar with *The Thief of Bagdad* will not even think that this film is a remake at all. *The Thief of Baguda Castle* could be marked as foreign by the title that follows the original, but the word *Baghdad* was audibly and visibly "Japanified" as "Bagudajō" (Baguda, whose Chinese characters mean "horse equipments" and "rice fields"; "jō" means a castle), and the film is replete with icons of premodern Japan. On the level of the narratives, the film aggressively transforms the story into a Japanese tale. After introducing the childish-looking hero, Dangobei, or "skewered dump-ling man," whose name connects his round face and body to a traditional Japanese sweet, the film begins with an intertitle, "Once upon a time, there was a city called Baguda in the country of Azuma." Dangobei's face with em-phasized eye lines and lips imitates that of a kabuki actor. The first scene shows a street in front of a wall, on which people move from right to left or vice versa, simulating a theatrical stage. More than anything else, Ōfuji chose *chiyogami* to narrate the story of *The Thief of Baguda Castle* in a somewhat fetishistic manner. *Chiyogami*'s "beautiful colors," according to him, "contain unique elegance of traditional Japan."[20] Ōfuji's project could be regarded as the one that would "self-fashion" Japan's "traditional" culture.[21]

The ad lines of *The Thief of Baguda Castle* do not refer to *The Thief of Bag-dad* at all, despite the Walsh film's success in Japan, but simply emphasize the Japanese appearance of the film:

> The first attempt in our country.
> The birth of a wonderful animation.
> *Chiyogami*-technique of purely Japanese taste.
> The beautiful lines dance madly.
> The story that everyone can enjoy.[22]

This ad clearly publicized the Ōfuji film's technical achievement in uniting Japanese spectators as one ("everyone") with traditional Japanese culture and "taste." On the level of the forms, Ōfuji used an unusual material, *chi-yogami,* which could easily signify Japanese traditionality, for an animated film.

However, no matter how "Japanified" *The Thief of Baguda Castle* appears to be and no matter how intensely the film attempts to keep its distance from its foreign origin on the levels of narrative and setting, the film did not en-tirely bypass the issue of the foreign. Instead, the film's representation of pre-modern Japan was a "mediated" one. It was an orientalization of Japan's past

via Hollywood's orientalist imagination. *The Thief of Baguda Castle* used the dreamy romance of the Orient in *The Thief of Bagdad* to inject some magic into Japan's own phantasmic, long-gone past. According to the historian Anthony D. Smith, modern nations are constructed of more permanent cultural attributes such as memory, value, myth, and symbolism.[23] *The Thief of Baguda Castle* is constructed of myth and symbolism, appropriating the American version of orientalist myth and symbols into the Japanese contexts. In other words, it was appropriation of Western terms for the sake of Japan's own orientalism. While the Walsh film partakes of "Americanization" discourses of the 1920s in the United States, the Ōfuji film was embedded in the nationalization of film culture in Japan, strategically dealing with the notion of the foreign. By the 1920s, "cinema" (*eiga*) in Japan was emerging as national cinema, formed by specific discourses on "Japan," only with reference to foreign films.[24] The historian Marilyn Ivy argues that Japan is "literally unimaginable outside its positioning vis-à-vis the West." She claims that "there was no discursively unified notion of 'Japanese' before the eighteenth century," when Japan encountered the West and ended its isolationist policy. At the same time, Ivy argues, via the literary critic Karatani Kōjin, "the foreign—because of its very threat [as colonial powers]—must be transformed into a manageable sign of order" in Japan.[25] What was ambivalently critical in the production and reception of *The Thief of Baguda Castle* was this modern notion of "Japan," which was in fact a mediated construct via the West, and the notion of "foreign," which must have been contained.

NO MATTER HOW "JAPANIFIED" *THE THIEF OF BAGUDA CASTLE* APPEARS TO BE . . . THE FILM DID NOT ENTIRELY BYPASS THE ISSUE OF THE FOREIGN.

Kimura Chiio (a.k.a. Chieo), who became a screenwriter for Nikkatsu and wrote for films including Mizoguchi Kenji's *Tokyo March* (1929, *Tokyo kōshinkyoku*), even used the term *orientalism* in his review of *The Thief of Baguda Castle* in *Kinema junpō*.

> I respect the author's careful efforts that have completed this elaborate work with *chiyogami* and his idea to use *chiyogami* for shadow pictures. . . . Naturally, this work is not equal to films with painted pictures that already exist in terms of realism (needless to say, films with painted pictures are not very realistic), but it has unique quality and taste that cannot be achieved by realism. The author is clever enough to have chosen a fairy tale for his debut work. After all, this film should only be appreciated as a work for a peep

show. It is an exotic entertainment that spits out a strange kind of rhythm when it is screened with an appropriate musical accompaniment. It is a form of Orientalism. The rhythm of *omikoshi* (Japanese portable sacred palanquin parading through the streets during a *Shintō* festival)! To me, this is exactly how *chiyogami* animation films should exist.[26]

While Kimura praised Ōfuji's craftsmanship and innovative techniques, he recognized this *chiyogami* anime's strategy of orientalizing Japan's past in the form of a festive fairy tale.

On the levels of its styles and its generic configuration, in particular, the representation of Japan in *The Thief of Baguda Castle* could be regarded as being mediated by Hollywood cinema. Stylistically, despite its form as an animated film with *chiyogami*, *The Thief of Baguda Castle* fully utilizes various cinematic techniques that had been effectively used in Hollywood films, including multiple shot sizes, camera movements, point-of-view shots, deep-space compositions, crosscutting, and intertitles. For instance, the film's narrative begins with the "iris in" technique: images of flower petals opening like a camera shutter, which leads to an establishing extreme long shot of a mountain, stars, and the Baguda Castle on the left. Without a cut, the lighting/color change indicates the morning, and the camera tilts down to the street below the castle.

The following scene effectively uses multiple shot sizes, point-of-view shots, and flashbacks to highlight the protagonist's psychological developments, which are the narrative's leading force. On the street, in a long shot, Dangobei bows to a lady, whose face is hidden behind a parasol. As she shows her face, it is black and ugly. When another lady with a parasol appears in front of Dangobei, an irised close-up of the lady with a black face is inserted. When the princess with sensual red lips, who looks like the American star Clara Bow, appears, she does so in Dangobei's point-of-view shot (irised close-up). In this sense, it could be argued that *The Thief of Baguda Castle* imitates the so-called classical Hollywood cinema's ideological system of male gaze and female objectification. The princess, intentionally or not, drops *omamori*, a Shinto keepsake, for Dangobei. He looks at the keepsake (close-up). The shot of the keepsake dissolves into a close-up of the princess, and then dissolves back to the close-up of the keepsake. The point-of-view shots and the flashback juxtapose the keepsake and the princess and objectifies/fetishizes the latter in the mind of the focalized male protagonist, Dangobei. When Dangobei thinks of the princess, her face is inserted on her head in double exposure. Thus, despite its premodern Japanese setting, the narrative of *The Thief of Baguda Castle*

progresses along with Dangobei's psychological development and emotional commitment to the princess, which is emphasized by such cinematic techniques as point-of-view shots, flashbacks, and double exposures. This film follows a typical narrational strategy in classical Hollywood cinema.

In the following scene, another cinematic technique, crosscutting, which was developed in D. W. Griffith's melodramatic films in the early period of classical Hollywood cinema, is used effectively to emphasize a heroic characterization of Dangobei. The adventures of Dangobei and his rival are displayed back-to-back, and this editing technique distinguishes the hero's success from the other's failure. For instance, in a snow country, the rival does not save the female snow spirit who is running away from the villainous horseman (the chase, another typical narrative device in classical Hollywood cinema, is displayed in a deep space composition), saying, "Scary, scary. I should not get close to danger." On the contrary, Dangobei stabs the horseman with his sword and saves the snow spirit. His sword dissolves into an umbrella. On the umbrella, Dangobei keeps snowflakes, which he uses to protect himself from the dragon's fire in the following scene at the demon pond. His rival wastes the snowflakes and is burned in the dragon's fire.

Generically speaking, *The Thief of Baguda Castle* appears to distance itself from *The Thief of Bagdad,* a mainstream Hollywood adventure film. *The Thief of Baguda Castle* was a mixture of *jidaigeki* (period drama usually set in the Edo period, 1603–1867) and *kyōiku eiga* (educational film), in the form of an animated film. *Kyōiku eiga* corresponded to the Ministry of Education's pedagogical film activities in the 1920s, particularly after 1921 when the ministry started recommending films that they considered to have socially educational values. Ōfuji's *Jiyūeiga kenkyūjo* (Free Film Laboratory), established at his home in 1926, was considered to be one of those companies that produced educational films.[27] *The Thief of Baguda Castle* was the first film produced at the Free Film Laboratory. Yet, no matter how different its generic status is, *The Thief of Baguda Castle* is still considered to be a work mediated by Hollywood. In fact, both *jidaigeki* films and educational films were significantly influenced by Hollywood cinema in the 1910s and 1920s.

Jidaigeki became the most popular film genre by the late 1920s, but it stood in an ambivalent position, between premodern and modern. *Jidaigeki* was emerging in the 1920s as a new "purely cinematic" genre that was meant to overcome the unrealistic theatricality of kabuki-influenced *kyūgeki* (old drama), the most popular film genre in Japan in the 1910s, mostly set in premodern period and emphasizing sword-fighting dances. Even though *kyūgeki* did include some camera movements and Méliès-style trick editing, they

mostly used long takes and long shots without female actors, which was often criticized by young intellectual film critics as uncinematic.[28]

The term *jidaigeki* appeared only in 1923, when Shōchiku Kinema released *Onna to kaizoku* (*Woman and Pirates*) and used the term *shin jidaigeki* (a new period drama) in the film's ad. It was not simply a new name given to the same kind of products for a publicity purpose. While mostly set in the premodern period and emphasizing sword-fighting scenes like *kyūgeki*, *jidaigeki* used numerous cinematic techniques, such as intertitles, rapid editing, numerous camera movements, choreography influenced by the serial films from the United States and Europe, and the swashbuckler films of Fairbanks, the most popular foreign actor in Japan in the 1920s. In particular, sword fighting in *jidaigeki*, which was called *chambara*, was more speedy and realistic than that in *kyūgeki*, which was more stylized. The innovative styles of *jidaigeki* corresponded to changes in the audience's taste, especially in the 1920s because of the rapid modernization, the reconstruction of social and media landscape of Tokyo after the 1923 Great Kantō Earthquake, and the simultaneous rearticulation of time and space in everyday life. Even Makino Shōzō, "the father of Japanese cinema," who produced numerous *kyūgeki* films with the first movie star in Japan, Onoe Matsunosuke, established Makino Eiga Company in 1921 and, especially after 1923, made significant numbers of action-packed *jidaigeki*. In fact, Makino Eiga, affiliated with United Artists (Fairbanks was one of its founders), had the right to distribute their films in Japan. *The Thief of Bagdad* was thus exhibited in Japan together with Makino films. Makino Eiga even produced numerous *jidaigeki* remakes of Fairbanks films, such as *Robin Fuddo no yume* (1924, *Robin Hood's Dreams*).[29] Therefore, Ōfuji's remake of *The Thief of Bagdad* into *jidaigeki* was not exceptional with regard to this trend.

However, *The Thief of Baguda Castle* was different from the *jidaigeki* films of the period. Obviously, it was not a live-action film but an animated one. More significantly, *The Thief of Baguda Castle* was first exhibited at Shinjuku Shōchiku Theater, a first-run theater for the Shōchiku Kamata studio, which was known by then as the home of American-style modern comedies, not *jidaigeki* films.[30] On the level of exhibition, *The Thief of Baguda Castle* was mediated by Hollywood cinema in this sense.

More than anything else, the characterization of the protagonist in *The Thief of Baguda Castle* did not correspond to the major trend of *jidaigeki*. The most popular *jidaigeki* stars of the time, most typically Bandō Tsumasaburō, often played antiheroes who suffer in the inhuman feudal system and severe economic conditions. The popularity of *jidaigeki*, its antiheroes, and more

realistic and (self)destructive sword fighting might have corresponded to the post–World War I severe social and economic conditions in Japan. Deviation from *kyūgeki*'s theatricality and full use of cinematic techniques in *jidaigeki* became possible because of changes in social conditions and the corresponding transformation of the mass audience's taste.

On the contrary, Dangobei is depicted not as a rebellious force but as a hardworking and faithful feudal samurai. Pedagogical intertitles keep reminding the viewers of the story's morals as the hero's adventure proceeds. Right before Dangobei begins his treasure-hunting adventure, an intertitle declares the pedagogical moral of the entire film, "All the happiness of thy life is achieved by making efforts." This line is repeated at the end of the film. In addition to this overarching moral, each scene is structured around a smaller moral.[31] The moral of the scene in the snow country is "He that gives lends." Dangobei saves a female snow spirit from a half-man, half-horse monster, while his rival stays away. Consequently, in return the snow spirit takes Dangobei to the castle filled with treasures. The moral of the scene at the demon pond is the importance of economizing. An intertitle states, "Do not even waste snowflakes." Dangobei is able to protect himself from the dragon's fire only because he has saved such trivial things as snowflakes. Thus the hero's adventure is pedagogically articulated as a learning process, which is a typical device of educational films, whose production and exhibition were initiated by Japanese governmental officials.

The anime scholar Akita Takahiro claims, "Educational value was required of cartoon films in this period [by the authorities], and old tales were often used as subject matters to deliver allegories or morals."[32] In the wake of the controversy over the incredibly popular French serial *Zigomar*, shown in Japan in late 1911, officials were convinced of the powerful impact that film had on audiences, especially young ones.[33] Japanese governmental officials rapidly concluded that they should turn that force to their own purposes. Numata Yuzuru, the chief of motion picture censorship at the Tokyo Metropolitan Police Department, insisted, "[Motion pictures] have become a national and social enterprise. . . . It is necessary by any means to improve it. . . . No art form will progress without a true protector, and [the protector for motion pictures is] a nation, . . . and the Police Department is the direct force of the nation."[34] In 1917 the Tokyo Metropolitan Police established and enforced the regulations on the motion picture exhibition (*Katsudō shashin kōgyō torishimari kisoku*), in the name of "public safety" and "public education."[35]

The Tokyo Metropolitan Police's regulations were mediated by the U.S. regulations on Hollywood cinema by the National Board of Review of Motion

Pictures. The National Board advised "regarding morally objectionable elements" in motion pictures and tried to codify films into workable middle-class standards, "morally, educationally and artistically," to guide the production and exhibition of motion pictures. The major film producers later came to agree to submit their films to the committee and comply with any recommended changes. Even though the National Board had no legal powers, there was very little indication that the producers deliberately ignored their suggestions.[36] In fact, Tokyo Metropolitan Police officials worked with the National Board to form their regulations. From January 1918 until at least 1923, Tachibana Takahiro, an officer of the Censor Section of the Tokyo Metropolitan Police, sent numerous letters to the secretaries of the National Board and exchanged opinions and information about motion picture censorship.[37]

Under these conditions, the Ministry of Education started recommending particular films, including animated films that promoted governmental policies, to Japanese audiences in 1916.[38] In fact, early animators relied on educational institutions for patronage, which were subject to state policies. One of the early animators, Kitayama Seitarō, made animated films, *Chokin no susume* (1917, *Promoting Savings*) and *Chiri mo tsumoreba yama to naru* (1917, *Many a Mickle Makes a Muckle*), to promote savings for the Deposit Bureau of the Ministry of Post and Telecommunications as early as 1917. Another animator, Yamamoto Sanae, made such promotional films as *Shokurin* (1924, *Forestation*) for the Ministry of Agriculture and Forestry; *Yūbin no tabi* (1924, *The Journey of a Letter*) for the Ministry of Post and Telecommunication; and *Baidoku no denpa* (1926, *The Spread of Syphilis*) for the Ministry of Education. Thus, in the historical contexts of *jidaigeki*'s popularity and government policy on educational films, *The Thief of Baguda Castle* was generically connected to the Hollywood imagination, as well as stylistically.

The issue of mediation by foreign cinema in *The Thief of Baguda Castle* characterizes a certain tendency in Japanese film culture of the 1910s and the 1920s. This tendency is most typified by the so-called *jun'eigageki undō*, the Pure Film Movement. In the early 1910s, in such film journals as *Kinema Record*, primarily young intellectual figures, from film critics and filmmakers to government officials, began to criticize the production, exhibition, and reception of mainstream commercial films in Japan. Their writings and subsequent experimental filmmaking are often noted as the Pure Film Movement.

This "loosely defined discourse-based 'movement'" was composed of "diverse paths leading to a single destination . . . or common cause, [which] was the realization of culturally respectable film, endowed with both aesthetic legitimacy and contemporary realism, that theoretically would challenge a

mainstream commercial product that had theatrical origins."[39] According to the film historian Joanne Bernardi, one goal of the Pure Film advocates was to attain "an internationally viable level of narrational clarity for films also endowed with a comprehensible and distinct national and cultural identity."[40] They criticized mainstream commercial Japanese motion pictures, which had appealed to "mass" audiences, because for the most part they were merely reproducing stage repertories of *kyūgeki* and *shinpa* (new school, or modern drama influenced by traditional kabuki styles). Pure Film advocates found inspiration in imported films, American and European film magazines and instructional books on cinema, and news of the latest production techniques brought back by a number of filmmakers and producers who toured the Hollywood studios during the American film industry's sudden boom in production after World War I. They insisted on modernizing Japanese films with formal and narrative techniques, such as varied and complex camera work (in particular, close-up shots and moving-camera techniques), continuity editing, artificial lighting, and spoken titles (dialogue intertitles).

With regard to the styles of *The Thief of Baguda Castle,* in addition to the numerous techniques, including close-ups and continuity editing, that function to enhance Dangobei's psychological motivations and heroic characterization, one of the movement's major stylistic goals is extensively used in the film: *fukidashi,* words written in a balloon-shaped frame near a character's mouth, a typical technique in cartoons. The Pure Film advocates emphasized the use of intertitles to bypass the *benshi,* live performers who supplied narration, explication, and comic banter during film screenings, because they disrupted the cinematic qualities of film and discouraged filmmakers from using the medium to tell the story. By 1926, when *The Thief of Baguda Castle* was released, the role of the *benshi* had become more "subordinate" to the intrinsic narration of cinema because of the rising production-centered (not exhibition-oriented) film industry in Japan and the state's aspiration and intervention to regulate audience through *benshi.* However, particularly as public educators under the state's regulation, the popularity and influence of the *benshi* over audience members continued, according to the film historian Jeffrey A. Dym, into the "golden age" in 1926.[41] Such influential Pure Film advocates as Kaeriyama Norimasa and Tanizaki Jun'ichirō claimed that *benshi* served no educational function and should be absolutely obedient to films and ultimately eliminated.[42]

In addition to such aesthetic issues, as the film critic Aaron Gerow suggests, there were nationalist discourses on cinema among these young intellectual critics that aimed at the mutual development of Japanese cinema and

Japanese national identity.[43] The advocates of this discursive tendency emphasized the educational value of cinema and its potential for strengthening public morality. They shared their desires to change the cinematic experience in Japan, even resorting to state regulations, including producing and promoting educational films.

The Pure Film advocates insisted that cinema was a national project and that it should serve the nation. Kaeriyama tried to rearticulate the motion picture, which had been considered lower-class entertainment, as an art form that would be useful both to edify the individual and to awaken "the Japanese to a sense of national identity."[44] In *Katsudō no sekai*, an educational magazine that originally started with the intention of giving advice appropriate for Japanese young people to obtain success in their lives, but turned in its third issue into a magazine devoted to cinema, Kamata Eikichi, the president of Keiō University, proposed an application of the motion picture for education and "for the national interests."[45]

The Pure Film advocates insisted that the proper mixture of cinematic and technical innovations from the West and unique Japanese content would lead Japanese cinema to an internationally viable level of narrational clarity and an exportable and marketable product. Yet the Pure Film advocates were not satisfied with slavishly imitating foreign products. Mukai Shunkō of *Katsudō gahō* insisted on making films that would use Western techniques but would express *yamato damashii*, the pure Japanese spirit, that he, and others, considered to represent Japan's power and strength as a nation.[46] In this sense, the discursive tendency in the Pure Film Movement was political, economic, and strategic, as well as aesthetic: "To totalize and nationalize the field of Japanese cinema."[47]

The ambivalent nationalist attitude of the Pure Film Movement was, in fact, in accordance with governmental discourses of modernization in Japan, even though the movement was not directly under the government's control. To obtain recognition as a nation in international relations, the Japanese government had undertaken certain policies to show their achievement toward modernization in a Western sense since the late nineteenth century. The government tried to use Western standards and ideas to construct Japan's own national identity and to escape from being colonized by Western imperialism.[48] The contradictory attitude of the Japanese government toward modernization and nationalism was indicated by its slogan "Japanese Spirit and Western Culture" (*wakon yōsai*).

If one were to understand nationalism in the sense of the ideology of the modern nation-state, the Japanese government's attempt to incorporate

Western-style modernization into the local culture was intrinsic to the very notion of nationalism in Japan. In the 1920s, with the influential trend of Americanization in the urban consumer culture that flourished in Tokyo after the Great Kantō Earthquake, displays of Japaneseness tended to be suppressed in various media, such as numerous newly published magazines, popular songs, ra-

> THE PURE FILM ADVOCATES INSISTED THAT THE PROPER MIXTURE OF CINEMATIC AND TECHNICAL INNOVATIONS FROM THE WEST AND UNIQUE JAPANESE CONTENT WOULD LEAD JAPANESE CINEMA TO AN INTERNATIONALLY VIABLE LEVEL OF NARRATIONAL CLARITY AND AN EXPORTABLE AND MARKETABLE PRODUCT.

dio, and movie theaters. In the 1930s, in accordance with the advancement of imperialism, a nationalist tendency, a "recurrence to tradition" or "invention of tradition" that revalued Japaneseness, became observable.

However, in reality, there was no discontinuity between the 1920s and the 1930s. A binary view, with the 1920s as the decade of Americanization and the 1930s as that of Japanization, is likely to overlook the actual continuity of popular imagination and social discourses on race and nation between the two decades. Throughout the 1920s and 1930s Japanese intellectuals continuously discussed the concept of Americanism in relation to Japanese nationalism.[49]

Nationalism is a claim for uniqueness within a world of nations, and thus assumes *inter*nationalism as its condition of possibility. The historian Michael Hechter argues that nationalism is the attempt of culturally distinct peoples to attain political self-determination among nations. Hechter writes that "nationalism is collective action designed to render the boundaries of the nation congruent with those of its governance unit. . . . *State-building nationalism* is the nationalism that is embodied in the attempt to assimilate or incorporate culturally distinctive territories in a given state. It is the result of the conscious efforts of central rulers to make a multicultural population culturally homogeneous. . . . *Unification nationalism* involves the merger of a politically divided but culturally homogeneous territory into one state, as famously occurred in nineteenth-century Germany and Italy. In this case, the effort to render cultural and governance boundaries congruent requires the establishment of a new state encompassing the members of the nation."[50] This intrinsic logic of nationalism was critical in the negotiation in *The Thief of Baguda Castle* between the presumed universality of cinematic styles and the locality of the premodern Japanese tale and the *chiyogami* medium.

CONCLUSION

As Japan expanded imperialistically toward Asia, Japanese intellectuals, many of whom were big fans of foreign films, began to articulate "Japan" as "an alternative time and place outside of the 'logic of civilization' and the progressive history of modernity."[51] "Modernity" here was synonymous with Westernization. The historian Yumiko Iida argues that "'Japan' was located in an ambiguous position between the West and Asia, both assuming itself to be a part of the spiritual virtue of Asia while equally playing the role of an imperial power attempting to put Asia under its control by reducing 'Asia' to a rhetorical site grounding Japan's counter hegemonic revolt against the modern West." The discourse on the uniqueness (or the middle-ground-ness) of Japanese civilization was an attempt to overcome Japan's complex toward the West's "superiority," despite the fact that Japan had "continuing difficulties in coming to terms with the modernly configured world."[52] Under these sociopolitical conditions, Ōfuji's film *The Thief of Baguda Castle,* a mediated work via Hollywood cinema, was produced and received as an educational film that was meant to function as a national totalizing force.

But did *The Thief of Baguda Castle* really function in that way? Reexamining the Pure Film Movement, the literary critic Thomas LaMarre raises significant questions: "Does the use of a Western form or medium (cinema) in Japan force Japan into Western development and history? Or do Japanese traditions transform Western cinema? Does cinema 'westernize' Japan, or does Japan 'japanify' cinema?" LaMarre argues that the problem with such questions is that they suppose an insurmountable contradiction or incommensurable difference between Westernization and "Japanization." Yet, according to LaMarre, the two processes can and usually do proceed apace. As LaMarre suggests, modernity, "as the condensation of a number of different processes and histories, is not a linear process within the West or in relation to the West." In such modernity, there certainly was "complicity between Japan and West, for zones in which they become somehow interchangeable." As LaMarre insists, "cinematic materiality remains dynamic and thus escapes complete control or abstraction." The "dynamic materiality of cinema" can "open up new and constantly divergent unperceived modes of sensory perception, different spatial organization of daily lives as well as temporal experience and historical awareness."[53]

While both *The Thief of Bagdad* and *The Thief of Baguda Castle* were meant to become totalizing nationalist forces, with their spectacular visual effects, including the latter's unique usage of *chiyogami,* both films had the potential

to deviate from overtly ideological narratives and themes. Kurata Kunimasa of *Eiga hyōron* regarded *"manga eiga"* (cartoon films), including the "masterful" Ōfuji's *chiyogami* anime, as "nothing but a dessert after a main dish" because "the stories" of animated films "were too weak compared to serious artistic films." However, Kurata recognized the uniquely new sensory experiences in animated films: "It is tremendously fun to watch animated films' unrestricted infinite imagination jumping around and their lines moving in abrupt and witty manners." Moreover, Kurata particularly noted *chiyogami* anime's transnational potentiality: "*Chiyogami* film is in itself composed of too poor [paper] dolls, [paper] pine trees, and [paper] animals, but only when they are lyrically animated with Japanese-Western mixed scores, they create a strangely innocent atmosphere. This is exactly why cartoon films should exist."[54] In fact, Ōfuji's works were highly valued internationally. His works, including *Kujira* (1927, *Whale*), were exported to the Soviet Union and France, together with Kinugasa Teinosuke's avant-garde *jidaigeki, Jūjiro* (1928, *Crossroads*), a period film without sword fighting that was well received.[55] In the cases of *The Thief of Bagdad* and *The Thief of Baguda Castle,* the moral is: while cinema has often emerged as a national cinema, formed by specific discourses on nationalism and modernization, it has been a transnational cultural form in terms of spectatorial sensory perception and spatiotemporal experiences.

..

Notes

1. Miriam Bratu Hansen, "Fallen Women, Rising Stars, New Horizons: Shanghai Silent Film as Vernacular Modernism," *Film Quarterly* 54, no. 1 (2000): 13.

2. Vachel Lindsay, "The Thief of Bagdad," *Michigan Quarterly Review* 31, no. 2 (1992): 238. Lindsay had a deep interest in the Orient, too. In his celebrated book *The Art of the Moving Picture* (1915), no matter how naively orientalist, Lindsay favorably commented on Japanese culture and its potentially positive influence on American culture, by way of the acting skills of the Japanese silent film actor Sessue Hayakawa, who was a superstar in Hollywood in the late 1910s to the early 1920s. Lindsay wrote, "He [Hayakawa] has that atmosphere of pictorial romance which would make him a valuable man for the retelling of the old Japanese legends of Kwan-non and other tales that are rich, unused moving picture material, tales such as have been hinted at in the gleaming English of Lafcadio Hearn. The Japanese genius is eminently pictorial. Rightly viewed, every Japanese screen or bit of lacquer is from the Ancient Asia Columbus set sail to find. It would be a noble thing if American experts in the Japanese principles of decoration, of the school of Arthur W. Dow, should tell stories of old Japan with the assistance of such a man as Sessue Hayakawa. Such things go further than peace treaties. Dooming a talent like that of Mr. Hayakawa to the task of interpreting the Japanese spy does not conduce to accord with Japan, however the technique may move us to admiration. Let such of us as are at peace

get together, and tell the tales of our happy childhood to one another." Vachel Lindsay, *The Art of the Moving Picture* (1915; New York: Modern, 2000), 42.

3. According to *Variety*, Douglas Fairbanks Sr., star of *The Thief of Bagdad*, was inspired by *Waxworks* when he produced the film. *Variety*, 6 February 1929, reprinted in *Variety Film Reviews 1926–1929 Volume Three* (New York: Garland, 1983), n.p.

4. The second episode is about Ivan the Terrible and the third, Jack the Ripper.

5. *Variety*, 6 February 1929, n.p.

6. Harold J. Abramson, "Assimilation and Pluralism," in *Harvard Encyclopedia of American Ethnic Groups*, ed. Stephan Thernstrom (Cambridge, Mass.: Harvard University Press, 1980), 150–53.

7. Philip Gleason, "American Identity and Americanization," in Thernstrom, *Harvard Encyclopedia*, 38–40.

8. Anthony B. Chan, *Perpetually Cool: The Many Lives of Anna May Wong (1905–1961)* (Lanham, Md.: Scarecrow, 2003), 209.

9. *Variety*, 26 March 1924, reprinted in *Variety Film Reviews 1921–1925 Volume Two* (New York: Garland, 1983), n.p.

10. Chan, *Perpetually Cool*, 36; Kamiyama Sōjin, *Sugao no hariuddo* [Hollywood without make-up] (Tokyo: Jitsugyo no nihonsha, 1930), 187–90.

11. "Arabian Nights Satire," *New York Times*, 19 March 1924, reprinted in *The New York Times Film Reviews, 1913–1968* (New York: New York Times and Arno, 1970), 1:189.

12. Gaylyn Studlar, *This Mad Masquerade: Stardom and Masculinity in the Jazz Age* (New York: Columbia University Press, 1996), 33–34.

13. "Arabian Nights Satire," 1:189.

14. John C. Eisele, "The Wild West: Deconstructing the Language of Genre in the Hollywood Eastern," *Cinema Journal* 41, no. 4 (2002): 81.

15. All translations of Japanese texts in this essay are mine unless otherwise noted. Muraji, "'Bagudaddo no tōzoku' o mite" [After watching *The Thief of Bagdad*], *Eiga ōrai*, February 1925, 62.

16. Izawa Ransho, "Kamiyama Sōjin wa kaibutsu dewanai" [Kamiyama Sōjin is not a monster], *Eiga jidai* 3, no. 1 (1927): 64.

17. Ushihara Kiyohiko, "Sōjin shi to watashi" [Mr. Sōjin and I], *Eiga jidai* 1, no. 4 (1926): 26.

18. Kamiyama Sōjin, "Ume no hana ni soeru tayori" [A letter accompanying a plum blossom], *Kinema junpō*, 21 April 1927, 22.

19. Ōfuji Noburō, "Chiyogami eiga to shikisai eiga nitsuite" [On *chiyogami* films and color films], *Eiga hyōron*, July 1934, 65. The extant version of *The Thief of Baguda Castle* is only eleven minutes long. Cut-paper animation involves drawings that are cut out and then placed on backgrounds and photographed. The photography has to be done on a level table or desk to keep the cutouts in place. Ōfuji's name is still influential in the world of anime as the Ōfuji Noburō Award, which is presented to the best experimental animation each year.

20. Ibid., 65.

21. Marilyn Ivy, *Discourses of the Vanishing: Modernity, Phantasm, Japan* (Chicago: University of Chicago Press, 1995), 11.

22. Quoted in Yamaguchi Katsunori and Watanabe Yasushi, *Nihon animeeshon eiga shi* [The history of Japanese animation] (Osaka: Yubunsha, 1977), 16.

23. Anthony D. Smith, *The Ethnic Origins of Nations* (1986; rpt. Oxford: Blackwell, 1998).

24. Aaron Andrew Gerow, "Writing a Pure Cinema: Articulations of Early Japanese Film" (PhD diss., University of Iowa, 1996).

25. Ivy, *Discourses of the Vanishing*, 3–4.

26. Kimura Chiio, "*Bagudajō no tōzoku*" [*The Thief of Baguda Castle*], *Kinema junpō*, 1 August 1926, 52.

27. Tanaka Jun'ichiro, *Nihon kyōiku eiga hattatsu shi* [The history of the development of educational films in Japan] (Tokyo: Kagyūsha, 1979).

28. Itakura Fumiaki, "'Kyūgeki' kara 'jidaigeki' e: Eiga seisakusha to eiga kōgyōsha no hegemonī tōsō" [From kyūgeki to jidaigeki: The hegemonic struggle between film producers and film exhibitors], in *Jidaigeki densetsu: Chanbara eiga no kagayaki* [Legend of jidaigeki: The flash of *chambara* films], ed. Iwamoto Kenji (Tokyo: Shinwasha, 2005), 89–114.

29. Tomita Mika, "Makino eiga jidaigeki: Hanshashiau media" [Makino *eiga jidaigeki*: Reflecting media], in Iwamoto, *Jidaigeki densetsu*, 129, 133.

30. Yamaguchi and Watanabe, *Nihon animeeshon eiga shi*, 15.

31. *The Thief of Bagdad* also declares its moral in intertitles, "Happiness must be earned," at the beginning and the ending, but in *The Thief of Baguda Castle*, the notion of "making efforts" is emphasized. There are no smaller morals explicitly stated in *The Thief of Bagdad*.

32. Akita Takahiro, "Manga eiga no dōbutsu kyarakutā: Animeishon to modanizumu" [Animal characters in cartoon films: Animation and modernism], in *Nihon eiga to modanizumu* [Japanese cinema and modernism], ed. Iwamoto Kenji (Tokyo: Riburopōto, 1991), 163.

33. Gerow, "Writing a Pure Cinema," 11, 59, 151.

34. Numata Yuzuru, "Posutā no machi ni tachite" [Standing in the city filled with posters], *Katsudō gahō* 1, no. 4 (1917): 112–15.

35. *Yorozu chōhō*, 25 May 1917, in *Shinbun shūsei Taishō hennenshi 1917-1* [Periodical history of Taishō through newspapers] (Tokyo: Meiji, Taishō, Shōwa Shinbun Kenkyūkai, 1980–87), 764.

36. The National Board of Review of Motion Pictures, *Report regarding Pictures Reviewed and a Financial Statement*, New York, 1 January 1917, quoted in Charles Matthew Feldman, *The National Board of Censorship (Review) of Motion Pictures, 1909–1922* (New York: Arno, 1977), 122. The National Board of Censorship, which was established in 1909 by the People's Institute of New York as a voluntary extralegal organization, started as an advisory committee for the New York exhibitors of motion pictures to evaluate and preview films prior to their public release. The National Board, with its continual correspondence with city officials and numerous social organizations (mayors, license bureaus, police departments, and boards of public welfare), attempted to improve the quality of popular motion pictures and quell the wave of protests and attacks by social and religious groups against motion pictures. The National Board of Review of Motion Pictures, *The Standards and Policy of the National Board of Review of Motion Pictures*, New York, 1 October 1916, 5; Wilton A. Barrett, "The Work of the National Board of Review," *Annals of the American Academy of Political and Social Science* 128 (November 1926): 178; Feldman, *National Board*, 5–6, 211–12.

37. "National Board of Review of Motion Pictures Records, 1906–1971," Box 84: Foreign Correspondence Japan, New York Public Library, New York.

38. Gerow, "Writing a Pure Cinema," 203.

39. Joanne Bernardi, *Writing in Light: The Silent Scenario and the Japanese Pure Film Movement* (Detroit: Wayne State University Press, 2001), 22.

40. Ibid., 13.

41. Hideaki Fujiki, "*Benshi* as Stars: The Irony of the Popularity and Respectability of Voice Performers in Japanese Cinema," *Cinema Journal* 45, no. 2 (2006): 68–84; Gerow, "Writing a Pure Cinema," 193–201, 209–37; Aaron Gerow, "The *Benshi* inside the Viewer: Subjectivity and the Family-State in the Silent Film," in *In Praise of Film Studies: Essays in Honor of Makino Mamoru*, ed. Aaron Gerow and Abé Mark Nornes (Ann Arbor, Mich.: Kinema Club, 2001), 130–38; Jeffrey A. Dym, *Benshi, Japanese Silent Film Narrators, and Their Forgotten Narrative Art of Setsumei: A History of Japanese Silent Film Narration* (New York: Mellen, 2003).

42. Fujiki, "Benshi as Stars," 78.

43. Gerow, "Writing a Pure Cinema," 300–302.

44. Kakeisanjin (Kaeriyama Norimasa), "Geijutsu toshiteno katsudō shashin" [Motion pictures as art], *Katsudō shashin kai* 19 (February 1911): 15–16; Kakeisanjin, "Katsudō shashin ga atauru chishiki" [Knowledge that motion pictures can provide], *Katsudō shashin kai* 20 (March 1911): 16; Kakeisanjin, "Katsudō shashin geijutsu ron" [Theory of motion picture art], *Katsudō shashin kai* 26 (September 1911): 4.

45. Kamata Eikichi, "Zento tabō naru katsudō shashin kai" [Promising future of the motion picture world], *Katsudō no sekai* 1, no. 1 (1916): 96–99.

46. Mukai Shunkō, "Katsudō shashinkai no shin keikō: Kigeki no zensei jidai kuru" [A new tendency in motion pictures: The golden period of comedy has come], *Katsudō gahō* (March 1917), quoted in Bernardi, *Writing in Light*, 192.

47. Thomas LaMarre, *Shadows on the Screen: Tanizaki Jun'ichiro on Cinema and "Oriental" Aesthetics* (Ann Arbor: Center for Japanese Studies, the University of Michigan, 2005), 80.

48. Stefan Tanaka, *Japan's Orient: Rendering Pasts into History* (Berkeley: University of California Press, 1993), 182.

49. Ben-Ami Shillony, "Friend or Foe: The Ambivalent Images of the U.S. and China in Wartime Japan," in *The Ambivalence of Nationalism: Modern Japan between East and West*, ed. James W. White, Michio Umegaki, Thomas R. H. Havens (Lanham, Md.: University Press of America, 1990), 187–211.

50. Michael Hechter, *Containing Nationalism* (Oxford: Oxford University Press, 2000), 15–17.

51. Yumiko Iida, *Rethinking Identity in Modern Japan: Nationalism as Aesthetics* (London: Routledge, 2002), 4.

52. Ibid.

53. LaMarre, *Shadows on the Screen*, 19, 80–84.

54. Kurata Kunimasa, "Manga eiga no tokuisei" [Unique qualities of cartoon films], *Eiga hyōron*, July 1934, 28–32.

55. Yamaguchi and Watanabe, *Nihon animeeshon eiga shi*, 19.

HIROMI MIZUNO

When Pacifist Japan Fights: Historicizing Desires in Anime

This essay proposes a critical history of fantasy. By that, I mean locating meanings, ambiguities, and possibilities of desires between the text (the anime) and the context (history). Every fantasy is based on desires, and so is Japanese anime fantasy. Instead of focusing on the anime creator's intention or techniques, I seek to treat the anime as a historical text that needs to be contextualized yet embodies context within itself. Desires are conceived here as multiple, since every historical text speaks of not just one but multiple, sometimes conflicting, desires.

Desires are also historical. I discuss *Space Battleship Yamato* (1977, *Uchū senkan Yamato*) and *Silent Service* (1995, *Chinmoku no kantai*) because they allow us to analyze cold war and post–cold war desires of Japan. Central to both anime is Yamato, the Japanese Imperial Navy's battleship. The largest battleship ever built, Yamato was the pride of the Imperial Navy but was sunk by the United States in 1945 without contributing much to the Japanese war effort. The two films are quite different. *Space Battleship Yamato* is Japan's first animated space opera on TV, fitting well into the category of fantasy fiction with alien attacks and sci-fi weapons; *Silent Service* is explicitly a political commentary whose story takes place within an earthly geopolitical setting

without imaginary beings and technology. Yet both *Space Battleship Yamato* and *Silent Service* invoke nostalgia, glory, and an alternative reality by utilizing the image of Yamato. Both films, with lengthy battle scenes, deal with a fantasy of postwar Japan where the pacifist constitution renounces war. And both deal with complex desires for peace, the right to fight, to defend the nation, to determine the nation's own course, when Japan's peace, defense, and future are in many ways in the hands of the world hegemonist, the United States. Shifting political environments before and after the cold war set the stage differently for these desires to be played out in the two anime.

As my analysis demonstrates, these desires are highly gendered. The two anime, read as historical texts, reflect and contain the historical contexts of Japan's feminized position vis-à-vis the United States. Japan's pacifist constitution furthermore complicates how Japan copes with this feminization. Considering the strong connection that scholars and activists have found between masculinity and war, on the one hand, and between femininity and peace, on the other, how postwar Japan's masculinity has been negotiated with constitutional pacifism is an interesting yet underexamined question.[1] My reading of cold war anime and post–cold war anime below illuminates the shifting ambivalence and tensions around national and masculine desires of pacifist Japan.

WHEN PACIFIST JAPAN FIGHTS IN SPACE: *SPACE BATTLESHIP YAMATO* AND JAPAN'S COLD WAR

Often considered as the beginning point of the golden age of Japanese anime, *Space Battleship Yamato* marked the transition from giant robot superhero to more elaborate space operas in the late 1970s.[2] The immensely popular story of *Yamato* is dramatic yet simple. In the year 2199, a mysterious alien empire, the Gamilus, attacks earth. The radioactive bombs of the Gamilus render earth uninhabitable for humans and drive them underground. The earth's only hope is Yamato, a space battleship equipped with a faster-than-light engine and a powerful "wave-motion gun." Yamato's mission is to go to Planet Iscandar to receive a device, the Cosmo Cleaner, that can clean earth's radiation-polluted air. Through challenging yet victorious battles with Gamilus fleets across the galaxy, Yamato saves the human race from annihilation. Besides this simple, apocalyptic narrative of a crusade against evil, which is very much a cold war narrative, the details and tensions in this anime make it fascinating to discuss and to read, ultimately, as a cold war text (Figure 1).

> THE POSTWAR JAPANESE CONSTITUTION PROHIBITS JAPAN FROM HAVING A MILITARY, FOR THE ALLIED POWERS DEEMED AN ARMED JAPAN TO BE A SERIOUS THREAT TO HUMAN PEACE. IT IS THUS THE ULTIMATE IRONY AND FANTASY THAT JAPAN'S WORLD WAR II BATTLESHIP RESCUES HUMANITY AND EARTH.

While the story takes place in a distant future, the anime makes sure that the viewer knows the Yamato's origin. At the beginning of the film (and in the second episode of the TV series), the viewer is informed, through the narrator, of the magnificence of Yamato, the Imperial Navy ship, and its tragic end in 1945. When the earth's surface becomes uninhabitable because of radiation, humans turn to none other than the sunken Yamato lying on the ocean floor (the anime does not specify where, but we know the battleship was sunk southwest of Kyushu) (Figure 2). The Earth Defense Force converts the Yamato into an undefeatable space battleship in secret from public, just the way the real Yamato was built.[3] The space battleship in fact looks exactly like the actual Yamato (which would in reality make it aerodynamically inefficient) but is now equipped with the special engine and the wave-motion gun, two technologies that earth acquired from a messenger from Planet Iscandar.

The resurrection of Yamato entails much more than blatant nostalgia and desire to reclaim lost glory. The postwar Japanese constitution prohibits Japan from having a military, for the Allied Powers deemed an armed Japan to be a serious threat to human peace. It is thus the ultimate irony and fantasy that Japan's World War II battleship rescues humanity and earth. The actual Yamato watched Japan atomic-bombed from the bottom of the ocean, unable to do anything; but in the anime Yamato saves not only Japan but also the whole earth from radioactive contamination.[4]

The fantasy of the film is also seen in the sense that the ship's crew (as well as the staff of the Earth Defense Force) is Japanese. One should not shrug one's shoulders and conclude that this is because it is a Japanese anime. There are many mainstream anime at the time that featured non-Japanese protagonists. The works produced by Tōei Animation, the powerhouse of anime production in the 1960s and the 1970s, are full of those, such as *Heidi, Girl of the Alps* (1974, *Arupusu no shōjo Haiji*) and *Lun Lun the Flower Girl* (1979–1980, *Hananoko Ranran*). Other anime produced by the creator of *Yamato* such as *Space Pirate Captain Harlock* (1978, *Uchū kaizoku kyaputen haarokku*) and his earlier works are in fact among them. So are many other popular space opera animations that followed *Yamato* such as *Gundam* (1979, *Kidō senshi Gandamu*). The choice of the battleship Yamato and Japanese crew cannot be simply explained as the consideration of preference or familiarity of audience.

FIGURE 1. Yamato departing earth for Iscandar.

FIGURE 2. Old Yamato in ruin.

The significance of the Japanese crew becomes clearer when we examine the names of the main characters. The protagonist of the *Yamato* series is Kodai Susumu, a brave, talented, and passionate young man with a warm sense of humor. The characters of his name literally translate to "ancient time" (*kodai*) and "to progress" (*susumu*). Representing both tradition and progress, he symbolizes Japan's new generation. His older brother, Mamoru, is more "old fashioned," as his name—"ancient time" and "to protect"—indicates. Mamoru appears at the beginning of the anime, disobeying the captain's order to retreat. "If you are a man, you must fight till death," says Mamoru before he dives into the enemy fleet in a kamikaze fashion. The names of many characters use historical names familiar to most Japanese. For example, the captain of Yamato, an old and wise guardian of Kodai Susumu, is named Okita Jūzō. Captain Okita suffers from radiation and dies at the very end of the film as the Yamato approaches earth. Anyone familiar with Japanese history would think of Okita Sōshi, a leader of *Shinsengumi,* the group of samurai hired by the Tokugawa government to kill anti-Tokugawa revolutionaries at the dawn of the Meiji Restoration. Like Captain Okita in the anime, Okita Sōshi also dies of illness in 1868 just before the takeover of the Tokugawa government was completed.[5] The name of another Yamato crew member also comes from *Shinsengumi,* Hijikata Toshizō, who continued to fight even after the last Tokugawa shogun gave up his castle. And Tokugawa is indeed the name of the Yamato's main engineer. No significant character is named after any recognizable figures from the Meiji, Taishō, or Shōwa periods. In other words, even though Yamato itself is clearly resurrected from World War II, the ship's warriors are linked to a past historical period, the period not tainted by modern Japan's engagement in the defeated imperial war. I discuss the effect of this shortly.

The name choice of the enemy is equally significant to our reading of this anime as a cold war text. Most of the members of the Gamilus Empire have German-sounding names such as Shultz, Hiss, Gantz, and Domel. The leader of the empire is referred to as Desler Füfrer. Good-looking, mustache-less, and blue-skinned (all Gamilus men have blue skin), Desler does not demonstrate any physical resemblance to Hitler. However, Desler and Hitler sound strikingly similar when pronounced in Japanese, and Gamilus warriors salute their dictator in a modified Nazi fashion. Having the Nazi-like enemy in the anime distances Yamato—and the Japanese viewer—from Japan's Axis past. Using Japanese names from the Tokugawa period for the main characters reinforces this psychological distance. This helps the viewer to forget (or not to learn, as almost all the viewers were of the postwar generation)

about Japan's role in World War II and to fancy that Japan is/was the one who challenged and destroyed the evil empire. This is the ultimate fantasy of postwar Japan, a wish fulfilling rewriting of the history that takes place in distant future and space.

This fantasy is best understood as not only that of postwar Japan but also that of Japan's cold war—more specifically, of the 1955 system. The 1955 system is Japan's domestic political arrangements of the cold war. Under this system (until its collapse in 1993), the Liberal Democratic Party—which was created in 1955 as a result of the merger between two conservative parties, the Democratic Party and the Liberal Party—maintained its political dominance, with the oppositional Japan Socialist Party content to be forever oppositional. The LDP maintained its dominance domestically through pork-barrel politics and internationally by gaining the backing of the United States.[6] The main architect of the system, Kishi Nobusuke, prime minister from 1957 to 1958, was a former A-class war criminal. Kishi, like Yoshida Shigeru, who earlier held the position of prime minister during most of the U.S. occupation, secured Japan's sovereignty, economic prosperity, and political stability by aligning Japan with the United States. This cold war alliance, however, raised a fundamental tension with the pacifism of the Shōwa constitution. The United States's strategic interest in Japan lay in rendering Japan into an armed wall against the spread of communism in East Asia, but Japan's constitution, drafted by the United States itself, prohibited Japan from having armed forces. Solutions to this dilemma have been all constitutionally ambivalent: the creation of the National Police Reserve (former Self-Defense Forces) by the U.S. occupation authorities during the Korean War; its renaming and expansion into the National Self-Defense Forces (SDF) in 1954; and the series of United States–Japan security treaties that have allowed the American military to stay in Japan after 1952. While the Japanese Supreme Court justified SDF as an exercise of the nation-state's right to self-defense in 1959, it is the economic and strategic interests of Japan and the United States that really justified the SDF and U.S. military presence in Japan during the cold war. The presence of the U.S. military saved Japan from military expenditure, which helped the country recover from wartime damages and become the number two capitalist power. In exchange for the right to possess a military, Japan gained security and economic prosperity. Quite literally, thus, the peace and prosperity enjoyed by postwar Japan was protected under U.S. tutelage.

Many scholars have pointed out a gendered aspect of this relationship. Yoshikuni Igarashi, for example, argues that this gendered "foundational

> YAMATO IS THE ANIME THAT
> ILLUMINATES, RATHER THAN
> RESOLVES, THE DILEMMA OF
> PEACE, WAR, AND MASCULINITY
> OF POSTWAR JAPAN.

narrative" of United States–Japanese postwar relations shaped the popular imagination of the two countries: "Through the bomb, the United States, gendered as male, rescued and converted Japan [into a peaceful, democratic country], figured as a desperate woman."[7] As Igarashi and other scholars have noted, one can see the gendered postwar relation between the two nations in many places, including the famous photo of General Douglas MacArthur and Emperor Hirohito immediately after Japan's surrender and the prominence of the theme of impotent men in postwar Japanese literature.[8]

What is particularly noteworthy about *Yamato* as a cold war text is the complete absence of the United States. No American institution appears in the anime. It is simply Yamato/Japan representing earth, fighting against the Nazi-like alien empire. This helps postwar Japan to reassert a masculinity that was brutally compromised after the defeat in World War II, the U.S. occupation, and the pacifist Showa constitution. By eliminating the American presence from the anime and by casting Japanese men as the protectors, *Yamato* presents a counternarrative to the "foundational narrative," a fantasy against the dominant narrative of the past and present of postwar Japan. This is not just postwar Japan's fantasy: it is a male fantasy.

Masculinity is not a fixed attribute of the male body but a constantly negotiated social construction. As R. W. Connell has argued, therefore, masculinity is prone to crisis as the society undergoes changes.[9] Japanese masculinity is no exception. In addition to the series of emasculating experiences mentioned above, the postwar masculinity of Japan has needed to negotiate with what came to be considered as part of national identity: constitutional pacifism. The fundamental issue here is how to resolve the dilemma posed by Article 9 that makes it unconstitutional for Japan to arm itself and historically associates national defense to prewar fascism. That is, postwar Japanese masculinity needed not only to deal with the lack of access to military but also to actively incorporate pacifism into its construction if it were to claim the pacifist national identity.[10] This is a difficult task, as pacifism is historically associated with women. This is the case in Japan, too; for example, the development of the postwar antinuclear peace movement, which by the early 1970s gained world recognition, is mainly associated with women activists.[11]

In *Yamato,* the dilemma of reclaiming masculinity and claiming pacifism at the same time is captured most vividly in the protagonist Kodai Susumu's monologue in the climactic scene and following celebration of the success

of the Yamato's mission. The Yamato successfully destroys the Gamilus, as Kodai and his lover, Mori Yuki, see the battle's aftermath. The Gamilus city is completely demolished, Gamilus soldiers all dead, and Planet Gamilus annihilated. Instead of rejoicing over the victory, however, Yuki breaks into tears, murmuring, "What have we done? What have we done?" (Figure 3). With apparent dismay and anger, Kodai also bitterly talks to himself, with tears flowing from his eyes: "In order to save Earth, we destroyed another planet. We should not have fought. We should have loved. Victory . . . tastes like ashes!" (Figure 4).[12] After this solemn scene in which war is repented, the Yamato crew nonetheless celebrates the victory and their successful journey back to earth. Captain Okita, in his bed, takes his last breath holding his family photo. Despite Kodai's lament, the battles and deaths that filled Yamato's journey are justified at the end for the ultimate peace and love of family and humanity. The militarism of *Yamato* is coated with the message of peace and love. Kodai's (and Yamato's) masculinity is not compromised by his desire for peace and love. The anime depicts the hero Kodai as a man who is loving and peace seeking yet is willing to fight when necessary.

FIGURE 3. Yuki and Kodai after the decisive battle. **FIGURE 4 (INSET).** Kodai's remorseful tears.

Yet *Yamato* is not providing an androgynous figure as the ideal man. On the contrary, to avoid feminizing pacifist masculinity, the anime deploys the overtly stereotypical gendered dichotomy to accentuate femininity. For example, the nature/civilization dichotomy draws the gender line in the spaceship. Unlike the male Yamato crew members who bear historical names, the only female crew member stands for nature: Mori Yuki, forest and snow. Yuki is not just a pretty flower doing nothing in the ship. She reads the data for the captain in the main cabin and picks up guns along with her male colleagues. Nonetheless, she also helps the doctor as his nurse and is expected to provide warmth and mothering to male Yamato crew members. The only other female characters are the ones from Planet Iscandar, Queen Stasha and her sister, Sasha. Sasha delivers to earth the technologies Yamato needs to make a trip to Iscandar and dies in this self-sacrificial mission at the very beginning of the anime. Later the viewer learns that Planet Iscandar is a twin planet of Gamilus; if Gamilus is destroyed, Iscandar will also cease to exist. As opposed to the all-male empire of Gamilus that attempts to take over earth in its search for survival, Queen Stasha chooses to surrender to fate and saves earth, knowing that it will lead to the death of her planet. Planet Iscandar, personified as female, represents ultimate pacifism and self-sacrifice.

At the fundamental level, *Yamato*'s sugarcoated message of the pacifist fighter collapses. Fight for peace, or fight for love, echoes like the trite propaganda of any war, if not particularly the cold war. In this sense, *Yamato* is the anime that illuminates, rather than resolves, the dilemma of peace, war, and masculinity of postwar Japan. Kodai oscillates between the desire to fight, the lament for war, the desire to be the protector of his own kind, and the desire to save others: conflicting desires that Japan in the 1970s could not realize. But the happy ending, the setting in space, the character-name choice, the alien enemy, and the overfeminized women all help viewers to distance themselves from such a tension and to appreciate the anime as a pacifist fantasy with masculine warriors.

WHEN PACIFIST JAPAN FIGHTS AT SEA: *SILENT SERVICE* AND THE POST–COLD WAR DESIRE

The dilemma of the pacifist constitution and the desire to be a masculine nation capable of fighting takes a dramatic turn in the post–cold war period. As the imminent threat of communism disappeared, the significance of the United States–Japan security alliance became ambivalent. In addition,

unlike the immediate postwar years when the demilitarization of Japan was deemed necessary to world peace, the world peace of the 1990s demanded Japan's military contribution, as the nation learned the hard way in the wake of the first Gulf war of 1991. Japan contributed a large sum of money (approximately thirteen billion dollars) instead of personnel because of constitutional limitations. Japan's slow and limited support—although its financial contribution was larger than any other country's—met harsh criticism from the United States. Upon this international embarrassment, the LDP proposed a bill that became the International Peace Cooperation Law in 1992 that allows the Self-Defense Force to be dispatched abroad for the first time.[13] Although the scope of activity is limited to United Nations peace-keeping and humanitarian operations, the fact that the SDF, whose presence had been justified on the basis of the nation-state's right to self-defense, could now be deployed abroad for an unrelated cause raised tremendous anxiety in Japan. Moreover, the line between peacekeeping operations and combat

> SILENT SERVICE IS NOT A MERE ENTERTAINMENT BUT A SERIOUS CRITICISM OF U.S. NUCLEAR POLICY, ITS WORLD HEGEMONY, AND THE U.S.–JAPAN SECURITY TREATY

is often ambiguous, as the current war in Iraq has demonstrated so clearly. The post–cold war paradigm has presented Japan with a new paradox: the international community (especially the United States) demands the active military involvement of Japan under the name of world peace, for which the major obstacle is Japan's pacifist constitution. Should Japan reexamine the pacifist constitution to respond to this call? Or should and can Japan present its own style of leadership that would define world peace separately from American interests?

Silent Service deals with these very questions. Unlike *Space Battleship Yamato, Silent Service* does not fantasize Japan's world (or earth) leadership in the absence of the United States. It indeed makes Japan directly challenge the U.S. Pacific Fleet. Nonetheless, *Silent Service* is as much a fantasy as *Yamato,* since this is a highly unlikely scenario, especially considering the Japanese prime minister's persistent efforts to fulfill U.S. interests. It is a fantasy that exemplifies post–cold war desires of Japan.

Silent Service (*Chinmoku no kantai*) was originally a manga by Kawaguchi Kaiji,[14] a long-running series that appeared in a Japanese manga magazine, *Morning* [Mōningu], from 1989 to 1996. It is a submarine action story, somewhat similar to *Red October,* although the author's political message makes it more than just good entertainment. It received a prestigious Kōdansha Manga

Award in 1990 and has attracted much attention from both the political Right and Left (it was even mentioned in one session of the Japanese House of Representatives). The original video animation (OVA) in Japanese as well as with English subtitles appeared in 1996, on which my discussion below is based.

The story starts with the completion of a nuclear-powered and nuclear-capable submarine, the Seabat, that was developed by the United States and Japan. Like the original Yamato and the space battleship Yamato, this project also was hidden from the public. A party is discretely held to celebrate the successful completion, and Seabat engages in its first test voyage from a Japanese marine station. The Seabat, whose construction cost was paid by Japan and with all crewmen but one being Japanese, nonetheless officially belongs to the U.S. Seventh Fleet. Once at sea, however, the Japanese captain Kaieda takes over the submarine and announces that he and his crew loaded a nuclear weapon on board without the knowledge of the U.S. and Japanese governments. Moreover, Kaieda declares that the submarine is no longer the Seabat but an independent nation called "Yamato." Yamato is invoked here because it is the name of an ancient nation in Japan, but its double reference to the World War II battleship is also clear: Kaieda engraves "Yamato" on the submarine's exterior before its departure (Figure 5). To resurrect the World War II Yamato sunk by planes, *Space Battleship Yamato* made the ship fly; *Silent Service* made Yamato a state-of-the-art submarine that would never sink. The Yamato equipped with a nuclear weapon is as fantastic as the Yamato that travels in space to save earth from nuclear contamination. The masculine desire that supports this fantasy, however, is no longer that of pacifist warriors of the 1955 system. It instead demands a different masculinity for Japan.

When the manga started in 1989, *Silent Service* was originally set in the cold war. However, the Berlin Wall and the Soviet Union collapsed soon after that, and understandably the cold war disappeared from the manga. The main themes then became the meaning of nuclear weapons in a post–cold war world and of Japan's security relationship to the United States. Does the United States need nuclear weapons to maintain its role as world police even after the Soviet Union's collapse? Could the rest of the world be independent of American influence when American nuclear power is so overwhelming? What would happen if there existed a nuclear weapon that does not belong to any nation-state? Would it not be the ultimate way for nuclear weapons to exercise a deterrent effect? These are the underlined questions of this anime.

Kaieda's ridiculous declaration of independence takes both the U.S. and Japanese governments by great surprise, but it is his declaration of nuclear possession that moves the whole story forward. Neither government is

"YAMATO"

FIGURE 5. "Yamato" engraved in Seabat.

convinced that Yamato possesses a nuclear weapon, but they are not sure that it does not. This puts the United States in a dilemma: capturing and destroying Yamato could mean facing a nuclear attack, but if the Yamato crew gets away with sabotaging the Seabat, it would weaken the United States's claim as the world police. The U.S. president, Nicholas Bennet, initially orders the U.S. fleet to capture the Yamato/Seabat. In an aggressive chase, however, the United States is outwitted by Kaieda and his talented crewmen, who not only manage to escape close calls but also do considerable damage to the U.S. submarine fleets. In the middle of the anime, Bennet prevents an attack on the Yamato for fear of its nuclear possession. The United States suffers a double loss: it loses its nuclear hegemony and leadership, as it proves that one nuclear submarine can stop the action of the United States, and it also destroys Japan–U.S. relations, first by attacking the Japanese crew, who should be its military ally, and second by revealing the United States's distrust in Japan's "no nuclear" policy. *Silent Service* is not a mere entertainment but a serious criticism of U.S. nuclear policy, its world hegemony, and the U.S.–Japan Security Treaty (Figure 6).

FIGURE 6. "Yamato" facing the American fleet.

Silent Service also places Japan in a dilemma, a different but equally grave one. If the Japanese government supports Kaieda by acknowledging his independence declaration and making a military alliance with Yamato as Kaieda requests, then it would anger the United States and would certainly mean the end of the U.S.–Japan Security Treaty. It would also mean that the Japanese government would have to admit that Kaieda's possession of a nuclear weapon (that is, Japan's possession of it) is probable. But the other option is to maintain the United States–Japan alliance by assisting the destruction of the Yamato/Seabat and the killing of the Japanese crew. The Japanese government is unable to make a decision until almost the end of the anime. Meanwhile, the SDF is called to escort the Yamato/Seabat back to Japan. Without the Japanese government formally recognizing Yamato as an independent nation, Kaieda and his crew are considered Japanese nationals, which justifies the deployment of the Self-Defense Force. Yet this very justification disables the SDF in resisting U.S. attacks, as I describe below.

The finale of the anime is a long, dramatic engagement among the SDF, Yamato, and the U.S. Third Fleet (the U.S. Pacific Fleet) while the U.S. president and the Japanese prime minister meet in Pearl Harbor.[15] At this brief, hostile summit, the American president declares war on Japan. In the end,

he decides to ignore Yamato's nuclear warn-
ing, since he is more afraid of losing his na-
tion's face. Prime Minister Takegami, on the
other hand, is determined not to fight. Re-
ferred to as "liberal" in the anime, Takegami
does not want to render Japan into a mili-

taristic nation. He screams at both American and Japanese attendants of
the summit: "Japan should never fight a war again!" His persistent request
that the United States cease fire and let the SDF rescue injured Japanese and
American soldiers, however, receives no response from Bennet. Meanwhile,
the prime minister's refusal to fight puts the SDF in a difficult position. As
Kaieda is attacked by the U.S. Third Fleet, the best the SDF can do is to locate
its ships in front of the U.S. fleet to shield the Yamato/Seabat. The target of
the American attack is the Yamato/Seabat, but physical closeness inevitably
brings heavy damage to the SDF ships. The SDF captain, however, does not
fire back. They cannot engage in a battle. "Sticking to defensive support" is
the limit of the SDF. He bitterly murmurs: "Defensive support should mean
a battle that begins with an enemy's aggression. . . . But, in reality, Japan's
situation demands that it never recognize that aggression."

This point on the limitation of the SDF defensive role (and implied limi-
tation of the Japanese pacifist constitution) is heavily emphasized during the
nearly five minutes of the U.S. Third Fleet attacks. In contrast, Kaieda's Ya-
mato fires back at the flagship of the U.S. Third Fleet, the Enterprise, making
a point that if Japan is attacked, it should fight back. The battle ends with the
complete victory of Kaieda: the U.S. Third Fleet, including the Enterprise and
a new Aegis cruiser equipped with the latest data system, is wiped out. Also
shattered is American confidence. Worse, this leaves the United States under
the nuclear threat of the Yamato without having a chance to verify its claim
to nuclear possession. For Japan, however, it means the beginning of a new
direction. The anime ends with Prime Minister Takegami's speech to the na-
tion declaring that Japan is going to form an alliance with Yamato. Isolating
Yamato from the world would only increase the possibility of its nuclear use,
he explains, and thus Japan should take a lead in maintaining world peace by
embracing Yamato, not the United States.

Silent Service captures post–cold war Japanese desires to create a new
identity, new direction, and new leadership role. It is a critique of the 1955
system as much as of U.S. nuclear hegemony. In the anime, politicians and
bureaucrats who adhere to the U.S.–Japan Security Treaty are referred to as
the "old generation." This includes not just those who are afraid of diplomatic

conflicts with America but also those who want to use American intelligence and technological power for the benefit of Japan: like a "shadow prime minister," an older man whose financial and political power has moved Japanese politics behind the scenes. The "old generation" in the anime represents LDP and business leaders of postwar Japan, of the 1955 system. In fact, Prime Minister Takegami is clearly a parody of Takeshita Noboru, who was Japan's real prime minister from November 1987 to June 1989.[16] Takeshita was a quintessential politician of the 1955 system in many ways. He solidified his political power through pork barrel politics in a typical LDP style and maintained strong connections to construction companies. The Recruit Scandal that exposed his corruption forced him to resign in 1989 and contributed to the end of the 1955 system in 1993. The immense gap between the real and fictional prime ministers makes it clear that this parody is meant to be a critique of Takeshita and the 1955 system he represents. The anime criticizes the cowardice, irresponsibility, and cunning of this generation. Instead, it is those who are introduced in the anime as "the younger generation of nationalist bureaucrats" who urge Prime Minister Takegami to form an alliance with Yamato, that is, to choose a path independent of the United States. Americans are portrayed as arrogant, untrustworthy, and racist so that the viewer would be sympathetic to this generation. Through Takegami's speech at the end of the anime (with uplifting music in background), the anime presents its vision for a new Japan: Japan should seek a way to world peace independent of U.S. military backing and nuclear hegemony.

Does *Silent Service* embrace rising Japanese neo-nationalism? To the average American viewer, the anime probably appears blatantly nationalistic: it names the submarine Yamato; it boldly rewrites history by making the Japanese destroy the USS Enterprise, the most decorated ship of World War II; and it casts a positive light on the new nationalist generation. It also portrays the SDF as a defense force crippled by the peace constitution and the U.S.–Japan Security Treaty. At the same time, however, its final message is sent through the liberal Takegami, who declares not to fight ever again. As I explained earlier, Takegami chooses to make an alliance with Yamato so that there will not be a war. It is not the remilitarization of Japan that is emphasized in this anime but the attempt to find a new world peace that would not have to be at the mercy of American interests.

This desire for Japan's new leadership is difficult to label "Right" or "Left." *Silent Service* in fact appealed to both political camps in Japan. This is perhaps not surprising, since in postwar Japan both extreme Right and Left have criticized the U.S.–Japan alliance. Moreover, the end of the cold

war has blurred the Right–Left distinction on many issues. The relationship between the SDF and Article 9 is one of them. The questioning of the constitutionality of the SDF was a rallying point of the Socialist and Communist Parties against the LDP, as they insisted that only unarmed neutrality could keep Japan from getting embroiled in a war of the United States's making. With the end of the cold war, however, "neutrality" ceased to mean much. Furthermore, the first major conflicts of the post–cold war world, the first and current Gulf wars, demanded that Japan dispatch the SDF overseas for the sake of world peace and international cooperation. Making the SDF into a "normal" military has been the agenda

> IT IS NOT THE REMILITARIZATION OF JAPAN THAT IS EMPHASIZED IN THIS ANIME BUT THE ATTEMPT TO FIND A NEW WORLD PEACE THAT WOULD NOT HAVE TO BE AT THE MERCY OF AMERICAN INTERESTS.

of conservative LDP members for decades, and these post–cold war events opened up a possibility for revising the pacifist constitution. The International Peace Cooperation Law of 1992 allowed the SDF to join peacekeeping operations overseas. By the mid-1990s, the Japan Socialist Party (which changed its name to Japan Social Democratic Party in 1996) no longer questioned the legitimacy of the SDF nor the U.S.–Japan Security Treaty, and various study groups and organizations have submitted their proposals on the revision of Article 9.[17] Although a 2005 poll shows that more Japanese (62 percent) are opposed to revising Article 9 than are supportive (30 percent), the SDF's role will likely continue to be adjusted with changing international situations and demands, as it has been in the past.

Like *Yamato, Silent Service* contains contradictions and tensions. On the one hand, it demands that Japan sever its bilateral security treaty with the United States and calls for a more transnational solution to world peace by creating a non-nation-state nuclear power, the Yamato. On the other hand, Yamato is such a part of Japan's national history and identity that it is doubtful whether Japan's alliance with Yamato would set a new model for the world. In fact, imagining Korea and China also making an alliance with Yamato brings up colonial memories. Furthermore, while the anime upholds pacifism through the character of Takegami, it nonetheless emphasizes the limitation of the SDF and positively portrays Yamato's capacity to fire back. It is as though Japan and Yamato represent a schizophrenic desire of post–cold war Japan split between a pacifist nation that creates world peace through transnational diplomacy and a nuclear-capable nation that can fight: that is, a military and political power parallel to the United States. It is difficult not

to conflate Yamato and Japan, peace and defense, and autonomy and hegemony here. In this sense, the anime, like the previously discussed *Yamato,* attests to complex, conflicting desires of post–cold war Japan for nationalism, internationalism, peace, independence from the United States, and the "normal" military.

Silent Service is a masculine anime. The only women who do appear are bystanders on the street listening to Takegami's televised speech of the national decision. Recently scholars have paid much attention to the "feminized men" in Japanese popular culture of the 1990s and present, who wear makeup, dye their hair, and present themselves as sensitive and apolitical.[18] *Silent Service,* however, presents a dramatically different masculinity, one constructed around the issues of security, leadership, and future of the nation (Figure 7). As explained in the anime, Kaieda and his crew (who appear to be in their late twenties and early thirties) are determined to stay in Yamato to serve the cause of Japan's independence from the United States, at the expense of their wives and children. They are like kamikaze pilots devoting their lives to the nation, except that there is no tragic desperation in the anime that is often associated with a kamikaze pilot. They remain cool throughout the story, as if they were enjoying a rewarding chess game. Kaieda does not lament his act of destruction, unlike Kodai in *Yamato.* No sweat, no tears. In contrast to the American captains who are arrogant and reckless, Kaieda and his men appear confident (but not arrogant) and in control. Kaieda is described as cautious, a cool, smart, prudent patriot who dares to fire back at the U.S. fleet. The anime presents a masculinity that is appealing to post–cold war Japanese youth who yearn for confidence and a mission yet avoid the passionate fighting spirit of the Japan of the high-economic growth era that Kodai exhibited.

FIGURE 7. Kaieda.

While the gendered "foundational narrative" of the U.S.–Japan relationship forms the context of both anime, *Yamato* and *Silent Service* respond to it differently. *Yamato* in the 1970s could not bring in any reference to the United States in the picture in order to establish a fantasy of Japanese men protecting the globe. Kodai is a passionate pacifist warrior who fights for peace with all his might but sheds tears after killing aliens. Love for earth, love for humanity, love for families, and love for lovers furnish the narrative prominently. The Yamato needed to fight in space, where America could

not reach, in order to incorporate these messages. *Silent Service,* in contrast, has no sweat, no tears. The only romance one sees is concern for the nation. Criticizing both domestic and international cold war arrangements, it boldly challenges the United States directly and presents a Japanese masculinity— through prudent, smart Japanese men—that defeat the Yankee-style masculinity of the United States.

Both scenarios are fantasies. While severing the U.S.–Japan security relationship is a real option being discussed in Japan,[19] to this day the U.S.–Japan security relationship continues to play a vital role in shaping Japanese policies, and the Koizumi government consistently insisted on fulfilling American interests for the war in Iraq. The debates on revising the constitution and Japan's security carry on, embracing various shapes of desires for peace, defense, military, autonomy, national pride, and a chance to assert masculinity. My reading of these desires in these two postwar Japanese anime works is not meant to argue that one can figure out the intentions of the anime creators. Rather, a critical look at the anime fantasies as postwar texts requires analyzing these desires in order to contextualize them. As the battleship Yamato's enduring presence in the postwar anime illustrates, the historical context is not simply "the background" of the text but is a crucial aspect of the text. Analyzing desires, their ambiguity, and complexity that variously configure this intertwined text–context relation helps us read these anime works not as a history of anime but as a history of Japan, and not as an embodiment or a representation of some unchanging "authentic" Japanese culture and masculinity but as a site of a constant construction of national identity and masculinity.

..

Notes

1. Scholarship of this theoretical orientation is plentiful. See Michael Kimmel, Robert W. Connell, and Jeff Hearn, eds., *Handbook of Studies of Men and Masculinities* (Thousand Oaks, Calif.: Sage, 2005); Cynthia Enloe, *The Curious Feminist: Searching for Women in a New Age of Empire* (Berkeley: University of California Press, 2004); John Tosh et al., eds., *Masculinities in Politics and War* (Manchester, U.K.: Manchester University Press, 2004); and Joshua Goldstein, *War and Gender: How Gender Shapes the War System and Vice Versa* (Cambridge: Cambridge University Press, 2003). The link between masculinity and violence was also the central topic of UNESCO's expert group meeting in September 1997, "Male Roles and Masculinities in the Perspective of a Culture of Peace."

2. *Uchū senkan Yamato* was created by Matsumoto Reiji and was originally aired on TV from 1974 to 1975 ("Quest for Iscandar"). My discussion is based on the theater version released in 1977, available in the United States with English subtitles. The edited

version of the original TV series was introduced to the United States as *Star Blazers* in 1977. The original *Yamato* was followed by a series of TV and theater-version films: *Saraba uchū senkan Yamato* [*Farewell Space Battleship Yamato*] (1978, theater); *Uchū senkan Yamato 2* [*Space Battleship Yamato 2*] (1978–79, TV); *Aratanaru tabidachi* [*New Voyage*] (1979, TV; 1981, theater); *Yamato yo towani* [*Yamato to Eternity*] (1980, theater); *Uchū senkan Yamato 3* [*Space Battleship Yamato 3*] (1980–81, TV); and *Uchū senkan Yamato kanketsuhen* [*Final Space Battleship Yamato*] (1983, theater).

3. For more detailed description of the making of the ship, see Janusz Skulski, *The Battleship Yamato* (Annapolis, Md.: Naval Institute Press, 1989).

4. In 1974 when *Space Battleship Yamato* was first aired, Japan was engulfed with controversy involving the U.S. nuclear ships and submarines using military bases in Japan. Despite the "three non-nuclear principles" of Japan, according to Erwin Reischauer's 1981 statement, American ships carrying nuclear weapons had ported Japan, and the nuclear-capable aircraft carrier USS Midway homeported Yokosuka between 1973 and 1992.

5. Of course, there are some discrepancies between the two Okitas. Captain Okita is an old man, while Okita Sōshi was one of the youngest members of the *Shinsengumi* (twenty-four years old when he died), often portrayed in fiction and manga as a beautiful boy. While Yamato's mission was successful and justified, the Tokugawa government lost the civil war in 1868.

6. See, for example, Gavan McCormack, *The Emptiness of Japanese Affluence* (New York: Sharpe, 2001) for how the system of collusion worked under the 1955 system. For more details about party politics before and after the 1955 system, see Junnosuke Masumi, "The 1955 System in Japan and Its Subsequent Development," *Asian Survey* 28, no. 3 (1988): 286–306.

7. Igarashi Yoshikuni, *Bodies of Memory: Narratives of War in Postwar Japanese Culture, 1945–1970* (Princeton, N.J.: Princeton University Press, 2000), 20.

8. For a fascinating discussion of postwar Japanese masculinity complex, see Christine Marran, "The Space of Empire in Numa Shōzo's Science Fiction Novel Beast Yapuu (1957–1959)," *Landscapes Imagined and Remembered: Proceedings of the Association for Japanese Literary Studies* 6 (2005): 147–54; and the last chapter of her forthcoming book *She Had It Coming: The Poison Woman in Japanese Modernity*.

9. R. W. Connell, *Masculinities* (Berkeley: University of California Press, 1995).

10. Gendering national identities is an extremely complex process. As many scholars have demonstrated, however, national identity has historically been established as male even (or especially so) in the cases of those nations that have been feminized by the Western powers or that have extolled women as their unique reservoir of culture. See, for example, Deniz Kandiyoti, *Gendering the Middle East* (Syracuse, N.Y.: Syracuse University Press, 1996); Sangeeta Ray, *En-Gendering India: Woman and Nation in Colonial and Postcolonial Narratives* (Durham, N.C.: Duke University Press, 2000); and Tani Barlow, *The Question of Women in Chinese Feminism* (Durham, N.C.: Duke University Press, 2004).

11. Women, especially mothers, were pioneers in the antinuclear peace movement in Japan. The Japanese Mothers' Conference (Nihon hahaoya taikai), organized in 1955, played a pivotal role in the movement. See Kimura Yasuko, *Inochi no uta kagayakase nagara: Hahaoya taikai monogatari* (Let us shine the songs of life: The story of the Mothers' Conference) (Tokyo: Kamogawa shuppan, 1999). While discussing the gendered association

with peace, I do not indicate any biological determinism here. As R. W. Connell and others have argued, the historical and statistical connection between men and violence is rather a result of social and cultural construction, not biology. R. W. Connell, *The Men and the Boys* (Berkeley: University of California Press, 2000), chap. 12.

12. Love as the ultimate message appears again soon after as Kodai Susumu's brother, Mamoru, who was discovered alive, decides to stay on Planet Iscandar in order to be with Queen Stasha. He has chosen love.

13. In 1989 Japan was substantially engaged in a UN peacekeeping operation in Namibia, but it was electoral observers (civilian personnel), not SDF, that were sent there.

14. The original manga, *Chinmoku no kantai* by Kawaguchi Kaiji, received the Kōdansha Award in 1990. The author is known for his political manga. Another well-known manga by Kawaguchi is *Zipang* (Jipangu). My discussion is based on the film/OVA version (directed by Takahashi Ryōsuke) released in 1996 in both Japanese and English.

15. The anime makes President Bennet explain that the choice of Pearl Harbor for the site of the summit is to raise patriotic antagonism against Japan among U.S. citizens. A phantasmic incorporation and rewriting of history into the anime should be noted here: during World War II, the U.S. Third Fleet was responsible for much of the campaign in the Pacific Theater, and surrender documents were signed on its flagship, the USS Missouri; the Enterprise is easily destroyed by Yamato in the anime.

16. In Japanese, the two names, Takeshita and Takegami, are only one character difference, the former meaning "below bamboos" and the latter "above bamboos." Unlike *Space Battleship Yamato,* the naming of the prime minister character seems to be the only one that bears significance in *Silent Service.*

17. See Glenn D. Hook and Gavan McCormack, *Japan's Contested Constitution* (New York: Routledge, 2001) for more detailed discussion on the post–cold war politics surrounding constitutional revision as well as translations of some proposals for constitutional revision.

18. See, for example, Yumiko Iida, "Beyond the 'Feminization of Masculinity': Transforming Patriarchy with the 'Feminine' in Contemporary Japanese Youth Culture," *Inter-Asian Cultural Studies* 6, no. 1 (2005): 56–74; and Fabienne Darling-Wolf, "SMAP, Sex, and Masculinity: Constructing the Perfect Female Fantasy in Japanese Popular Music," *Popular Music and Society* 27, no. 3 (2004): 357–70.

19. For discussions on security policies in Japan, see Christopher Hughes, "Japan's Security Policy, the US-Japan Alliance, and the 'War on Terror': Incrementalism Confirmed or Radical Leap?" *Australian Journal of International Affairs* 58, no. 4 (2004): 427–45; and Anthony DiFilippo, "Opposing Positions in Japan's Security Policy: Toward a New Security Dynamic," *East Asia: An International Quarterly* 20, no. 1 (2002): 107–36.

CHRISTOPHER BOLTON

• • •

The Quick and the Undead: Visual and Political Dynamics in *Blood: The Last Vampire*

In the films of Oshii Mamoru, political struggle is not only palpable—it is positively sensual. Oshii's films chart the efforts of people to make a difference or leave a trace in a politicized, mediated world where the importance of the individual is increasingly uncertain. The threat to individual agency is represented by political or technological networks that are ubiquitous but also invisible—power structures governing individual lives so completely that the structures themselves escape detection. They can script an individual's actions, rewrite memories, even substitute their own simulated reality for an individual's lived life, all without leaving a mark.

Opposing the tyranny of these structures is a longing for individual significance that is often expressed as a sensuous desire for the individual body. Time and again in Oshii's films, it is romantic and carnal desire that assert the worth of the human. We see it in *Patlabor 2* (1993), whose mecha pilots must strip off their claustrophobic mechanical suits in order to make human contact; in Oshii's script for *Jin-Roh* (2000), where factional politics are momentarily suspended by a fairy-tale love story between a terrorist and a secret policeman; and in *Ghost in the Shell* (1995), where the ambivalent narrative about networked, disembodied consciousness is countered by the shapely

> IN *BLOOD*, THE PLANES VISUALLY
> REPRESENT THE WEIGHT AND
> SOLIDITY OF PRESENT REALITIES,
> AS WELL AS THE ILLUSORY QUALITY
> OF JAPANESE POLITICS AND THE
> COUNTRY'S SUPPRESSED BUT
> STILL-HAUNTING MEMORIES OF ITS
> OWN WARTIME AGGRESSION.

physique of the cyborg heroine.[1] All this produces an interesting paradox in Oshii's films: his characters are sometimes described as ghosts in the machine—the last traces of resistance haunting these political and technological networks—but, in fact, his human characters are the films' most reassuringly tangible features, while the machinery and technology of these invisible, inescapable networks are often far more ghostly and far more haunting.

A noteworthy example is *Blood: The Last Vampire,* directed by Kitakubo Hiroyuki and a team of young artists working under Oshii's tutelage.[2] *Blood* is a vampire story set on an American air force base in Japan during the Vietnam War. Released in 2000, it was one of the first anime to make heavy use of photorealistic digital effects, though at many points it preserves the stylized quality of conventional animation. While the vampires and human characters are largely two-dimensional, the planes taking off and landing in the background are rendered as more photorealistic three-dimensional forms. At one level, the planes disrupt the film's fantasy by evoking the realities of Vietnam, realities that are in many ways more frightening than any ghost story. But at the same time, the planes have a ghostly quality of their own that makes them much more complex signifiers. They represent not only the reality of politics but its unrealities as well.

These unrealities include the cracks and contradictions in the national identity that was forged for Japan after World War II. Japan became a newly pacifist nation that renounced the militarism of the thirties and forties, but it has also supported and profited from American wars in Vietnam and elsewhere. Japan's ability to formulate an independent defense policy has been hindered by fears in Japan and in the rest of Asia that Japanese pacifism is only a thin veneer and that prewar militarism could reassert itself at any time. In *Blood,* the planes visually represent the weight and solidity of present realities, as well as the illusory quality of Japanese politics and the country's suppressed but still-haunting memories of its own wartime aggression.

At the same time, the film's two-dimensional vampire heroine Saya seems at first to be a cartoonish fantasy—a camp parody of anime vixens. But Saya's sexiness and violence have a reassuring physicality that promises an escape from the intangibility and uncertainty of politics. In this sense, *Blood* is a film that could only have been made as an anime: it is the work's strange

admixture of fantasy and photorealism that comments most provocatively on Japan's present historical moment. This essay begins by examining political dynamics in *Blood*'s plot and then links this to the film's physical dynamics—the way mass and motion are portrayed by the film's unique combination of two- and three-dimensional animation.

FROM GHOSTS IN THE MACHINE TO VAMPIRES ON THE SUBWAY: THE PLOT OF *BLOOD*

Blood opens on a nearly deserted Tokyo subway train as it approaches its final stop of the night. A coldly attractive young girl stares at the only other passenger in the car, an exhausted office worker. Interior and exterior shots of the train alternate with shots of the two characters and the opening credits, building tension while showcasing the 3-D animation used to render several very complex perspective shots inside and outside the moving train. Suddenly the girl leaps from her seat, races toward her fellow passenger, and cuts him down with a samurai sword.

As the girl exits the train, she is met by two American agents of an unnamed secret organization, and we learn from their conversation that her victim belonged to a vampirelike race of monsters who can take human form. The monsters are called chiropterans (after the biological order that includes bats), and the girl, Saya, has been enlisted to hunt them down. This terse dialogue between Saya and the agent named David is the only background the film provides, but it establishes that Saya is also a vampire herself. The link and the distinction between her and the chiropterans are explained only with David's cryptic comment that "she is the only remaining original."

The scene also sets up the mission that will occupy Saya for the rest of the fifty-minute film: the monsters have emerged from hibernation and infiltrated the U.S. air force base in Yokota, where they have already murdered several people. Saya poses as a student to visit the base school where the last murder took place, in hopes of ferreting out the chiropterans who are passing as humans. She locates them on Halloween night and fights three of them in a running battle, climaxing with a dramatic fight in a burning hangar and a chase across the runways.

The monsters are killed, and the incident is hushed up. In the final scene, some days later, the sole civilian witness (the school nurse) wonders what she has seen. All of the scenes up to now have been in the fading light of late afternoon or at night, but now in daylight, the monsters seem no more than

a bad dream. At the same time, a suspicion or a fear that has lurked in the shadows for the whole film now comes into the light: it is clear right from the opening shot (of a rotary dial telephone) that the film is set in the near past, but aside from small details in the background of one or two scenes, for most of the film there is no indication of the year. In the closing minutes, though, we see a calendar marked 1966, and the final shot shows a B-52 bomber taking off into the clear blue sky while an English voice-over describes the bombing war in Vietnam. The end credits alternate with dim and grainy (ghostly) news footage of the war.

The ending leaves no doubt that vampirism is a metaphor for the U.S.–Japan military relationship, though the vampire in this case could be either America or Japan. The U.S. bases established in Japan after the occupation have been a staging area for U.S. wars in Korea, Vietnam, and the Middle East. In the heated debates that center on these bases, one position portrays the United States as a foreign parasite that has exploited its Japanese host in order to prosecute its own wars; another accuses Japan of being the parasite—of enjoying the shelter of the U.S. military umbrella with minimal risk and expenditure.

This dialectic of exploitation and dependence is reproduced in local communities around the base. Like Dracula's manor, large U.S. bases form the foundation of local economies. But in Okinawa, for example, well-publicized incidents of U.S. marines raping local girls have created a nationwide image of the bases as harboring monsters who raid the populace and then escape back to the safety of the castle. And the deafening jet noise from bases like Yokota has become a charged symbol of U.S. indifference to the surrounding Japanese communities. In *Blood,* the G.I. bars and brothels around Yokota are a hunting ground for the chiropterans. When the body of a murdered hostess is discovered early in the film, one character speculates that the woman's American boyfriend might be involved in her death, but the comment is all but drowned out by the noise of a passing plane.

THE VAMPIRE AS METAPHOR

In Western literature, the vampire is a privileged figure for otherness and a powerful metaphor for racial or cultural mixing. The vampire is familiar but also foreign; it crosses gender lines as an effeminately alluring male or a castrating female; and it breaches blood and body boundaries in a way that suggests sexual communion but also perversion and pollution. It is for these

reasons that Donna Haraway makes the vampire a central metaphor as she traces constructions of race in twentieth-century biology.

> A figure that both promises and threatens racial and sexual mixing, the vampire feeds off the normalized human. . . . Deeply shaped by murderous ideologies since their modern popularization in the European accounts of the late eighteenth century—especially racism, sexism and homophobia— stories of the undead also exceed and invert each of those systems of discrimination to show the violence infesting supposedly wholesome life and nature and the revivifying promise of what is supposed to be decadent and against nature.[3]

Kotani Mari argues that the vampire represents a similar kind of otherness in Japanese manga and prose fiction, but an otherness that is doubled because the vampire enters Japanese literature as a foreign genre. Kotani writes that vampires have represented the threat and appeal of a Western other since the first Japanese vampire fiction in the thirties. But she also describes recent authors like Kasai Kiyoshi who have reversed this paradigm, casting the Japanese as a race of vampires themselves. The nationalist metaphor is transformed further by Kikuchi Hideyuki's hybrid human/vampire heroes, as well as Ōhara Mariko's parasitic vampires that infest and manipulate their human hosts: both authors blur or erase the lines between native and foreign, or self and other, and show us "how we should speculate on the topic of hybridity in a post-colonialist and post-creolian age."[4]

Like Haraway's vampire, the vampires in *Blood* symbolize racial or cultural difference and conflict, including the racialized violence of colonialism or imperialism. But *Blood* also shows the confusions and reversals that Kotani predicts. It is a film about familiarity and unfamiliarity: the way that one culture can regard another as monstrous, but also the blurring of boundaries between the monsters and us. The chiropterans are batlike creatures who can masquerade as humans, and Saya is clearly one of Kotani's hybrid heroines, a creature somewhere between us and them. Saya is on "our" side, but she sneers at the humans she protects and feels a kinship with the chiropterans she kills.

The ambiguity of Saya's vampire identity is matched by a cultural ambiguity: she seems simultaneously American and Japanese. *Blood* has an interracial and international cast of black, white, Japanese, and seemingly bicultural characters, and while some are drawn in a way that seems to deliberately emphasize racial stereotypes, Saya and others are ambiguous.[5] More than one

character asks Saya uncertainly if she is Japanese, but she pointedly refuses to answer. She speaks both Japanese and English with seeming fluency. And she seems to be passing for a Japanese visitor at the base school, although she is unfamiliar with Japanese customs: David has to explain to her that the sailor suit she has been given to wear is a Japanese school uniform.

This schoolgirl's uniform is a distinctly sexual fetish in *Blood* (as in so many other anime), but it takes on a strangely ironic status on Saya, who has become jaded and perverted over the course of a hundred years, even as she retains the body of a little girl. Saya is sexy in the vampire's liminal, transgressive way, but her eternal youth, her threatening allure, and the rest of her vampiric sex appeal have been translated into a series of exaggerated anime archetypes: she is savior and avenger, executioner and demon lover, a sword-wielding sorceress in a middy uniform (Figure 1).

On the night of the base Halloween party (a backdrop that further ironizes these horror stereotypes), Saya shows up at the school infirmary just in time to save the school nurse from two chiropterans disguised as female students. (The nurse is the film's emblematic victim, and she too seems

AT YOKOTA AIR FORCE BASE
BEASTS LURK WITHIN
VICIOUS KILLERS WITH AN APPETITE FOR BLOOD
ONLY ONE WOMAN CAN ELIMINATE THEM

...THE LAST REMAINING ORIGINAL

FIGURE 1. A publicity still of Saya. This precise pose does not appear in the film, but it faithfully captures the film's portrayal of Saya as a kind of veteran and maiden—a violent, sexualized child soldier. From a package insert in Manga Entertainment's American DVD.

alternately American and Japanese: she possesses the apparently bicultural name Masako Caroline Asano, and many of the same ambiguous qualities as Saya [Figure 2].) Saya kills one monster and wounds the other, but her sword is broken in the struggle, and the remaining monster abducts the nurse. The creatures are immune to gunfire, and only a genuine warrior's sword is strong enough to cut them, so Saya steals a replacement sword from the window of a nearby antique store and gives chase. When she strikes the chiropteran, however, the sword turns out to be a fake modern reproduction, and it bends in half. With the tables turned, the monster traps the weaponless Saya and the nurse in a hangar, which catches fire. In the scene's feverish climax, the monster is about to devour Saya when David arrives with a genuine sword that he flings desperately toward her. Framed dramatically against the flames, Saya screams for the sword and then catches, draws, and swings the blade in one motion to cut the chiropteran in half.

This conclusion does not provide a simple answer to the question of who is the vampire and who is the victim in the U.S.–Japan relationship. Neither the heroine nor the central victim is definitively American or Japanese. Both are threatened by the chiropterans, but do these monsters represent America menacing Japan, or Japan taking its revenge on the American interloper?

FIGURE 2. Saya and the school nurse have features and behaviors that mark them as both American and Japanese.

The tangled symbolism stems precisely from the tangled politics of post-war Japan. The chiropterans can probably best be associated with violence, militarism, and war itself—not only U.S. cold war imperialism and interventionism but also the Japanese militarism of World War II. Like the hibernating monsters, that militarism has lain dormant or disguised since the occupation, but now it threatens to reemerge. Clothed in a military-style school uniform and armed with a samurai sword, Saya seems to represent a truer, nobler, and more disciplined warrior spirit that will actually rein in the violence. In the logic of this and other films connected to Oshii, Japan is threatened by a crisis of that true spirit, symbolized by the sword that turns out to be fake. If it does not regain its martial and cultural identity, Japan will fall into the kind of violence represented by the chiropterans—supporting U.S. imperialism by proxy or resorting to military adventurism itself. Japanese and not-Japanese, Saya represents a new Japan that rediscovers its samurai values, a strong Japan that now fights against war itself.

The contradiction of a warrior who fights war stems in part from the collision of Oshii's leftist politics with the violent military/action genre he favors. But it is also a tension that reflects the contradictions and conflicting desires of postwar Japanese national identity. After World War II, the American occupation disarmed Japan and imposed a constitution that renounced the right to wage war and maintain an army. The military pact between the two countries assumed that Japan would maintain only "defensive" forces and would be protected by American troops, in return for supporting U.S. bases and combat operations diplomatically, logistically, and monetarily. The legacy of this policy is a Japanese national identity that is arguably split: a militarily noninterventionist and constitutionally pacifist country that was also a launching pad for several American wars.

> BLOOD SEEMS TO YEARN FOR A JAPAN THAT IS MILITARILY STRONG AND INDEPENDENT BUT ALSO PEACE LOVING AND NONINTERVENTIONIST.

The defense pact incited protests when it was signed in the fifties and again when it was renewed in the sixties. More recently, the government's decision to deploy support troops in the Gulf and Iraq wars has fostered national debate. The paradox of Japan's position is seen in the fact that calls for a more militarily independent Japan now come from the Right and the Left—from some who think Japan should commit its own troops to combat in Iraq and elsewhere, and from others who want Japan to stand up and oppose U.S. aggression. But for many in Japan and Asia, the idea of a militarily

independent Japan (especially Japanese troops abroad), represents an alarming echo of the country's wartime past. Like other Oshii films (where this political critique is sometimes even more explicit), *Blood* seems to yearn for a Japan that is militarily strong and independent but also peace loving and noninterventionist.[6]

So while Saya's character has the elements of a sexual fantasy cobbled together from fetishistic images, she is more importantly a fantasy of national agency and identity—a fantasy that is almost sexually stirring and disturbing, inevitable and naive. Her physical power and presence represent the hope for a force that can cut through the perceived inaction and paralysis of Japanese politics. By the time it achieves violent release in the burning hangar, the repressed tension between David and Saya is as much political as it is sexual: from David (that is, from the United States), she receives the sword she could not find. With it, she regains the warrior spirit Japan lost after World War II, and with this new blade she incarnates a new Japan, one on an independent equal footing with the West. With youth's innocent strength and age's sad wisdom, Saya can rescue the Japanese–U.S. partnership (maybe in the person of the nurse) from falling into the militarism and imperialism it has in the past—a threat represented by the ravening chiropterans. With her sword reforged, she will conquer war itself and guard the peace.

There is an ironic, even tongue-in-cheek quality to the film's idea that Japan's savior will take the form of a sword-wielding vampire schoolgirl in a sailor suit. What the mix of seriousness and pastiche in these overlapping sexual and national fantasies really conveys is the idea that Saya does not represent a real political solution so much as she points out the paradoxes of Japan's political identity vis-à-vis the United States and the contradictions that seem to inhere in every (im)possible solution. In fact, the film's hope is tinged with such irony that it sometimes verges on nihilism, a kind of despair we see more clearly in the edgy *Blood* manga that Tamaoki Benkyō based on the film. This work shows us Saya in the present day, now caged like an animal by the U.S. military and released only to hunt. Tamaoki is best known for his pornographic comics, and here Saya's nemesis is a sadistic lesbian vampire who leads a motorcycle gang and uses her cell phone to troll for disillusioned youth. Saya defeats her, but there is ultimately little distinction between good and evil: the villain turns out to be Saya's own alter ego and twin.[7]

The film is slightly more sanguine. In the ironic, self-referential style that characterizes so many anime, the film is shot through with a stirring but always slightly sardonic optimism. Just as Donna Haraway relies on fantastic, ironic narratives about vampires or cyborgs to make her most dangerous

claims, *Blood* reflects on dangerous issues by translating them into a fantastic genre and an animated medium that allow us to deal with these painful realities from a distance. Yet at several points, *Blood*'s more realistic 3-D animation threatens to disrupt that metaphoric quality and break into the real. This is the subject taken up below.

SPACES AND PLANES: THE VISUAL DYNAMICS OF *BLOOD*

This brings us to the visual differences between anime and live action, and the formal style of *Blood*. Here I would like to start with a question about the final climactic battle with the chiropterans. After Saya kills the monster inside the burning hangar, a third chiropteran appears and perches dramatically on the hangar roof, then grows wings and glides out over the runways. As Saya and David pursue it in a jeep, they realize it is heading for a plane that is taxiing toward takeoff. For some reason, they must stop it before it reaches the plane, but it is not exactly clear why. Will it attack and crash the aircraft? Or will it cling to the wing and escape beyond David and Saya's reach? If the chiropteran only wants to get away, why did it come to the base in the first place, and why aren't David and Saya content to see it go? A viewer can construct several plausible explanations, but the urgency of this final scene suggests the need for a decisive answer. The second half of this essay works toward such an answer, by considering what Saya and the planes represent on a visual level.

Thomas LaMarre has argued compellingly that the most interesting approach to anime connects its meaning with its specific visual qualities, particularly those qualities that set it apart from live-action cinema. LaMarre's essay "From Animation to Anime" takes up the case of "limited animation," anime's practice of reducing the number of illustrations that make up an animated sequence.[8] Originally a cost-cutting expedient, limited animation has given rise to a number of specific effects that have now come to be regarded as positive parts of anime's aesthetic. Among these are long close-ups in which nothing moves except the characters' mouths or eyes, a jerky energy when characters do move (caused by drawing fewer intermediate stages of a given motion), and an image-compositing technique that replaces an articulated moving figure with a single static drawing of the figure, which is then photographed as it slides in front of a static background. This last practice of "moving the drawing" instead of "drawing the movement" produces rigid

figures that appear to float across the background in a layer of their own, rather than articulated figures that move in and out of the background in three dimensions.

For LaMarre, this last effect generates a kind of weightless, floating quality that creates a sense of freedom for the character and spectator alike. LaMarre supports this with a clever reading of the flying scenes in Miyazaki Hayao's *Castle in the Sky* (1986, *Tenkū no shiro Rapyuta*), where these static figures in horizontal movement produce a sense of gliding weightlessly on the wind. In this way, the formal visual quality of the movement mirrors the story's theme (and that of several other Miyazaki stories), in which characters gain freedom by harnessing the wind and their own inner potential rather than by relying on a mechanical technology fueled by scarce resources. "Minimum technology" becomes both the environmentalist mandate of Miyazaki's films and the philosophy of their production. For LaMarre, this freedom enables the protagonist to escape the burden of history in a way that is suggestive for *Blood. Castle*'s heroine Sheeta is among the last descendants of a people who ruled floating cities equipped with apocalyptic weapons, yet Sheeta has an inner freedom that empowers her to reject this legacy and gives her the strength to destroy the last remnants of her people's dangerous technology.

Like most animation of the time, *Castle in the Sky* was produced by drawing and painting figures on transparent celluloid, layering these "cels" over background paintings, and photographing them for each frame. The limited number of layers and the difficulty of portraying movement toward or away from the camera both reinforced the flat, sliding quality of the motion, according to LaMarre. *Blood*'s innovation was to include backgrounds and objects that were modeled in three dimensions using computer graphics imagery (CGI).[9] A computer can calculate the appearance of these elements and environments from any angle and generate as many frames as needed, allowing the animators to produce sequences in which intricate shapes can rotate smoothly and the virtual camera can move through complex sets. Some software can also calculate the motion of drawn objects in ways that take into account inertia and other dynamic forces. This gives computer-rendered objects a sense of depth, mass, and momentum that hand-drawn characters do not have.

While many of the characters in *Blood* are two-dimensional caricatures, the planes in the background are rendered in three dimensions, in historically accurate detail (Figures 3–5). Harnessing a persistent bias that cinematic or photographic realism is somehow closer to unmediated experience than two-dimensional drawing, the filmmakers use this photorealism to associate the planes with a more profound reality. As they take off or return from

a destination we can imagine as Vietnam, these aircraft are the film's most prominent signifier for the world of war and geopolitics outside the vampire story. But what is more interesting is the way that *Blood* juxtaposes three-dimensional computer-rendered elements with the kind of limited animation LaMarre describes. In the opening scene, when Saya races through the train car toward the disguised chiropteran, the train cars are rendered with an almost exaggerated linear perspective, while Saya remains a "moving drawing"—a static figure who flies through the car toward her target. Here Saya evokes the same sense of weightlessness and freedom as Miyazaki's Sheeta. Faster than a locomotive, she is also free of its ponderous inertia. As she strikes down postwar political threats in the person of the chiropteran, Saya may even be quick enough to dodge around the historical dilemmas *Blood* presents—in effect escaping the difficult legacy of World War II just as Sheeta escapes the burden of her family history. This fast freedom is the ultimate object of desire that Saya represents. But in the end it is probably unattainable: all around her, the ponderous shapes of other figures—the train, the planes—remind us of a weightier reality.[10]

These, then, are the links between political and visual dynamics—political movements and physical motion—in the film. At the most intuitive level, *Blood* lulls us into a fantasy world not only with its occult plot but with its flat visuals; yet, whenever a plane appears, it has a cinematic realism that calls us back to the reality of Vietnam. At a more complex level, the juxtaposition is not just between two-dimensional cartoonishness and three-dimensional realism but between visions of fast, floating freedom versus the lumbering weighty responsibilities imposed on postwar Japan. There is a further wrinkle in the fact that while the planes seem real and weighty, they also have a ghostly quality of their own, a quality of the dead returned to life. Often this is achieved with lighting and sound effects: a cargo plane that roars overhead appears only as a looming silhouette. A fighter taxiing away from the camera floats lightly into the air behind a shimmering veil of heat (Figures 4 and 5). In the climax, a huge C-130 transport or gunship lumbers into the sky, glowing eerily in the dawn light, while Saya stands in front of it, a tiny, flat silhouette. The planes also gain a ghostly quality by combining detailed three-dimensionality with a drawn quality that they never lose. They become uncanny by approaching cinematic realism and stopping short.

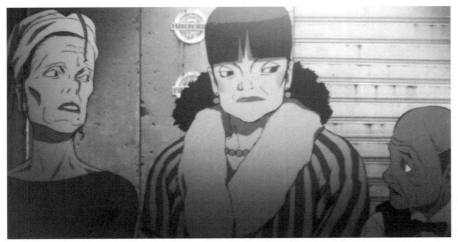

FIGURE 3. Characters from the bars near the base show the caricatured quality of the film's human figures. The transvestite manager on the left turns out to be a monster in disguise.

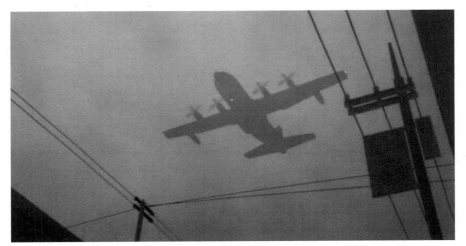

FIGURE 4. Part of a computer-modeled tracking shot where we see the plane rotate through different perspectives. At the same time it remains mysteriously veiled by darkness and fog.

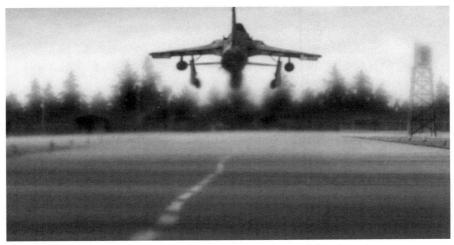

FIGURE 5. Heat haze distorts the fighter and runway, giving them a ghostly quality.

RESURRECTED MEMORIES:
COMPUTER GRAPHICS AND THE UNDEAD

Livia Monnet explains the ghostly quality of CGI's *almost* cinematic realism in a reading of *Final Fantasy: The Spirits Within* (2001), an ostensibly photo-realistic film in which everything is computer modeled and rendered. Monnet points out that despite their visual realism, the film's characters have a ghostly, uncanny, or undead quality generated by the many layers of simulation that separate them from the human. Each CGI body is "a *ghostly, invaded body,* a computer-animated trace of a real, referential movement"—for example, the movement of a human motion-capture actor whose gestures have been recorded and copied to animate a 3-D model of a human body:

> The elastic, dot-constellation figures produced by the computer from motion-capture data provided by real human actors absorbed, as it were, the latter's "lifeblood," which then became the "living material" of the digital actor's "lifelike" behavior. . . . *Final Fantasy*'s virtual actors perform as undead, digital vampires or zombies.[11]

Monnet sees these formal visual qualities as intimately intertwined with the film's science fiction plot, which involves a set of monstrous phantoms that infect and devour human bodies. The phantoms are also undead—a malevolent spiritual energy left over from an extinct civilization. Monnet identifies the reason for this plot and style as an impulse *Final Fantasy* inherits from early cinema, an urge to confront and overcome death. Just as early film theory attributed an animism to motion pictures, *Final Fantasy* strives like Doctor Frankenstein to animate its figures, but ends up with uncanny characters that seem half alive.

Freud identifies the uncanny with the return of repressed ideas or beliefs—the "primitive" belief that a lifeless object can come to life, as well as sexual fears that have been repressed. Extending and critiquing Freud, Monnet notes that the heroine of *Final Fantasy* is a passive host, or "medium," in which the action plays out. Monnet thereby relates the uncanny quality of the film's CGI actors with the haunting return of this suppressed female agency.

These ideas are helpful for thinking about undead agency in *Blood*. But just as Miyazaki's *Castle in the Sky* turns limited animation into a virtue, *Blood* leverages the uncanny limitations of CGI to good effect, using them to acknowledge and foreground issues of lost agency and lost or repressed memory. For a Japanese audience, this includes the perceived loss of Japan's

historical or political agency after World War II, as well as the fear of reclaiming that agency and risking a return to prewar aggression. For many in and out of Japan, what has been repressed is thoughtful debate about Japan's wartime responsibilities and history. U.S. viewers may also be reminded of America's own repressed complicity in all of the above, as well as the willfully forgotten lessons of Vietnam. This is why the F-4 Phantoms and other planes are the film's true ghosts, spookier and scarier than the chiropterans: they haunt us with the return of an uncomfortable reality—not just an everyday reality we set aside when we entered the theater but political truths we have suppressed in our everyday lives. Only a Harawayan figure like Saya—the product of "desire and fear," "shaped by murderous ideologies" herself—can bring this suppressed violence to the surface and simultaneously head it off.

PLANES, TRAINS, AND THE AIR MOBILE: *BLOOD*'S CLIMAX AND CRISIS

We can now revisit and reread the film's final chase. Why must David and Saya prevent the chiropteran from reaching the plane? The aircraft is not in danger. It is a C-130 Galaxy, a hundred feet long and forty feet tall, and as we get closer, it towers over Saya and the monster. The real worry is what powers the monster will gain if it joins with this mechanical behemoth. If the chiropterans represent an awakening Japanese militarism, the fear of renewed Japanese intervention abroad is figured as the threat that the monster will escape Japan's shores on America's back and reach out as far as Vietnam. This will repeat the grim history of 1940, when Japan's expansion into French Indochina was a prelude to the Pacific War.[12]

More broadly, and more in line with the visual argument above, the fear in this scene is that latent Japanese militarism (which has been pushed back into the realm of fantasy up to now) will somehow merge with the three-dimensional world of the plane and reassert itself. The fear that the chiropteran will reach the plane is the fear that Japan's imperialists will rise from the (un)dead, that the two-dimensional nightmare will somehow become a three-dimensional reality. This is the catastrophe Saya averts. When David pulls the speeding jeep alongside the plane, she fatally slashes the monster just short of the plane's wing. As the aircraft turns away from her and wheels into the sky, Saya remains a flattened silhouette in the foreground. She has succeeded in keeping the creature in her own two-dimensional world, but she cannot

enter the real world either. In this film, the rearmed peaceful Japan she symbolizes is ultimately just a pipe dream.

For *Blood*'s audience, then, the sexual and political fantasies that Saya represents both remain unattainable. Anime bodies and beings can certainly provoke sexual desire in the viewer, but without even an actor or actress to stand in for the character in our fantasies, that desire for the anime body must be tinged with a particular hopelessness. All the more so when the character is a self-conscious pastiche of fetishes like Saya. In *Blood*, the frustrated sexual desire that is a feature of so many anime becomes an analogue for unconsummated political yearnings as well. Exiled from the fantasy, the spectator remains trapped in the real world.

This sense of foreclosed possibilities on the part of the spectator is also discussed by LaMarre. He suggests that Miyazaki's use of sliding layers gives an increased freedom and agency not only to his characters but to the viewer as well. The spectator and the characters occupy adjacent layers that are in "relative motion." The world "is sensed but not quite objectifiable (in the sense of forming stable points of reference)," opening the possibility that anime might help us spectators alter or rethink the deterministic roles imposed on us by modern film and modern history.[13] For LaMarre, this space of possibility is represented by a train, a moving environment whose windows flash sequential images in a way that leaves us unsure if it is the world or we ourselves that are in motion.

Writing on very similar visual issues in anime by Miyazaki and fiction by Edogawa Ranpo, Thomas Looser sees the view from a train window in the opposite way. With its differential movement of near and far objects, Looser regards it as a triumph of three-dimensional linear perspective and a dominating imperialistic gaze.[14] So what kind of train is the subway we board with Saya in the opening scenes of *Blood*? In fact, its exaggerated linear perspective associates it with Looser's more pessimistic vision. There is even a sense in which the subway scenes and other rendered environments seem to fix the spectator's position more firmly, trapping and pinning us down in return for letting us see things that cel-based animation cannot show.

This difference between the two trains speaks to the difference between Miyazaki and Oshii. If Miyazaki makes his points by freeing the spectator, Oshii makes them by implicating us uncomfortably in the projects he criticizes. He provokes our desire for freedom but frustrates it by confining us claustrophobically inside the machine. For example, when the chiropteran stands on the roof of the burning hangar preparing to fly, the camera rotates around the building in an ostentatiously perspectival view, while the frame shakes in

a way that mimics news footage taken from a helicopter. (Less than a minute later, a shot of agents in a helicopter brings the association to the surface.) In the aerial shot of the hangar, we have been transported inside the plane. In LaMarre's parlance, we have become the "viewing machine-subject" that Miyazaki so carefully avoids.[15] Now we are not only watching; we have become part of the machine's projects. Now it is we who are providing air support.

If there is optimism in *Blood* and Oshii's other work, it is less a dream of political revolution than a more modest and more visual hope that anime might allow us to see things hidden by other media, or perhaps remember scenes that we have repressed. In this way, the darkness of *Blood* does shine some light on postwar Japanese political identity, and the film hopes that this knowledge might make some small difference. As *Blood*'s spectators, we cannot share Saya's inhuman speed or agency, but Oshii seems to hope that if we can see the train coming, we just might be able to get out of the way.

..

Notes

This essay is based on papers delivered at two conferences: "Digital Cultures in Asia" at Academia Sinica in Taiwan, July 2005, and "Schoolgirls and Mobile Suits" at the Minneapolis College of Art and Design, October 2005. I benefited greatly from comments by the conference participants, as well as from feedback by Kotani Mari and Eliot Corley at earlier stages in the project.

1. *Kōkaku kidōtai: Ghost in the Shell,* dir. Oshii Mamoru (1995); translated as *Ghost in the Shell,* DVD (Manga Entertainment, 1998); *Kidō keisatsu patoreibaa 2: The Movie,* dir. Oshii Mamoru (1993); translated as *Patlabor 2: The Movie,* DVD (Manga Video, 2000); *Jinrō,* dir. Okiura Hiroyuki, script by Oshii Mamoru (2000); translated as *Jin-Roh: The Wolf Brigade,* DVD (Viz, 2002).

2. *Blood: The Last Vampire,* dir. Kitakubo Hiroyuki, planning assistance by Oshii Mamoru (2000); translated on DVD (Manga Entertainment, 2001). For more on Oshii's key role in the collaborative process, see the documentary "Making of *Blood: The Last Vampire*" on the American DVD. For various interpretations of the film by the various creators, see Brian Ruh, *Stray Dog of Anime: The Films of Mamoru Oshii* (New York: Palgrave, 2004), 154–64.

3. Donna Haraway, *Modest_Witness@Second_Millennium.FemaleMan©_Meets_Onco-Mouse™: Feminism and Technoscience* (New York: Routledge, 1977), 214–15.

4. Kotani Mari, "Techno-Gothic Japan: From Seishi Yokomizo's *The Death's-Head Stranger* to Mariko Ohara's *Ephemera the Vampire*," in *Blood Read: The Vampire as Metaphor in Contemporary Culture,* ed. Joan Gordon and Veronica Hollinger (Philadelphia: University of Pennsylvania Press, 1997), 194.

5. At one point in the film, a woman fleeing from the chiropteran runs into a black airman drawn as a caricature, with a large flat nose, bulging white eyes, and enormous lips. In a scene calculated to startle (and perhaps disturb) the viewer, she looks into his face and screams for several seconds before realizing that he is not a monster himself. The

uncomfortable joke evokes civilian and military racial tensions in the sixties and the monstrousness of the black other (or black soldier) in the racist imagination. The scene drives its point home by lynching this character a few frames later: a chiropteran lurking in a tree grabs him from above and pulls his head into the branches, then kills him as his twitching legs dangle from the tree. Once noticed, the violent symbolism of this scene threatens to overwhelm the whole film.

6. For example, see Oshii's *Patlabor 2,* released shortly after the first Gulf war. Michael Fisch and I have both considered these issues in the context of that film. Michael Fisch, "Nation, War, and Japan's Future in the Science Fiction Anime Film *Patlabor 2,*" *Science Fiction Studies* 27, no. 1 (2000): 49–68; Christopher Bolton, "The Mecha's Blind Spot: *Patlabor 2* and the Phenomenology of Anime," in *Robot Ghosts and Wired Dreams: Japanese Science Fiction from Origins to Anime,* ed. Christopher Bolton, Istvan Csicsery-Ronay Jr., and Takayuki Tatsumi (Minneapolis: University of Minnesota Press, 2007).

7. Other *Blood* spin-offs include a television series set and released in 2005 and a sequence of novels, including a recently translated novel by Oshii himself (reviewed in this volume). Tamaoki Benkyō, *Blood: The Last Vampire 2000*; translated by Carl Gustav Horn as *Blood: The Last Vampire 2002* (San Francisco: Viz, 2002); Oshii Mamoru, *Blood The Last Vampire: Kemonotachi no yoru* (Tokyo: Kadokawa horaa bunko, 2002); translated by Camellia Nieh as *Blood The Last Vampire: Night of the Beasts* (Milwaukie, Ore.: DH Press, 2005); *Blood+,* TV series (2005–); available on Japanese DVD (Aniplex, 2005–).

8. Thomas LaMarre, "From Animation to Anime: Drawing Movements and Moving Drawings," *Japan Forum* 14, no. 2 (2002): 329–67.

9. *Blood*'s animators also increased the number of layers that compose in each shot using software like Photoshop. For technical details, see the "Making of" documentary on the American DVD.

10. LaMarre argues that a deliberate gap between cel and digital animation can push us to abandon these very assumptions about cinema's nearness to reality, as well as broader notions about the historical indexicality of (visual) language. This opens the possibility of thinking in new ways about history itself. While I identify Saya's two-dimensionality as representing an attractive freedom that is ultimately unrealistic, LaMarre sees a more radical and more sustainable freedom in the heroine of Rintarō's *Metropolis* (2001), a cyborg who combines two- and three-dimensional attributes in a single character. Thomas LaMarre, "The First Time as Farce: Digital Animation and the Repetition of Cinema," in *Cinema Anime: Critical Engagements with Japanese Animation,* ed. Steven T. Brown (New York: Palgrave, 2006), 161–88.

11. Livia Monnet, "Invasion of the Women Snatchers: The Problem of A-Life and the Uncanny in *Final Fantasy: The Spirits Within,*" in Bolton, Csicsery-Ronay Jr., and Tatsumi, *Robot Ghosts and Wired Dreams.*

12. This fear is born out in the 2005 television series, which begins with a scene of Saya and the chiropterans slaughtering American soldiers and local villagers in Vietnam.

13. LaMarre, "From Animation to Anime," 364–65.

14. Thomas Looser, "From Edogawa to Miyazaki: Cinematic and *Anime*-ic Architectures of Early and Late Twentieth-Century Japan," *Japan Forum* 14, no. 2 (2002): 297–327.

15. LaMarre, "From Animation to Anime," 364.

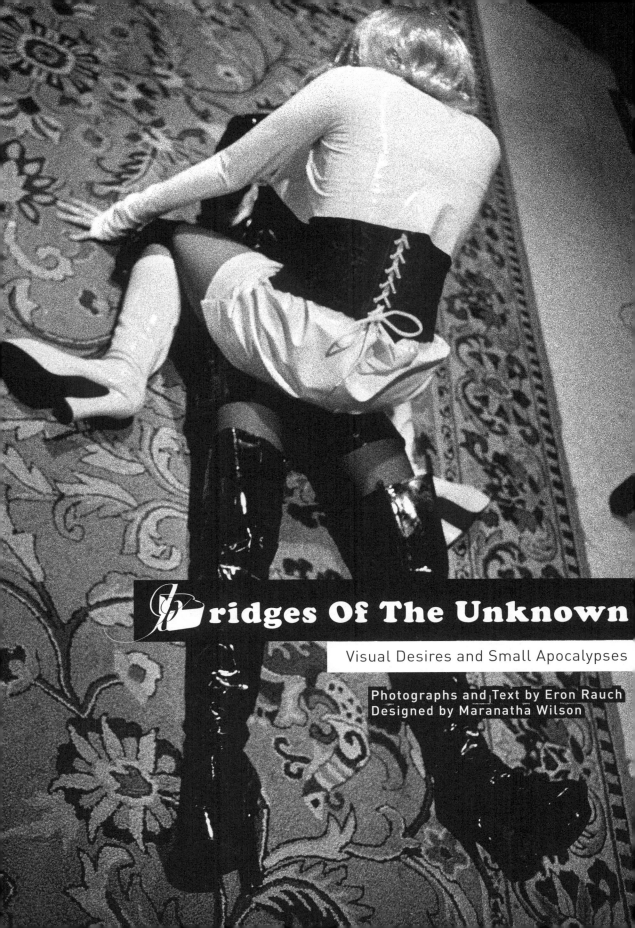

ridges Of The Unknown

Visual Desires and Small Apocalypses

Photographs and Text by Eron Rauch
Designed by Maranatha Wilson

I can remember one early Sunday morning at an anime convention. I was drunk in a random hotel bathroom, unzipping the oversized zipper of a young woman's vinyl cosplay costume. She looked up from under her wig, smirked, and said, "Now things are getting interesting..."

Then her friend walked in, and all I could think was, "Fuck! Why didn't I bring my camera?" In hindsight, I might place this as the satori moment in which I was repurposed from a fan carrying a camera to a producer of art carrying a fandom. But the value of the presentation of this story is based on its ambiguous status as both autobiography and allegory.

"Now things are g

ting Interesting . . ."

Through this body of images, I am telling a "history" but always wrapped in my own conflicted criticisms.

I choose to work with these inherent conflicts of view because it was only in the disturbingly hard battle to avoid mythologizing or reducing to the banal my personal history of grappling with the process of making art that I found the project.

And for fans, these conventions are their pilgrimage. All acr America, nearly every state has a yearly convention of thou-sands of people packed into the same type of hotels, awake for days, moving through simultaneous moments of lucidity and uncertainty in terms of what exactly they are trying enac Amid these intensified conditions, my project asks the ques-tion, is there even any value in trying to be self-critical? Afte all, in *Rock My Religion,* Dan Graham wrote of the history of

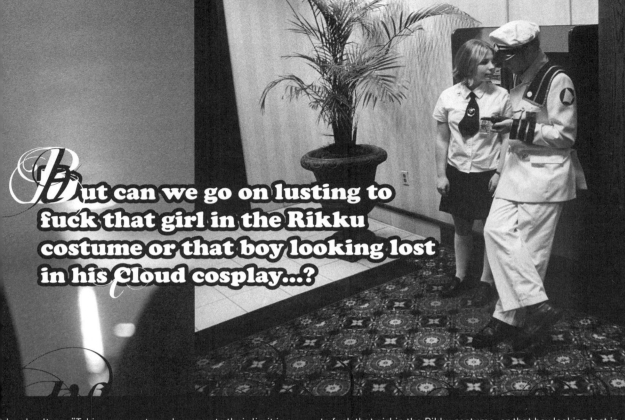

But can we go on lusting to fuck that girl in the Rikku costume or that boy looking lost in his Cloud cosplay…?

ck subculture: "Taking momentary pleasures to their limit is a
y of transcending history and death, and, in a doomed world,
even inevitable."[1]

awareness of one's own desires seems to be the most dif-
ult choice for the critical artist or academic. It seems to be
at to experience the "transcendence" of the fan, we must
crifice history and critical discourse. But can we go on lusting

to fuck that girl in the Rikku costume, or that boy looking lost in
his Cloud cosplay (or pass on both and buy a new set of DVDs),
after the fleeting intrusion of an anxiety about the hidden gravi-
ties inherent in our "participation"?

The choice between knowledge and Eden: that is, a choice
between timelessness and chronology. That choice may seem
to be cliché, but if these photographs are to address how desire

During a recent con, a group of us were discussing the idea of cosplay sex while watching Ecstasy of the Angels projected across a corner of the hotel room, listening to Sonic Youth, and drinking gin & juice.

is built and navigated, they must start at that trailhead. And into this anxiety-ridden dialogue of desire and criticism, the camera's presence becomes an astute embodiment of two major thrusts of conventions:

A hyperawareness of the split between the heterogeneous masses undulating in complicated current around the localized "I."

The loneliness of knowing the boundaries of the self's presence is continually reflected in the awkwardness of imagining what might be outside of the narrow frames presented.

Photographs of such events of personal/temporal intensity reenact a continual, but sudden, realization of the "I" in the reverie of a masked carnival.

Desire may be born of a waiting—of not having contact, yet anticipating its potential.

Like looking at a photograph, anime conventions are such a dominantly visual affair. "You," separate and looking, is the dominant method of First Contact.

Specifically, visual forms of communication are the most po[w]erful initial sparks that lead to deeper meanings: costumes, signs, haircuts, t-shirts, shoes, poses, gestures, key chains [—] all are ephemera produced by both the fans and the industry that function as signifiers of desire in a sophisticated system called fandom that exert the gravities of depth and identity o[n] the masses. In subtle and overt ways, everyone who choose[s] to be involved is attempting to effect and coalesce the netwo[rk] of fan-trust into what they consider to be an ideal intersecti[on] of desire.

There are many threads of photographic significance, both criti-
cal and personal, that surge through my growing archive from
cons, but a major current is the manipulation and communica-
tion via the body of fan culture's propelling desires.

During a recent con, a group of us were discussing the idea
of cosplay sex while watching *Ecstasy of the Angels* projected
across a corner of the hotel room, listening to Sonic Youth, and
drinking gin and juice. As the night progressed to morning, an
intricate debate unfolded as to whether cosplay sex is or is not
"real" sex. A few days later I was mulling over both sides of the
argument, and I realized that when it came to my photographic
project, how, aside from costumes, props, and scenery, would
a viewer know the subjects were fans? Without such signs and
symbols, how could I have a "visual" project? How could the
cosplayers enact "cosplay" sex without costumes that display
their identity and desire?

The camera, which positions the image from an outside point
of view, makes the fans into subjects but quickly becomes
its own subject.

This project is as melodramatic as this rhetoric, but it also is
as self-critical and comic. Photography has become my way to
structure my dialogue with myself, and at the same time is a
critical discourse on fandom and desire.

Autobiography becomes subsumed by the camera's (re)pre-
sentation which is not only the method but also the under-
lying metaphor of power and history, in terms of what can
be "known."

Conscious awareness of a language of desire seems to bring
forth the rip tide of change. By allowing my nexus of desire to
be the location of an interposing, exploding, freeze-framing,

juxtaposing, and ciphering view of fan desire, I think I stumbled on what Takashi Okada has suggested during an interview with Takashi Murakami in Little Boy "making a sekai-kei [literally, world-type] ends artists' careers."

Making art with a critical relationship to your own context is an honest trauma—an act of increasing velocity that moves you, as at the end of *Utena,* out of static, assumed relationships to your context. No longer do the desires and modes of a certain school, house, or fandom seem immutable and inherent. There

is a vertigo but also a growing excitement in realizing that t are other goals, other communications—other desires to be engaged—even if they are yet unknown. Yet in this moment of liberation there is also a dangerous trap of selfishness: a strong lure of self-righteousness, pretension, even condes sion. Beyond the apocalypse of the self, there is wisdom in understanding that the choices of others are not as simple judge as we would care to admit—understanding that there not a singular apocalypse of which we have sole ownership Rather, we should always remember that in everyone it is t

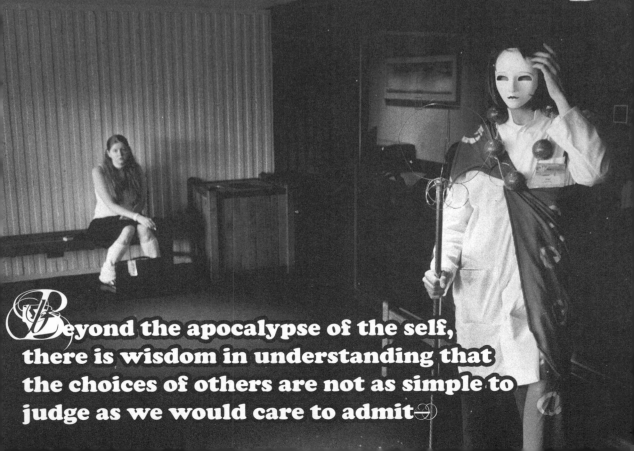

Beyond the apocalypse of the self, there is wisdom in understanding that the choices of others are not as simple to judge as we would care to admit

SHIGERU: The mind which confuses Reality with the Truth.

MAYA: The angle of view, the position. If these are slightly different, what is inside your mind will change a lot.

YOUJI: There are as many truths as there are people.

KENSUKE: But there's only one truth that you have, which is formed from your narrow view of the world. It is revised information to protect yourself, the twisted truth.

TOUJI: Oh, yes. the view of the world that one can have is quite small.

HIKARI: Yes, you measure things only by your own small measure.

ASUKA: One sees things with the truth, given by others.[3]

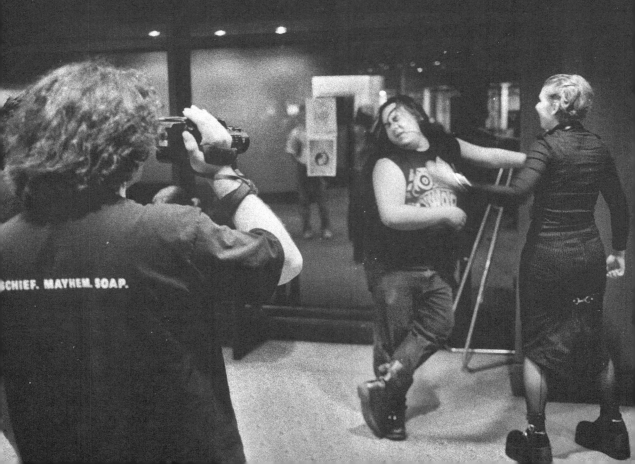

Rather than dictate, dominate, or judge from my position from the "outside," I must try to remember that the truths we have used to get where we are have been given by others. I should be gracious and compassionate.

These photographs try to reveal an understanding: that there are always other "insides." Both with photography and art it is important to avoid settling into either mode uncritically. If I have learned anything from an emerging awareness of the *otaku* languages of desire, it is that at any moment I should be ready to honor other views that will necessitate moving on again.

So instead of striving to dismantle or conquer every location of culture we stumble onto, we who find ourselves outside should strive to map, elucidate, and respect the relationships and paths of the intricate and compelling landscapes in which we find ourselves. The spirit of critical discourse has a built-in responsibility to those whom we never fully understand but who have given us precious pieces of their truths. And it is our responsibility to contribute our own truths about the continuous complications of desire uncovered by our stumbling trek through that difficult landscape, which is always larger than we had previously seen.

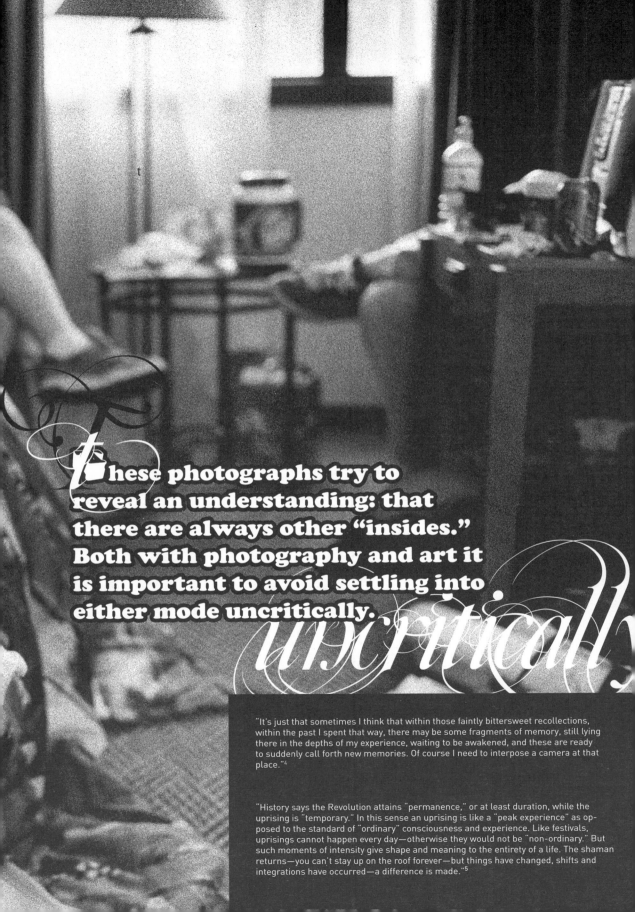

These photographs try to reveal an understanding: that there are always other "insides." Both with photography and art it is important to avoid settling into either mode uncritically. *uncritically*

"It's just that sometimes I think that within those faintly bittersweet recollections, within the past I spent that way, there may be some fragments of memory, still lying there in the depths of my experience, waiting to be awakened, and these are ready to suddenly call forth new memories. Of course I need to interpose a camera at that place."[4]

"History says the Revolution attains "permanence," or at least duration, while the uprising is "temporary." In this sense an uprising is like a "peak experience" as opposed to the standard of "ordinary" consciousness and experience. Like festivals, uprisings cannot happen every day—otherwise they would not be "non-ordinary." But such moments of intensity give shape and meaning to the entirety of a life. The shaman returns—you can't stay up on the roof forever—but things have changed, shifts and integrations have occurred—a difference is made."[5]

Notes

1. Dan Graham, *Rock My Religion* (Cambridge, Mass.: MIT Press, 1993).

2. Takashi Okada, interview by Toshio Okada and Kaichirō Morikawa, "Otaku Talk," trans. Reiko Tomii, in *Little Boy: The Arts of Japan's Exploding Subculture,* ed. Takashi Murakami (New Haven, Conn.: Yale University Press, 2005), 180.

3. "Take Care of Yourself," episode 26 of Neon Genesis Evangelion, March 27, 1996 (Gainax), in *Neon Genesis Evangelion,* DVD (ADV Films, 2001).

4. Daido Moriyama, *Memories of a Dog,* trans. John Junkerman (Tucson, Ariz.: Nazraeli, 2004), 50.

5. Hakim Bey, *T.A.Z.: The Temporary Autonomous Zone, Ontological Anarchy, Poetic Terrorism* (Brooklyn, N.Y.: Autonomedia, 1991), http://www.hermetic.com/bey/taz_cont.html.

動物化
Animalization

MARGHERITA LONG

Malice@Doll: Konaka, Specularization, and the Virtual Feminine

The postapocalyptic setting of Konaka Chiaki's script for the 2001 OVA series *Malice@Doll* offers a sharp critique of urban office life and the pornographic pleasures that are supposed to make it bearable for salarymen. The characters, who live in a massive, void-suspended office complex called an "Organ," are divided into "machines" with male names like "Todd," "Joe," and "Freddy," and "dolls" with female names like "Doris," "Heather," and "Misty." Although the female characters appear to be human, we learn that they are inorganic robot-puppets created by humans to serve as prostitutes. In contrast, the male characters are not anthropomorphic. They have low-tech metal bodies suited to their functions as, for instance, janitors, mechanics, and solderers. Both dolls and machines are governed by the "Systems Administrator," Joe, and his police force, a band of "Leukocytes." That the police force is named for the white blood cell that attacks foreign bodies suggests that an overemphasis on protecting against computer viruses may have created an atmosphere so hostile to actual organic infections, mutations, and adaptations that human and other evolving life forms were supplanted altogether. The sense of sterility is compounded by the characters' names, which in their full form are e-mail addresses: doris@doll, heather@doll, joe@administrator, todd@repairer, chuck@

solderer, devo@leukocyte. Upon meeting, characters recite the other's full e-mail name, as if running an identification program. "Kon. Nichi. Wa. Joe. Atto. Adomin." The greeting points to the inhumanity of a society in which functions, not relations, determine identity. Konaka underscores its sense-lessness by having dolls and machines continue to perform their jobs for humans, a.k.a. "gods," even now that humans are extinct. The servile janitor goes on literally *licking* the floor day in and day out, though no one cares any longer about its cleanliness. Malice, the title character, goes streetwalking every day, though there are no longer any patrons to solicit.

Konaka's dystopia is thus different from other recent Japanese anime that explore human identity in the virtual age by invoking what Susan Napier, following Scott Bukatman, calls "terminal identity." If identity before the computer age implied both mind and body, "terminal identity" drops the body from the equation, replacing it with the a-materiality of cerebral free play at, and often, *as* a computer terminal. The result, as Napier reads it in various anime series from *Space Battleship Yamato* to *Neon Genesis Evangelion*, is a "terminal culture" that "fuses reality and fantasy into techno-surrealism" by calling the material world into question.[1] While Napier argues that "terminal culture" is greeted with more anxiety in Japan than elsewhere, what is interesting about Konaka's *Malice@Doll* is that it denies the possibility of dis-embodied subjectivity from the outset. To have a mind one must also have an organic body, it implies. Conversely, being inorganic, Konaka's automatons are also mindless, in the full sense of the word. And although machines and dolls are supposed to have been invented by humans as service robots, there is a strong sense in which they represent humanity's own fate. The story suggests that if men reduce themselves to systems administrators and conduct their relationships entirely on the Internet, according to computer protocols, they become little more than mechanized maintenance crews for an ironically named, because inorganic, "Organ." And if they spend their office days visiting porn sites and their nights visiting sex workers, the function of women in their society becomes equally bloodless. Malice, the title character, is defined as a provider of "fleeting relief from the reproductive urges" of her patrons.[2]

Konaka's story opens as Malice awakens from a dream to find her creaky doll body soft, warm, and capable of both crying and menstruating. Not only has she been made human, but the kiss that she is programmed to offer everyone she meets (her mantra: "I am a doll. This is all I can do . . .") now has the power to awaken organic life in others. At the end of the film she escapes from the Organ, floating off on angel's wings in an elegant backstroke as the series theme song "Kiss Me Blind" swells in a chorus of redemption.

Viewers recognize the tune as one that Malice has been humming wordlessly all along. But when *Malice@Doll* was released in Japan in 2001, in the UK in 2003, and in North America in 2004, online reviews were often less appreciative of the happy ending than confused by the failure of Konaka's script to answer a number of pressing questions.[3] Why are Malice's dreams repeatedly visited by a "ghostly apparition of a small girl in Victorian Dress holding a white ball/pearl"?[4] Why is Malice restored to a perfect human form, while those she kisses are transformed into grotesque hybrids of bone, claw, and feather? Why is she content to go on kissing, when other newly organic bodies waste no time intertwining in spectacular couplings of insatiable sexual union? Most of all, why is Malice's transformation seemingly brought about by a "*Legend of the Overfiend*-style rape by a multi-tentacled 'biomechanical creature'"?[5]

This essay attempts to answer these questions by reading *Malice@Doll* within the larger context of what I will call Konaka's "Alice" series, a collection of scripts for anime, video games, and live-action films, all of which are more or less overt homages to Lewis Carroll's *Alice's Adventures in Wonderland* (1865) and its sequel, *Through the Looking Glass, and What Alice Found There* (1871). First in the series is *Alice 6,* a TV movie Konaka wrote and produced with his brother in 1995, in which six Alices go down the rabbit hole instead of one. Then there is *Alice in Cyberland,* a 1997 *bishōjo geemu* (beautiful-girl game, with subsequent OVA series) that Konaka designed for Sony PlayStation in which characters named Arisu (Alice), Juri (Julie), and Reina are screen proxies through which girl players can romp around an Internet Wonderland that comes into being when, as in Carroll's story, everyday language and logic turn first absurd, then absurdly insightful. A year later the same three girl-game figures reappear in *Serial Experiments Lain* to teach Lain that the fantasy of uploading human consciousness into the Web is suicidal and that the rewards of virtual reality are better reaped in girl-space rather than cyberspace. In the 1998-99 anime series *Fushigi mahō fuan fuan frāmashii* (Mysterious witchcraft fun fun pharmacy), Carroll's *Through the Looking Glass* is reenacted by a girl who navigates a chessboard called "niko niko shōtengai" (smiley shopping court) to learn from a Chinese herbal medicine–selling Red Queen that *all* girls have the power to practice magic. Finally, in 2001's *Malice@Doll,* the obvious link to Carroll is the looking glass itself, with the title character Malice able to exceed her inorganic identity only by escaping her prostitute's sleeping dais, which is surrounded by mirrors.

What links all the scripts in the Alice series is the premise that the virtual world is not a future utopia on the other side of a computer screen but

an unrealized aspect of the present. This is a different concept of the virtual than what we find alternately celebrated and feared in the cyberspaces created by means of what Napier calls anime's unique freedom from "the obligation to represent the real."[6] For Konaka, the real, in all its organic specificity, is the source of freedom and possibility; the direction of progress is *toward* embodiment rather than away. What makes Konaka's Alice figures significant in this respect is their ability to tap into energies of relating and renewing that are latent, his scripts imply, in the bodies of all prepubescent girls.

> **WHAT LINKS ALL THE SCRIPTS IN THE ALICE SERIES IS THE PREMISE THAT THE VIRTUAL WORLD IS NOT A FUTURE UTOPIA ON THE OTHER SIDE OF A COMPUTER SCREEN BUT AN UNREALIZED ASPECT OF THE PRESENT.**

Prepubescence means that an Alice body is still replete with the powers and possibilities of femininity that are themselves typically driven underground with the onset of womanhood.

Konaka's insistence on the promise of embodiment allies him with a recent strain of feminist criticism that is critical, in Vicki Kirby's words, of a "conceptualization of progress that sees mind in terms of masculine control, separating itself from a body feminized as its natural, dumb support."[7] Disguising itself amid the hoopla of "new" discourses on virtual reality, this conceptualization is actually a very old Cartesian fantasy: the mind–body split. Yet recognizing it as such does not mean giving up on the concept of the virtual altogether. In fact, the feminist philosopher Elizabeth Grosz has written of the virtual in language remarkably similar to that used by Konaka to describe his interests and motivations. For both thinkers, the history of the virtual is much older than the history of "virtual reality," since it is simultaneous with the history of the present. As Grosz writes,

> The virtual reality of computer space is fundamentally no different from the virtual reality of writing, reading, drawing, or even thinking: the virtual is the space of emergence of the new, the unthought, the unrealized, which at every moment loads the presence of the present with supplementarity, redoubling a world though parallel universes, universes that might have been.[8]

Now, here is Konaka in a 1999 interview with the anime journalist Nakajima Shinsuke:

> Whether I'm writing a scenario or a novel, I'm really only interested in

situations in which something extraordinary emerges from the ordinary. . . . I am never drawn to writing scripts that involve swords or magic, the distant past or the extreme future. What I like to write about are other worlds that invade this one, or even just establish one tiny point of contact, only to have it turn out that the two worlds were already completely entangled.[9]

For a close reading of *Malice@Doll,* it is essential to start with this idea of a "tiny point of contact" where the actual and the virtual open onto each other to load the present, as Grosz says, with supplementarity. For this tiny point of contact turns out to have a visual component in the white pearl carried by the mysterious Victorian girl through all the most "loaded" scenes in the film.

We know the pearl is important because it bounces emphatically across an empty black screen twice in the opening scene. Malice shudders in her sleep, experiencing what, by the end of the film, we realize is a recurring dream composed of two competing story lines. In the first, she is being led by the Victorian girl with blonde hair and blue eyes (Carroll's Alice?) to a place in the Organ she has never seen before. This newly discovered place, a spherically shaped "ballroom," houses a red sun-and-moon-composite globoid called a "Vessel." Although it is the Vessel that ostensibly rapes Malice in the opening dream, it is also the Vessel that (after morphing briefly into a rabbit—more Carroll?) lovingly envelops Malice in the closing scene, dissolving upward in glimmering shards of light as she curls into the fetal position within. In the second story line of the recurring dream, Malice is being led by her own memories to scenes of servicing the "gods" before they went extinct. Split-second staccato flashbacks show her on her round bed/dais, with men licking the balls of her feet, gagging her with a rubber ball, and gripping her bulbous naked breasts as if they were baseballs. The two story lines, one ultimately redemptive and virtual, the other depressing and actual, seem to have nothing in common save the pearl, which sometimes bounces between them on its own and other times is carried, glowing and basketball-sized, by the Victorian girl. Yet one important visual connection is that both stories are told in the language of spheres and discs: the virtual world has its ballroom and its globoid Vessel, the actual world its sexualized balls of doll-flesh and rubber, and disc-shaped bed-dais.

While the glowing pearl is the tiny spherical point that brings the two larger spheres into contact, two other equally spherical clues suggest that the ability to pass from one to the other is related to the problem of reflectivity. First is a conceptual drawing, absent from the film but adorning the cover of the DVD box, showing Malice *inside* the pearl, studying its surface with both

her eyes and her fingers (Figure 1). Second are the opening stage directions in Konaka's script, setting up Malice's initial dream by referencing a story by Edogawa Ranpo, the father of Japanese mystery and horror fiction:

Scene 1. Indoors. Dark. Malice's bedroom.
Spending even one night here would drive any normal human insane.
Lenses and pieces of metal are scattered in little junk heaps here and there,
as if the place had been designed by the protagonist of *Kagami jigoku*.[10]

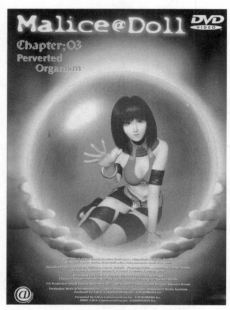

FIGURE 1. Malice inside the Pearl. *Malice@Doll*, dir. Motonaga Keitarō (2001).

Edogawa wrote *Kagami jigoku,* "Hell of Mirrors," in 1929. It tells the story of a young man who has himself encased in a glass sphere, the outside of which is painted with mercury to make the inside a perfectly round mirror reflecting him in every direction. In this way, the man becomes the first person in human history to experience the sight of infinite 360-degree self-reflectivity. The encounter drives him insane, and the story ends when his servants shatter the glass and he stumbles out a madman.[11] In Malice's bedroom, Ranpo's mirror-globe is approximated by the full-length mirrors that surround her bed-dais (Figures 2 and 3). It is to the dais and its mirrors that Malice retreats when her new human identity is rejected by her fellow dolls and machines. "Who am I?" she asks. "What do I want?" Eventually, the inner safety of the nonreflective pearl will allow her to answer these questions in a new way. For most of the film, however, she suffers mightily inside her own hell of mirrors, her identity crisis precipitated by memories that reflect her doll identity from every excruciating angle.

The most vivid such memory shows Malice revisiting the scene of her origin. In an old-fashioned workshop, doll appendages and doll torsos lie in various stages of assemblage, their porcelain skin as yet unpainted (Figure 4). Drawing close to one of the mannequins, Malice sees it open its eyes and realizes that it is she herself. As if in acquiescence, she slowly utters her mantra, "Atashi wa, dōru." Then the scene shifts to the bedroom with the dais. A series of overbearing male silhouettes flash quickly by, as if lit by a strobe. One binds Malice in leather straps and gags her with the black rubber ball.

FIGURES 2 AND 3. Mirrors flanking Malice's bed.

FIGURE 4. Malice at the Doll Factory.

One pulls her hair and mounts her from behind. One kneels at her feet, rubs his cheeks against her stockings, and licks the enamel of her high heels. One is held close to her breast, "exactly as if she were the Virgin Mary."[12] In the final flashback, a man slices deep into her cheek with a knife, but finds the interior bloodless. Watching and remembering all this, Malice begins to cry. Crying, she worries that her doll body, which is not supposed to cry, must be irreparably damaged.

Clearly, however, what is damaged is not Malice but the society that manufactured her to cater to male desires like these. To Japanese viewers, Malice's repertoire—sadist, masochist, goddess, beast—would be familiar from the street advertisements for men's sexual entertainment that one finds scattered in phone booths and train stations in every major urban center. Though fads may change, patronage remains steady, as does its cultural representation in manga, anime, sports newspapers, and late-night television. Taken as a whole, however, there is nothing particularly Japanese about this sexual repertoire or its familiarity. Malice is the same "eternal woman" we know well from Sigmund Freud: at once exalted and debased, sacred and profane, prostitute and mother. In three essays called "Contributions to the Psychology of Love" from 1910, 1912, and 1918, Freud relates the apparently contradictory desires of patients who want their women to be both chaste

and promiscuous, and who, satisfied by neither, are compelled to seek an endless series of affairs. Yet Freud explains that such desires are neither contradictory nor pathological. They are normal and universal, he says, for the simple reason that a man models all his love objects on his mother:

> If we survey the different features of the fantasized woman, it will hardly seem probable that they should all be derived from a single source. Yet psychoanalytic exploration into the life-histories of men has no difficulty in showing that [they] are derived from the infantile fixation of tender feelings on the mother.[13]

According to Freud, a man overvalues his love object because his original object, his mother, is unique and irreplaceable. He thinks of his love object as a prostitute because his mother too betrayed him by sleeping with his father and was thus little different from a whore. A man debases his love object because it is only by doing so that he can bring his affectionate currents, for his exalted mother, in line with his passionate currents, for the whore he wants to steal from his father. Finally, a man spends his life chasing an endless series of this same love object because the prohibition of actual incest with his mother means that every surrogate will fail to provide the satisfaction he desires. The parallels between Freud's universal male subject and Malice's patrons could hardly be more obvious. Overvaluing her, they lick her feet and treat her like the Virgin Mary. Debasing her, they gag her and cut her. Wanting prostitutes, they visit not only Malice but a whole cadre of "dolls," insatiably, endlessly, until they drive themselves to extinction.

MALICE IS THE SAME "ETERNAL WOMAN" WE KNOW WELL FROM SIGMUND FREUD: AT ONCE EXALTED AND DEBASED, SACRED AND PROFANE, PROSTITUTE AND MOTHER.

If spending "even one night" in Malice's mirrored bedroom is enough to drive her insane, is it not because she is forced to contemplate herself precisely as the woman her patrons desire? Konaka's mirror scenes can be read as vivid literalizations of the metaphor of specularization that the feminist philosopher Luce Irigaray uses to describe both the accuracy, and the tragedy, of Freud's account. For it is not just that male subjectivity is founded on the prohibition of the mother's body. Rather, it is founded on the substitution of her body, her wondrous life-giving force, for this tiresome series of bloodless substitutes that Konaka captures so well in his collection of doll personae: Heather, the innocent virgin; Misty, the S-M queen; Amanda, the

impossibly large-breasted Amazonian matron. Is this really what men want? Is this who women are? The genius of Konaka's "hell of mirrors" is the way it suggests not only that it *is* what men want but that what they want *dictates* who women are, female "identity" mirrored back as its perfect reflection. Malice asks, "Who am I?" But all she can see when she imagines her origin is the doll factory, manufacturing her from the stock ingredients of overdetermined male fantasies. Irigaray calls the process "specularization" to take account of the way femininity is itself little more than a mirror of male desire.[14] Her radical claim is that we will never know what femininity might actually be until we can escape this hell of mirrors known as oedipal subjectivity. Glossing Irigaray, Grosz proposes that femininity belongs therefore to the virtual rather than the actual: "Sexual difference is that which has yet to take place, and thus exists only in virtuality, in and through a future anterior."[15] In Konaka's parlance, what has yet to take place is precisely the "Alice" who remains offscreen for most of the film. She has yet to take place because she remains latent in Malice, in the "Bad Alice" who represents femininity entirely co-opted by a "normal" male desire that Konaka shows to be unequivocally pathological.

Does such a reading give Konaka too much credit? His account of specularity may have much in common with feminist accounts, but the fact remains that viewers can still come away from the film with comments like the one on the back of the ArtsMagic DVD box: "If you like hentai anime or good old fashioned tentacle sex, then this one is for you."[16] How can we be sure that Malice's rape by the biomechanical creature is not gratuitous sexual violence for the enjoyment of the *hentai* (pervert) set?

First, we know that this creature represents the maternal body through the way it ultimately gestates Malice as she lies curled in a fetal position within a womblike chamber that will transport her to a different future (Figure 5). But before it can transport her, Malice must encounter the creature as a horrific phallic monster, sending forth huge snakelike tentacles that impale her through the chest, then sprout smaller tentacles to violate all her orifices. Perhaps the point is exactly that this *is* "good old fashioned tentacle sex" but that we are not supposed to consume it uncritically. For what becomes clear when we read the scene in parallel with the strobe-lit scenes of Malice being violated by the "gods" is that this rape is a simultaneous enactment of all the separate indignities she suffers as a prostitute at the hands of her patrons. The way Konaka sets up the equivalence is perfect, since it shows that this "phallic mother" is itself a reflection of rapacious male behavior that, because of Japanese "decency" codes, is signified in manga and anime by way of a

FIGURE 5. Malice in the fetal position.

blank but hardly absent erect penis. The scene underscores the irony of it being illegal to depict the instruments of rape as such but legal to depict them as "huge flexible organs with sharp snake-like heads" and attribute them to the maternal body![17]

This aspect of Konaka's story is also classically psychoanalytic, in that Freud too posits the "phallic mother" as the omnipotent, yet-uncastrated being with whom children imagine they were joined prior to the prohibition of the mother's body by the father.[18] Again femininity is the victim of specularization, made to reflect back the default male organ rather than any of her own. But the point is that the phallic mother is not an anomaly invented either by Freud or by Konaka. She is simply another example of what Irigaray calls the "isomorphism" of a society in which everyone is defined in terms of the phallus. Konaka's dystopia could hardly be a clearer illustration, peopled entirely by gods who wield the phallus, dolls who service it, and machines who keep the whole operation running.

When Malice wants to access a different reality, loading this dystopia with supplementarity, her points of contact with its unrealized virtuality are dreams about her origin. She dreams first that if she is a doll, she must have come from a doll factory. As we have seen, this dream does not offer contact with a parallel universe because it is resolutely specular, keeping her trapped in the phallic actual. Next she dreams that if she is human, she must have

come from a mother. This nightmare into the past is specular, too, at least initially. She finds that even the maternal origin, source of all humanity, is defined solely in terms of phallic power. But in the climax of *Malice@Doll,* Malice dreams her way past the rapaciousness of the Vessel, dismantling it piece by piece until it begins to reassemble itself, miraculously, into a source of life and nurturing. Once it does so, she is able to sleep blissfully inside, dreaming for the first time without being reflected back to herself as the tired collection of phallic femininities that the film has presented so clearly: sadist, masochist, virgin, and whore, all variations on "mother." Konaka ensures that these figures remain banished from Malice's future by staging the final dream as an encounter between Malice and an alter ego named "Naked Malice" whose body is represented only by the promise of glowing white light (Figure 6). "You have been dreaming that, in reality, dolls have bodies like this," she tells Malice, assuring her not only that dolls *can* dream but that in their dreams the shapes and abilities of their bodies are infinite.[19]

This gesture toward organic infinity is fleshed out, literally, in the figures of the other dolls and machines when Malice kisses them back to life. One by one they are transformed into spectacular hybrids of bone, claw, and feather, each more elaborate than the last, and each capable of even more sexual

FIGURE 6. Naked Malice.

pleasure. The point would seem to be less that they are grotesque than that they are unimaginably original and diverse. For it is significant that, in order to confront the Vessel, Malice must pass through a room that looks like a wildly disorganized museum of natural history strewn with bizarre skeletons and fossils of creatures that never existed. We recognize them as preserved versions of the living creatures that begin to slither all over the Organ as soon as Malice acquires her power to reorganicize. She mentions that no one in the Organ has ever seen this room. As she walks through it, we realize that her ability to access it is contingent upon her ability to dream herself back into history past the false barrier of the phallic mother. Doing so puts her in contact with an immense font of evolutionary creativity representing the infinity of alternate life forms that remained virtual so long as the history of the Organ was commensurate with the history of isomorphism. Though the creatures do indeed seem grotesque to our specularized eyes, Konaka suggests that, seen otherwise, they become not scary but fascinating in their endless variety. By its very nature, the virtual exceeds the actual in terms of the scale of latent differences. "Malice" carries the latency of girlhood, of "Alice," by virtue of her connection with the Victorian girl. This is why her reorganicization restores her to perfect female form. In contrast, the other dolls and machines carry different latencies, and different passions, far in excess of those of human women and men.

This is one reason Malice is content to go on merely kissing while the others explore new forms of sexual expression. Yet in the end, Malice's kiss is significant less as a realization of her virtual than as one of the "tiny points of contact" already latent in the actual. Like Lewis Carroll, Konaka proposes that what a girl needs in order to access the virtual is not advanced technology but simply a dream. And, like dreaming, the other forms of technology he uses to load the present with supplementarity are almost as old as the human body itself: kisses and dolls.[20] So it is significant that Malice's mantras invoke precisely these three elements. When we first hear her uttering them in her role as prostitute, they seem pathetically limited and limiting. But when Malice utters her mantras to those she is about to make organic, they become powerful to the degree that they pivot on the huge potential of her girl body:

> Atashi wa, dōru. [I am a doll.]
> Kisu o shite ageru. [I'll give you a kiss.]
> Yume o mite ageru. [I'll dream you a dream.]
> Atashi ni wa, kore shika dekinai. [This is all I'm capable of doing.]

The triumph of *Malice@Doll* is to show that all a doll is capable of doing is really quite immeasurable! Through dreams and kisses, Malice resuscitates entire millennia of organic variety that have been rendered unlivable by our porno-phallic reality.

Still, should we be troubled that the film jumps so quickly from the sexual singularity of isomorphism to the infinity of nonsexually specific life forms, without first specifying what *femininity* would be like after the reign of the phallus? In other words, should we be satisfied to encounter virtual Malice only as the blank emptiness of white light? Feminists have posed similar questions of the philosopher Gilles Deleuze, whose admiration for Carroll's *Alice in Wonderland* is like Konaka's in that he too uses the figure of the girl to contemplate a kind of difference not based on mirroring, doubling, binaries, or what Deleuze calls "majoritarian" distinctions based on a privileged, original term. For Deleuze, Alice is an example of "infinite identity"—of "the paradox of pure becoming"—because her dream confounds the opposition between large and small bodies, forward and backward time, cold and hot weather, active and passive actions.[21] And in Deleuze's philosophy, the sort of infinite identity Alice achieves is contingent on specifically feminine latencies: "All becomings begin with and pass through becoming-woman."[22] Feminists have not tended to object to Deleuze's reasoning on this point. When he and Félix Guattari write that "the question is fundamentally that of the body . . . they *steal* from us in order to fabricate opposable organisms," pointing out that "the body is stolen first from the little girl," they follow logic similar to that of *Malice@Doll*.[23] In order to discover what our isomorphic system has foreclosed, we need to revisit the site of that foreclosure, that original "theft," be it the prepubescent girl or the phallic mother. What has drawn feminist concern is the speed with which Deleuze and Guattari move from the becoming-woman made possible by such revisits to other forms of becoming. As Grosz observes,

> If becoming-woman is the medium through which all becomings must pass, it is, however, only a provisional becoming or a stage in a trajectory or movement which takes as its end the most microscopic and fragmenting of processes, which they describe as "becoming imperceptible."[24]

The same charge might be levied against the way Konaka ends *Malice@Doll*, with both the girl/Malice and the mother/Vessel dissolving upward in glimmering shards of molten light, their ethereality in stark contrast to the specificity of the reorganicized dolls and machines that have begun squirming all

over the Organ. Is it not premature to posit an infinite number of sexual identities if we have only barely begun to speak of two? Does it not take more than abstraction to establish the female half of

what Irigaray calls the "at least two" of meaningful sexual difference? The rush from "the one" to "the multiple" betrays its feminist impetus if the feminine is lost along the way.

As if mindful of such concerns, Konaka makes "the multiple" vanish from the Organ as soon as virtual-Malice departs. In the final scene, after she and the Vessel have dissolved, Malice sprouts luminous wings and flies through the void surrounding the Organ, her song "Kiss Me Blind" filling the neighborhood of the remaining dolls' brothel. As they gather outside to watch and listen, we realize with a start that they have reverted to their original prostitute bodies and are quickly losing all memory of the gifts they received from Malice. One says she recognizes Malice's song but hates it. Others cannot see or hear Malice at all. In the absence of Malice's new nonphallic femininity, it seems the other dolls are destined to return to the status quo that their Systems Administrator Joe had defended throughout the film. Dismissing Malice's tears as "leaking coolant," he had intoned, "In this world there are no machines that are not broken. The thing to do is keep getting repaired and live forever."[25] Overriding her alarm over the violence of the "gods," he had said, "It is not for dolls to hate the function that dolls were created to perform."[26] Has Konaka taken his characters from "the one," to the feminine, to the multiple, only to trap them back in the violent, broken monotony of the one?

Yet just when the film's utopian momentum seems lost, Malice swoops down from the heavens to bestow one final kiss on Joe. He had decided too late that he wanted to be kissed and had been left still wanting "to see what Malice sees" when she strode off to confront the biomechanical creature. When Joe finally receives his kiss, we realize that what he wants is to be "kissed blind" to the mandates of the system he has administered so resolutely until now. It seems like far less than what feminists worry Deleuze wants—multiplicity, imperceptibility, infinity. Yet perhaps it is also far more. If the rush from the one to the multiple renders the feminine *and* the multiple untenable, then we will always be searching for new ways to load the present with the tiny point of contact that can open it to a different future. More than any result, it is this search that defines Konaka as a scriptwriter, just as it defines Joe. The parallel between the two men is made explicit in an interview included with the DVD, in which Konaka says his favorite *Malice*

character is Joe. "As a man," he says, "I can't help being terribly moved by the final kiss between Joe and Malice." Rather than appropriate her feminine powers of becoming with a "Malice c'est moi" approach, Konaka maintains a separate masculine role for himself. Through the tiny point of contact that is her kiss, he will continue to write a "blind" alternative to specularity, accessing the virtual as a space for the emergence of the new.

..

Notes

1. Susan Napier, "When the Machines Stop: Fantasy, Reality, and Terminal Identity in *Neon Genesis Evangelion* and *Serial Experiments Lain*," *Science Fiction Studies* 29, no. 3 (2002): 419.

2. The film is remarkably faithful to Konaka's screenplay, downloadable from his "Alice6" Web site in three acts with English titles: "Episode 1: Hard Fresh," "Episode 2: Oral Infection," and "Episode 3: Perverted Organism." Quotations here are from the original screenplay; translations are mine. Konaka Chiaki, "Episode 1: Hard Fresh," *Marisu dōru shinario,* http://www.konaka.com/alice6/PDF/Malice%40Doll_1.pdf (accessed February 16, 2006), 14.

3. The Japanese release was on three discs, *Malice@Doll Chapters 1, 2 and 3,* dir. Motonaga Keitarō, OVA (2001). The film had its theatrical world premier at the London Science Fiction Film Festival in January 2003. Its first home video release outside Japan was *Malice@Doll,* subtitled DVD (ArtsMagicDVD, 2004).

4. Lee Bailes, "The Rumour Machine," http://rumourmachine.com/Reviews/Malice_Doll.htm (accessed February 17, 2006).

5. Yunda Eddie Feng, "DVDTown," http://www.dvdtown.com/review/malice@doll/12832/2264/ (accessed February 17, 2006).

6. Napier, "When the Machines Stop," 422.

7. Vicki Kirby, *Telling Flesh: The Substance of the Corporeal* (New York: Routledge, 1997), 137.

8. Elizabeth Grosz, *Architecture from the Outside* (Cambridge, Mass.: MIT, 2001), 78.

9. Konaka Chiaki and Nakajima Shinsuke, "Konaka Chiaki Intabyū" [Interview with Konaka Chiaki], (Winter 1999), http://www.konaka.com/alice6/lain/hkint_j.html (accessed February 15, 2006).

10. Konaka, "Episode 1," 1.

11. See "Hell of Mirrors" in James B. Harris, trans., *Japanese Tales of Mystery and Imagination* (Routland, Vt.: Tuttle, 1956), 107–22.

12. Konaka, "Episode 2: Oral Infection," *Marisu dōru shinario,* http://www.konaka.com/alice6/PDF/Malice%40Doll_1.pdf (accessed February 16, 2006), 6.

13. Sigmund Freud, "A Special Type of Object Choice Made by Men (Contributions to the Psychology of Love I)," in *The Standard Edition of the Complete Works of Sigmund Freud,* trans. and ed. James Strachey (London: Hogarth, 1953), 11: 168.

14. See Luce Irigaray, *Speculum of the Other Woman,* trans. Gillian C. Gill (Ithaca, N.Y.: Cornell University Press, 1985).

15. Elizabeth Grosz, *Time Travels: Feminism, Nature, Power* (Durham, N.C.: Duke University Press, 2005), 175.

16. ArtsMagicDVD attributes the quote to an online review from the London Science Fiction Film Festival Web site, where the original reads, "If you like hentai, anime, tentacles . . . you gonna love this!" See http://www.sci-fi-london.com/2003web/news.htm (accessed May 12, 2006).

17. Konaka, "Episode 1," 10.

18. Freud discusses the phallic mother in "Three Essays on the Theory of Sexuality" (1905), "Fetishism" (1927), and "Femininity" (1932). See the *Standard Edition*, 7:125–248, 21:147–58, and 22:112–35.

19. Konaka, "Episode 3: Perverted Organism," *Marisu dōru shinario*, http://www.konaka.com/alice6/PDF/Malice%40Doll_1.pdf (accessed February 16, 2006), 12.

20. The issue of realizing the virtual through older technologies is important to the story of the film's own genesis. Although it was created almost entirely by computer graphics, Konaka and the director Motonaga explain in an interview included with the DVD that they emulated not the perfection of CGI but the spare, jerky look of 1980s Czechoslovakian stop-motion doll animators like Jan Svankmajer and Jiri Trnka. This is a vote in favor of the power of the material over the purely conceptual. And it reminds us that the plot of *Malice,* though based in a computerized office dystopia governed by things like e-mail protocols, features no computers whatsoever. Vicki Kirby has written that the "terminal" tends to act as a "prophylactic interface," keeping the messiness of materiality on one side of the screen while the virtual floats free on the other (*Telling Flesh,* 137). Konaka rejects this, just like Carroll rejects it, by insisting on having his heroine go *through* the looking glass. When there is no "terminal," there is no barrier to the past, so the virtual can be accessed in all its material complexity.

21. Gilles Deleuze, *The Logic of Sense,* trans. Mark Lester, ed. Constantin V. Boundas (New York: Columbia University Press, 1990), 2.

22. Gilles Deleuze and Félix Guattari, *A Thousand Plateaus: Capitalism and Schizophrenia,* trans. Brian Massumi (Minneapolis: University of Minnesota Press, 1987), 277.

23. Ibid., 276. For a feminist reading of their "stolen first from the girl" remark, see Dorothea Olkowski, "Body, Knowledge, and Becoming-Woman: Morpho-logic in Deleuze and Irigaray," in *Deleuze and Feminist Theory,* ed. Ian Buchanan and Claire Colebrook (Edinburgh: Edinburgh University Press, 2000), 86–109.

24. Elizabeth Grosz, "A Thousand Tiny Sexes: Feminism and Rhizomatics," *Topoi: An International Review of Philosophy* 12, no. 2 (1993): 178.

25. Konaka, "Episode 2," 3.

26. Konaka, "Episode 3," 13.

AZUMA HIROKI

Translated by Yuriko Furuhata and Marc Steinberg

● ● ●

The Animalization
of Otaku Culture

INTRODUCTION

Thomas LaMarre

Azuma Hiroki is a philosopher and cultural critic who has in recent years become a major intellectual figure in Japan, writing on issues as diverse as representation, art history, *otaku* subculture, narrative structure, and, lately, freedom in the post-9/11 world. His work is notable for the strong theoretical background that it brings to the analysis of subculture, especially *otaku* subculture. Azuma initially worked on the philosophy of Jacques Derrida, and in his first book, *Sonzaiteki, yūbinteki: Jacques Derrida ni tsuite* (1998, Ontological, postal: On Jacques Derrida), he traces Derrida's usage of the logic of the postal to lay the grounds for a new theory of communication. Already in his second book, *Yūbinteki fuantachi* (1999, Postal anxieties), a collection of diverse essays and reflections, Azuma pushed his Derridean-inspired theory of communication further in the direction of an analysis of subculture, particularly in his discussion of *The End of Evangelion*. Yet it is in a collection of interviews and exchanges, *Fukashina mono no sekai* (2000, On the overvisualized

world) that Azuma truly comes to the fore as one of the most important commentators on contemporary Japanese popular culture and subcultures, especially on anime and *otaku*.

English readers will find links on his Web site to translated essays on such topics as "Two Deconstructions" and "Superflat Japanese Postmodernism." One of the other important statements of Azuma's neodeconstructive approach to the analysis of anime visuality appears in English and Japanese in the catalog to an exhibition put together by the artist Murakami Takashi, *Superflat* (2000). In this essay, looking at transformations in perspective and depth, Azuma argues for a shift in anime-inflected art from privileging the gaze to privileging the ghost, from the modern to the postmodern: "We have only a growing proliferation of eerie signs for the 'eye,' and we are unsure whether they are living or dead, watching or being watched."[1]

Azuma's background in deconstruction initially made him an especially acute observer of the autodeconstructive tendencies of anime and *otaku* subculture. As his work progressed, however, he began to see such tendencies in terms of the emergence of a new structure of communication and control. It is in *Dōbutsuka suru posutomodan: Otaku kara mita Nihon shakai* (2001, Animalizing postmodern: Otaku and postmodern Japanese society) that Azuma persuasively argues that *otaku* are not merely a site where one might deconstruct Japanese culture; rather, *otaku* subculture presents the emergence of a new "database structure," which he links to a new mode of cultural reception dubbed "animalization."

To introduce Azuma's work on database, *otaku,* and animalization to English-language readers, *Mechademia* has chosen an essay in which he introduces the basic ideas from *Dōbutsuka suru posutomodan*. The essay first appeared in a volume edited by Azuma titled *Mōjō genron F-kai* (2003, Net-State Discourse F). It derives from a conference presentation given by Azuma just prior to the publication of *Dōbutsuka suru posutomodan*. In it, Azuma first speaks in some detail about events leading up to the conference. In the interest of presenting readers with a direct statement of his theory, we decided, with his permission, to provide an explanatory overview of his preliminary remarks and to begin the translation where he launches into his discussion of anime and postmodern Japan.

The "net-state" project that provided the occasion for his talk began as a discussion hosted on Azuma's Web site to which various contributors would present their opinions of a recent book. Gradually, as contributions increased, the "net-state book review" expanded into "net-state discourse."[2] Discussion of a recent book by Saitō Tamaki, *Sentō bishōjo no seishin bunseki*

(2000, A Psychoanalysis of Fighting Beautiful Girls), provided the occasion for the volume *Mōjō genron F-kai*. A lively debate began online, and Azuma wished to continue the debate. When the opportunity arose to collaborate with Shimoda Masahiro, the administrator of the Tinami Web site (a manga and anime search engine), the result was a symposium that continued the debate around Saitō's book, with an emphasis on *otaku*.

While Azuma offers only cursory remarks about the Saitō book at the start of his talk, it is important to note how he distinguishes his approach from Saitō's: the status of the subject. Basically, Azuma sees in Saitō's psychoanalytic approach a philosophical position that begins and ends with the subject. That is, such an analysis presumes that anime or *otaku* subculture constitutes a stable subject that in turn constitutes it. Hence one can speak of *otaku* desire for certain things. Deconstruction differs from psychoanalysis in this respect, and Azuma does not begin with *otaku* activities as a stable subject position or an identity. This does not mean that he wishes to discredit or dismiss the problem of the subject (*shutai*) or of the other (*tasha*). But such questions are not his point of departure. Rather, he begins with *otaku* activities as affective response: certain character traits—today it is cat ears and maid's uniforms, tomorrow it may be feathers—arouse or stimulate a group of viewers. Azuma uses the noun *moe* and the verb *moeru,* which are rendered in translation here as "affect" and "to arouse," respectively. He thus looks at *otaku* activity in terms of an "animalistic" behavioral response. For him, *otaku* activities do not involve the formation of a subject so much as a behavioral response that is open to sophisticated techniques of statistical control.

Similarly, Azuma insists that subculture is not an object or a set of things but a movement. Consequently, he feels that the critic of *otaku* culture cannot stand outside it and observe it but must participate in it. But how can one participate in a culture of animalistic response, which remains prey to techniques of control, and also find sufficient distance to offer a critical account of it? How does one function as a critic while participating in a movement, going with the flow? It is here that Azuma's theory of the animalizing postmodern issues its greatest challenge. For he effectively finds in *otaku* activities a deconstructive movement (a radical flattening of hierarchies) as well as a new site for the implementation of social control. He thus invites us to think questions of the subject and the other anew, in a postmodern sociohistorical context, in which they appear as effects, not causes, of the movement of images. His approach, then, is not a simple embrace of the *otaku* subculture but an exploration (that is, at once participation and evaluation) of what might effectively constitute countermovement within subculture circulation.

THE ANIMALIZATION OF *OTAKU* CULTURE

I would first like to signal the basic importance of "postmodern" thought. One might roughly define the postmodern as the period after 1970. Yet in the case of Japan a bit more precision may be called for.

Building upon the theory of Ōsawa Masachi, I would suggest three large divisions on the basis of ideologies in postwar Japan, that is, Japan after 1945. First, the period from 1945 to 1970 was a stage in which overarching unities such as grand narratives, ideals, society, and the nation still functioned. It corresponds to what Ōsawa called the "Era of Ideals." One might also call it the "prepostmodern."

The next period, from 1970 to 1995, is one in which grand narratives had broken down yet were constructed as fictions. This is what Ōsawa called the "Era of Fiction." I take it as the "First Period of the Postmodern."

Then, after 1995, is the era in which grand narratives have completely disappeared. I would like to dub this the "Era of Animals." One might also call it the "Second Period of the Postmodern."

Two events mark the boundary years of 1970 and 1995: one is Japan's Red Army incident,[3] and the other is the Aum Shinrikyō incident.[4] The Japanese Red Army aimed at realizing certain ideals, namely revolution, which did not in fact lead to social transformation but instead increasingly descended into delusion. It finally ended in factionalist infighting. In this sense, the Coalition Red Army incident is an event that embodied the impasse of the Era of Ideals yet was already stepping into the Era of Fiction.

In contrast, the sarin gas attack in the Tokyo Metro by members of Aum Shinrikyō in 1995 is the very image of revolution as fiction. In short, it was a revolutionary movement as fiction insofar as the young people who carried it out were under the influence of *Uchū senkan Yamato* (*Space Battleship Yamato*, a.k.a. *Star Blazers*) or *Kidō senshi Gundam* (*Mobile Suits Gundam*) or else New Age thought. Yet there is a second layer to it. What struck me about the media coverage surrounding Aum Shinrikyō was the revelation of their heavy use of drugs, how the sect used drugs and electronic devices to brainwash people. You may recall how much media attention fell on techniques of mind control. Simply put, the fundamental idea behind mind control is the treatment of people as animals. The human power of reason is not especially strong; in a specific physiological environment, people easily lose their faculty of thought. It is easy under such conditions to write over personality and memory by flooding them with information. It is reminiscent of animal testing.

Considered in this light, Aum Shinrikyō appears not only to extend the worldview of fiction but also to constitute a revolutionary collective that viewed humans as animals and even deployed technologies to treat humans as animals. In short, the Aum Shinrikyō that became visible in 1995 had one foot in the Era of Fiction and the other in the Era of Animals. For this reason, it was an emblematic movement.

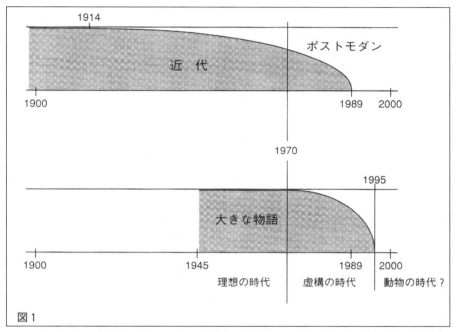

FIGURE 1. The top time line shows the transition from modernity (the shaded section) to the postmodern (the unshaded white section). The bottom time line shows the decline of grand narratives (shaded section). The period from 1945 to 1970 is labeled "Era of Ideals"; the period from 1970 to 1995 is labeled "Era of Fiction"; and the era beginning in 2000 is labeled "Era of Animals."

Let me offer two diagrams in summary. The global shift from modern to postmodern can be schematized as in the upper diagram. Japan appears in the lower diagram: between 1970 and 1995, the "grand narratives" under-pinning the modern nation gradually collapsed. It is this period that corre-sponds to the Era of Fiction. The Era of Animals is Japan's period of complete postmodernization.

* * *

My second point concerns the "database" character of the postmodern world-view. The Era of Ideals/Modernity formed a structure in which a single grand narrative/ideal controlled the diverse small narratives throughout the world. Consequently, cultural criticism and social criticism consisted in analyzing grand narratives as reflected within the various small narratives (works of art and literature). In the postmodern, however, grand narratives have collapsed. What is emerging in their place is a new model that might be called "grand database."

Here I would like to present a pair of diagrams that appears in *The Animalizing Postmodern* depicting the modern world-image (the tree model) and the postmodern world-image (the database model). The modern world formed a tree structure. At least that is how people imagined it. The postmodern world no longer has grand narratives, however. Depending on what parts of the world are inputted, people may grasp any number of small world-images. Put another way, there has been a transformation from a neurotic worldview to an MPD (multiple personality disorder) worldview.

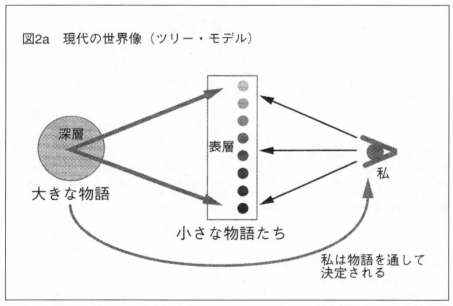

FIGURE 2. The world-image of the contemporary age: the tree model. ["Contemporary" in this title would seem to be a typographical error; the same diagram in Azuma's book, *Animalizing Postmodern,* is labeled "The world image of the modern age," which corresponds more properly to the argument in his text.—Trans.] The shaded circle is labeled "Depth" and associated with "Grand Narratives." The center rectangle is labeled "Surface" and is associated with "Small Narratives." The right-hand-side eye-shaped figure is labeled "I," which, the figure notes, is "Determined through narratives."

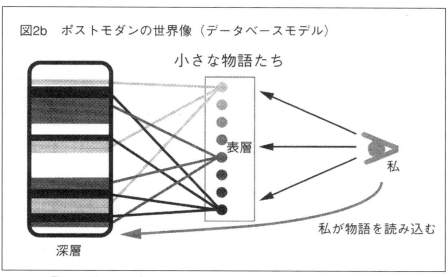

図2b　ポストモダンの世界像（データベースモデル）

小さな物語たち

表層

私

私が物語を読み込む

深層

FIGURE 3. The world-image of the postmodern age: the database model. The striped rectangle on the left is labeled "Depth." The center rectangle is labeled "Surface" and is associated with "Small narratives." The eye on the right side is labeled "I," and is the one who "reads into (inputs) the narratives."

The collapse of the cold war structure and the advent of the Internet most clearly symbolize the shift from "narrative to database." The Internet is but one vast database in which appears any number of worlds that differ depending on input. Until 1989, the world was organized by ideology, but now the image of the "net" as the matrix for cultural diversity is becoming dominant. This tendency is unlikely to change, even under the influence of the 9/11 terrorist attacks.

Such a "databaseification" of the world is supported economically by globalization and technologically by the spread of information technology (IT). Everyone seems to feel intuitively that databaseification, globalization, informatization, postmodernization, and cultural diversification are but parts of one massive transformation. But insufficient attention has been drawn to postmodernization as the cultural flip side of the same techno-economic shift.

To the above two generalizations, as a third point, I will add that such social transformations have greatly altered the nature of *otaku* culture. This change appears concretely as a shift from the supremacy of narrative to the supremacy of characters and from myths of authorship to databases of affective elements (*moe yōso*).

Not surprisingly, *Neon Genesis Evangelion*, which appeared in 1995, proves important. As with Aum Shinrikyō, this work also had dual implications, straddling the Era of Fiction and the Era of Animals. This anime is a work that initially aspired to grand narrative in a very straightforward way. As the title suggests, it is an evangelical narrative of human salvation. In any event, this grand narrative broke down spectacularly in the last episode of the TV series. Moreover, what appeared at the moment of its breakdown was the world of secondary or fan production. Specifically, what appeared in the twenty-fifth and twenty-sixth episodes of the TV series *Evangelion* was the world of secondary production as already in circulation through the Comiket (comic market) and personal computer communications. In other words, its creators made a parody of the parody in advance. And, in their rather wonderful way, they pieced together an autocritique of their impasse.

In other words, in his effort to see this grand narrative through to the end, its director Anno Hideaki ultimately could not help but criticize the character industry, in order to preserve his status as author, as a matter of self-defense. Anno flirted with the impossible task of constructing a grand narrative in the 1990s, but in the end it proved impossible, and all that remained was Ayanami Rei as a *moe kyara*, that is, as an affective figure. In this respect, I think that the scene in the twenty-sixth episode of *Evangelion* in which Ayanami Rei appears running with bread in her mouth marks a turning point in *otaku* culture, the moment when the Era of Fictions became the Era of Animals, when the Era of Fictional Histories gave way to the Era of Affective Response to Characters (*kyara moe*). This is why *Evangelion* remains such an important work.

The main character of *DiGi Charat* known as Dejiko follows from this transition. The character design for Dejiko combines various affective elements, such as bells, cat ears, and the maid uniform. It is not simply I who pays attention to such elements as a critic. As a search engine such as Tinami makes clear, *otaku* themselves make such distinctions. Dejiko has been a powerful force in the *otaku* market for some two years, surely because it exemplifies the major trend in *otaku* characters today: the goal is not to design a "singular and unique human" but to assemble innumerable basic elements.

Of particular interest is the lack of narrative background for the character. Dejiko is not a character or personage from a specific story but the "image character" for a game and anime shop called "Gamers." Then, at some point, because it is prominently featured in merchandising and commercials, Dejiko became so popular that anime and games were constructed around this figure. As young *otaku* consumers and industry producers will attest, the 1990s saw

a rapid decline in the importance of fiction and narrative within *otaku* culture. Nothing symbolizes this transformation so perfectly as Dejiko.

Another interesting aspect of Dejiko should also be noted: Dejiko's design is not a simple effect of this transformation but a mocking parody that betrays a malicious response to it. For instance, Dejiko appears with cat ears, yet it's just a cat-ear hat that you can remove. The character itself does cosplay. What a great set-up! Affective elements can be put on or taken off, just as the consumer pleases, allowing any number of assemblages. Thus the Dejiko design seems to assume a kind of cynicism in its production, as if asking, "Say, what would happen if all these affective elements were brought together?" That this cynicism met with so much success is pretty amazing.

FIGURE 4. This is the image of Dejiko (Digi Charat) and is an example of a "moe" character, pointing out the various "affective (*moe*) elements," such as "hair tied up like feelers," "cat ears," "bells," "green hair," "tail," "maid costume," and "large hands and feet."

At any rate, especially in light of its self-referential aspect, I see Dejiko as the character that epitomizes the "Post-*Evangelion* Age." In terms of its assemblage of affective elements, *DiGi Charat* shows greater malice than other recent anime such as *Sister Princess* or *Happy Lesson*. The advent of Dejiko thus raises serious questions. Can a character that assembles affective elements truly "affect" *otaku* in a satisfactory way? Is there no longer any need for narrative or fiction in the manner of *Gundam* or *Evangelion*? In a recent dialogue with me, Ōtsuka Eiji also agreed that these are the questions that concern him as a writer.[5]

In 1989, Ōtsuka published a book titled *Monogatari shōhiron* (On narrative consumption).[6] If I may summarize here, he observes that, in the 1980s, in the Era of Fiction, in the absence of narratives that presented society as whole, a desire for them persisted, and, as a consequence, grand narratives supplied the background for various *otaku*-related works appearing at that time. Individual works only presented "small narratives," and the consumer was the one who read grand narratives into the background of the individual works. With *Gundam,* for instance, from the very first TV series in 1979, it was as if the world of "Space Century" had an independent existence, and as that one part sold well, new series developed, one after another. Secondary production and quiz books also burst onto the scene. Among Ōtsuka's examples are Nagano Mamoru's *Five Star Stories* and "*Bikkuriman* Chocolate."

Ōtsuka referred to this state of affairs as "narrative consumption," but I think that, after 1995, "grand narratives" do not have that much influence on the consumer habits of *otaku*. In my opinion, it would be better to think of the current situation in which *DiGi Charat* and "gal-games" (*gyaru-gee*) lead the market in terms of "database consumption." Rather than grand narratives, today is it not sets and affective elements that are the background for *otaku* works? Does this not correspond to the complete disappearance in the Era of Animals of that "desire for grand narratives" that still haunted the Era of Fiction like a ghost? In brief, I would argue that 1995 marks a turning point, after which the nature of *otaku* culture undergoes great changes, which are in turn profoundly connected to transformations occurring in Japanese society as a whole.

Had there not been such connections, I doubt as a critic that I would have paid so much attention to *otaku*. Most theories of *otaku* to date have offered explanations of *otaku* from within, in terms of psychology or behavior, up close and personal, and so are largely unconcerned with perspectives on society and alterity. My approach is quite different, however. Rather than take *otaku* culture as a ghetto isolated from society, I wish to grasp it as the site that most sensitively registers social transformations.

I would now like to speak to the nature of today's new *otaku* culture based on "database consumption," which differs greatly from the *otaku* culture as based on "narrative consumption" between 1980 and 1995. This is but a short presentation of the ideas fully elaborated in *Animalizing Postmodern,* however, and so I will present only one phenomenon that symbolizes the new situation.

Since 1995, anime and manga no longer occupy a central position within *otaku* culture. In their stead, a new type of computer game called "gal-games" or "beautiful girl games" have rapidly taken over. Among them a novelistic type of game, "novel games," has become very influential. On the computer screen, players read a novel with multiple endings and illustrations of beautiful girls.

It is striking how consumption of this genre provides a clear example of the double structure characteristic of database consumption as described above: on the one hand, there is a database of sets and elements, and, on the other hand, users assemble small narratives from them as they please. Take, for instance, this screen grab from a cult favorite novel game, *Kizuato* (Scar). An image is made from an assemblage of any number of elements, such as

screenplay, character, background, and so on. Moreover, using special free-ware, consumers can easily analyze the assemblage and can freely appropriate the data for secondary productions. In other words, they take delight in both the surface layer and the deep layer of the game.

This double structure divides consumer behavior into two distinct types. This is not to say that there are two groups of consumers. Rather, one consumer uses two distinct techniques in consuming a single game.

One is at the level of screenplay and the screen, that is, the surface layer. *Otaku* consume each episode in solitude at this level. Significantly, sensitivity elements such as "crying" and "affection" are powerfully emphasized at this level.

The novel games currently attracting the most attention are Key's *Kanon* and *Air,* which are also referred to as "crying games" and which have hardly any pornographic elements. While gal-games started as pornographic games, the importance of such sexual elements as conquest of girls for sex has all but disappeared. Instead, there is nothing more than a skillful assemblage of crying elements and affective elements. A scenario in which the heroine is actually a fox is enough to move the consumer to tears.

Then there is the database level. As indicated in the prior diagram, this is the level of data. The scenarios and the corpus of character designs that provide the matrix for secondary production might well be thought of as "data." Yet the bits of data that constitute the game's deep level are not consumed in solitude. What's the use of being all alone in your affective response to the pictures that you've extracted? *Otaku* use these pictures to make secondary productions that they actively exchange on the Internet and at the Comiket. Thus there develops a kind of sociality.

With the advent of the computer, for instance, appeared a form of secondary production called the "Mad Movie." These image-based works, which circulate mainly on the Internet, use sound and images pulled from video games to construct worlds that differ from that of the original game. It is remarkable how it pushes one step beyond previous secondary production, to the very limit of simulacra. While fanzines (*dōjinshi*) may be thought as of simulacra of their originals, fanzines still retain a residual of authorship insofar as fans draw the characters by hand. With the Mad Movie, fans make a different work by assembling elements pulled from the original. This implies a certain sphere of values. Basically, any number of data assemblages is possible, which makes the original game into but one other possibility, so why can't you make your own style of game through a different data assemblage?

FIGURE 5. Screen grab from the novel game *Kizuato* (Scar) produced by Leaf.

FIGURE 6. The left-hand section is labeled "Simulacra." The gray line down the middle is labeled "Program." The right-hand section is labeled "Database."

At any rate, I think that the two-tiered mode of consumption that appears with novel games reflects the two-layered structure of the postmodern itself. On the one hand, *otaku* fluctuate between hope and despair through the "small narratives" that appear on the game surface. That kind of sensitivity they experience in solitude before the computer screen. Sensitivity does not lead to communication. On the other hand, *otaku* break down such sensitive narratives and exchange pure data/information, acquiring a different kind of sociality at the same time. In other words, herein coexist two images of the consumer: that of the solitary animalesque consumer who withdraws into favorite "small narratives," cutting off communication with the outside world, and that of the humanesque consumer who actively intervenes in received commodities, constructing a flexible network of communication via the "grand database." In this respect, recent *otaku* culture is the indicator of a very interesting movement.

Such a phenomenon may provide an important frame of reference for divining the future by asking how people will live in a world from which grand narratives have disappeared and wherein small narratives and the grand database coexist in a state of dissociation—but without simply reducing discussion to "today's youth" or "today's *otaku*."

..

Notes

1. Azuma Hiroki, "Superflat Speculations," in *Super Flat,* ed. Murakami Takashi (Tokyo: MADRAS, 2001), 151.

2. Azuma coined the term *net-state discourse* (*mōjō genron*) by playing with the Chinese term for "online." The Chinese term uses characters that literally mean "on the net," pronounced *mōjō* in Japanese. Azuma replaced the *jō,* indicating the "on" in the Chinese "on the net," with the *jō,* referring to a state or condition—whence "net-state." Azuma's neologism is intended to convey the sense of a discourse that stretches like the webs of a net.

3. In March 1970, at the Tokyo International Airport, the Japanese Red Army hijacked a domestic flight (a Japan Airlines Boeing 727) with 129 passengers. The JRA forced the plane to Fukuoka and later to Seoul, where it let the passengers go before flying to North Korea.

4. A religious group with official status in Japan from 1987, the Aum Shinrikyō released sarin gas into a Tokyo subway in 1995, killing twelve and injuring thousands. Its leader, Asahara Shōkō, and a number of senior officials were found guilty of the attack and sentenced to death, but the indictment is currently under appeal.

5. Ōtsuka Eiji and Azuma Hiroki, "Hihyō to otaku to posutomodan"[Criticism, otaku, and the postmodern], *Shōsetsu Tripper* (Summer 2001): 2–33.

6. Ōtsuka Eiji, *Teibon: Monogatari shōhiron* (Tokyo: Kadokawa, 2001) (originally published as *Monogatari shōhiron* in 1989).

PATRICK DRAZEN

• • •

Sex and the Single Pig: Desire and Flight in *Porco Rosso*

When Japanese animation (anime) began gaining more notice in the United States in the 1980s, alarms were sounded in some quarters. Watchdogs of public morality (usually self-appointed conservatives, politically and religiously) complained that Japanese animation was excessively violent and sexually suggestive, if not blatantly pornographic. These objections have been raised before, in Japan as well as in the United States, and are based on an unfair comparison. In the United States, comics and animation are defined as media to be consumed primarily by children. Anime, on the other hand, like the comics (manga) from which many anime are derived, has no such limitation, and the sophisticated stories of some titles scan more like novels than fairy tales.

The long string of feature-length anime from Miyazaki Hayao (who wears the various hats of director, writer, scenarist, and producer) occupies a middle ground. His work is colorful, uncomplicated, and often revolves around children. Yet his plots are often complex and nonjudgmental, leaving open questions of guilt and innocence, good and evil. Examples are many, although chief among them is Lady Eboshi in *Princess Mononoke* (1997, *Mononoke-hime*), who provided jobs and dignity to the castoffs of society while also despoiling the environment and selling arms to the highest bidder.

> PORCO ROSSO IS SET IN A SPECIFIC TIME AND PLACE BUT ALSO CARRIES ELEMENTS RESEMBLING A FAIRY TALE.

Miyazaki's *Kurenai no buta,* literally *The Crimson Pig* (also known as *Porco Rosso*), went through several incarnations before it premiered in its final form in 1992. Speaking at the 1988 Nagoya Film Festival, Miyazaki spoke of a project in which a former military officer, a middle-aged man who happens to be a pig, sets out on a quest for fun, adventure, and romance. The latter is provided by a young waitress who gets kidnapped by the pig, although they ultimately fall in love. The girl's character developed from a waitress into a saloon singer, suggesting the role played by Marilyn Monroe in the 1954 film *River of No Return,* except, as Miyazaki put it, "younger and purer."[1] This description of the saloon singer suggests elements of both Fio and Gina in the final version of *Porco Rosso* and mirrors the evolution of *My Neighbor Totoro* (1988, *Tonari no Totoro*), which Miyazaki had just completed when he spoke in Nagoya; *Totoro* started out with a single child heroine who was eventually "split up" into the sisters Satsuki and Mei.[2] This also suggests that, in the final fight scene of *Porco Rosso,* the American aviator Donald Curtis may have been speaking in Miyazaki's editorial voice when he yells at Porco, "You can't have both [women]!"

In the four years between the Nagoya talk and the finished film, the story appeared in *Model Graphix* magazine as a manga titled *Miscellaneous Notes, The Era of Seaplanes* (*Zassō nōto, hikōteijidai*); this manga led to a commission from Japan Air Lines for a short in-flight movie, which later expanded to feature length.

Porco Rosso is set in a specific time and place (the Adriatic Sea in about 1930) but also carries elements resembling a fairy tale.[3] A World War I fighter pilot, Marco, undergoes a "curse" in combat, which leaves his face resembling that of a pig, hence his other name, Porco. Saying that "the kiss of love" breaks the spell is almost deceptive, neglecting the singular circumstances that create this unique yet archetypal plot. The plot's circumstances are informed by sex to perhaps a greater degree than any other Miyazaki anime.

For reasons that we can only guess at, Miyazaki's first independent production, *Lupin III: The Castle of Cagliostro* (1979, *Rupan sansei: Kariosutoro no shiro*), should have been at least one example of his handling of sexually oriented material. Between 1971 and 1980 Miyazaki directed nineteen television episodes featuring the Lupin character, writing two of those episodes at about the time he created *Lupin III.* Lupin, the creation of the manga artist Katō Kazuhiko, known as Monkey Punch, was a daring and adventurous thief always one step ahead of the law. He was also a conscious parody of

the James Bond character (the manga first appeared in 1967, when the Bond craze was at its highest pitch), echoing the British agent's apparent ability to seduce any and every woman who crosses his path (and the women are, almost without exception, voluptuous sex goddesses). This ribald adolescent male fantasy is also played for laughs, thereby defusing (up to a point, anyway) feminist objections.

Miyazaki, who both wrote and directed *Lupin III,* pays only lip service to this side of Lupin's character. Early in the film, when Lupin has arrived in Count Cagliostro's country, a serving girl to Princess Clarisse brings Lupin (and the audience) up to speed with a large chunk of exposition, including this exchange:

> SERVING GIRL: But poor Lady Clarisse! The Count is a notorious womanizer.
> LUPIN III: You mean like me! What are you doing tonight?

This is as close to Lupin the rake as the movie gets. Lupin eventually meets up with Clarisse. Contrary to what the audience might have expected, Lupin describes her as "a very gentle and wonderful child" and later explains why he acts with extreme chivalry toward her. More than ten years earlier, Lupin was still learning his criminal craft when he was shot; a young princess named Clarisse found him and nursed him back to health.[4] In one English dub of the movie, he actually says that he feels like a "big brother" toward Clarisse. Which leaves sex right out of the picture.

A lot can change in a decade, but throughout the movie Lupin keeps his feelings of gratitude and protection toward Clarisse. In the decade after *Lupin III,* however, we moved from the dashing young rake Lupin to the middle-aged roué Porco.

Porco, too, has a reputation as a womanizer, and we hear a little suggestive dialogue to affirm this reputation, such as this exchange in Gina's hotel restaurant:

> LADY IN THE RESTAURANT: Hi, Porco . . . tell me all about your adventure.
> PORCO ROSSO: Next time the two of us are alone.[5]

Just before his first dogfight with Curtis, Porco states his disinclination to fight the air pirates, stating another agenda in terms that imply the sexual: "Too bad I'm going on vacation. White sheets, beautiful women . . ." After he's

shot down, he calls Gina, who scolds him: "No matter how much we worry about you, you flying boat pilots only regard women as nails in a landing pier." In other words, pilots such as Porco find women valuable only to the extent that they are useful. Why an independent woman such as Gina, already married three times to flying boat pilots, would even consider Porco is a complex question to be addressed later.

When Porco first meets Fio, granddaughter of the airplane mechanic Piccolo, and his first description of her is as "cute," Piccolo's reaction is blunt: "Keep your hands off her!" Later he repeats: "Don't lay a hand on her!" This reinforces the notion that Porco is a pig with a reputation. Despite this warning, when Porco tells Fio that he'll allow her to work on his plane, he phrases it in personal as well as professional terms: "Insufficient sleep will keep you from doing a good job. And it doesn't help your looks." It's also interesting to note that, when he meets his friend Major Fierrali (his name in the 1993 translation; he's also referred to by Helen McCarthy as Feralin)[6] of the Italian Air Force in the movie theater, he's warned that one of the crimes for which the Fascists want Porco is "display of indecent materials." This makes Porco laugh. There is simply no explanation for this line except to suggest either or both of two possibilities: the capricious nature of the Fascist justice system or Porco's reputation for illicit sexuality. Because Miyazaki has described Porco as something of a self-caricature, perhaps he was also trying to break away from the reputation earned through such movies as *Tonari no Totoro* and *Kiki's Delivery Service* (1989, *Majo no takkyūbin*), aimed solidly at children. In 1989 he told an interviewer for *Comic Box,* "I'd love to do a movie that is frowned on by the PTA."[7]

When Porco has to leave Milan in a hurry, Fio offers to go with him, and this time he brings up sex as a reason she shouldn't go: "You're a respectable young lady. Besides, you're not married yet." He may not be concerned about the propriety of Fio being alone on an island with a pilot, except for the fact that he would be the pilot. The argument gets more direct:

> PORCO ROSSO: Hey, I'm a man, you know. We're going to be camping alone on a deserted island.
> FIO: I don't care, I love camping!
> PORCO ROSSO: I'm not talking about *that*.

If anyone in the film seems overtly interested in sex and tries to act on that interest, it is Fio. Given not only the tendency of Miyazaki's movies to shy away from the sexual but also the tendency of many adolescent girl

characters to shy away from sex even when it's desired and offered,[8] Fio seems unusually frank. This may be a Mediterranean trait (or stereotype), but it's an impression of Fio that's reinforced several times during the movie.

One example occurs once work starts on Porco's plane. Dozens of Piccolo's female relatives join Fio in the overhaul; when they stop for lunch, they all sit at a long table, waiting to eat until after Piccolo says the grace. During the grace, with everyone looking down, Fio looks up, smiles, and winks at Porco. The gesture could be a non sequitur; on the other hand, it comes as Piccolo asks God to forgive them using the hands of women to build a fighter plane. Earlier, Fio had challenged Porco, who was on the verge of leaving, whether he thought she was too young to work on his plane. Fio may have been signaling Porco that she was not too young to be included among the "women" working on the plane. This may be a minor, even insignificant gesture, but it is one of many that define Fio's character.

When Fio finally wins the argument and gets Porco to take her along on the rebuilt plane's maiden flight, she still tries to press her sexual nature. Porco tells her that she has to remove one of the machine guns: "There's almost no space between the guns even if you have a small butt." Fio's comeback: "My butt is bigger than it looks." She again tries to appear mature.

When Porco and Fio arrive at Porco's cove, the air pirates and Curtis are already there. In the midst of their arguing and Fio's scolding, a bargain is struck: Curtis and Porco will fight. If Curtis wins, he gets to marry Fio; if he loses, he has to pay the outstanding amount of Porco's bill to Piccolo. The deal is foolish—Fio is only seventeen years old—but it buys Porco and Fio some time. As soon as the others leave the island, the apparently calm and collected Fio gets the shivers; to work off the nervous energy from the confrontation, she proceeds to strip down to her underwear and go swimming in the cove, not caring (apparently) whether Porco is watching her.

Even in the solitude of the island, Porco never tries to approach Fio. She, however, takes the initiative and kisses him—twice. The first time happens on the island, after she speaks of "the fairy tale where a prince is turned into a frog." Porco advises her not to waste kisses on him. Later that night, Fio gives Porco a kiss on the cheek anyway. The second kiss comes later.

Porco may be unwilling to try his luck with a girl half his age, but his ambivalent relationship with a woman his own age is unique in Miyazaki's film catalog. It's as if Miyazaki looked beyond anime to frame the romance of Porco and Gina, settling on something inspired perhaps by Humphrey Bogart and Lauren Bacall.

Gina keeps a hotel, where she is also a singer. For now, we only need to

note that her place is called the Hotel Adriano and that the Adriano is also the name painted on the first plane she ever rode in with Marco, when both were teenagers. The significance of that flight will be examined later.

Gina, unlike the "cute" Fio, is older and strikingly good-looking. She's talented, self-assured, and is more than capable of quieting any potential brawls in her restaurant. She also loves Porco in a way that is more than merely an "ongoing dream of romantic fulfillment," as McCarthy describes it.[9] The origins of that love are complex and are spelled out in stages as the film progresses. Finally, while there is nothing blatantly sexual in the character of Gina—in fact, she dresses in the boyish "flapper" style of the time and also appears at the fight wearing what could be men's clothing—this does nothing to downplay her femininity or deny the possibility that Gina and Porco have had an ongoing sexual relationship. Again, it is never explicitly stated, but he has that reputation, even if we never see him act on it.

Gina is, along with characters including Lady Eboshi and the Queen of Torumekia in *Nausicaä,* a complex older woman in a medium dominated by virginal adolescents. Her relationship with Porco, complete with sexual tension, is at the heart of the entire story.

She first appears in the "saloon singer" role, and her choice of songs is interestingly multitextured. "Les temps des cerises" (The time of the cherries) is a setting of a poem by the nineteenth-century French writer Jean Baptiste Clement. Clement is best remembered for this poem and for the two-month communard uprising in Paris in the spring of 1871 in which he took part. This brief experiment in localized socialism was violently suppressed, but it gave rise to a romanticized view of political activism in that time and place, in much the same way that opponents of fascism romanticized resistance in the Spanish Civil War.

Some of the lyrics to "Les temps des cerises" include "When you are in the time of cherries / If you are afraid of unhappy love affairs, / Avoid the beautiful ones. / I who do not fear cruel sorrows, / I will not live without suffering one day . . . / When you are at the time of cherries / You will have also sorrows of love!" Gina's song, therefore, is more than just a memory of a short but happy time of love, a mood well suited not only to French chansons but also to the Japanese feeling toward the all-too-fleeting essence of life known as *mono no aware.* It is also a statement that Gina, on her island hotel in the Adriatic, uses to resist, in her own way, the rise of fascism in nearby Italy. This open, though gentle, protest against fascism has sexual connotations even beyond the symbolism of sex inherent in the springtime of the year and the fact that both cherry blossom season and the communard uprising took place in the spring.

Socialism has often been misunderstood and mistrusted in capitalist countries because its calls for sexual equality have often been interpreted as arguments for sexual license. Liam O Ruairc, in his history of Irish socialism, has noted that "certain socialist attitudes towards conventional views of monogamy and marital morality seemed shocking in those days were [sic] criticisms of marriage sounded like encouraging sexual libertarianism. So sexual problems/issues, like religion, were declared by [some socialist leaders] to be beyond the scope of socialist discussion. This limited the theoretical understanding of women's oppression."[10]

It also sets up the conversation in the garden between Gina and Curtis, where she opines that Curtis, the ambitious American aviator, is still too young to understand that "life is more complicated here than in your country. If you're only looking for a fling, that's easy." Speaking as someone who has married three times by the time she meets Curtis, and who still has hopes that Porco will come to her garden, Gina speaks from unconventional experience when she dismisses Curtis as a "little boy."

The garden itself is a metaphor bordering on the sexual; however, it is also gender specific. A garden, after all, is nature brought under control by civilization, and civilization, in this context as well as others, generally means a woman.[11] In hoping that Porco will come to her garden, Gina hopes that he will surrender to her civilizing influences and abandon his self-centered, "wild" life.

Gina and Porco talk several times in the film. While Gina shows a range of emotion, from anger to sorrow to nostalgia, Porco tries to keep a distance between them. He asks her to get rid of the last remaining photo showing Marco with a human face. They speak over the telephone when Porco is on his way to Milan. They speak after the fight, when Porco hands Fio off to Gina. Gina clearly loves him, and he just as clearly tries to deflect her feelings. Always in the background of their conversations, and their lives, is flight.

To say that, in Miyazaki films, flight can be a metaphor for sex is simplistic and misleading. Flight is very often a solitary pursuit for his characters. Think of Nausicaä journeying to and from her valley on her mehve, or Kiki making deliveries on her broom, or Howl trying to stop two warring armies: this is not the stuff of erotica. However, when the ordinarily solitary condition of flight is shared with another, a component of sex—intimacy—may come into play. This is the kind of "flight as sex" imagery Miyazaki employs, and it appears in films other than *Porco Rosso*. It's poetic, it's "safe sex," and it conveniently allows for the deepening of an emotional relationship even between underage parties.

Examples include the scene in *Laputa: Castle in the Sky* (1986, *Tenkū no shiro Rapyuta*) with Pazu and Sheeta in the "crow's nest" of Ma Dola's ship, just before they land on the floating city. During the final credits of *Kiki's Delivery Service,* we see that Tombo has built his human-powered aircraft and that he and Kiki fly together over the sea. This is a significant scene, since, for much of the movie, Kiki has been interested in Tombo but also worried that she can't compete for his attention with the older, savvier, and prettier girls of his acquaintance. This sequence indicates that she has won that particular contest, by being the only girl Tombo knows who shares his interest in flight. And, as if to establish that this is more than just a friendship, the other sequences under the closing credits include scenes of marriage and children: the baker, his wife, and their new baby, and Jiji with his mate and their kittens.

> WHEN THE ORDINARILY SOLITARY CONDITION OF FLIGHT IS SHARED WITH ANOTHER, A COMPONENT OF SEX—INTIMACY—MAY COME INTO PLAY.

Perhaps the most overt example is the "sky-diving" scene between Chihiro and Haku in *Spirited Away* (2001, *Sen to Chihiro no kamikakushi*). As they exchange tender words, the quintessential symbol of emotion in anime—tears—well up in Chihiro's eyes, and (in a break with convention at once surprising and logical) rather than run down her cheeks, the tears ball up and float away.

In this context, we are ready to examine the flashback flying scene in *Porco Rosso*. Gina watches Porco's rebuilt plane performing aerobatic maneuvers over her hotel, in what can be construed as a mating ritual. Suddenly, Gina recalls two adolescents riding in an airplane that looks very much like the Wright Brothers prototype that first flew in 1903. Since *Porco Rosso* takes place in or about 1929, when Gina and Porco are middle aged, they would have been teenagers at the beginning of the century, when powered flight was a new experience. Earlier, at Piccolo's workshop, we had been told that Porco first flew in 1910, when he was seventeen years old. Gina's flashback to that flight—because she was there, too—is pivotal to our understanding of both characters.

We see them flying low over a body of water, clearly thrilled by this unique experience. As the young Marco looks over his shoulder at Gina, seated behind and above him, a sudden gust of wind picks up Gina's voluminous skirts. What Marco sees is her legs, encased in frilly, billowing bloomers. Still, this is a far more intimate look at a girl than was customary at that time, and he quickly turns back to pilot the aircraft, while blushing profoundly. Gina, meanwhile, is still wrestling with her wind-blown skirt.

At a hundred years' remove, it's hard to think of a similar moment of accidental intimacy that would take place today in which both parties would still be fully clothed. But that moment turned out to be a defining

one for both young people. Gina would grow up to be something of a "woman of mystery," married three times to three pilots, while still hanging on to her "wager" that Porco—who competed with Berlini for her hand in marriage—will come to her in her garden, separated from yet near to the hotel that bears the name of the plane she was riding in when she and Marco experienced a conjunction of flight and sex. Marco/Porco likewise grows up fusing flight and sex in his life, although for him the two are exclusive. Sex is something to do when he's not flying; Gina combines the two with her three pilot husbands and hopes that Porco will follow suit.

Porco, however, cannot go to her garden in the movie. His feelings for her are still conflicted by his belief that he does not deserve to be loved and that he is, in fact as well as in appearance, a pig. This history comes out in the "bedtime story" Porco tells Fio on the island. It was the last mission flown by Berlini, which took place just after he had been married to Gina. We don't really know how Marco felt about his best friend marrying Gina, since we don't yet know his own feelings for Gina, but they become plain in the story.

Fio prefaces the story by invoking a fairy-tale motif: a cursed man who requires a kiss to return to human form. Porco rejects the comparison by telling the story of how he became a pig. In the summer of 1918, Marco and Berlini must return to battle, only two days after Gina married Berlini (Marco was best man) and no honeymoon. Chased by three enemy planes, Marco flies into a cloud, then emerges to behold what can only be called a pilot's Valhalla. Stretching across the upper atmosphere in a white streak reminiscent of the Milky Way are the planes of pilots killed in the war. As Marco watches, he sees other planes rise silently up to join the others, Berlini among them. He calls out to his friend: "Are you going to leave Gina all alone?! I'll go in your place!" Of course, Marco is alive and cannot trade places with his dead friend. He sinks back into the cloud, loses consciousness, and comes to again while flying inches above the Mediterranean.

When Fio invokes God as the reason Porco hadn't died, he returns to the answer he gave Gina in the restaurant: "I thought [God] was telling me to fly on alone, forever. . . . The good guys were the ones who died." Fio tells him that he really is good and kisses him on the cheek, but nothing changes.

There is nothing magical about Marco's face changing, turning him into Porco. This is a manifestation, although a fanciful one, of survivor guilt. Aphrodite Matsakis, in her book *Survivor Guilt,* draws on the definition of Edward Kubany, "a cognitive behavioral psychologist who has worked extensively with abused women and combat veterans." In this case, Marco's guilt is "a negative feeling state that is triggered by the belief that one should have thought, felt, or acted differently."[12] The different action in this case, which cannot come to pass, is the hope that Marco could somehow have prevented the death of Berlini and abandonment of Gina. This suggests that Marco saw himself as a poor substitute for Berlini, perhaps even before the wedding, and that he would be inadequate to console Gina over the loss of her husband.

Porco clings to the vision of Berlini's plane ascending to the pilots' Valhalla, and his survivor guilt has been confused with his feelings of unworthiness in the area of romance. A telling indication of this is in the scene at Gina's restaurant, when she tells him that the body of her third husband has been found, after he had been missing for three years. Porco's comment is brief, self-slighting, and anticipates his words to Fio on the island: "Good guys always die." Porco didn't die and therefore is not a good guy; the self-deprecating belief "proves" itself. It takes Fio's parting kiss—this time on the lips—after the fight with Curtis and Curtis's declaration that Gina still loves him to finally turn Porco back into Marco.

As the film ends, we are in the present. The voice of an adult Fio still refuses to say whether Gina ever won her wager, telling the viewer that it's a secret. Yet McCarthy has pointed out that, as the Piccolo corporate jet approaches Gina's island, the audience can just glimpse a seaplane, bright red against the blue of the Adriatic, "docked at the jetty at the far end of the island, the one that leads to the secret garden."[13]

Did he come to the garden and stay there, and did Gina and Marco live a conventional, happily ever after clichéd marriage? Given the adventurous and unorthodox lives both had lived up to that point, it doesn't seem likely. If Marco stayed on the island, he would have had no need for the plane, but Gina never asked her other three pilot husbands to stop flying. Perhaps Marco kept the plane there in case he needed a quick getaway; after all, the aerial bombardments of World War II were about to begin, with the Italian air force attacking Ethiopia and the Spanish city of Guernica. Neither Marco (whose friend Fierrali is still in the Italian Air Force) nor Gina (who we see receiving encoded messages from Fierrali with a hidden radio) would be safe in the years to come.

Beyond all this is the secret garden—or, if you prefer, the bedroom door. The story stops there, as Fio, and Miyazaki, intended.

Notes

1. Helen McCarthy, *Hayao Miyazaki: Master of Japanese Animation* (Berkeley: Stone Bridge, 2002), 162–63.

2. Ibid., 120.

3. The manga dated the story as taking place in 1929; http://www.nausicaa.net/miyazaki/porco/faq.html#when (accessed July 10, 2006).

4. In a fascinating parallel, Clarisse nurses the injured Lupin back to health in the same manner that the princess Nausicaä nursed the wounded Odysseus in Homer's *Odyssey*. This plot twist may well be part of the birth of Miyazaki's next film, *Nausicaä of the Valley of the Wind* (1984, *Kaze no tani no Naushika*). In another interesting parallel, the roles of Clarisse and Nausicaä were performed by the same voice actress, Shimamoto Sumi.

5. From the 1993 translation by Ono Kōji, subsequently revised and posted on the Web at http://www.nausicaa.net/miyazaki/porco/script_porco_en_r.txt. The English translation for the Disney release of the DVD, and even the "dub-titles" that accompany the Japanese language track of the DVD, contains omissions and inaccuracies.

6. McCarthy, *Hayao Miyazaki*, 172.

7. Ibid., 163.

8. The many examples of such sexual ambivalence would constitute a paper in themselves. Two examples can suffice: Watase Yū's manga *Absolute Boyfriend* (2003–5, *Zettai kareshi*) gives virginal high school student Izawa Riiko a robotic boyfriend named Night. Even though he's caring and noble, Night is still incredibly naive. He repeatedly offers to make love to Riiko, and she repeatedly refuses. Similarly, in the anime version of *His and Her Circumstances* (1998–99, *Kareshi kanojo no jijō*), the first time Yukino considers possibly sleeping with her new boyfriend Sōichirō, she immediately changes her mind as she recalls a pop song by the duo Pink Lady warning girls about predatory boys.

9. McCarthy, *Hayao Miyazaki*, 170.

10. "Ireland's OWN History: Connolly on Women, Religion, and Sex," http://irelandsown.net/connolly13.html (accessed July 10, 2006).

11. Peter Biskind's *Seeing Is Believing: or, How Hollywood Taught Us to Stop Worrying and Love the Fifties* (New York: Pantheon, 1983) is an examination of postwar American movies. He argues that, in a time of soldiers returning home, American popular culture told the GIs that they needed to channel their military aggressions into middle-class domesticity. Sometimes the message was overt (as in *Bombers B-52*) and sometimes more indirect (*Red River*), but women were almost invariably cast as the bringers of civilization in fifties Hollywood.

12. Aphrodite Matsakis, *Survivor Guilt: A Self-Help Guide* (Oakland, Calif.: New Harbinger Publications, 1999), 19–20.

13. McCarthy, *Hayao Miyazaki*, 178.

TIMOTHY PERPER AND MARTHA CORNOG ●●●

The Education of Desire:
Futari etchi and the Globalization
of Sexual Tolerance

Step up love story: Futari etchi, by Katsu Aki, is a sexually explicit manga published by Hakusensha since 1997 in at least thirty volumes in several series. It has appeared in French, German, and Spanish editions and has recently been licensed by TokyoPop for English translations. An original animated video also exists, but we focus on the manga in French and Japanese.[1] *Futari etchi* is an extraordinary piece of work that raises difficult but fascinating questions about the portrayal of sexuality in manga and about globalization of sex-tolerant views of sex education and behavior.

The Japanese title blends English and Japanese. *Futari* means "couple" and *etchi* (or *ecchi*) means "H," an abbreviation for *hentai,* "perverted" or "sexy." We'd probably translate the title as something like "Step-by-step love story: X-rated couple." It is the story of the newlyweds Yura and Makoto as they confront a transition from complete sexual inexperience to an arranged marriage and its sexual and erotic challenges. Throughout, Katsu uses their story as a platform to provide not only an ongoing narrative but also systematic and well-designed serious lessons in sexuality itself. This combination of story plus sex education gives *Futari etchi* a unique place in manga and in the world's sex education literature.

Futari etchi will pose some questions for American readers literate in Japanese, French, German, or Spanish. These center on differences between education in sexuality and education in morality. In U.S. sex education in schools, moral lessons are often incorporated. Teaching about sexual anatomy and physiology is often linked didactically to lessons in those social ideals that specifically perceive obligatory linkages among sexual activity, marriage, marital exclusivity, and heterosexuality (e.g., "abstinence-only" sex education). But teaching about moral themes like these plays little role in *Futari etchi*. Responsibility, yes; morality, no.

For some U.S. readers, *Futari etchi* will raise issues of pornography, meaning the portrayal of sexual activity for purposes of arousal or pleasure. In the normative American sexual script, pornography exists only as stigmatized and marginalized depictions that operate at the edges of moral, meaning bourgeois, society. However, *Futari etchi* systematically surrounds a marital narrative with explicit depictions of sexual activity and with equally explicit lessons in sexual anatomy, physiology, behavior, and statistics.

Futari etchi can be compared to American sex manuals like *The New Joy of Sex* or *What Your Mother Never Told You about S-e-x*.[2] Such sex manuals are usually explicitly illustrated, but none integrates a sustained graphic narrative with statistical sidebars, information, and advice—which *Futari etchi* does. The combination probably attracts readers who would disdain standard sex manuals even if they need or want the information. Such manuals cannot create the reader traction delivered by plot and character embodying the educational messages of *Futari etchi*.

Futari etchi raises some serious questions about manga, sexuality, and sex education. The series is very popular—the back cover of volume 11 (French version) claims that more than sixteen million copies have been sold in Japan. Moreover, editions in the three European languages suggest that many non-Japanese read the story: eleven volumes in French, sixteen in Spanish, and twenty-three in German as of January 2006. What gives *Futari etchi* its unique features and what might account for its popularity?

THE CREATION OF DESIRE

Broadly speaking, four elements create and maintain interest in manga: character, narrative, artwork, and setting. Koike Kazuo has suggested that first among these is strong character development.[3] Makoto and Yura certainly qualify.

We encounter here a visual asymmetry widespread in manga. Women characters are often visually more salient—certainly more beautiful—than men. In Katsu's skilled artwork, again Yura qualifies. She is extremely pretty, with lush black hair, large eyes, a winsome smile, and a full-breasted figure.[4] Her wavy hair may not meet older traditional views of Japanese beauty—which stressed that a woman's hair should be straight—but the gracefully illuminated curves of her hair give her an eroticism that appeals to male and female readers and certainly to her new husband.[5] Such appeal quickly becomes visual and tactile allure, and with allure the story enters the domains of desire and the erotic.

> THE BASIC LESSON OF *FUTARI ETCHI* IS THAT SEXUAL FEAR, IGNORANCE, INEXPERIENCE, AND SHAME CAN ALL BE OVERCOME.

"Appeal" and "allure" both refer to attractiveness and to how someone like Yura can elicit positive regard and create interest. But they are not the same: *allure* implies fascination and enticement, and therefore refers to desire—and desire, when embodied, is the threshold of eroticism.

This transition from *appeal* to *allure* to *desire* is the hallmark of eroticism. Allure moves away from cuteness (*kawaii*) to stronger emotions, captured in Japanese words like *tsuya* and *yōen,* which specifically refer to captivating and enticing physical allure.[6] Makoto is frankly aroused by Yura. And thereby is created the first marital issue that the narrative of *Futari etchi* addresses: their wedding night.

Against the expectations of pornography, Yura and Makoto do not make love on their wedding night. They are too timid, too virginal. Though both are twenty-five years old, neither has ever dated, let alone had sexual intercourse, and their marriage was arranged through a marriage broker. (Arranged marriages still exist in Japan, although they are statistically not very common.)[7] For Yura and Makoto, the sexual body is simultaneously a source of allure, mystery, and shame. Yura does not know what to call her own vulva or Makoto's penis and only murmurs or falls silent. They have no words for expressing desire or for talking about sexual embarrassment. Allure and attraction are alien, mixing excitement and fear. Paralyzed, neither knows what

to do or expect, and they end up watching a horror flick, embarrassed and disappointed.

It is a realistic scenario portrayed without blame. Uncertainty and fear close them off from each other and from themselves. But the basic lesson of *Futari etchi* is that sexual fear, ignorance, inexperience, and shame can all be overcome.

FIRST COITUS

The next day and evening, they both slowly decide that they will not let themselves be defeated. Each timidly makes overtures to the other; not knowing what to expect, they begin to kiss and touch. He starts to undress her (and an illustrated sidebar shows how to unsnap a bra). To him, she has beautiful, exciting breasts, but her hands are clasped to her face, eyes half-closed: she is ashamed—and silent.

When, next, he starts to take off her pants, she asks if he doesn't want to turn off the light. "Why?" he says, thinking that if it is dark, he won't be able to see her. Now she *says* she is ashamed.

Shame is the first—and crucial—obstacle. Makoto proffers an alternative—to leave only a small lamp lit. Soon he sees her completely naked, and he is very aroused. He too undresses, and she thinks his erect penis is quite strange. He covers it with his hands, saying, "Don't look!" (A sidebar gives average penis sizes.) He lies on top of her, between her legs, and starts caressing her breasts. She thinks it feels funny—not meaning *amusing* but *odd*—but unexpectedly she likes it.

We are seeing—and therefore learning—that socially and psychologically constructed feelings like shame, anxiety, fear, and reluctance are not the only components in Yura and Makoto's interaction. Embodied processes of erotic desire also have begun to emerge. Negative feelings vie with the erotic body, which is awakening with a power of its own. The conflict is therefore not between Yura, timid and shy, and Makoto, eager and aroused—that is, it is not between stereotypes of reluctant women and overeager men—but between sex-negative social and psychological states of mind and feeling, and sex-positive responses of the naked body to the partner and the partner's interest. Both Yura and Makoto feel all these emotions: each is anxious and fearful, each is aroused. So there is no conflict *between* them, only *within* them. And encouraged by their success so far—actually, by their bodies' successes so far—they continue.

"I adore this," he thinks, caressing her breasts. We see her face, flushed, eyes half-closed, but even as she thinks that it feels strange, her body responds. The page contains eight panels; their bodies appear in six and their faces in six, a nice balance between expressive emotion and body-centered eroticism that exists throughout *Futari etchi*. Now Makoto reaches between her legs, and she grips the sheets, face flushed, head turned. She is beginning to lubricate. It is a lesson communicated by pictures rather than words. Her turned head is not a rejection but is part of normal physiological sexual response. By turning her head, she exposes her neck and breasts and becomes even more alluring.

"So that's what it feels like when it's caressed down there," she thinks; "I can't keep myself from moaning. . . ." A sidebar comments, "From all evidence, Yura has never masturbated. Although just about all guys have practiced it, that's not the case for over 60% of women." (The 60 percent figure is compatible with data on sexual behavior in Japan.)[8] So, for a Japanese woman, Yura's unfamiliarity with vulval responsiveness is set within the limits of normality.

He lifts up her legs to enter her, but she objects: "I feel like a frog." "OK," he exclaims, "we'll try it differently." After several attempts—which don't work—he asks if this is her first time, and, touched, she says it is. "She's like me," he thinks, delighted that they are on the same footing.

Even more aroused, he thrusts and finally enters her. But she pushes him away: "It hurts!" Now the text breaks into several sidebars. Two show a schematic drawing of the penis entering the vagina—conventional sex ed, this, making it look simple and painless. But two other drawings show the hymen, and it is clear why first coitus can be so painful for the woman. These are among the most remarkable illustrations in *Futari etchi*—drawings of the hymen are not commonplace in sex manuals. Once hymenal anatomy is understood, we easily see why Makoto wants to be gentle. Still another sidebar recommends that the man should make only "light movements" after first penetration and only gradually speed up. (Such concern is not recent in Japanese erotology—the thousand-year-old *Ishimpo* [an alternate romanization of the Japanese title *Ishinpō*], a Heian-era treatise on Taoist erotology, provides several herbal recipes for alleviating the woman's pain during first coitus.)[9]

Now moving more gently and very pleased, Makoto asks her if she is enjoying it. But she says, "For me, not truly." Then, only moments after intromission, he unexpectedly ejaculates, and she asks if it's over already. He is desolated, embarrassed, and admits that for him too it was his first time. "We were both virgins?" she asks, and he nods mutely. But she reassures him. "It isn't serious," she says; "We will both improve, you and I."

AN ONTOLOGY OF SEX

A crucial implication follows: sexual arousal is gradual. It does not appear fully engorged from nowhere. Yura's and Makoto's bodies are negotiating their way through this process, and Katsu realistically depicts it, step by step by step. In the artwork and dialogue, we see a *sequence* of events, not instant consummation or gratification but many events that lead one to the next. It is courtship, not as wooing with flowers and meals but as an embodied sequence of events that increasingly recruits modalities of the senses—vision, touch, taste, and, finally, orgasm.[10]

Katsu's depiction complements Yonezawa Rika's extensive drawings of precopulatory courtship in her manga *Tenshi no mayu* (1998, Cocoon of angels), with its details of how men and women look, talk, touch, kiss, and finally have intercourse. Ovid wrote *The Art of Love* two thousand years ago, but surely he would have approved of these detailed portrayals of the stages of love.[11]

A second implication is that emotions are integral to actions. The conventions of pornography erase all emotions except those needed to arouse the *viewer,* but Katsu's purposes are not pornographic. Instead, the highly accomplished artwork and narrative lead the viewer through Yura and Makoto's emotionally charged drama of arousal, hope, pain, and disappointment. We see that their "first time" was not really a success, but it *was* normal. Thus sexuality is not an automatic pleasure garden of erotic delight. The emphasis is on realism, not romanticized (soft- or hard-core) fantasy.

> DESIRE IS A STATE OF BEING-IN-THIS-WORLD THAT ENGAGES BOTH YURA AND MAKOTO AND LOCATES THEM SOCIALLY AND EMOTIONALLY.

A third implication: fear and failure are not permanent. Although Yura and Makoto encounter roadblocks, they *have* negotiated their way through their first sexual experience. Intellectually they realize that they need not succumb to failure. Physically, their bodies have become interested in doing it again. Now they *want* to overcome failure and want not only to do it again but to do it *better.*

Yura and Makoto accept the implication that sexuality is something their bodies can do with each other. In fact—and this appears as an inference about the universe itself—it is something that their bodies can excel at doing if they keep practicing.

Desire is therefore not merely anatomical or neural excitation. *Futari etchi* is antireductionist in its continuing resistance to making sexuality nothing

but organs, nerves, and neurotransmitters. Instead, desire is a state of being-in-this-world that engages both Yura and Makoto and locates them socially and emotionally. Like karma—by which we mean a Buddhist principle of cause and effect that opposes the search for nonworldly nirvana[12]—sexuality cements loyalty to people, feelings, and events. In *Futari etchi,* desire is an engine of *engagement* with the world in marital and, hence, social connectedness in the here and now. Sexuality and its correlatives in beauty and allure become ontological, a fundamental principle of the world itself.

This vision of sexuality and sexual desire—eros, if you prefer—is widespread in manga. In only two pages of *Sakura tsūshin* (2001, Cherry blossom letters; the anime adaptation of this manga is known in the United States as *Sakura Diaries*), the manga artist Ūjin (known in the United States as U-Jin) centers Tōma's fascination with the beautiful Mieko in the social context of a college lecture hall *and* in the biological context of dopamine release in Tōma's brain. In Tōma's and Makoto's reactions, sexuality is not simple genitality but touches the entire universe. Likewise, in the anime *Maria-sama ga miteru* (2004, The Virgin Mary is watching), Sei's profound recognition of Shiori both locates the two women in a girl's school and reorganizes their lives with the knowledge that they love each other. [13] These shifts rewrite the world and recast its parameters. Likewise, Yura and Makoto become characters in an ontological drama in which sexuality is basic in all of its universes—biological/anatomical, intellectual/cognitive, emotional, and social and cultural.

This transformation does not mean that Yura and Makoto now wander about in a dreamy haze of sexual bliss. They do not. Instead, they understand the world differently. Sexuality, hitherto a mystery and a secret place to them, has been revealed as an overarching process, exciting, alluring, and welcoming.

ASSIMILATION

Sexuality brings Yura and Makoto into a new matrix of social and personal relationships with the world. We might think that marriage, not sexuality, links them to society, since marriage is the juridical event that proclaims them to be adults. But sexuality with its reproductive, emotional, and social implications is the issue—not juridicality.

Once the Japanese ideal would have been forming a "close and lasting marital bond, harmonious, cooperative, and blessed with children." But there have been significant—and demographically profound—slippages in the

need for children to establish a new family and household, or *katei*.[14] Yet the hope remains, especially among older Japanese, that children not only follow from sexuality but will be joyously welcomed.

Indeed, throughout *Futari etchi*, it is clear that Yura's and Makoto's parents want grandchildren. In other manga, even if pregnancy is not a common theme, it can be quite welcome. Examples include Sailor Moon, pregnant at the very end of the last volume of Takeuchi Naoko's masterpiece (1992–97, *Bishōjo senshi seiraa mūn*); Karula Olzen and Princess Kahm in Manabe Jōji's *Drakūn* (1988–91, *Dorakūn: Rhūhimehei*) and *Outlanders* (1986, *Autorandaasu*); and Godai Kyōko, whose daughter Haruka is born at the end of Takahashi Rumiko's *Maison Ikkoku* (1982–86, *Mezon Ikkoku*). Children are to be welcomed even when the father is a dragon (in Utatane Hiroyuki's 1993 *Ryūhō*, known in the United States as *Ryu-Ho*) or when the mothers are mermaids (Mana-ko's 2003 *Itazura na kanojo* [Trickster girlfriend]).[15]

But Yura is not a mermaid (nor a frog). She knows by now that she and Makoto must confront decisions about becoming parents.

CONTRACEPTION

Fertility control in Japan is very complex. Since 1945, three methods have been most widely used in Japan: condoms, the rhythm method (known as the "Ogino" method), and abortion. By the early 1990s, the Japanese birthrate had undeniably fallen below population replacement levels, and AIDS had become a serious issue. In response, the Ministry of Education promoted promarriage and pronatal education in schools while downplaying contraception, the Ministry of Health and Welfare promoted abstinence as an anti-AIDS strategy, and the Japanese Sex Education Association promoted not only contraception but tolerance for singlehood and gay and lesbian lifestyles.[16] However, specific sexuality education curricula are not mandated by any government ministry, and teachers and local schools make their own decisions about what to include and exclude in such courses.[17] The result is striking variation in what students are taught and why.

Kawahara observes that in consequence the mass media, including manga, play a large role in informing young people about sexuality, lifestyles, and contraception.[18] *Futari etchi* deals quite explicitly with contraception and from the outset takes a strong family-planning position.

Early in the story, Yura decides that she and Makoto must prevent unplanned pregnancy. A sidebar underscores her decision: "There are certain

things one should think about when one is married. For example, *choosing when to have children.*" That night she tells him to use a condom, and he goes out and buys some from a vending machine. Throughout, condoms are their primary contraceptive choice. (In at least one episode, she buys them herself.)

A stronger version of this theme occurs a good bit later, when Yura's menstrual period is ten days late. Their parents are delighted, but she and Makoto are very concerned. However, her period was only late, and a sidebar explains that stress or fatigue can delay menstruation. The parents express regret, but Makoto reassures them that they should be patient: "It's only a question of time." Although Yura and Makoto want children, neither is ready to start a family.

Several implicit concerns underlie these episodes. One is that Yura insists on contraception. Thus she models a reproductively self-confident woman for female and male readers. Makoto is also a model for readers, as a responsive and responsible man whose behavior approaches the ideally harmonious and cooperative marital bond mentioned above.

An even stronger assertion of the woman's right to contraception occurs in a later example, where such harmony is absent. Yura's younger sister, Rika, is sexually active with several men and with one man in particular, her "boy-friend" Yamada. She argues with him about condoms, because he hates to wear them. So far she has not succeeded in making him reliably responsible about contraception—sometimes, yes; in general, no.

So she and Yura hatch a plot: tell him that Rika is pregnant. Rika also obtains some polyurethane condoms (which preserve penile sensitivity) and visits Yamada at his college campus to announce the bad news. He is very up-set and offers to marry her. When she admits her ruse, he gets angry but she shows him that she can put the condom on his penis with her mouth. They make love, and he likes the new condoms. But all is not well: he withdraws his marriage proposal, and they go back to arguing.

Yura and Rika both assertively model a woman's right to contraception. However, their men differ from each other: Makoto is reproductively responsible but Yamada is not. So Rika and Yamada illustrate *dis*harmony and *non*cooperation, the opposite of what should be.

Katsu's concern with Rika and Yamada exemplifies *Futari etchi*'s aesthetic realism and its strong focus on real-life choices and situations. Kawahara observed how young women can consider using pregnancy to manipulate their boyfriends.[19] She describes students in a vocational high school who wrote a skit for their classmates about a girl claiming to be pregnant in order to get money out of the man, supposedly for an abortion. Although a much less

pleasant scenario than Rika's story, it too illustrates women's cleverness and resistance to men.

Abortion is never mentioned as a method of fertility control in the volumes of *Futari etchi* that we have seen. An important point underlies the omission. Sex education in Japan is not reported to deal extensively with contraception, but the Japanese Sex Education Association holds that schools should teach contraception rather than allow young women to become pregnant and obtain abortions.[20] Katsu's position is similar: teach contraception thoroughly, making abortion unnecessary.

FAMILY AND SOCIETY

Throughout *Futari etchi,* sexuality is part of a larger social matrix involving family, friends, and coworkers. The salience of families is very great.

As observed above, Yura and Makoto repeatedly confront their families' hopes for grandchildren. Their parents belong to an older, more pronatal generation and do not necessarily accept or understand their children's commitment to family planning. Thus, in one episode, Yura's very attractive (*bijin*) mother, Chiharu, visits them in their thin-walled apartment. At dinner, she asks directly if they are thinking of having children. Both demur politely. Blushing, Makoto says, "Not in the immediate future," and Yura, also blushing, adds that they want to live just as a couple for a while. But mother will not be put off. She tells Yura, "That's fine, but you aren't so young anymore" (Yura is now about twenty-six), and she then reminds Makoto of his duty as a man to provide children for his wife. Embarrassed, Yura and Makoto try to avoid the issue.

Chiharu keeps up the pressure. Although Yura and Makoto consider celibacy while she is visiting, they manage a quickie in the bathroom with Yura perched on the sink. They try to be quiet, but that fails. "Sitting on a cold surface like that," Chiharu says tartly, "isn't very good for the ovaries."

Later, Chiharu has some observations for her husband. When he asks her if the young couple is getting along well, she says "Yes . . . and they were doing it on the bathroom sink, the lucky devils!" He looks away awkwardly, a sidebar adding that he has sex with his wife only about once a month.

Yura and Makoto's siblings get into the game as well. None of them have children, but they are certainly interested in Yura and Makoto's sex life. Makoto's older, married brother Akira uses every opportunity to give outspoken advice, whereas Makoto's younger sister Jun is still becoming a sexual person

and is filled with questions about How to Find Her Great Love. Yura's sister, Rika, is sexually enterprising and assertive, and has several young men in tow in addition to Yamada. She is constantly offering the much shyer Yura advice on sexual positions, activities, and fun-things-to-do with your body. So *Futari etchi* portrays a complex array of attitudes and sexual possibilities not only to Yura and Makoto but also to the reader.

Friends and coworkers add to the roster of complications: marriage, especially to an appealing bride, is not a neutral event. Makoto's female coworkers think he is now much sexier, and one young woman wants to have an affair with him. His male coworkers envy and admire him as A Married Man, especially when they meet the lovely Yura. They are certain that he is in sexual paradise, which embarrasses and flatters Makoto.

In the meantime, Yura and Makoto are becoming more and more sexually comfortable and adventurous with each other. They explore foreplay, the G-spot, Kegel exercises, female lubrication, taking baths together, oral sex, and a variety of sexual positions. Throughout, helpful sidebars offer advice. For example, if you're planning to have sex in a car, stay away from the horn and don't get completely undressed—you may have to make a quick getaway. When Makoto finds some massage lotion and slathers it on to enhance Yura's already sensuously beautiful body, she squeals in loud protest: "Eee! It's cold!" A dryly amused sidebar recommends that one warm the lotion between the hands *before* using it.

Yura and Makoto have come a long way. And with them, so has the reader. *Futari etchi* covers not merely the mechanics of sex but its social and emotional meanings, its implications for friends and family, and its place in society as an engine of social relationships and biological reproduction. Along the line, a great many helpful—sometimes serious, sometimes amused—sidebars explain sexual anatomy, physiology, and psychology, all set into a framework of tolerance and acceptance of human desire.

THE EDUCATION OF DESIRE

Fiction has been used in modern Japan to convey sexual and marital instruction for over a century. For example, late Meiji and Taishō period writing (ca. 1890–1926) frequently dealt with the then radical notion of *ren'ai,* or love marriage.[21] However, from the 1930s onward, these educational-literary efforts were suppressed by imperialist and ultranationalist goals. After 1945, the Japanese elementary through high school system was rebuilt along

> *FUTARI ETCHI* BELONGS TO A LONG TRADITION OF JAPANESE ART THAT PLACES SEXUALITY AT THE FOREFRONT, INDEPENDENT OF BUREAUCRATIC PLANS AND POLICIES.

westernized democratic lines, supplanting militaristic educational goals for a high birthrate wherein women played only domestic and reproductive roles. Nonetheless, postwar Japanese sexual education policies still foreground perceived political and demographic necessities and can bypass individual desire and pleasure. Sexuality in the service of the body politic implies that desire must be "disciplined," to use Michel Foucault's widely quoted concept: in modernity, sexuality is constituted only through the law and thereby exists only by virtue of the law.[22]

Against that view stands embodied experience with its implicit claim that sexuality belongs to Yura and Makoto as a birthright. *Futari etchi* spends no time debating theory: the choice to have children is *theirs,* not the state's. The right to enjoy their bodies is *theirs,* not to be denied by governments. The narrative and sidebars show them—and the reader—how to make sexuality one's own and thereby escape the appliqué of political necessity laid on it by politicians. If the state declines to teach about condoms, then this story *will* teach contraception—and how to use body lotion. *Futari etchi* belongs to a long tradition of Japanese art that places sexuality at the forefront, independent of bureaucratic plans and policies.

An interesting question for future research concerns reader reactions to *Futari etchi.* On one Web site, *Futari etchi* in unlicensed English translation had a 91 percent rating, ranked 31 out of 346 titles, putting it in the top 10 percent of reader popularity. Readers on another Web site clearly liked the combination of sexually explicit art and "science," as one reader put it.[23] Further information about these reactions would be valuable for researchers in sex education and popular culture, especially reactions from readers of the licensed French, German, Spanish, and Japanese editions.

Futari etchi is underlain by a strong position of sexual responsibility, which foregrounds nuances and complexities not in a pornographic utopia but in reality. For many readers, it seems that pleasure and responsibility form a very welcome message. The translation of *Futari etchi* into French, German, and Spanish points to a globalization of sexual tolerance, also reflected in the tolerance of male-male sexuality in *yaoi* manga.[24] We hope that the English-speaking world will appreciate and benefit from *Futari etchi*'s message of enjoyable and responsible sexuality.

Notes

We would like to thank William Benzon and Robert T. Francoeur for helpful comments. We also thank Maureen Donovan of the Ohio State University Cartoon Research Library and Liana Zhou of the Kinsey Institute Library for generous help with references. Our gratitude also goes to Philip Tromovitch of Tokyo Medical and Dental University, for comments about Japanese sex education.

1. Katsu Aki, *Step up love story: Futari etchi* (Tokyo: Hakusensha, 1997–), www .younganimal.com/futarih/comics/index.html; translated into French by Christophe Martins Da Silva as *Step up love story: Futari H* (Brussels, Belgium: Pika Edition Senpai, 2004–), www.senpai.fr/ficheserie.php?id=27. References throughout the text refer to the French edition. Unlicensed and unauthorized English translations ("scanlations") of *Futari etchi* exist on the Web but were not used to prepare this essay.

2. Alex Comfort, *The New Joy of Sex* (New York: Crown, 1991); and Hilda Hutcherson, *What Your Mother Never Told You about S-e-x* (New York: Putnam's, 2002).

3. Quoted in "Kazuo Koike," in *Lone Wolf and Cub*, vol. 4 of *The Bell Warden*, by Koike Kazuo and Kojima Goseki (Milwaukie, Ore.: Dark Horse Comics, 2000), 312.

4. See Katsu Aki, *Yura Yura (Futari etchi manga)* (Tokyo: Hakusensha, 2001).

5. Alice Mabel Bacon, *Japanese Girls and Women* (1891; rpt. New York: Gordan, 1975), 58 n. 1.

6. Timothy Perper and Martha Cornog, "Eroticism for the Masses: Japanese Manga Comics and Their Assimilation into the U.S.," *Sexuality and Culture* 6 (2002): 70–73.

7. Walter Edwards, *Modern Japan through Its Weddings: Gender, Person, and Society in Ritual Portrayal* (Stanford, Calif.: Stanford University Press, 1989), chap. 3.

8. See Hatano Yoshiro and Shimazaki Suguo, "Japan (Nippon)," in *The Continuum Complete International Encyclopedia of Sexuality, Updated with More Countries,* ed. Robert T. Francoeur and Raymond J. Noonan (New York: Continuum, 2004), 645.

9. Howard S. Levy and Ishihara Akira, *The Tao of Sex: The Essence of Medical Prescriptions (Ishimpo),* 3rd ed. (Lower Lake, Calif.: Integral, 1989), 156–57.

10. Timothy Perper, *Sex Signals: The Biology of Love* (Philadelphia: ISI, 1985).

11. Yonezawa Rika, *Tenshi no mayu* [Cocoon of angels] (Tokyo: Hakusensha, 1998); and Ovid, *The Art of Love* (New York: Stravon, 1949).

12. F. Hadland Davis, *Myths and Legends of Japan* (1913; rpt. New York: Dover, 1992), 144.

13. U-Jin, *Sakura tsūshin* [Cherry blossom letters], vol. 1 (Tokyo: Action Comics/ Futabasha, 2001), 20–22; and *Maria-sama ga miteru* [The Virgin Mary is watching], dir. by Matsushita Yukihiro, TV series (2004), subtitled DVD (Tokyo: Geneon, 2004), episode 11.

14. Edwards, *Modern Japan through Its Weddings,* 113, 123–25. See also Samuel Coleman, *Family Planning in Japanese Society: Traditional Birth Control in a Modern Urban Culture* (1983; rpt. Princeton, N.J.: Princeton University Press, 1991); and Kawahara Yukari, "Diverse Strategies in Classroom Instruction: Sex Education in Japanese Secondary Schools," *Japanese Studies* 20 (2000): 295–311.

15. Utatane Hiroyuki, "Ryu-Ho," in *Countdown: Sex Bombs* (Seattle: Eros Comix, 1996), 79–88; and Mana-ko, *Itazura na kanojo* [Trickster girlfriend] (Tokyo: Belle Comics/ Furomu Shuppan, 2003).

16. Coleman, *Family Planning in Japanese Society*; and Kawahara Yukari, "Politics, Pedagogy, and Sexuality: Sex Education in Japanese Secondary Schools" (PhD diss., Yale University, 1996; Ann Arbor, Mich.: University Microfilms #9713673).

17. Kawahara, "Politics, Pedagogy, and Sexuality"; and Philip Tromovitch, e-mail message to authors, November 25, 2005.

18. Kawahara, "Politics, Pedagogy, and Sexuality."

19. Ibid.

20. Kawahara, "Politics, Pedagogy, and Sexuality"; and Kawahara, "Diverse Strategies in Classroom Instruction."

21. Suzuki Michiko, "Progress and Love Marriage: Rereading Tanizaki Jun'ichirō's Chijin no Ai," *Journal of Japanese Studies* 31 (2005): 357–84.

22. Michel Foucault, *The History of Sexuality,* trans. Robert Hurley, 3 vols. (New York: Pantheon, 1978), 1: 113.

23. A total of 1,472 readers posted comments; see http://www.cgwild.net/ downloadlist.cfm?titleid=308 (accessed April 2, 2006); for the complete list, see http:// www.cgwild.net/titlesbyrating.cfm (accessed April 2, 2006). On the combination of explicit art and "science," see http://www.stoptazmo.com/manga-series-comments/ futari_ecchi/futari_ecchi_007.php (accessed April 2, 2006).

24. Mark McHarry, "*Yaoi*: Redrawing Male Love," *Guide Magazine* (November 2003), http://www.guidemag.com/magcontent/invokemagcontent.cfm?ID=FB6AEC3D-D13C-4976-82C190236231C0F7 (accessed June 18, 2004).

My Father, He Killed Me; My Mother, She Ate Me: Self, Desire, Engendering, and the Mother in *Neon Genesis Evangelion*

In an oneiric excerpt from the *Zohar,* a key text of Jewish mysticism, we learn of a strange event that takes place before the primal parents' expulsion from Eden:

> Now return: Adam and Eve are still in Paradise when Samael, with a little boy in tow, accosts Eve. "Would you mind merely keeping an eye on my son?" he asks her. "I will soon return." Eve agrees.
>
> Returning from a walk in Paradise, Adam follows the piercing squeals of the child back to Eve.
>
> "It is Samael's," she tells a vexed Adam. His anxiety increases along with the screams of the little one, which grow unbearably violent. Beside himself, Adam delivers a blow that kills the youngster then and there. Yet its body continues to wail at a fever pitch, monstrous groans that do not stop when Adam cuts the corpse into bits.
>
> Then Adam cooked the pieces of flesh and bone that remained, to wipe out this fiend. Together with Eve, he ate all that was left. They had hardly finished when Samael called for his son. Denying all knowledge of his son, the culprits were protesting their innocence when suddenly a louder voice

cried out from within their stomachs to silence them: it was the dead boy's voice, come straight from their hearts, his words directed to Samael.

"Leave me, now that I've pierced the hearts of both Adam and Eve. I remain in their hearts forever, and in their children's hearts, their children's children—until the last generation I abide here."[1]

Taken out of its context as part of a multilayered text of rabbinical hermeneutics aimed toward psychic and spiritual insight, this story forces us to engage it on a most primeval level, one that is essentially preverbal. It is by inference rather than direct analysis that we become aware of a compendium of some of the most primal human fears and anxieties, among them the uncanniness of birth and death; the many forms and terrors of ingestion, including sex; the cannibalistic bond of parent-child relationships and the allure of incest, as well as the presence in our entrails of the seeds of both reproduction and death. It is this level of primal sexual, thanatic, and generative terror that I wish to address in regard to Anno Hideaki's *Neon Genesis Evangelion* (*Shinseiki evangerion*), a corpus that includes the initial twenty-six-episode TV series (aired from October 1995 to March 1996) and the subsequent feature films, *Death and Rebirth* (1997) and *End of Evangelion* (1997).[2] As the title indicates, *Neon Genesis Evangelion* literally posits itself as the "gospel of a new genesis," a work that questions and ponders the source and meaning of human life. By drawing on particular Judeo-Christian mytho-religious sources, specifically the kabbalistic and "gnostic" interpretations of *The Book of Genesis* that inform Anno's script,[3] I hope to address the series' strong generative thematics. I suggest this birthing and reproductive imperative is located in the figure of the mother, who paradoxically becomes a tyrannical, self-reproducing and re-creating entity that impedes generational progression and maturation. However, in the end and in the guise of her more benign and reproductive aspects, she becomes the final sacrifice that paves the entrance into a new order of psychological and sexual potentiality.

Evangelion is, without doubt, one of the most complex anime serials produced in the late 1990s, a rumination and critique on its own nature as cultural and ideological product, art and artifice. The show's proclivity for self-referentiality, parody, pastiche, metalepsis, and, ultimately, deconstruction provides us with a general instance of what Umberto Eco has termed *opera aperta,* or "open work," a piece that allows and even requires multiple interpretations from the reader.[4] There is no single or straight interpretation of *Evangelion* based on its plot sources: like many of the esoteric works it references, it is layered, crowded with riddles, arguably overcoded. Elements are

> EVANGELION IS, WITHOUT DOUBT, ONE OF THE MOST COMPLEX ANIME SERIALS PRODUCED IN THE LATE 1990S, A RUMINATION AND CRITIQUE ON ITS OWN NATURE AS CULTURAL AND IDEOLOGICAL PRODUCT, ART AND ARTIFICE.

shuffled, recombined, and altered to provide a new mythology that nevertheless maintains a dialectical connection to the original traditions.

A combination of family melodrama and coming-of-age narrative, the series follows the story of solipsistic teenager Ikari Shinji. In a postapocalyptic world following a disaster known as the Second Impact, Shinji and two other troubled fourteen year olds, Asuka Sōryū Langley and Ayanami Rei, have been chosen to pilot the exclusive Evangelion (or Eva) units, which are employed to protect humanity from the attacks of ostensibly alien life forms called "angels" (*shito* in Japanese). The creation of the three Eva units (00, 01, and 02) and the defensive work are carried out by an institution known as Nerv ("nerve" in German), a subsidiary of the Seele organization (German for "soul"). A new angel appears in each episode, always different and seemingly more powerful than the last. Variously taking the form of monsters, clouds, and abstract geometric shapes, the angels attack the Nerv base with progressively powerful versions of the ultimate weapon, the "AT field," but are successively repulsed by the Evas.

Nerv is commanded by Ikari Gendō, Shinji's estranged father. Most of Nerv's main personnel, are, in fact, tied by a combination of past and blood histories, a sort of dysfunctional postapocalyptic original family. As the story progresses, we learn that the Evas are not mere robots to which the children neurologically connect but huge organic shells made in the image of the first angel, which was found in Antarctica and is known as Adam. Adam's counterpart is the angel Lilith, a giant humanoid figure Nerv has captured and keeps crucified in the basement of their headquarters (see Figure 1). In fact, it was the hubristic human attempt to reduce Adam to embryonic form that caused the explosion of the Second Impact. Like angels and humans, the Evas have souls, and it is later discovered that Shinji and Asuka's units have those of their disappeared mothers. The third Eva might have the soul of Akagi Naoko, the mastermind behind Nerv's supercomputer MAGI and mother of the computer engineer Akagi Ritsuko.

We learn that Gendō and Seele have been pursuing distinct goals under the pretense of defending humanity. Both seek to generate a Third Impact that will obliterate humanity and return human souls to a primeval preconscious state of being. But while Seele's aim is religious and apocalyptic in nature, Gendō instead wants to launch the "Instrumentality Process." This

will dissolve humankind into an insubstantial and undifferentiated psychic commonality, enabling Gendō's longed-for reunion with Yui, his dead wife and Shinji's mother. The last angel to attack Nerv takes the shape of a teenager called Nagisa Kaoru. He explains that while the angels are derived from Adam, humanity (or the "Lilim") has sprung from Lilith, and that the return of either life form to its respective source will obliterate the other one. At this point, it becomes clear that what is at stake for Nerv, Seele, and even the angels is a kind of return to an original womb. We also learn that Rei is a clone made from human and angelic material: the crucified Lilith and Shinji's mother, Yui. Fleshed out of Lilith and Adam respectively, Rei and Kaoru come to stand in for the primeval parents.[5] Kaoru points out that they are "the same," emphasizing the similarity between the two apparently opposed primal angels. The difference between humans and angels is also ultimately illusory. Kaoru reveals that the AT field, the angelic weapon humans have learned to copy, is in fact the soul that links them both. By the final film, humanity is disclosed as the "last angel," suggesting that the final source of life is a cosmic whole comprising all the dualities that are necessary for separate forms of life and consciousness to exist (see Figure 2).

FIGURE 1. The angel Lilith held in Nerv's basement, shown in episode 15 from the TV series.

FIGURE 2. Manifesting life's consciousness and forces, Rei and Kaoru face Shinji across a primordial sea of human bodies/souls in *End of Evangelion*.

As is also made clear in the movie, it is up to Shinji to decide whether humanity should dissolve into an eternal unified psyche (his father's dream) or whether individuals should maintain their differentiated characters along with the physical and psychic alienation resulting from that condition. His final choice is a return to individuation firmly anchored in the body's materiality. This is merely hinted at in the last two episodes, which take place in an ambivalent space encompassing the protagonist's mind and the animator's blank cells. These focus on Shinji's final psychic individuation, but the movie caps the character's journey by emphasizing the physicality of his struggle.

While *Evangelion* turns on concepts of origin and regeneration and bases its narrative on specifically Judeo-Christian tales of human origin, it does not follow the biblical text per se as much as assorted religious interpretations. Gnostic Christian versions of the creation story,[6] as well as Judaic traditions from the Midrash, *Zohar,* and other kabbalistic and rabbinical commentary on *Genesis,* contribute a sizable part of its source material. The figures of Adam and Lilith, the concept of Lilith's brood—the *lilim*—and some of the angel lore are all drawn from Hebrew sources. The diagram of the tree of the *sefirot,* which decorates the ceiling of Gendō's office and is displayed during the TV series opening titles (see Figure 3), is also a prominent kabbalistic image that, as I show below, is related to creation and engenderment.

FIGURE 3. In a symbolic gesture suggestive of an act of cosmic creation, a shadowy female hand traces an invisible line while a diagram of the tree of the *sefirot,* which traces the pathways between infinity and the material world, floats upward during the opening titles of the *Evangelion* TV series.

Lilith appears in a number of Jewish commentaries that address the discrepancies between Genesis 1.26–27 and 2.22–23. In Genesis 1.26 God talks about creating humankind in the plural sense, and 1.27 reads, "So God created man [Hebrew: *et ha adam*] in his image, / in the image of God he created him; / male and female he created them [Heb.: *otam*]." But 2.22 narrates Eve's creation from Adam's rib, and 2.23 ends with the words "this one shall be called Woman [Heb.: *ishshah*], / for out of Man [Heb.: *ish*] this one was taken."[7] This incongruity, which owes to the fact that there are two versions of Genesis woven into one (the so-called Priestly and non-Priestly sources), has resulted in a variety of religious interpretations (both Judaic and Christian), including that of Lilith as the "First Woman." According to some traditions, she was Adam's first wife, made from soil just like he was (albeit from debris, rather than pure earth) and not from Adam himself. The *Zohar* says she fled when Adam received a spirit and God separated Adam's female aspect, Eve, from him; *The Alphabet of Ben Sira* says they parted over discrepancies of who should be on top during the sexual act (Lilith insisted that, since she had been created

> AS IN THE CASE OF THE GNOSTIC MYTH, THE EXISTENCE OF A FEMININE PRESENCE THAT IS TELEOLOGICALLY MATERNAL IS A CRUCIAL ASPECT OF *EVANGELION*.

equal to Adam, she should).[8] The *Alphabet* also mentions that she knows the secret name of God, which allows her to reach a particular covenant with him after she illicitly leaves Eden and Adam. As a symbol, Lilith represents the female aspect of temptation and is portrayed as belonging to the "Other Side," a kind of shadow world where libidinal and deep unconscious desires go unchecked. She is the female aspect of a *qliphah* (a shell or husk of evil), the male part being Samael, who figures in the opening quote. In this male–female duality they form a couple that functions vis-à-vis Adam and Eve. Samael preys on women, while Lilith preys on men during their dreams, leading to nocturnal emissions and spilled seed that produces demons.

This prompts possible readings of *Evangelion* as a narrative of psychic struggles between ego and unconscious, Jungian shadow and anima/animus. It also situates the series at the beginning of psychic and mythic time rather than at the end of it. The primal parents in the anime—the angels Adam and Lilith as well as their agents, the human/angel clone Rei and the humanlike angel Kaoru—parallel the original male and female entities of Hebrew myth. *Evangelion*'s Adam is associated with the angels, beings indiscernible to the human mind and associated with a higher power, while the scientifically arrogant, passion-prone, and dysfunctional humans are linked to Lilith, a figure associated with forbidden knowledge of the godhead, unrestrained desire (both physical and psychic), and irrationality in the Jewish sources.

In the gnostic retellings of Genesis, not only does Eve have a counterpart: God does as well.[9] These sources posit the concept of a fallen material world fashioned by a tyrannical demiurge who, along with his associates, tried to create humanity as a copy of a luminous, original Perfect Human or an Adam of Light, "an unflawed distillation of the divine image" (see Figure 4).[10] In *Evangelion,* the demiurge and his corulers (the archons) are clearly paralleled by Gendō and the Nerv personnel who experiment with the angels Adam and Lilith: both ultimately fail to imbue higher life into their material creation. According to some gnostic accounts, it was the spark of life from the true Divinity or, in other versions, the breath provided by a female emanation of the divine that brought the created Adam to his feet and imbued him with the inherent knowledge of the Divinity. If we consider the *Evangelion* narrative in regard to these sources, the role of the angels Adam and Lilith becomes evident: they represent an ultimate life-essence that escapes human ingenuity but is part of human nature.

FIGURE 4. The angel Adam as a gnostic-inspired giant of light before being reduced to embryonic form, shown in episode 21 from the TV series.

Certain gnostic sources also contribute the very important trope of a female trinity, Eve, Zoe (Life), and Sophia (Wisdom), increasingly sublime and dematerialized aspects of the female principle. Generally, as recounted in the text *On the Origin of the World,* Sophia is the female emanation of the divine, Zoe is her manifestation as material life purveyor, and Eve is both a manifestation of Zoe and the material but divinely informed husk that is left behind when Zoe-Eve's essence enters the Tree of Knowledge, thwarting a plan by the demiurge and his archons to rape her. In *Evangelion,* these variegated aspects of the archetypal feminine are carried out in Shinji's relation to a triad composed by his caretaker, Katsuragi Misato, and his fellow pilots Rei and Asuka; they inform the maternal narrative and are also present in Naoko's description of her creation, the MAGI. Despite being named after the Three Wise Men of traditional Christian lore, the computer represents the three aspects of Naoko's self: woman, mother, scientist.[11]

As in the case of the gnostic myth, the existence of a feminine presence that is teleologically maternal is a crucial aspect of *Evangelion.* There are plenty of maternal figures in the series, but only three of them are actual mothers:

Yui, Kyōko, and Naoko have given birth to Shinji, Asuka, and Ritsuko, respectively. Although all of them have ceased to exist in their original individuated shape and entered into the Evas and MAGI, their persons have an almost immutable psychic hold on their children. What is more, their threatening and monstrous aspect seems to be located in the body's materiality, whether that of the Evas, the visceral interiors of the MAGI supercomputers, or the offspring themselves. Just as the Evas and MAGI have absorbed the women, they in turn absorb their children back into these mechanical hybrid bodies: this is the case every time Ritsuko crawls inside MAGI to fix it or the children climb into the "entry plug" cockpits that are then inserted into the Evas. If, in the title of this essay, I have inverted the famous line from Jakob and Wilhelm Grimm's retelling of "The Juniper Tree," "My mother, she killed me. / My father, he ate me,"[12] it is because in *Evangelion* the figure of the mother becomes both literally and metaphorically cannibalistic, ingesting both the bodies and psyches of her children in order to perpetuate herself as an entity whose presence is rooted in her material inescapability.

Mother–daughter relations in *Evangelion* are extremely interesting, all the more given their violence and vampiric, often sterile nature. Here, however, I focus on the figures of Yui and Shinji, given the prominence of the mother–son bond in the narrative of ingestion, death, and rebirth located in the mother's body. As a barely formed memory in Shinji's mind, Yui appears as a benign Madonna. This is particularly evident in the sketch of a breast-feeding woman shown in episodes 20 and 26, as well as in the director's cut of episode 21, where Yui plays with a young Shinji while talking to a colleague. When Shinji is inside the Eva, she appears to him as an essence, a vague memory of a smell, even a state of mind (e.g., episodes 16, 20). It is important to notice, however, that disembodiment is the key to all these memories, not only because of their nature as memories per se but because Yui did not die. Unlike Naoko and Kyōko, whose ends are depicted in materially grotesque and gruesome images, Yui might have ceased to exist as a fleshed ego but did not cease to *be*. Naoko and Kyōko both apparently commit suicide, but in episode 20, Ritsuko recalls that Yui simply physically disappeared inside the Eva. Unlike Kyōko, who survived only to go mad, Yui lost her "ego border" and became that essence which defined her self: while Naoko and Kyōko were characterized and even died by their "woman" aspect in fits of jealousy and guilt, Yui became "all-mother." The shell in which that maternal quintessence survives, exists and, most important, manifests herself is Eva 01.

Shinji's mother, then, contains a kind of Sophia-Zoe-Eve trinity within herself. Her intellectual brilliance, maternal wisdom, status as one of the

founding members of Nerv, and immateriality of her essence, if not her presence, recall Sophia, while the life and soul she has imbued into Unit 01 suggest the role of Zoe. The shell represented by Eve in the gnostic myth is, of course, the Eva itself. Indeed, Yui/Eva often acts as protectress and salve against the demiurgic Gendō, who plays paternal tyrant to Shinji's earthen Adam. But her benign, physically sublimated aspects coexist with the physical ambivalence and violence of the Eva.

When, in episode 14, Asuka tauntingly asks Shinji, who has swapped Evas with Rei, "Hey, Shin-chan, how do you like mommy's breast? Or is it more like inside her womb?" she is not merely pointing to the fundamentally motherly aspect of the Evas. She is also adding to the foreshadowing of Rei's essential nature as a clone of Shinji's mother. No matter which Eva he is in, he will constantly return to her, either through an entry plug in Eva 01 or Ayanami Rei's memories, impression, and "smell" in Eva 00. Shinji's comment, "It smells like Ayanami," elicits the question from Asuka, "What does he mean, smell? Is he a pervert?" which offers an additional, oblique comment on the potential threat of incest. An incestuous moment is symbolically realized whenever a unit takes her child into her via the vaginal/womblike space that receives the phallicized entry plug, enacting a return to the womb (see Figure 5). In Shinji's case, this is further developed when, after attaining a 400 percent synch level with Eva 01, he actually dissolves or disappears in the liquid interior of the entry plug.

It is worth looking in more detail at this incident, which takes place in episode 20, significantly titled "Oral Stage." In episode 19 Shinji has willfully decided to stop piloting after an incident involving his father. When Eva 03 is taken over by an angel, Shinji refuses to act against it, so Gendō takes control of Shinji's Eva and uses

FIGURE 5. Shinji curls into fetal position inside Eva 01, surrounded by the uterine LCL liquid that keeps him alive in his cockpit during episode 20 from the TV series.

it to butcher the hijacked unit 03. The pilot of unit 03, Shinji then learns, was one of his school friends. As he is leaving town, a new angel attacks, quickly defeats Rei and Asuka, and proceeds on to Nerv's headquarters. After a crucial encounter with Kaji Ryōji, his adopted father-figure, Shinji returns to Nerv,

asserts himself to Gendō ("I am the pilot of Evangelion 01! Ikari Shinji!") and pilots the Eva, dragging the angel out of headquarters just in the nick of time. Once outside, the Eva's power supply runs out, but just when all seems lost, Unit 01 responds to Shinji's frenetic pleas and proceeds to defeat the angel. In the process, she regenerates her lost arm with flesh taken off her enemy's body. Once the angel has been vanquished, Unit 01, growling and walking on all fours, begins to eat it, consuming the angel's power-core, the S-2 engine. This happens along with a reincorporation of the flesh of the child, as Shinji himself is swallowed by Unit 01 in episode 20.

In episode 24, Kaoru asserts that the angels and Evas are derived from Adam (either as human-made replicas or actual offspring) and that humans are Lilith's brood. Elsewhere, we learn that Eva 01 was built from Lilith's flesh. If all this is true, then, in this scene, the Eva is eating its sibling (the angel, child of Lilith's primordial counterpart Adam) along with its child and progenitor (Shinji, a manifestation of Lilith) and even its own self, since it was created from Lilith by Nerv. She becomes wholly individuated and complete (or, as Ryōji says, "awakes") once she has ingested the flesh of her counterpart as well as that which engendered and composes her. This not only results in an inversion of the birthing process but also an inversion of death, which is normally taken to occur outside the womb—it is, in fact, the inevitable ontological result of exiting the womb. The Eva is, then, a physically potent alpha and omega: a being that, by erasing the traces of both its inception and procreation, has become utterly invulnerable and single, embodying its origin, reproduction, and end.[13]

The Eva's ingestion of Shinji wrenches him away from his own physical self as well as his father's side, bringing him the closest he can possibly get to his place of origin. Inside, he confronts, among other things, the trinity of Misato, Rei, and Asuka, who float naked in an ethereal, luminous space and repeatedly ask him if he wants to become one with them. This event functions on various levels. On the one hand, it is a reference to Gendō's secular conception of the gnostic concept of the "pleroma,"[14] an absolute dissolution of individual consciousnesses into a collective eternal awareness that, by eliminating all lacks that result from unfulfilled desires, eliminates all traces of ego. Melding with Misato, Rei, and Asuka, Shinji ceases to be who he is, and they cease to be themselves, becoming part of an asexual, impersonal, and immaterial bliss that exists outside time and space. This is exactly what starts happening in episode 25, when Gendō's Instrumentality project is launched. But the disappearance inside the Eva is also Shinji's encounter with a sort of "eternal feminine" that is traced back to the mother not as an individual but

as a state of being. This mother–child du-
ality/proximity is the closest postnatal
approximation to a cessation of alterity.
By swallowing Shinji, holding him inside
for several days, and then expelling him,
Eva/Yui reconstitutes herself as source
and potentiality, a union of mother and

> THE EVA'S INGESTION OF SHINJI
> WRENCHES HIM AWAY FROM HIS
> OWN PHYSICAL SELF AS WELL AS
> HIS FATHER'S SIDE, BRINGING HIM
> THE CLOSEST HE CAN POSSIBLY
> GET TO HIS PLACE OF ORIGIN.

child that by bringing dissolution also brings about corporealization. Inside
the Eva, Shinji dies and is gestated at the same time, enclosing within himself
all the life potential contained in the motherly life source.

However, if we focus on this event as a portrayal of sexual anxiety, one
that is inherently tied to the mother's image, then we have to anchor this
in the body's materiality. (After all, even if Shinji's "corpo-reality" has dis-
solved, he is still inside the Eva's body.) Thus the pertinent associated myth
might not be the gnostic trinity of Eve-Zoe-Sophia, who represent a tran-
scendence of the body, but the Jewish Lilith, the mythical primal consort,
killer of children and oneiric temptress, who makes men fruitlessly spill
their seed and whose love, once tasted, prevents them from ever finding
satisfaction with human women. As David Rosenberg points out, the kab-
balah's imagery of "failed sex, especially the spilling of semen in sleep or
masturbation" attributed to "unconscious intercourse with Lilith . . . proves
psychologically valid today in terms of the mind's daily struggle between
unsuppressed desires and thoughts."[15] At the same time this imagery of
sexual wastage implies a negation of the procreative human impulse. These
two levels of interpretation are made manifest in *Evangelion.* The crucified
figure in Nerv's basement shows an aspect of Lilith that constitutes an ex-
ternal physical presence who, in her primal maternity, offers the keys to
both engendering and physical dissolution, with the latter's implied cessa-
tion of sexual and psychic desires. But in *End of Evangelion,* when Rei finally
melds with the crucified angel to begin the process of Instrumentality and
becomes a giant, metamorphosing force, the presence of Lilith is rendered
simultaneously physical and abstract. As a motherly figure who, in the sec-
ond half of the movie, participates actively in Shinji's internal discourse,
counsels him during the dissolution of Instrumentality, is depicted melding
with him in physical coitus—holding him in her lap and ultimately giving
way to the physical presence of Yui—she also becomes a symbol of inter-
nalized sexuality, onanism, oedipal desire, and stagnation, a cipher for the
refusal and/or inability to individuate sexually and psychically, as well as the
latent potential to do so (see Figure 6).

FIGURE 6. Rei melds with Shinji in a psychic coitus of sorts during *End of Evangelion,* simultaneously portraying sexual desires and anxieties and the immaterial unity brought about by Instrumentality.

The myth of Lilith is part of a tradition emblematized in the diagram of the tree of the *sefirot,* mentioned earlier in this essay. The *sefirot* are interacting and reproducing emanations of Ein Sof, the Divine Being, an ultimate source that exists beyond human comprehension. They encompass the creative, generative power of divinity in ten different aspects and bridge the physical and metaphysical distances between infinity and the created world. The image of the tree whose symbolic roots are at the source of divine power and whose branches reach down into the plane of physical reality represents the notion of a continuous and fluid relationship with the divine. Seen in correlation to the human body, this diagram envisions the act of human reproduction as a kind of theogony: "In the eyes of the kabbalists, the genealogy of bodies makes manifest an invisible chain whose first links constitute the divine order itself, the creative activity brought forth in human procreative activity."[16] This stands almost in direct opposition to the gnostic notions of corporeality, which, although they recognize the body as "the best *visible* trace of the divine in the material world"[17] also paradoxically categorize it as an "enclosure of the light,"[18] the "prison" in which a tyrannical demiurge has confined the essentially divine soul (just as Gendō's construction of the Evas ultimately confines the souls of his wife and others within these shells).

While gnostic revisions of Genesis conceive the very creation of man as a fall from an abstracted original bliss, kabbalistic readings tend to focus on the divine imperative "Be fruitful and multiply, and fill the earth."[19] It is these two opposing views that are at play during the anime's grand finale, which starts in the last two episodes of the TV series and finishes in the movie *End of Evangelion*.

Through a complex series of events, humanity's final encounters with the angels trigger the Instrumentality process, which unravels the fabric of the existing world and threatens to swallow up all individuals into a single collective state. Shinji alone remains unaffected, perhaps because he is shielded by Eva/Yui and chosen over Gendō by Lilith/Rei, and is presented with the chance to refuse Instrumentality and remake the physical world. While Gendō and Seele both sought, through different means and with different attitudes, a cessation of individuation and an end to materiality, reproduction, and engenderment, Shinji eventually embraces the procreative imperative, returning the whole narrative to physicality and, furthermore, to the body as potential source of life. This was already implied in the last installment of the TV series when the protagonist let go of the psychological ghosts of his parents in order to individuate himself fully ("To my father, thank you. To my mother, farewell"). However, the final two episodes contained a number of metatextual elements that problematized not only the nature of representation but also that of a material reality existing outside the individual mind,[20] opening up questions about the physical integrity of the body. *End of Evangelion* resolves this mind–body dichotomy with a smorgasbord of mytho-sexual and sexual images and, more important, a series of eminently physical final gestures: Shinji tries to strangle Asuka, Asuka strokes Shinji's cheek, Shinji collapses sobbing, and Asuka's final words, "How disgusting," tie mental impressions and emotions to an elementary bodily response (repulsion). These brief exchanges signal a return to the immanence of the body.

In episode 20, Yui's disembodied voice floats through the uterine consciousness of the Eva 01: "If you have the will to live, anywhere can be heaven." She repeats similar words to Shinji toward the conclusion of *End of Evangelion*. Unlike the vampiric Naoko and Kyōko, Yui/Eva 01/Rei/Lilith ultimately acts as *the* force of development and engenderment. Her self-reproducing nature becomes the final sacrifice that will allow

> SHINJI EVENTUALLY EMBRACES THE PROCREATIVE IMPERATIVE, RETURNING THE WHOLE NARRATIVE TO PHYSICALITY AND, FURTHERMORE, TO THE BODY AS POTENTIAL SOURCE OF LIFE.

the "new genesis" promised in the title to come into being. The fact that Rei/Lilith melds with or transforms into Kaoru suggests a variety of possibilities: while it arguably adds homosociality and unresolved homosexual desires to the list of issues impeding Shinji's sexual and psychic maturation, it also calls attention to the fact that split, dualistic appearances are ultimately manifestations of a holistic cosmic force (see Figure 7). This is important because bringing Adam/Kaoru and Lilith/Rei into one emphasizes the essentially androgynous character of the procreative embodiment, prompting us to locate the motherly potential in Shinji's male body. His refusal of Instrumentality is, after all, humanity's rebirth.

In other words, Shinji's own birthing process must come to an end, and he must now embody the generative power. While this force was previously personified as a circular process by the maternal figure, Shinji presents it in its linear aspect, opening up the possibility of generational reproduction and a new beginning for humanity. Mother and child are indeed one but, like the angels Adam and Lilith, they must be one differently and separately in the world of Shinji's choosing. It is indispensable that Shinji let go both of his mother's ghost and the Eva in order to individuate fully. By the same token, the mother in all her aspects (Yui/Eva 01/Lilith/Rei) must end the cyclicality of her relationship with the son and cut the metaphoric umbilical cord that still ties them: Yui, Rei, the Eva, and Lilith must all cease to be physically

FIGURE 7. Branching out at the torso like a Y, a giant and malleable Rei-Kaoru approaches Shinji's gleaming Eva 01 in *End of Evangelion,* underscoring the androgynous natures of the psyche and the generative impulse.

present in Shinji's new world. As Eva 01 floats into outer space to live as "eternal proof that humankind has existed" (here humans have indeed created god), the body of Lilith/Rei crumbles. While this material manifestation of the "All Mother" could also have become the way to an eternal, cyclical return to a uterine unconsciousness, it is her physical death and disintegration that are the ultimate source of life and herald a new reproductive order.

In the final scene, Shinji and the reborn Asuka lie on the shore by a sea of LCL, the uterine fluid that fills the entry plugs and *Evangelion*'s primordial soup. Discouraging as this might seem, the two dysfunctional teenagers now stand as a new Adam and Eve, a primal earthly couple through whose direct—or indirect—agency the world will repopulate itself. In a sense, they will all be the children of the eternal Eva-mother, and the reconstitution and engenderment of human life will continue, carrying inside all its fears and anxieties, along with its creative and generative power, "until the last generation."

..

Notes

1. Translation by David Rosenberg, included in his book *Dreams of Being Eaten Alive: The Literary Core of the Kabbalah* (New York: Harmony Books, 2000), 63–64.

2. *Shinseiki evangerion,* dir. Anno Hideaki, TV series, 26 episodes (1995–96); translated as *Neon Genesis Evangelion: Platinum Complete,* 6-DVD box set (ADV Films, 2005); *End of Evangelion,* dir. Anno Hideaki (1997), DVD (Manga Entertainment, 2002).

3. The use of the term *gnostic* is increasingly debated among historians. Here I use it as the convenient denomination commonly ascribed to the works that concern me, mainly the Nag Hammadi texts. See *The Nag Hammadi Library in English,* ed. James M. Robinson, 3rd rev. ed. (New York: HarperCollins, 1990).

4. Umberto Eco, *Opera aperta* (Milan: Bompiani, 1962). Some of these aspects, as well as their relevance in the problematic conclusion of the TV series, have been addressed by Susan Napier in her article "When the Machines Stop: Fantasy, Reality, and Terminal Identity in *Neon Genesis Evangelion* and *Serial Experiments Lain,*" *Science Fiction Studies* 29 (2002): 419–35.

5. This is made evident during *End of Evangelion,* where the two characters are often depicted side by side as geminate, linked or mirror images, and Rei even metamorphoses into Kaoru.

6. As far as Christian sources are concerned, a substantial part of *Evangelion*'s narrative is derived from the so-called Gnostic Gospels, though it also deals with a variety of notions related to orthodox Christian narratives like the book of Revelation and the New Testament's Gospels. In fact, depending on what *Evangelion* source we pick, Kaoru, Rei, Shinji, and Gendō can all be seen, at different points of the narrative and under different guises, as valid Christ figures or analogues. This kind of interpretive network applies to all major characters and events in the series. It could also be said that Hinduism, Zoroastrianism, and Buddhism are important narrative and ideological undercurrents. The series does

not necessarily engage all these narratives in a coherent, consistent, or comparable manner, but uses them to shape its scope and vision. Ultimately, it seems to me that, in the specific case of Christian lore, the orthodox elements are subsumed by the gnostic vision, maybe because the latter is more congenial to Anno's psychological, introspective narrative intent.

7. *The New Oxford Annotated Bible,* 3rd ed. (Oxford: Oxford University Press, 2001).

8. *Le Zohar,* 6 vols. translated and annotated by Charles Mopsik (Éditions Verdier, 1981–99); Elena Romero, *Andanzas y prodigios de Ben-Sirá: Edición del texto judeoespañol y traducción del texto hebreo* (Madrid: Consejo Superior de Investigaciones Científicas, 2001).

9. See *The Apocryphon of John, The Hypostasis of the Archons, On the Origin of the World,* and *The Testimony of Truth,* in *The Nag Hammadi Library,* 104–23, 161–69, 170–89, 448–59.

10. Michael A. Williams, "Divine Image—Prison of Flesh: Perceptions of the Body in Ancient Gnosticism," in *Fragments for a History of the Human Body,* ed. Michel Feher, Ramona Naddaff, and Nadia Tazi (New York: Zone, 1989), 1:132.

11. As Dennis Redmond has pointed out, this also stands as a twist on the patriarchal structure of Father, Son, and Holy Ghost. Redmond, *The World Is Watching: Video as Multinational Aesthetics, 1967–1995,* chapters 6 and 7, http://www.efn.org/~dredmond/GV.html (accessed December 14, 2005).

12. Jacob and Wilhelm Grimm, "The Juniper Tree," in *The Complete Fairy Tales of the Brothers Grimm,* trans. Jack Zipes (New York: Bantam Books, 1992), 175.

13. A similar event has already been portrayed in episode 16, "Splitting of the Breast." In this case, Shinji and Unit 01 are swallowed by an angel's Dirac sea, and when Shinji has lost all hope, Eva 01 activates itself and proceeds to literally rip its way out of the angel's round shadow.

14. Gnostic myth distinguishes between the lower manifestations of the universe (i.e., the material world and its psychic and material elements) and the pleroma as a transcendental space that contains the Divinity and its emanations and manifestations, a higher state of being beyond rational comprehension. When I speak of Gendō's Instrumentality project as a "secular pleroma," it is because his view is based on a massive, human psychic integration that does not aspire to relocation in a higher spiritual and religious existence, as Gendō's rival Seele does.

15. Rosenberg, *Dreams of Being Eaten Alive,* 18.

16. Charles Mopsik, "The Body of Engenderment in the Hebrew Bible, the Rabbinic Tradition and the Kabbalah," in Feher, Naddaff, and Tazia, *Fragments for a History,* 1:68.

17. Williams, "Divine Image," 130.

18. *On the Origin of the World,* 180.

19. Genesis 1:28, *New Oxford Annotated Bible.*

20. Among the many problematic elements in the last two episodes of the TV series, we have scenes in which the scriptwriters appear, implicitly if not explicitly, and rewrite the show's ending; sequences of events that seem to take place within a theater inside Shinji's mind; and moments where the characters appear as preparatory sketches or are drawn upon the animator's blank cel from scratch. See Napier, "When the Machines Stop."

希望
Horizons

Fly Away Old Home: Memory and Salvation in *Haibane-Renmei*

When the shadows of this life have gone,
I'll fly away
Like a bird from prison bars has flown,
I'll fly away
—"I'll Fly Away" (traditional Southern gospel song)

A girl is falling from the sky. Distractedly she wonders where she is as a crow grabs onto her robe and vainly tries to stop her descent. "You can't," she calmly tells it, "but thank you." The crow leaves as the clouds part, showing the ground rushing up. In the next scene, five young women with halos and small nonfunctional wings are very excited about the appearance of a gray cocoon nearly filling one room in their rundown dormitory. Inside the cocoon floats the falling girl, now asleep. After the cocoon bursts open, the girl wakes up in a bed surrounded by the winged girls. One of the older ones, the apparent leader of the group, lights a cigarette, then leans forward to say, "Now, tell us about your dream."

Thus begins Abe Yoshitoshi's (known in the United States as yoshitoshi ABe) haunting thirteen-episode anime series *Haibane-Renmei*.[1] It is unique

among anime in that it focuses on spiritual questions implicit in the use of dreams and memories that lead ultimately to the characters' quests for forgiveness and salvation. The spirituality of *Haibane-Renmei,* like the religious traditions of Japan itself, is a conglomeration of elements. It appropriates Buddhist and Christian ideas and imagery without ever explicitly alluding to either one. ABe combines these religious traditions with his own personal spiritual elements to create a curious mixture that produces an original and emotionally powerful anime. The most obvious appropriated Christian element is the appearance of the young women themselves. Despite their wings and halos, they are not angels but Haibane (Japanese for "gray or charcoal-colored feathers"), and ABe has said explicitly that they do not represent Christian angels.[2] As the falling girl tries to remember her name, she realizes she has lost all of her memories before her dream. She has entered a strange afterlife that can be viewed as either some form of purgatory (Christian) or as simply another reincarnation on the wheel of life (Buddhist). She is given a new halo, and her wings emerge later in a bloody sequence that is part fever dream and reminiscent of childbirth.

FIGURE 1. The Old Home Haibane look on expectantly at the about-to-burst cocoon. Reki is in the center with the cigarette. Clockwise from the upper left are Hikari, Nemu, Kū, and Kana. Copyright yoshitoshi ABe * Aureole Secret Factory.

The salvation possible through the power of memory is the key element in *Haibane-Renmei*. As all Haibane emerge without any knowledge of their previous life, the recovery of some memory and understanding of their actions from before their cocoon dream becomes the key to self-discovery, identity, and finally the mode of their forgiveness and salvation. The first thing the group does is bestow a defining name on the Haibane hatchling in a shamanic-like tradition of taking a name from the cocoon dream, so the falling girl is named "Rakka" (Japanese for "falling"). The name of the leader, Reki, means "pebbles" because she dreamed of walking on a pebbled road.

Rakka begins exploring her strange new life as a Haibane in this dream world known as Glie (pronounced *guri*). Their residence is an old countryside boarding school called "Old Home" where they care for about ten young Haibane children under the age of six. A few miles away is the small town where normal humans live and beyond that are at least two more Haibane "nests" in the countryside. The town and countryside are completely surrounded by a thirty-meter-high wall, and neither Haibane nor humans are allowed outside. The world of Glie is a claustrophobic one, but few of the human residents seem to notice or care. Living their entire lives there, they seem to exist in a comfortable dreamlike eternal present with little regard for their own past or curiosity about the world beyond, or even the existence of the Haibane within their world. Strange hooded and masked people from outside the wall called the Tōga are allowed in on a limited basis through the wall's one gate to trade, but they can interact only with the members of a monastic sect in Glie called the Haibane Renmei ("charcoal feather federation"). The only other creatures allowed to transgress the wall are the birds who, according to the Glie folklore, carry the lost memories from the Haibane's previous lives. Thus the wall becomes the border between the memories of the past and the lack of memory in Glie's present.

The Renmei sect oversees the welfare of the Haibane, regulating their interactions with the humans. The sect appears to have some knowledge of the Haibane's past existence that it keeps secret from them. The Haibane must work, but they get no pay. Instead, the Renmei see that their needs are supplied. Here ABe turns the traditional Christian imagery of angels upside down. While angels have direct knowledge of God and are superior to humans in the Christian spiritual and social order, the Haibane are treated as second-class citizens in Glie. Although the humans consider the Haibane as

> THE SALVATION POSSIBLE THROUGH THE POWER OF MEMORY IS THE KEY ELEMENT IN *HAIBANE-RENMEI.*

lucky omens, most keep their distance from them. The Haibane are not al-
lowed to live in the town: hence their "nests" in abandoned buildings in the
countryside, and they are allowed to own only used possessions, including
their clothing. In both imagery and terminology, the Haibane are frequently
equated with the birds that play a profound and sublime role in this story.
ABe seems to be suggesting that the Haibane, being without memory, are
somewhere between the level of the animals and humans, and it is our mem-
ories that make us fully human.

Haibane-Renmei owes as much in its contents and context to contem-
porary Japanese literature and film, and to ABe's own subconscious, as it
does to other anime. In an interview,[3] ABe revealed that his favorite novel is
Murakami Haruki's *Hardboiled Wonderland and the End of the World,* and that
some of the imagery in *Haibane-Renmei* was influenced by the imagery in
the novel: a dreamlike world surrounded by a wall, along with underground
waterways, bird imagery, and a library of unknown books. At their cores both
Murakami's novel and *Haibane-Renmei* represent struggles by their protago-
nists to find salvation and sense in the midst of obscure and mystic events.
The narrator in the novel's "End of the World" section works in the walled-off
town's library as its resident "dreamreader," where he "reads" the lost memo-
ries and dreams off of unicorn skulls. The theme of recapturing lost memo-
ries appears in both stories with protagonists who can achieve their salvation
only through the revelation of these lost dreams and memories.

Another influence for ABe was the 1998 Japanese film *Wandafuru raifu*
(*After Life*), a fantasy where the souls of the recently deceased are brought to
a dingy school dormitory where they must decide what one moment of their
entire life they will carry into eternity. Again this parallels *Haibane-Renmei*
in that some of the characters in the film are unable to move on to the next
stage of the afterlife until they come to terms with their actions in their pre-
vious life. But most unusually, *Haibane-Renmei* originated with ABe as an ex-
periment in writing a story completely from his subconscious. He wanted
"to see what would happen if I made up a story ad lib without a solid plan
for the characters and the world. I thought if I told a story with only things
that pop up in my mind spontaneously, I might be able to peep into my own
subconscious."[4] For example, the knowledge of the walls as the repository of
the memories of the people, which then released them at the end of the year,
was something he did not anticipate as an aspect of the story until he wrote
that line of dialogue. "I wondered why I had written such a thing," he said.
"But, as I felt it was a good image . . . I decided to adopt it, believing there
must be some meaning."[5]

The theme of attempting to recover the memory of their past first appears clearly in episode 5 where Rakka follows one of the older Haibane, Nemu, to her job in the Glie library. Nemu and her human supervisor, Sumika, have been trying vainly for years to find anything in

the library about the world outside the walls or the origin of this world. Without any official origin story, Nemu tried to write one, to construct a memory, as a gift to Sumika, but could not think of a conclusion. Rakka suggests a conclusion, and the episode ends with a voice-over as the two of them narrate their composite version. Nemu begins with the standard motif of God creating light, sky, land, and sea, and all the creatures in it. The mountains and valleys were created when his staff slipped, to which God says, "It was a mistake, but it was just as well," echoing perhaps ABe's own spontaneous creative process. God's first attempt to create beings in his image produces the Haibane, who are a failure because they are too similar to him. He turns their wings to gray, makes a hole in their halos, and pushes them to the back of his mind, planning to erase them later. God's second attempt produces humans without wings or halos, and that is satisfactory. Rakka picks up the story, saying that God then fell asleep, and the Haibane escaped while he was dreaming. Thus the Haibane are without their memories of consciousness: they are dream things living in a dream world. When God awoke, he, being tolerant of his mistakes, decided to let them be. God, like ABe, is creating ad lib, relying on inspired mistakes that work.

Religion can be considered as a "sacred canopy" as described by the sociologist Peter Berger.[6] In this view, religion serves as the social construction, the canopy or overarching belief system that surrounds and supports a society or a group, providing order to their personal experiences by (1) providing a history, a set of memories; (2) giving a sense of knowing their place within the cosmos that comes with an acknowledgment of the past times and places established through memory; and (3) providing meaning and salvation in the face of the upheavals and tragedies. In writing their own creation story, Rakka and Nemu are providing the first two parts for this religious system: they create a history where there was none and a structural meaning to their existence in relation to a cosmos that they no longer quite remember. The third and final role of religion appears next in the story.

Until now there had been no explanation, or even question, about the future or fate of the Haibane: Rakka was simply learning her way around this

new world. But in episode 6, Kū, the youngest of this group of Haibane (about fourteen years old), leaves one morning and fails to return when a thunderstorm strikes. Before leaving, she cryptically tells Rakka that the drinking cup in her mind is now full, thanking Rakka for supplying some of the drops. During the storm Rakka witnesses a shaft of light rise out of the Western Woods into the sky and then disappear. When she mentions this later, it upsets the others, and they explain that this indicates that Kū has reached her "Day of Flight," the time she leaves her existence as a Haibane and flies beyond the walls. The remaining five of them hike out to a ruined temple in the Western Woods near the wall, finding only a few remaining feathers and Kū's now dull halo lying on the ground. Reki explains to Rakka during the hike, "There is no way of telling when the day [of flight] will come or to whom. He or she just disappears without warning. No one knows why such things happen." Until now, Glie had been presented as a mysterious afterlife for the Haibane, but at this point it becomes clear that it is more of a way station. Each Haibane has only a few years to prepare for his or her Day of Flight to the next stage of existence. But the purpose of spending time at this way station, or what one is supposed to achieve in Glie, remains a mystery, even to the Haibane themselves.

> THE STAINS ON REKI'S AND RAKKA'S WINGS ARE REFLECTIONS OF THE STATE OF THEIR SOULS AND THEIR REPRESSED MEMORIES.

As winter arrives, the once cheerful Rakka sinks into depression over the loss of Kū, and black spots appear on the tips of her feathers. She begins cutting off the tips, but the spots, like a cancer, reappear and grow larger. Reki notices the cuts and confronts her, causing Rakka to break down completely. Reki reassures her that she is not ill and applies some special dye that covers over the spots. When Rakka asks why she has this dye, Reki confesses that her wings have been black since she emerged from her cocoon. She is a "sin-bound" Haibane, one who cannot fully remember her cocoon dream and will probably never have a Day of Flight. "A good Haibane lives here happily," she tells Rakka, "and goes beyond the walls when their time comes. But once in a while, a Haibane who cannot be blessed by the town is born. For such an unblessed Haibane the town becomes a cage which offers no escape."

The English term *sin-bound* is loaded with cultural meaning and connotations that may or may not exist in the original Japanese. The Japanese term used here is *tsumitsuki,* and its proper translation was a key point of debate among American fans.[7] *Tsumitsuki* combines *tsumi,* meaning "sin," "crime," or "guilt," with *tsuku,* meaning "attached to" or "stained with." Thus it could be

translated as "stained with sin" or "guilt-haunted."[8] In Christianity the term *sin* carries the connotation that the person has committed a moral wrong and that an absolute judgment has been imposed on them externally. But in Japanese culture, drawing from Shinto and Buddhist traditions, the concept of personal shame or guilt that is generated internally is more prevalent. Although ABe himself approved of the choice of "sin-bound" in the English translation,[9] "guilt-haunted" or "guilt-bound" might have been closer to the Japanese meaning. The stains on Reki's and Rakka's wings are reflections of the state of their souls and their repressed memories. Both of them are suffering from despair over their lost memories, creating a sense of guilt that each feels but cannot name. "This town exists for the Haibane," Reki tells Rakka, implying perhaps that the only reason Glie exists is to provide a stage for each Haibane to work through his or her spiritual dilemmas, but neither feels worthy of the care and grace given to them. For them, the problems of theodicy, the questions of suffering, evil, and their ultimate fate, hit home with full force. "I don't know why I became a Haibane," Rakka tells Reki later: "If I'm to disappear someday without accomplishing anything, what's the meaning of my existence?" In the recognition of their common plight, the plot turns from the story of Rakka into the intertwined story of Rakka and Reki as each takes a different path on their separate searches for salvation. "I think there is a meaning," Reki replies to Rakka's questions. "Only you have to find it."

Over several episodes the backstory of Reki emerges. She hatched from her cocoon with black-stained wings seven years before at age eleven and was discovered by Nemu and an older Haibane named Kuramori. The black wings frightened Nemu and the humans in town, but Kuramori protected Reki, giving her the first unconditional love she had experienced in this or, probably, her previous life. But for all her nurturing of Nemu and Reki, she never explained the Day of Flight to them, so when she disappeared without warning, Reki took it as a personal affront and felt abandoned and betrayed. Running away from Old Home, she was taken in by the coed nest of Haibane at the "Abandoned Factory" nest. Believing that Kuramori was still alive somewhere outside the walls, she convinced Hyōko, a teenaged male Haibane, to help her climb over the wall. But the walls were too powerful, and Hyōko nearly died just from touching them. For this crime the Haibane-Renmei sent Reki back to Old Home, forbidding her and Hyōko from crossing over to the other's territory. Although the town remained neutral territory, their anger at each other prevented any reconciliation afterward. Back at Old Home Reki still could not recall any of her cocoon dream other than walking on a pebbled road at night. Plagued by nightmare images from her forgotten cocoon dream,

she begins painting in an effort to re-create the images of her dreams. When asked what the show's spiritual message was, ABe said, "*Haibane* is my own process of trying to find answers to spiritual questions."[10] Both ABe and Reki use the creative process not only to recover their loss but also to construct a story in which they can build a potential for salvation in hopes of reconciling their creative constructions of the world with their memories.

Rakka's depression does not lift, and she flees to the countryside. At her lowest point, a crow calls to her. Until now, almost every episode had a scene where crows called and Rakka turned to look, most notably when a crow's call gets Rakka's attention just in time to see Kū's Day of Flight. What seemed to be just throwaway shots now take on a significant meaning. Kana alluded to this earlier, telling Rakka that the birds are believed to carry "lost items" from the Haibane's previous lives over the walls. Rakka follows them through the Western Woods to an abandoned well. As the crows watch, she climbs into the well but falls, is knocked unconscious, and redreams her cocoon dream of falling and the crow trying to help her. When she awakens, she is lying at the bottom of the dry well next to a crow's skeleton. She feels as if the remains are actually of someone from her previous life who had taken the form of a crow in her dream to protect her. A Buddhist concept of enlightenment is represented through Rakka's experience at the bottom of the well: it is a place of spiritual retreat, a place of solitude away from the world where she now can see and remember clearly. ABe is echoing a motif from another of Murakami's novels, *The Wind-Up Bird Chronicle,* where the narrator seeks enlightenment by retreating into an abandoned well in suburban Tokyo. Rakka's memory of the dream crow and her recognition of it as someone from her past become the first steps on her path to remembrance and enlightenment. She buries the bird's remains in the well's dirt floor, telling it, "I can't remember who you are, except that you're somebody precious to me. I thought no one would grieve, even if I were gone. But you were by my side. You became a bird to go over the walls and let me know that I was not alone."

Unable to climb out of the well, she is rescued when two members of the Tōga discover her. However, once she is out, they leave her to find her own way through the snowy woods. Lost, she encounters the Communicator, the head of the Renmei sect and the only one of them who is allowed to speak. As he leads her out of the woods, they discuss her dream and her realization that she had hurt someone in her previous life. She shows him her spotted feathers and asks if she is sin-bound. The Communicator replies by telling her a riddle. A key Buddhist concept is that salvation comes through understanding and enlightenment, and a Haibane must reach this same state before they

FIGURE 2. Kuramori holding Reki just after she emerged from her cocoon. Copyright yoshitoshi ABe * Aureole Secret Factory.

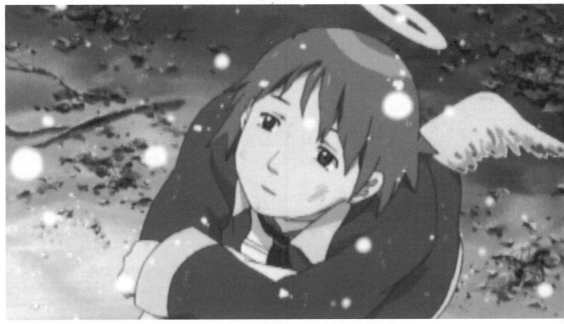

FIGURE 3. Rakka at the bottom of the well with snow falling. Copyright yoshitoshi ABe * Aureole Secret Factory.

are allowed their Day of Flight. The Communicator uses the classic Buddhist style of teaching with a koan, a paradoxical riddle. He tells Rakka, "One who recognizes their own sin, has no sin." Then he asks her if she is a sinner. Rakka sees the contradiction no matter which way she answers. The Communicator calls this the "Circle of Sin" where one is "going around in the same circle looking to find where the sin lies . . . you cannot help going in circles if you are alone . . . but if you have someone by your side . . ." With this clue, Rakka becomes enlightened not by answering the paradox but by going beyond it through her acceptance of the bird's gift of memory, through an acknowledgment of a need to recognize and bury the dead bird and thus make it right, and the enlightened path she discovers enables her to escape her circle of sin. Back at Old Home Reki discovers Rakka's wings are no longer discolored: she is no longer sin-bound. Though outwardly glad, Reki is inwardly hurt, fearing that Rakka no longer needs her and that yet another person she loves will "fly away" without her being able to follow.

The Renmei give Rakka a job cleaning the underground canal that runs along inside and under the massive circular wall that surround Glie. There she must gather the *kohaku* ("light leaves") that appear on walls inside the tunnel and from which halos are made for the new Haibane. The interior walls are covered with the plaques with unknown writing on them. The Communicator explains that each Haibane has a plaque, and "when the time comes" (presumably when they achieve their enlightenment), the writing on the plaque is mysteriously changed to reflect the "true name" of the Haibane.

A key theme in *Haibane-Renmei* is the meaning of names and the power they hold over the characters. This traditional belief in shamanic cultures shows up in modern fantasy works from Ursula Le Guin's *Earthsea* novels where wizards draw their power over nature from their knowledge of the true names of all things, to Miyazaki Hayao's film *Spirited Away,* where the witch Yubaba controls the workers at her bathhouse for the gods by stealing their names. The Haibane are given names based on their cocoon dream but receive their true names later as part of their journey to reach their Day of Flight. In Glie, they use Japanese writing and the true name is pronounced the same as the dream name but written with different characters to give it a different meaning: a type of pun that is possible in Japanese. The Communicator gives Rakka a box containing a tag with her name written not as her dream name, "falling," but as her true name meaning "involved nut." Arriving in Glie closed up and cut off from others like a seed, she had sprouted and grown by becoming involved with the others. This is a further example of the Buddhist concept of salvation through enlightenment, through coming to remember

and understand the self's true nature, in this case through the attainment of a true name that reflects the Haibane's innermost being. The Communicator also gives her a box containing the tag with Reki's true name, telling her not to give it to Reki until after the passing of the year festival.

The final part of the series focuses on Reki's ultimate fate and salvation. Resigned to never achieving her Day of Flight, she would be happy to stay indefinitely at Old Home, caring for the children and the newcomers. But the Communicator warns her that she has little time left. Later he explains to Rakka that while rare, it is possible for a Haibane's time to expire while still being in a state of spiritual darkness, never achieving a Day of Flight. Those who remain "are no longer called Haibane. They lose their wings and halos and live away from both the humans and the Haibane, and sooner or later they grow old and die. It is a quiet and peaceful, but lonely life." ABe may be implying that the Tōga or the Renmei themselves are "failed Haibane," but he never says so explicitly in the series and avoided answering the question when interviewed.[11]

> A KEY THEME IN *HAIBANE-RENMEI* IS THE MEANING OF NAMES AND THE POWER THEY HOLD OVER THE CHARACTERS.

The story's climax comes in the early morning hours after the passing of the year festival. Exhausted from the celebration, all the Old Home Haibane are asleep in the commons room as Reki sneaks out, saying "good-bye" as she leaves. Rakka wakes and follows her to her studio. In the dim light Rakka is horrified to see Reki has covered the walls, ceiling, and floor with a dark, disturbing painting of the scene from her cocoon dream. Rakka gives her the box with her name tag from the Communicator. Reki opens the box to find her name rewritten as "the one run over and torn apart." At last she remembers her dream and her death: the pebbled road is the railroad track on which she had committed suicide by throwing herself in front of a train. This knowledge of her true name and nature from her past drives her into complete despair, turning her wings completely black. Reki turns on Rakka, screaming that she hates her for being blessed while there is no hope for her own forgiveness. Rakka flees the room in tears, leaving Reki alone as an image of a distant train in the painting begins moving slowly toward her.

In Christianity, despair is the ultimate sin: the shutting off of oneself from hope, from God, and from the opportunity for salvation. This is why traditional Catholic theology considered suicide the one unforgivable sin: that the person had destroyed not only a life (his or her own) but also any chance for redemption. But in Christianity, salvation cannot be forced on someone

from the outside. Salvation comes only when the person recognizes his or her sins and is then granted forgiveness and thus redeemed. Alone in the dreamscape, Reki sees a memory of her younger human self before her suicide, who challenges her, asking why she never asked for help. "I was afraid," the older Reki sobs; "What if I ask for help from the bottom of my heart and nobody answers?" Convinced that she is beyond hope and not worthy of any salvation, Reki turns to face the oncoming train. She has killed herself once and been given a second chance for redemption in Glie; now the oncoming train represents the complete and the final obliteration of her soul.

Realizing that she had the bird to save her from her circle of sin but that Reki has no one, Rakka decides that "I will be the bird who saves Reki." Plunging back into the studio and the surreal dreamscape, Rakka sees Reki frozen in front of the oncoming train. When she tries to save her, the younger Reki holds Rakka back, saying, "Reki chose to vanish here." It is only when Reki works up the courage to ask for help outside herself, to call out to Rakka, that the spell is broken and Rakka is able to push her out of the way in time. Afterward Reki's wings have, for the first time in her existence as a Haibane, become a pure ashen gray, and the true name on her tag has been mysteriously rewritten to say "small stone," meaning "the stepping stone that guides the weak to their Day of Flight." Having at last recalled and overcome the lost memories of her past sins, and with the knowledge that she has finally been forgiven, Reki leaves Old Home at dawn to take her Day of Flight. Only Rakka is there to say good-bye, but the others join her later to witness the light of Reki's spirit rising into the sky. The final line in this series echoes the redemptive power of memories with a voice-over of Rakka saying, "I will never forget Reki."

Two key elements of Christianity come into play at the end. First, the idea that Reki must ask for help herself echoes the concept of free will in Christianity, which requires that the sinner must ask for forgiveness. Salvation cannot be forced on a person, and it is pride, stubbornness, or, in Reki's case, fear that prevents her from reaching outside herself for salvation. But it is Rakka from outside who brings Reki the "good news," the gospel she learned from the crow: *that she is not alone!* Reki's sin was *not* that she committed suicide but that she was so afraid of being hurt that she refused to ask for outside help and tried to work out her salvation alone. Second, Reki's dilemma echoes a classic debate within Christian theology over whether salvation is achieved by grace from outside or by works performed by the individual. Reki clearly chooses the latter. "I believed that if I stayed a good Haibane I would someday be able to shed this sense of guilt," she tells Rakka in her final dreamscape. Although her redemption ultimately comes from outside, Reki's efforts at

being "a good Haibane" were not wasted, as the final judgment of the Communicator states, "This was [originally] merely pretense . . . yet it became her true nature."

So in the end, what does ABe mean? He has said that he does not want to answer any of the puzzles in the story but would rather leave them ambiguous: "It is not a story to find answers, but one to wonder about the answers . . . think for yourself and apply your own answers to it. That will surely make this story very special for you."[12] Another clue comes from ABe's own essay where he writes that the story was about himself and the events that had occurred at the end of his teenaged years, including memories of "many deaths I had witnessed, and very similar incidents. . . . I had searched for a long time for meaning and relief, [because of] the many unreasonable deaths which had occurred before my own eyes; thus, I could say that this became one of the primary factors that gave birth to the Haibane."[13] And elsewhere, he repeats that the story is based on his personal memories, saying, "My experience is filtered into a fictional story, but if I could have the audience feel something similar to what I had felt at the end . . . then maybe it would become something meaningful."[14]

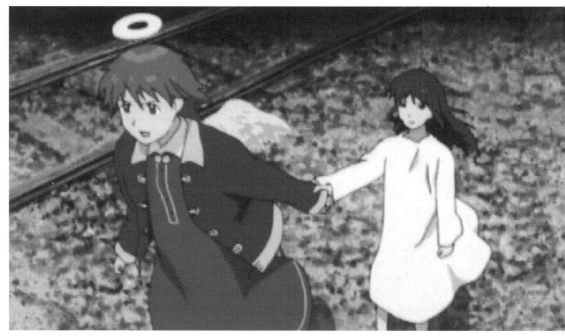

FIGURE 4. Rakka attempting to rescue Reki in her dreamscape but being held back by the younger human Reki. Copyright yoshitoshi ABe * Aureole Secret Factory.

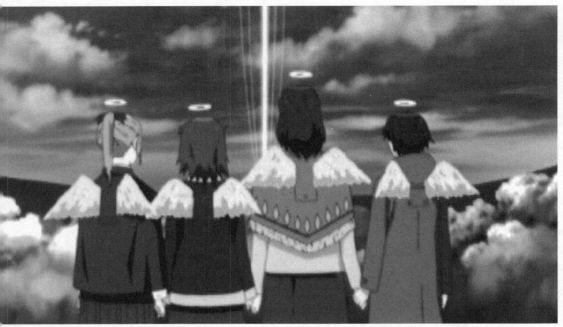

FIGURE 5. The remaining Old Home Haibane witnessing Reki's Day of Flight. Copyright yoshitoshi ABe * Aureole Secret Factory.

Notes

I am indebted to Frenchy Lunning, Deborah Scally, and Nobutoshi Ito for helpful discussions in preparing this essay.

1. *Haibane-Renmei* was originally broadcast on Japanese TV from October to December 2002. The series was released in Japan on 5 DVDs by Pioneer in early 2003 and in the United States on 4 DVDs by Geneon in late 2003 and early 2004. All quotations from the series are taken from the English translation used for the subtitles in the U.S. release.

2. Yoshitoshi Abe, panel interview at *Anime Expo,* Anaheim, California, July 2003.

3. Yoshitoshi Abe, interview by Marc Hairston and Nobutoshi Ito, translation by Nobotoshi Ito, *Animerica* 11, no. 9 (September 2003): 43–47.

4. Ibid.

5. Ibid.

6. Peter L. Berger, *The Sacred Canopy: Elements of a Sociological Theory of Religion* (New York: Doubleday, 1967), 35–38.

7. An excellent and intelligent forum of discussions about *Haibane-Renmei* is the "Old Home Bulletin Board: A Haibane-Renmei forum," http://cff.ssw.net/forum/. For a discussion of the translation of *tsumitsuki,* see the thread "Reki's interpretation of what it means to be '*tsumitsuki,*'" May 19–23, 2004, http://cff.ssw.net/forum/viewtopic.php?t=589 (accessed December 28, 2005).

8. Tom Wilkes ("ctw"), posting to "Old Home Bulletin Board," September 6, 2003,

http://cff.ssw.net/forum/viewtopic.php?p=954#954 (accessed December 28, 2005); Tom cited information from his Japanese tutor, Mikiyo Hattori.

9. Jonathan Klein, director of the English dub of *Haibane-Renmei,* e-mail message to author, September 14, 2003.

10. Abe, *Anime Expo* panel.

11. Abe, *Animerica* interview.

12. Ibid.

13. Yoshitoshi Abe, "See You, Oldhome," translated by Mikiyo Hattori and Tom Wilkes, posted to "Old Home Bulletin Board," April 2, 2004, http://cff.ssw.net/forum/viewtopic.php?t=458 (accessed December 26, 2005); this Japanese essay by Abe was originally published with the same English title in the liner notes for volume 5 of the Japanese DVD (Pioneer, 2003).

14. Yoshitoshi Abe, "*Haibane-Renmei* Creators' Interview," *Haibane-Renmei,* vol. 4, DVD (Geneon, 2004).

SHU KUGE

• • •

In the World That Is Infinitely Inclusive: Four Theses on *Voices of a Distant Star* and *The Wings of Honneamise*

There is a word, "world" [*sekai*]. Until about the time I was in a middle school, I thought the world meant the area where the signals of my cell phone would reach. But why is it? My cell phone doesn't reach anyone.
—*Voices of a Distant Star*

There is not "subject" and "object," but, rather, there are sites and places, distances: a possible *world* that is already a world.
—Jean-Luc Nancy, "Touching," in *The Sense of the World*

How does the acknowledgment of the immanent spatiality of a relationship, such as the physical distance between people, shape one's ethical as well as aesthetic sense of the "world" (*sekai*) as such? This essay detours from the predominant cultural habits that demarcate the world as a representation of abstract values. To understand the world as the representation of something other than the world itself may cause the loss of the world, because the subject who interprets the world forgets or even resists being part of the spatial world, which is always already inclusive. However, we are often driven to interpretations and thus to losing touch with the world. Being in "touch" with

> **A SPATIAL DISTANCE CAN CONNECT PEOPLE BY SEPARATING THEM; THEY SHARE THE DISTANCE THAT SEPARATES.**

the things in the world or the world itself means to experience one's spatial existence, for example, the fact that one occupies a certain space that continuously connects to other occupied or unoccupied spaces or one's movement in space produces a spatial experience that is not reducible to a meaning. Why is this so important? Such an affirmation of spatial and tangible experience should not be simply taken as a naive return to the immanent body. The experience of the spatiality of existence and relationship is important because that is the source of one's sense of connectedness and hope.

What this essay wants to prove is that distances inspire and connect us. This statement may sound absurd right now. How can a distance that separates us be something positive? But I hope that the following analyses of Shinkai Makoto's *Voices of a Distant Star* (2002, *Hoshi no koe*) and Yamaga Hiroyuki's *Royal Space Force: The Wings of Honneamise* (1987, *Oneamisu no tsubasa*) will make this statement compelling in the end.[1] The worlds presented in these Japanese anime are not peaceful. Mikako, the protagonist of *Voices of a Distant Star,* is a young elite soldier who has been selected for a mission to exterminate Tarsians, aliens threatening the human race. Mikako is an excellent fighter, and we can see in the film her marvelous combat skills. The setting of *The Wings of Honneamise* is a planet that resembles earth. Countries have fought over borderlines, and there is still political tension between them. Shirotsugh (an alternate romanization of the Japanese name Shirotsugu), the protagonist, as a child dreamed of becoming an elite soldier but could not join the military because of his poor grades. Instead, Shirotsugh signs up for the military that does not fight, that is, the Royal Space Force, a laughingstock among other military men. Mikako fights and Shirotsugh does not, but both are caught up in politics and wars that they did not begin. These two anime are by no means pacifist films. Like many other Japanese anime characters, Mikako and Shirotsugh discover truths through the experiences of war, and the fighting scenes, like many action video games, are meant to be entertaining. The underlying moral message of these movies seems bleak; both seem to imply that as long as human history lasts, there will be no end of wars. While such a moral message can be taken as nihilistic, the visual compositions of *Voices of a Distant Star* and *The Wings of Honneamise* invite the audience to a slightly optimistic perspective. These two Japanese animations refigure relationships injured by historical incidents into spatial continuities, which are still part of the world, but possess the potentiality of either suspending ultimate annihilation or penetrating

the designated historical or anthropological limit. This is not the denial of history but the empathetic move to accept the cruel world without translating it into a metaphysical meaning. Thus brutality still remains, but the spatial continuities constantly affirm that these characters are in touch with the cruel world, obliquely showing that this same world is in fact too vast for humans to comprehend, implying that the world remains generous beyond "our" historical imaginations.

DISTANCE, SHARING, SUSPENSION

A spatial distance can connect people by separating them; they share the distance that separates. Such spatial continuity affirms the fact that they live in one large world, instead of separate ones. In *Voices of a Distant Star,* Mikako, on a special mission to hunt threatening aliens, moves away from earth, eventually to another solar system. At every stop in her journey, she sends a text message from her cell phone to Noboru, her boyfriend left on earth. At one point, her e-mail takes a year to reach him. In another solar system, it takes more than eight years. While Mikako is stuck in a specific time and cannot grow up, Noboru goes through the cycles of seasons and matures. We can see that Mikako wears the same school uniform throughout the movie, but Noboru's clothes change according to season and age. While Mikako is usually trapped inside the cockpit of her "mobile suit," a giant combat robot, Noboru walks more freely on earth. While Mikako is more or less free from gravity, Noboru is anchored down by it. Their asymmetrical contexts magnify the enormousness of the distance, but the difference in turn shows the entire world is much bigger than they can imagine; their imaginations are too limited to grasp the "world." The distance between them indeed can be interpreted historically. At the end of the film, there are two scenes in which Mikako doubles: (1) missing Noboru so much, Mikako sees herself crying in a classroom, and (2) one of the Tarsians, the nemesis of humans, takes on a slightly mature figure of Mikako and talks to her. These scenes invite the audience to interpret the entire story from the perspective of Mikako as an older self who retrospectively observes the loneliness that she experienced as an adolescent. Maybe her love toward Noboru was never communicated to him at all, and the distance between them is now completely unbridgeable. Her loneliness lingers and travels through time, affecting her present self. Her solitariness in outer space, however, ironically connects her to Noboru, outside his time. Although they may not be able to "communicate" in a

conventional sense, they feel that they are present in the same vast universe, which essentially exceeds their historical imaginations.

The instance of a text message is stretched far beyond Mikako and Noboru's time; what is taken away is their "instance," or simultaneity. At the same time, this exaggerated context seems to dismantle the illusion they sustained when they were together on earth. Perhaps that they can share the time and space together simultaneously was actually a misapprehension or fantasy; there was always a spatial and temporal distance between them even when they were walking side by side. Two people cannot really occupy the exact same space—there always exists a temporal and spatial gap. Mikako's traveling to another solar system makes the degree of their spatial and temporal difference much more acute. In such a context, the digital instance of text message becomes the analog suspension of *postal* service. Neither can imagine the other party's "present" situation because the message arrives always already eight years old. Mikako could already be dead by the time her message reaches Noboru. He admits that the eight-year gap is equivalent to "forever." There is no way to overcome this cruel time difference that leaves them with a perpetual sense of belatedness. Nevertheless, the visual contrast between Mikako's and Noboru's worlds demonstrates some form of "solution" to this unbridgeable time difference. Throughout the movie, their worlds are spatially placed as parallel worlds, but the difference between their worlds, which are contiguously composed in the continuous movement of the anime as a whole, affirms that the spatial distance ironically proves the one continuous world that both inhabit *separately together*. This realization of continuity allows the characters (and the audience) to recognize that the space that divides them also connects them by separating. They *share* the same dividing distance spatially so that they can perceive each other's presence, if not "present time," which becomes more subjective in this context.

In *The Wings of Honneamise,* Shirotsugh volunteers to become the first man in space, but it does not mean that he lands on the moon or another planet. His mission is not so heroic if reaching or possessing a territory as a new property is always regarded as a heroic act: Shirotsugh becomes a human satellite, lingering in space. During the training, he meets Riqunni, a devout young woman who criticizes the arrogance of civilization, pointing out that it is originated through human transgression (her allusion is to the story of Prometheus stealing fire from the gods). Shirotsugh does not understand her religious commitment but is somewhat inspired by her. Surprisingly, Riqunni's first reaction to Shirotsugh's job is naive: she thinks it wonderful to depart from earthlings' tedious world and venture into space. Shirotsugh,

opportunistically, replies: "There are no national borders in space." Thus, there is no war. Both soon realize that his mission will be another violation of the gods' domain and a global display of power to other countries. Nevertheless, he does not step down from the mission. Rather, he becomes more enthusiastic, since he now has an urge to be inspired by a larger dimension of the world and tries to maintain the innocence of his mission as much as possible.

Like *Voices of a Distant Star,* the distance between two characters is a chief concern in *The Wings of Honneamise.* Shirotsugh is attracted to Riqunni, who shows no sexual interest in him. They become good friends and spend a lot of time together, but there is always an unexplainable gap between them. In one scene, Shirotsugh tries to force Riqunni to have sex with him; his eyes are hollow as if somebody else possessed him. Riqunni eventually knocks his lights out with a lamp. The next morning, Shirotsugh is about to apologize to her, but instead she immediately apologizes to him profusely that everything was her fault and then walks away. This awkward exchange does not help them communicate better, but sustains the physical distance, which Shirotsugh attempted to collapse the previous night. Other scenes actually show that they "communicate" best when they have a physical distance between them. For example, Shirotsugh visits Riqunni the day before he leaves for his mission, but she is not at home. He then hops into a trolley car, and Riqunni almost simultaneously steps out from the same car. She turns and recognizes Shirotsugh on board. They do not talk, but she smiles at him. As the trolley car slowly begins to move, Shirotsugh smiles back, saying "Ittekimasu," which literally means "I am going," a greeting that can be uttered only between family members and close friends. This scene lasts for less than thirty seconds, yet it demonstrates effectively and poetically what their relationship *is*. The physical distance between these two people connects them and sustains them in a particular continuity, although they appear not to share the same space. The same continuity also preserves the erotic energy between them. Collapsing this distance can mean the end of their relationship.

> SPATIALLY SPEAKING, CURIOSITY IS POSSIBLE WHEN THE CONTACT OF THE TWO BODIES IS SUSPENDED.

Adam Phillips states that "when we feel alive or sufficiently awake, something is always getting us going, apparently making us a promise."[2] In other words, "curiosity," a sense of being promised, is an essential element for a healthy relationship. Riqunni maintains distance from Shirotsugh and leaves herself as an object of desire somewhat obscure, probably because she fears that physical proximity as well as the clarity of her interest diminishes a certain degree of her and his curiosity in their relationship. It is not that she is

a tease, but she seems to know that ongoing curiosity, a drive toward the unknown, makes life more valuable; therefore, they can take care of each other better. In other words, the unknown should be sustained. Spatially speaking, curiosity is possible when the contact of the two bodies is suspended. The contact of bodies frequently involves one body possessing the other body, or penetrating the other to destroy it; such an experience can be pleasurable to both parties, yet the moment of possession or penetration oftentimes turns out to be the end of the unknown and thus curiosity. Recall that the main theme of *The Wings of Honneamise* is war over territories. Which country possesses how much land or how it penetrates the other is caricatured throughout the film and contrasted with the Royal Space Force, which actually does not possess any military force. It is not a coincidence that Shirotsugh's enthusiasm for space arises right after he meets Riqunni, who promotes the world of *mythos* that preserves the unknown (because it does not inquire about the "essence" of all that is), instead of that of *logos,* or logical reasoning, which rationalizes physical phenomena. As she sustains her distance from him, his curiosity toward her is also transposed to an unknown territory, that is, outer space. When Shirotsugh reaches the unknown, there is no physical contact. All he can do is float. He seems to realize that the world indeed has no boundaries; in fact, he can float in this one continuous spatiality that includes *everything.* Being sustained by this vast distance, Shirotsugh prays, as if it were the only way to tell others the grandeur of this world.

"STAR FRIENDSHIP"

Both *Voices of a Distant Star* and *The Wings of Honneamise* end with a similar image: the protagonists float in outer space while their beloved remaining on earth looks up at the snowy sky, feeling the distance that separates them. It seems implied that this distance is actually a vast world that contains both of them. As I have discussed, the "distance" between the characters should be understood as a spatial continuity that separates and connects at the same time. Distance evokes a desire for physical closeness, and this in turn inspires movement, but these characters in both *Voices of a Distant Star* and *The Wings of Honneamise* sustain the distance rather than shrink it because sustaining the movement toward closeness is crucial for their relationships to be vast and generous. The topological relationship between the floating and the remaining is actually a mimesis of a stellar relationship, such as the moon and the earth, the earth and the sun. Repetitive references to "stars" in these

movies should not be understood as metaphors; the characters in these anime aspire to become stars in space so as to overcome human dimensions of ethics and history. A stellar relationship is a nonhuman relation that is connected/separated by the law of physics, rather than by that of human values, yet it possesses

"DISTANCE" BETWEEN THE CHARACTERS SHOULD BE UNDERSTOOD AS A SPATIAL CONTINUITY THAT SEPARATES AND CONNECTS AT THE SAME TIME.

a poetical quality that expands one's limited worldview. Friedrich Nietzsche points out the great potentiality in a stellar relation in *The Gay Science*:

> *Star friendship*—We were friends and have become estranged. But this was right, and we do not want to conceal and obscure it from ourselves as if we had reason to feel ashamed. . . . That we have to become estranged is the law *above* us; by the same token we should also become more venerable for each other--and the memory of our former friendship more sacred. There is probably a tremendous but invisible stellar orbit in which our very different ways and goals may be *included* as small parts of this path; let us rise up to this thought. But our life is too short and our power of vision too small for us to be more than friends in this sense of this sublime possibility.—Let us then *believe* in our star friendship even if we should be compelled to be earth enemies.[3]

It is clear that Nietzsche's "science" here is a mythological and poetical kind. That is why his articulation here depends on metamorphosis rather than abstract logics. Generally, friendship is understood as a moral and abstract concept, but Nietzsche poetically figures friendship in terms of spatiality. These "friends-stars" are separated yet connected by the same orbit, or at least they share the same space. Through this poetical picture, Nietzsche suggests that the entire space as one world includes all the heterogeneous stars and their "invisible" orbits. Being in the same vast space, they are connected and separated at the same time, and there is always a spatial distance between them. Nevertheless, the same distance is also spatial continuity that sustains the entire constellation or network. Furthermore, they are *missing each other,* lest their gravities would cause a fatal collision. The image of human civilization here is very different from the history of human progress, for example, narrated by G. W. F. Hegel. By acknowledging the spatiality of human relationships, Nietzsche refigures relationality into something ontological rather than historical. "History," philosophically speaking, often belongs to *logos*, a logical and metaphysical progression of human subjectivity. Meanwhile,

Nietzsche's aim here is to restore the world to *mythos,* in which friendship should be regarded as a spatial and tangible experience.

Nietzsche seems to recognize that any pictorial image is too static and predictable to describe the generosity of friendship and the vastness of the world. That is why he remarks the limit of his imagination toward the end of the passage, calling out, "Let us then *believe* in our star friendship even if we should be compelled to be earth enemies." What does this resolution to belief signify? The line implies that this passage on star-friendship is his prayer, a call to friends who are *out there,* which cannot be shown in the frame of the picture he has set up. A moment of prayer takes place in both *Voices of a Distant Star* and *The Wings of Honneamise.* Mikako and Noboru in the former and Shirotsugh and Riqunni in the latter all form a star-friendship: one member of the couple is floating in outer space while the other remains on earth, looking up at the sky to feel her/his friend's presence somewhere out there. This visual presentation expands the dimension of a human relationship as well as that of the so-called world. The entire scale becomes so vast that it is no longer containable in the frame of the screen; as a matter of fact, the two characters cannot be shown on the same surface; one of them is always *beyond* the frame. This *montage* restores the purity of the couple's relationality, that is, relationality beyond history. It is interesting that the hope for such purity is punctuated with a moment of prayer or prayerlike gesture: Shirotsugh prays; Noboru looks up to the sky and imagines an instance that overcomes history. The film suggests that such an "instance" is not the same instance actualized by technologies or historical narrative. It is rather the empathetic spatial continuity that is the world itself.

I mentioned earlier that these two anime are by no means pacifist films; they do not carry obvious antiwar messages. Their characters are tragically caught in wars, but these characters accept their circumstances rather than resist them. At the same time, their acceptance is not the confirmation of war either. Political conflicts and violence are not resolved in these anime, but by visually affirming the spatiality of friendship beyond history, *Voices of a Distant Star* and *The Wings of Honneamise* suggest the world beyond human history as vast as outer space, which is always already shared by *every-body.*[4]

RHYTHM OF CONTINUITY

The rhythmic movements of cosmic planets existed before human civilization. We may try to bestow humanistic meanings to the universe, but it is

essentially indifferent to us and beyond our interpretations. The history of human civilization teaches us that "purposes" and "missions" are often used as sacrosanct excuses to commit violence. It is accepted as a truism that humans need to fight for some ideal goals to sustain civilization. At one point in *The Wings of Honneamise,* an interviewer asks Shirotsugh to talk about the "purpose" (*shimei*) of his mission. Shirotsugh does not know how to answer this question. The interviewer then says that numerous impoverished people could be saved by the budget used for the Royal Space Force's space mission. Shirotsugh maintains his carefree and playful attitude to elude the interviewer's seriousness, but he is certainly affected by the question. The later part of the movie suggests that Shirotsugh's adamant ignorance or, say, innocence implies that not having a purpose is his purpose; his mission has a point because it is blatantly useless. In fact, every military man and politician ridicules his mission because there are no aliens to fight; other rival countries assume that Shirotsugh's rocket carries missiles. Shirotsugh's lack of purpose (which also means not having a military force to destroy or to subjugate others) is an oblique political gesture against intrinsically war-driven human civilization, yet he still cannot escape from such a world in turmoil. His prayer at the end of the film means not only his hope for a better future but also his unconditional acceptance of *this* world. Meanwhile, there are aliens to fight in *Voices of a Distant Star*; the movie even suggests that defeating Tarsians is necessary for the progress of human history, which is, intriguingly, suggested by one Tarsian. However, Mikako, who is an elite soldier, remains indifferent to the moral value of human civilization while she accepts the circumstance of war and accomplishes her task as a soldier. She declares, "I don't understand" and "All I want is to see Noboru again." As mentioned earlier, she is trapped in a particular time and never grows up in the movie. In a sense, she fights for her as well as the world's *innocence,* which is not fully tainted by history. She pursues and kills Tarsians because they symbolize "civilization" at large. While *Voices of a Distant Star* and *The Wings of Honneamise* show that the fight against innocence is eventually lost, those protagonists' defeat in turn indirectly underlines the world's inherent innocence, which has been forgotten in the name of civilization.

In these two anime, one might trace the Japanese tradition of naturalism or *shizenshugi,* which is rooted in Japanese myth as well as Japanese Buddhist cosmology and ethics, which asserts that the world is intrinsically "pure." Meanwhile, humans disturb its equilibrium, out of fear and greed. The word "shizen" can be translated as "nature" in English, but the connotation is not delimited to objects existing in the physical world. It also can be read as

"jinen," which literally means to "become by itself," indicating the homeostasis of the world. Nature can take care of itself. Human agencies do not play transformative roles in this worldview. Four seasons repeat and will repeat even after all the humans disappear. Stellar constellations existed before human civilization; planets surely return even after you die. *Shizen* is such absolute continuity itself. This cosmology was revised in modern language in the early twentieth century by naturalist authors such as Kunikida Doppo, Shimazaki Tōson, and Tayama Katai. Landscapes and everyday life became these naturalists' preoccupations because they saw "natural" continuities and inherent rhythms, which are free from civilization. For instance, Katai even implies that the rhythm of nature has the power to undo civilization and its purposes.[5]

As a kinetic media, *Voices of a Distant Star* and *The Wings of Honneamise* demonstrate that anime is close to poetry: particular visual sequences create rhythms, restoring or reestablishing the "natural," the innocence of the world. I would like to clarify that "nature" (*shizen*) here does not mean a mere copy of a natural phenomenon. For example, Katai expresses his desire to replicate the rhythm of a running creek in writing, but he actually invents such a rhythm through a combination of words. Thomas LaMarre points out that natural sciences in Japanese anime "are not mobilized . . . to produce characters who correspond via resemblance to the natural world."[6] "Nature" in the cases of Japanese naturalism and anime indeed belongs to a mythological cosmology and physics, which concentrates on the *sense* of flowing, continuity, and permanence. LaMarre in the same essay describes that anime as a media consists of the "decomposing" and "recomposing" of movements in the natural world.[7] Thus the natural is not merely replicated but spatially *recomposed* as a work of art, which in turn affects the audience's perception of nature or the idea of the natural. There may be a play of familiarization and defamiliarization that accentuates the natural. At the end of *Voices of a Distant Star,* Mikako and Noboru traverse the distance, if not diminish it, through the visual memory of the ordinary. They simultaneously recall the most precious things and places in their lives: "Summer clouds," "cold rain," "the smell of a fall breeze," "the sound of rain drops hitting an umbrella," "the softness of spring soil," "the feeling of peace at the convenience store in the middle of the night," "the cool wind after school," "the smell of a chalkboard eraser," "the sound of a truck passing by in the middle of the night," "the smell of asphalt in the rain." Their voices interweave, and the images at the beginning of the movie, those ordinary places they have been together, are repeated in a rapid succession, corresponding to their words. Yet they are not

merely repeated: this time, they are *not* in these images; their absence indirectly affirms that those places and things will continue to exist even ater their deaths, in the same manner that "nature" will continue, indifferent to human history. This technique may remind the audiences of the way Ozu Yasujirō composes "nature" through his idiosyncratic style. Ozu's later films consist of a series of *plates*, whose main protagonists are spaces rather than characters. His camera rarely pans and frequently lingers on an empty space. These plates gathered in a forwarding movement of the film produce a rhythm that affirms absolute continuity indifferent to the decline of family traditions in the postwar Japan.

> AS A KINETIC MEDIA, *VOICES OF A DISTANT STAR* AND *THE WINGS OF HONNEAMISE* DEMONSTRATE THAT ANIME IS CLOSE TO POETRY: PARTICULAR VISUAL SEQUENCES CREATE RHYTHMS, RESTORING OR REESTABLISHING THE "NATURAL," THE INNOCENCE OF THE WORLD.

However, the indifference of nature, which is visually created in Shinkai's anime and Ozu's films, does not deny a given historical context but accepts it. Their works do not call for transformation; instead, they try to restore the purity of the world or the "natural," which is necessarily mythological. Such an artistic endeavor should be understood as an oblique ethical gesture against human civilization.

The Wings of Honneamise closes with Shirotsugh's prayer: he is now in a satellite, revolving around earth. The first things he realizes are the tiny lights on earth that "look like stars," implying that domestic hustling and bustling is invisible from space. Then Shirotsugh broadcasts his prayer through a radio frequency that is so minor that few on earth will be able to catch it. In a sense, Shirotsugh's prayer is not directed at specific people; its addressee is still unknown; it is addressed to the receiver who is still to come in the unknown future. He prays, "This space will become another trifle (*kudaranai*) place where humans inhabit and fight. . . . Please forgive us. . . . Please don't place darkness onto our path." Then he opens his eyes, and a strong ray of light sneaks inside the satellite and blinds him. The camera moves swiftly to the upper right corner, and a series of murky images unfold, as if the ray of light were projecting a film about the history of civilization on Shirotsugh's mental screen: they are about technologies, wars, masses, and daily activities of the human race. These images interpose one another, as if browsing history or mythology books. The image of a smith hammering a hot bar of iron on the anvil is repeated to punctuate these images, and a bright red balloon guides the audience through them. The images underline the mere repetitiveness

of human civilization that does not "progress." Only the technological differences in each period change the intensity of energy and force. This series brings the audience back to the conversation between Shirotsugh and his superior in the middle of the film: The Captain confessed to Shirotsugh that before becoming a soldier, he wanted to become a historian and regretted later that he had studied history at all. For in the midst of war, he rediscovered how repetitive human history had been. The message of the movie is pessimistic, imposing an ethical question: knowing the repetitiveness of human history, how can we go on? After the series of murky images, the camera suddenly comes back to earth: Riqunni is distributing her religious fliers on the street. Snow begins to fall, and she vacantly looks up at the sky. The camera goes away from her toward the sky and captures again the image of Shirotsugh's satellite silently floating.

What is common between the aforementioned scenes from *Voices of a Distant Star* and these "history" sequences from *The Wings of Honneamise* is that they affirm the absolute continuity of nature, which is best described in terms of myth. To a great extent, human civilization does not help the characters in these anime; only a vast cosmology that extends beyond human dimension can help or, to be more precise, can *inspire* them to accept the cruel world so that they can believe in the *generosity* of the world that includes everything and continues even after their deaths. Both anime visually show what the moment of "sympathy" would look like: it looks like the moment one looks up at the sky, *spacing out* and daydreaming about these visual images of absolute continuity. Upon the thought of the universe, one "spaces out" or feels a bit stupid because its dimension is fundamentally unimaginable and sublime. In this aesthetic experience, one is sustained in duration and oblivious to time. We are not sure whether Noboru and Riqunni are optimistic or not. Probably they are not, because their lovers are both out of reach; they are at the limit where humans cannot fully grasp. However, their visual and spatial recomposition of the continuity of nature allows them to be in duration that does not negate but affirms the nothingness of the world. According to Henri Bergson, *la durée* can include all heterogeneity of feelings without negating one another. There is no negation in duration. That is why "sympathy," which consists of contradictory feelings such as pity, abhorrence, and obligation to others and the world, is possible only in the mode of duration.[8] Shinkai's comment on his *The Place We Promised in Our Earlier Day* (2004, *Kumono mukō, yakusoku no basho*) is pertinent here. Upon explaining the importance of landscapes in his works, Shinkai talks about his high school years: he was often bullied and did not

want to go to school, but he was consoled by familiar views from his commuting train: "There was always something to see." And these at once familiar and fresh views granted him a sense of hope.[9] The locomotion is the best example of *la durée*; it can contain heterogeneous elements that the rider perceives in its movement forward. The subject's perception in locomotive movement also can combine, without dissolving, the two spatial planes of perception, the train and the landscape. There is a generous sense of openness in such a synthesis.

PRESENCE/ABSENCE

The Wings of Honneamise closes with a blank appearance of outer space, which suggests the world that humans normally cannot see even if it is the continuation of their world. In other words, humans do not see the vastness of the world or, to be more precise, cannot conceptualize it, since it is beyond their available historical narratives.[10] Perhaps only mythos can describe its grandeur while respecting its mystery. The empty appearance of outer space presented at the end of *The Wings of Honneamise* seems to implicate the audience in this image: you *are* in this cosmic world. A similar ontological affirmation is operated nonvisually at the end of *Voices of a Distant Star*. Mikako floats in space after a harsh battle, and Noboru on earth looks up at a snowy sky, thinking about her. Both mutter simultaneously, "I am here" (*watashi/boku wa koko ni iruyo*). Their voices interpose one another, as if they were next to each other. The last image of the anime is not an image but those words "koko ni iruyo" inscribed in the middle of whitewash screen. The word *koko* is a demonstrative that points to a specific spot in space ("Look, *here*"). In other words, when such a demonstrative is used, the subject is aware of a specific historical context. The nonimage at the end of *Voices of a Distant Star* thus counters the demonstrative with contradiction: the blank space lacks specificity. However, it is possible to understand this absence of visual specificity as the way to present the vastness and generosity of the world whose spatiality could not be contained in the screen's frame. In other words, it simultaneously marks the limit of anime as a visual media and

> THE HIDDEN STATEMENT OF "I AM NOT THERE" IN "I AM HERE" FROM *VOICES OF A DISTANT STAR* AND *THE WINGS OF HONNEAMISE* IS A SENSE OF NOTHINGNESS (*KYOMU*) THAT THE WORLD CONTINUES WITHOUT THEIR EXISTENCE WHILE THEY ARE STILL INEVITABLY PART OF IT.

induces the audience's imagination about the enormous world, which is essentially beyond a person's frame of representation.

There is also a poignant message in Shirotsugh's solitary prayer and Mikako's and Noboru's "I am here." Both implicitly underline the loneliness of the character's positionality in the world: "I am *here*" means that "I am *not* there with you." Presence is closely linked with absence; these ontological conditions are no longer separable. One can say, "I am here" because one is absent from *there*. Yet "I am here" and "I am not there" do not always mean the same thing. The latter would imply some other potentiality than what the demonstrative designates, perhaps, beyond its specificity. Hans Ulrich Gumbrecht and Michael Marrinan explain Bergson's famous distinction between "the table is black" and "the table is not white": "While the first speaks of the table, the second *may* speak of that object, but is essentially a judgment about some other opinion, one that has found it white. . . . it announces that something else *should* be said without specifying what that might be."[11] Moreover, according to Bergson, no idea "will come forth from negation, for it has no other content than that of the affirmative judgment which it judges."[12] Connecting Bergson and Walter Benjamin, whose "entire chain of reasoning springs from a negation incapable of founding an idea," Gumbrecht and Marrinan state that Benjamin is implying that "behind a screen of smoke gently agitated by the breeze of aura is a nothingness—an absence that will not speak its name."[13] I would similarly argue that the hidden statement of "I am not there" in "I am here" from *Voices of a Distant Star* and *The Wings of Honneamise* is a sense of nothingness (*kyomu*) that the world continues without their existence while they are still inevitably part of it. Such a seemingly nihilistic sentiment is indeed melancholic, because it casts an undeniable doubt over the whole concept of history and the ideal image of civilization. At the same time, the awareness of nothingness can be interpreted as an ethical as well as aesthetic worldview, which generously accepts the cruel world and infinitely affirms the infinitely grand world that includes everything.

..

Notes

I would like to express my gratitude to the editors of *Mechademia,* who helped me improve this essay. This essay was not possible without conversations with Tasha Walston, Steven Velozo, and Jared Braiterman, who inspired me to write this piece.

1. *Hoshi no koe,* dir. Shinkai Makoto (2002); translated as *Voices of a Distant Star,* subtitled DVD (ADV Films, 2003); *Onemamisu no tsubasa,* dir. Yamaga Hiroyuki (1987); translated as *Royal Space Force: The Wings of Honneamise,* subtitled DVD (Manga Video, 2000).

2. Adam Phillips, *The Beast in the Nursery: On Curiosity and Other Appetites* (New York: Vintage Books, 1998), 9–10.

3. Friedrich Nietzsche, *The Gay Science,* trans. Walter Kaufmann (New York: Vintage Books, 1974), 225–26.

4. This is most effectively realized in Shinkai's five-minute 1999 anime, "She and Her Cat" (*Kanojo to kanojo no neko*; included as a special feature of *Voices of a Distant Star*). This poetical work is narrated by an anonymous cat, who expresses his admiration for his owner. Through his descriptions, which are concentrated on sensual matters, such as smell, temperature, space, and sound, the world becomes less burdened by historical identities and becomes more immanent. For example, proper names are not important here; their visual appearances are who they are. The cat is intentionally drawn cartoonlike against more photographic images, so his presence is humorously distinct and "light," not overpowering the entire work; in other words, he *floats* throughout the film. The anime ends with a line, "I think that I, and perhaps she, too, like *this* world" (*boku mo, soshite tabun kanojo mo, kono sekai no koto o sukinandato omou*). The owner's voice overlaps with the cat's. What the demonstrative "this" points to is at once specific and broad: while it certainly designates the familiar world that the cat and his owner inhabit, which includes their tiny and generic apartment, the scale of "this" appears to be vast and inclusive because the cat's descriptions are consistently sensuous and spatial. The audience feels at the end of the film that the world is more generous than they remember.

5. For a more detailed analysis of Katai and Japanese naturalism, see my article "Between Sight and Rhythm: Aspects of Modernity in Tayama Katai's 'Flat Depiction,'" *Review of Japanese Culture and Society* 14 (2002): 25–38. Another trace of Japanese naturalism in these anime should be mentioned as well. Respecting the affirmation of spatial continuity, Japanese naturalism tends to be antistructure because *shizen* moves in the opposite direction of totality or wholeness, which is infinity. Perhaps that is why there are no works of Japanese naturalism that can be categorized as bildungsroman, whose main protagonist often travels and eventually *returns,* manifesting not only the completion of his character's unity with the world but also the wholeness of the "program" of his education. Goethe's *Wilhelm Meister's Apprenticeship* is a prime example of this genre. Even Mary Shelley's *Frankenstein,* the parody of *Wilhelm Meister,* still maintains the structure of returning that suggests the totality of being human, to which one should aspire. Meanwhile, many protagonists in Japanese literature, film, and anime do not return, like those in *Voices of a Distant Star* and *The Wings of Honneamise.* Not returning means refusing to grow up, to acquire totality, or to create the enclosure of the world. For example, Murakami Haruki belongs to the tradition of Japanese naturalism to a great extent, because his characters do not come back. Their fantastic journeys and encounters are not meant to form their characters. Murakami's novels before *Sputnik Sweetheart* (whose protagonist actually returns!) converge upon the locomotive movements of these characters. Nonreturning affirms continuity while it decomposes a structure of history while accepting it. Therefore these characters remain "innocent," and the affirmation of innocence, like in *Voices of a Distant Star* and *The Wings of Honneamise,* is actually an indirect ethical gesture against the cruel world. There is not enough space to discuss this, but such a trait of Japanese naturalism has been criticized by many prominent critics, such as Karatani Kōjin and Katō Shūichi, because it prevents the subject from becoming an active moral agent or, say, becoming an

"adult." While respecting these critics' opinions, it is still important to acknowledge that the continuity created by nonreturning in fact creates an empathetic sense of openness.

6. Thomas LaMarre, "From Animation to *Anime:* Drawing Movements and Moving Drawings," *Japan Forum* 14, no. 2 (2002): 346.

7. Ibid., 330, 333, 359–65.

8. Henri Bergson, *Time and Free Will: An Essay on the Immediate Data of Consciousness,* trans. F. L. Pogson (Whitefish, Mont.: Kessinger, 1913), 18–19.

9. A special feature on *The Place We Promised in Our Earlier Day,* subtitled DVD (ADV Films, 2005).

10. Probably humans have to conduct many scientific as well as moral "tests" of the world to produce historical narratives, which may allow them to draw a logical explanation of the world ("epistemology") as opposed to mythological experience of the world. If civilization consists of a series of tests and their results, it can be said that our urge to test the world is motivated by the desire to triumph over the inherent "nothingness" of the world. On this topic of "test drive" and its political and ethical implications, see Avital Ronell, *The Test Drive* (Urbana: University of Illinois Press, 2005).

11. Hans Ulrich Gumbrecht and Michael Marrinan, *Mapping Benjamin: The Work of Art in the Digital Age* (Stanford, Calif.: Stanford University Press, 2003), 289.

12. Ibid., 289.

13. Ibid., 290.

Between the Child and the Mecha

Prevalent in the narratives of anime and manga are the toylike tin men known as the "mobile suit" or "mecha," who are so compelling in their display of a mechanistic majesty and so intriguing in their representation of a complex web of desire. Mecha take many forms, but there are several constants that unite these forms through both their narratives and their visual composition. In narrative they are primarily armor for warring purposes, serving as highly technological protective suits for police or armies, as modes of transport and air travel, and, most significant, as containers for spiritual and physical transcendence for the pilots or operators who control them. As visual images, they are nearly always masculine in form: heavily decked out in idealized weaponry, with each giant muscle of the male form exaggerated and abstracted into sculptural plates of metal that are streamlined into a dynamic composition of hypostatized masculinity.

Yet at the heart of the mecha phenomenon is the paradoxical pilot: a child, or at least an adolescent person. Sometimes female but always an immature identity, this pilot holds the other half of the dual mecha character. The pilot's gender tends to determine the nature of the narrative, in that "the female body is coded as a body-in-connection and the male body as a body-

in-isolation."[1] These gendered and polarized no-
tions of the body determine the goals of the nar-
rative and proscribe the course of the journey for
the pilots and the mecha that transports them.
Whether male or female, adolescent or just im-
mature, the pilot is generally posited as a hu-

man child: a person in the formative stage of development seeking a secured
identity through a bodily identification via sexual and gender-specific tac-
tics. These manga and anime stories produce a keen sense of poignancy and
yearning in the reader/viewer, as a mature secured identity is a rare item in
a contemporary postmodern culture that is obsessed and stuck in seemingly
endless adolescent modes of desire.

Between the child inside and the mecha outside is a gap: a symbol of a
yawning sense of lack suffused with a complex of narratives that lie between
the child-pilot subject and his or her mecha-ideal image of power and agency.
That gap is the space of lack and the consequent production of desire, the
space of conflicting drives and conflating worlds, and the space in which the
sets, lights, and costumes for the performance of the transformation into
maturity are set for what Jacques Lacan describes as the full emergence into
the symbolic realm.[2] These conditions within the space of the gap play per-
haps the most decisive roles in supplying the narrative with its contents, for
in that gap is scripted the journey that will counter the lack of the child with
the image of its desire.

RahXephon is a twenty-six-episode story of a young man's journey from
childhood to his destiny through his personal coming-of-age event that is at
the same time an event that transforms the world. The relationship between
him and his mecha, the RahXephon, is a compelling example of how these
sorts of narratives tend to speak to the issue of identity formation and the
desire that fuels their performance. This anime can be read as an allegory of
Lacan's landmark description of the three stages of subject development and
as such suggests a potential key to the mecha anime and the fascination they
hold. This essay charts the course of the anime against Lacan's description of
the mirror stage, *fort-da,* and the oedipal complex to reveal their compelling
coherence.[3]

The story of *RahXephon* is a dense interplay of interrelationships and an
intertwining narrative of world histories and personal memories. It begins
with the story of Kamina Ayato, a supposedly normal adolescent boy, who,
after being brought to a temple at the end of a subway line in Tokyo after a
train wreck, moves into a tale whose elements become clear only after the

> RAHXEPHON IS THE KEY TO ALL THE RELATIONSHIPS AND THE "WORLD EVENTS," AND THAT AYATO, AS THE ONLY PERSON WHO CAN PILOT IT, IS THE KEY TO THE RAHXEPHON.

viewer has experienced several more episodes. Ayato is an "Ollin": a godlike Mulian of transforming power once he comes into his full self. Yet in the beginning, he is an awkward and moody adolescent for whom the world is his own shallow and lonely existence. The backstory, in brief, is this: in 10,000 BC the empire of the Mu (also known as Atlantis) develops as an extremely advanced technological civilization. Out of this civilization comes the powerful and transforming RahXephon system, developed by Ernst Barbem, a Mulian scientist.[4] In experimenting with it, the world

> bifurcates in two, [as] humanity observes the "destruction" of the Continent of Mu. . . . In reality the continent and the Mu people . . . have been stranded in an alternate reality Earth. . . . Their new situation forces the inhabitants of Mu to resort to the construction of elaborate floating cities . . . the vast bulk of the civic infrastructure on both worlds has been destroyed. Collapse and regression into darker times begins on the human side of the dimensional divide.[5]

This situation has meant that the world has become "out of phase," or "out of time," and the world of the Mu and the world of earth, once one world, are now two. Time for the Mulian world has slowed way behind time in the outside world. A gap has appeared between the two worlds, symbolized by time, the sea, and the dome that surrounds Tokyo-Jupiter. This fact does not become clear until the end of the story, yet as the narrative unfolds, there is a sense that the gap between the worlds represents the gap that is the essential and symbolic landscape of mecha anime narratives.

The story's most intriguing and important aspect, however, is the strange destiny we understand involves Ayato and the RahXephon, the inner child and the outer armored warrior-suit. It becomes clear that the RahXephon is the key to all the relationships and the "world events," and that Ayato, as the only person who can pilot it, is the key to the RahXephon. Around this fact the two worlds collide in a swirling narrative of attack and counterattack that takes place through Ayato's narrative first inside Tokyo-Jupiter, then to the world outside, and continues back and forth as Ayato swivels from world to world in his attempt to understand his place. Deep into the story it becomes clear that the world is not only bifurcated into the Mulian dome of Tokyo-Jupiter and the world outside the dome, but for Ayato, it is also within the

familial gap between his mother, Maya, in Tokyo-Jupiter, and the world of his father, Watari Shirō/Professor Kamina, in the world outside the dome. Ayato's identity and "home" drifts in the gap between these worlds, under profound conditions of ambiguity and contestation as articulated by the demands of his parents and of the psyche.

THE MOTHER AND THE MIRROR

To understand the story's allegorical nature, its deep structure within the gap must be examined. According to Lacan, this gap appears at a specific moment in an individual's development: with the process of identification. After Ayato's experience in the subway wreck, he is pulled into what Lacan called the *mirror stage,* in which "the predominant sensation is one of fragmentation."[6] This stage explains the initial production of the subject in which key psychological structures are put in place. It begins in the infantile condition of a symbiotic relation with the mother's body that is an imagined state of bliss and plenitude, which is fragmented and brought into consciousness by the infant's recognition of itself as an image of self: that is, as if the infant has caught sight of its reflection in a mirror. Of course the image is not the self but the *image of self:* "This self, as the mirror situation suggests, is essentially narcissistic: we arrive at a sense of an 'I' by finding that 'I' reflected back to ourselves by some object or person in the world."[7] And we identify with that image. In the anime, it begins as Ayato is brought to a temple after the accident, lead by a vision of a girl in a yellow dress named Reika, whom he had loved when he was younger. In the immense temple gallery, standing at the edge of a broken shore, he finds a metaphoric reflection of his universe of dual worlds through the huge white egg, a symbol of Tokyo-Jupiter, which is lying across a pastel pool, which then cracks open to reveal the massive RahXephon mecha inside (Figure 1). Ayato instantly collapses into an unconscious fetal position, as the yellow-dress girl hails the mecha. In a later and transformative confrontation, Ayato, who is now emerging into his own self-consciousness, is pulled into the mecha. As he does so, he suddenly sees as the mecha sees: his mother, Maya, back on the shore, falls and cuts herself in front of the RahXephon as she tries to convince him to not to leave. He sees that her blood is blue: she is an "alien" who we understand are the invaders that have taken over and destroyed the rest of the world, all except Tokyo. That is, Ayato is positioned in the gallery to recognize the RahXephon as an ideal image of his self and thus identifies with it. It is itself a hatching

infant, who has fragmented the egg in which it had lain and has hatched at the moment of Ayato's recognition. The mecha's birth acts as a mirror for the performance of Ayato's own emergence from his unconscious fetal and infantile state toward self-consciousness and self-awareness. He, too, will have to break out of the egg of Tokyo-Jupiter to fully emerge as an individual.

FIGURE 1. Ayato confronts the RahXephon.

FIGURE 2. "Who am I?"

The mother, whom he rejects while merging with the RahXephon, bleeds as the separation takes place, and her wound distinguishes her as "alien," as now a different self, as Ayato's new process of self-construction begins. The process of Ayato's desire to consolidate his identity as a plot structure is frequently enforced throughout the *RahXephon* anime by the image of Ayato looking at himself in the mirror and asking the question: "Who am I?" (Figure 2). It serves to continually lock in Ayato's search for identity through the reflection of images as the story's substantive thematic vehicle. Although Lacan explains this initial phase as beginning with an *infant* catching sight of, and the subsequent identification with, the image of his body separated from the body of the mother,[8] a further layer of remove from a strict interpretation of Lacan's theory is necessary and will clarify Ayato's narrative as one of an allegorical description of Lacan's entire narrative. Ayato is initially infantilized by his submissive obedience to his domineering mother and is only separated from his mother's power once he becomes one with the RahXephon. In that instant, as he gains knowledge that her blood is blue, he separates from his mother: not just from her body and the place of her body but in his abjection of the visual evidence of her *difference* from his body, represented by her Mulian (alien) heritage. He refuses the knowledge through repression and forces the RahXephon to eject him from inside the protective world of his mother, Tokyo-Jupiter, to outside the dome and the rest of the world. That is, in the Lacanian sense of the narrative, he has assumed a "specular image,"[9] that of the male ideal of the RahXephon. Though Lacan's description further stipulates that the child is still "sunk in his motor incapacity and nursling dependence,"[10] yet as an allegory of this theory, Ayato is represented as impotent, submissive in all his contacts, and he has difficulty speaking and asserting himself after he arrives on the island of Nirai Kanai, home of TERRA, an organization designed to protect Japan from the continual attacks from inside the dome of Tokyo-Jupiter.

RAHXEPHON AS THE IMAGO

A way to understand the transformation and the nature of this gap of desire is to understand the nature of the RahXephon as an *imago*. In Lacan's mirror-stage theory, he develops a notion of "lack," which further explains the process of identification and the gap of desire for the image of the body outside the self. Lacan addresses *that which the self lacks* rather than the Freudian notion of the "object of desire": "He argues that the human subject has a split

identity, and that we all have a lack. The . . . entity seeking representation is not full in itself; it is not 'pure' because it needs something else. A lack is a precondition for representing oneself."[11] So Lacan's "lack" originates in the illusion of a corporeal unity experienced in the first phase of the mirror stage. Once this illusion is broken and the identity's fragmented nature revealed, the subject experiences a *lack,* or a split in the self's sense of identity into "that which I am," the subject's conscious self, and "that which I lack," revealed through aspects of the self as image. How that lack is articulated becomes part of the structure of individual desire and a blueprint for a projection of the ideal, in this case the image of the RahXephon, a mature and powerful masculine agent. Surprisingly perhaps, this lack plays an essential and literal role in the narrative formula of Ayato, the child inside, and its relation to the mecha Rahxephon. The point of the narrative journey of the mecha and child is "to bring [the] human subject, . . . to recognize and name their desire—the relation of a being to lack."[12]

In its ancient usage, imago refers to a "representation," and further, "the final stage of an animal after the process of all its stages of metamorphosing . . . the perfect stage."[13] Primarily, Lacan links the initial notion of self with an image of the self/body. This linkage or *embodiment* through an image or "representation" in childhood sets up the process of identification for future encounters with cultural representations of "perfect stages" or ideal images for the identification of an ideal self. For a Japanese boy, stories and images of samurai warriors, whose primary goals were to protect the world against bandits and warring nobles, begin to form an ideal image of the protective masculine ideal that has always figured prominently in Japanese anime and manga through the similar representations of the mecha. The *RahXephon* narrative is overcoded with various profiles of *masculine protection* of the world against the alien and feminized Mu. Through the machinations of the older men of this story, the mecha and pilot become the samurai warriors for this world.

Yet the concept of imago has further meaning for the mecha formation. In a key paragraph, Lacan introduces several points that reference and intersect the process of identification in the apprehension of cultural images, and specifically for this narrative, a mecha image:

> Indeed, for the *imagos*—whose veiled faces it is our privilege to see in outline in our daily experience and in the penumbra of symbolic efficacy—the mirror-image would seem to be the threshold of the visible world, if we go by the mirror disposition that the *imago of one's own body* presents in hallucinations or dreams, whether it concerns its individual features, or even its

infirmities, or its object-projections; or if we observe the role of the mirror apparatus in the appearances of the *double,* in which psychical realities, however heterogeneous, are manifested.[14]

The essential statement would seem to be that "the imagos . . . are the threshold of the visible world, [in whatever form they] are manifested." This statement seems to define the mirror image of the self-as-ideal as the point of origin for the succeeding projections of the imago; that the root of an imago is found in that primary and essential designation of self found in the initial contact with body-as-image. In other words, mecha must in some way act as a *double:* to reflect an essence of the self/identity in its visual/textual manifestation. Otherwise, the narcissistic recognition is lost: the power of desire is too remote from the desire of the self and the child inside to recognize and identify it as an aspect of the self.[15]

The "veiled face," or image of the mecha body, is an essential and formulaic part of the mecha construction. It would suggest a close affiliation between the construction of the mecha and the

THE POINT OF THE NARRATIVE JOURNEY OF THE MECHA AND CHILD IS "TO BRING [THE] HUMAN SUBJECT, . . . TO RECOGNIZE AND NAME THEIR DESIRE."

process for identification with the child inside for the viewer-subject. Its masked condition allows the "real" identity of the child inside to be supplied, through identification, by the viewer-subject. The viewer-subject steps into the gap to become the child underneath the armor and assumes the identity inferred by the conditions of desire. The mecha body represents the "perfect stage" attained through a psychic metamorphosis brought on by those same conditions. Thus Lacan's description and inclusion of the concept of the imago would seem to define the mecha in its construction of subjects.[16]

The notion of the "double" as a manifestation of the imago/mecha as a "threshold of the visible world" describes not only the physical manifestation of these psychical realities but the gap between the image and the self. In the vast proliferation of mecha narratives in manga and anime, there are many varied forms this doubled identity assumes, but the formula holds true to the structural notion of a double. The existence and subsequent performance of the double also secure the position of mecha narratives in the genre of fantasy and gothic narrative forms and provide insight into the *uncanny* mechanisms at work in mecha anime.[17]

Assuming the existence of a *lack* in the psyche, and assuming the consequent production of *desire,* what is the nature of that desire in the construction

of the mecha and the child inside? If the nature of lack is a sense of corporeal disunity (a split identity), then desire must in some way address the possible unification of the body with the psyche. Desire, then, is based in the subject's identification with a sense of a unified self. Cultural narratives respond to our recognition of the ultimate disunity of our body and self by propelling us toward stories in which the protagonist seeks unity through either a spiritual or a physical transcendence. This is a logical position as he seeks either the obliteration of his human condition or the amalgamation of higher abilities or conditions of humanity. In either form, the human condition in the achievement of these desires transcends to a position of an "other."[18]

FORT-DA

At this point, the world for Ayato becomes a dual presence: the world of the mother is located under the dome of Tokyo-Jupiter, and the world of the father outside the dome with TERRA. Tokyo-Jupiter is the place of his complacency and his submission, and the world of his infantilized childhood, and so although he begins to grow up in the world of the father, he is drawn back unconsciously to the world of the mother. It is a world in which the "truth" of Ayato's heritage and the reality of the absolute control of the Mu is utterly invisible to residents programmed not to see, yet profoundly evident to the outsider's eye. It is an interior world: claustrophobic and unchangingly normal, insular and "safe" from the larger and dangerous knowledge of the world outside. It is the world of the Mulians, a matriarchy with Ayato's mother, Maya, as the ruling entity, under whom all are controlled to the extent of controlling what it is possible to see and say. The weapons of the Mulians are the *Dolems* (Figure 3), which are usually in the form of the feminine human with open mouths from which they "sing" and activate their unique weapons of destructive resonance. This singing is tonal only, and as an allegorical symbol of Lacan's infantilized world of the imaginary, it is without words. The Dolem mouths are open like the mouths of baby chicks caught in the throes of the Freudian oral stage. The sting of these weapons is found in the lure of potential oneness with the maternal feminine, through a lullaby of longing for a return to the safety of the maternal world.

A scene shown frequently of Ayato sitting in the backseat while his mother drives the car (Figure 4), usually a symbol of power and agency for adolescent boys, becomes a metaphor for Ayato's lack of control, his complacent submission to the power of his mother, his inability to act as his

FIGURE 3. A Dolem from Tokyo-Jupiter.

own agent, and his psychological attachment to her body and identity. He is, when he is in Tokyo-Jupiter, nearly unconscious to all around him, and only awakens once he is called to do so by the memory of Reika Mishima, the girl in a yellow dress he paints obsessively (Figure 5), looking away toward the sea, the symbol of Ayato's condition of lack. Reika originates in the world of the mother, but in the outside world becomes the adult Haruka, a guide in the gap of desire from within the RahXephon. She is said to be the "soul" of the RahXephon, and as a complex of images and separate identities (Haruka: real-time/Reika: memory/Yellow Dress Girl: vision), she becomes a deconstructing sign of desire for Ayato.

Ayato, once he arrives in the world of his father, begins to travel back and forth between the two worlds. He experiences his own version of Freud's conception of *fort-da,* a concept Lacan brings into his own articulation of the stages of development of the subject. It is the second stage and represents the child's emergence into language, or the symbolic: the moment of communication and cultural acquisition.

> Freud interpreted [it] . . . as the infant's symbolic mastery of its mother's absence; but it can also be read as the first glimmerings of narrative. *Fort-da* is perhaps the shortest story we can imagine: an object is lost, then recovered . . . narrative as a source of consolation. . . . In Lacanian theory, it is an original lost object—the mother's body—which drives forward the narrative of our lives, impelling us to pursue substitutes for this lost paradise in the endless metonymic movement of desire.[19]

Thus begins Ayato's journey vacillating between the two worlds, living in the gaps between mother and father, between memory and reality, between his troubled interior and his doubled embodiment of child and RahXephon, and, finally, between his repressed desires and the fulfillment of them. As Lucie Armitt explains: "Forms [narratives] like fairytale or utopia contextualize narrative chronology in terms of what are effectively two competing spatial dimensions . . . predominately driven by an awareness of maturity (sexual or otherwise) as loss. . . . [it is] an ordered space, a horizon implying boundary and a perspective, a frontier."[20] Ayato's loss and repression has been the agent of the separation, and his consolidation of the two worlds will take many episodes to secure. As Lacan states:

> This is experienced as a temporal dialectic [Ayato's worlds are temporally misaligned by seven years] that decisively projects the formation of the individual in history. The *mirror stage* is a drama whose internal thrust is precipitated from insufficiency to anticipation—and which manufactures for the subject, caught up in the lure of spatial identification, the succession of phantasies that extends from a fragmented body-image to a form of its totality [the RahXephon] . . . and lastly, to the assumption of the amour of an alienating identity, which will mark with its rigid structure the subject's entire mental development.[21]

FIGURE 4. Ayato's mother "in the driver's seat . . ."

FIGURE 5. The girl in the yellow dress.

THE FATHER AND THE OEDIPAL COMPLEX

Ayato is introduced to the world of the father when he and Haruka, the mature manifestation of his lost love, land with the RahXephon on Nirai Kanai, an island near the dome and the home of the TERRA force, an army dedicated to protecting earth from the periodic attacks by the Dolems deployed from the Mu. From his first introduction on the island, Ayato is presented with a plethora of "father figures" who each in turn provide guidance and a certain model of masculinity. Watari Shirō, who is also Professor Kamina and Ayato's actual father, is the highest-ranking official of TERRA and the prototypical cold, *remote* father.

The world of the father, as seen through these men, is a hardened world of desperate battle and bitter memory. All of the "fathers" in this story are living in a past of pain: desperate for the redemption that Ayato's transformation will signal. They work as soldiers together, in a conspiracy of silent determination without concern for lives lost to protect the world from its reunification with the feminine "other," Tokyo-Jupiter. It is an overcoded masculine, instrumental, and militaristic world in which civilian citizens are only background aspects seen primarily as set dressing. All key characters are part of TERRA and work for what they understand as a strategy of protection.

Lacan refers to the world of the father as the law of the father, in that it is the imposition of the father's presence that breaks up the child from the mother's body through his signification of the law.[22] The child becomes aware of the taboo of incest and pulls away from the mother toward the larger community. This appearance of the law opens "up unconscious desire. . . . it is only when the child acknowledges the taboo or prohibition which the father symbolizes that it represses its guilty desire."[23] Ayato's feverish transference from father figure to father figure throughout the narrative extends his prolonged childhood and frustrates his desire for identification. His desire repressed, he begins hesitatingly to create relationships with the young women around him. His awakened sexual desire is key to Lacan's notion that it is only when the child accepts sexual and gender difference that the child can be considered properly socialized. With Ayato's remote father absent from his duties as the harbinger of the oedipal stage, it becomes clear that the entire anime is about the destructive deadliness of the child who does not grow up.

> THE ALLEGORY OF THE ANIME *RAHXEPHON* IS A CAUTIONARY TALE, WHEREIN THE COMMUNITY AT LARGE STEPS IN, IN THE FATHER'S ABSENCE, TO CREATE SUBSTITUTES AND SCENARIOS TO FORCE THE PRODUCTION OF THE NECESSARY TRANSFORMATION FROM CHILD TO MATURE SUBJECT.

The allegory of the anime *RahXephon* is a cautionary tale, wherein the community at large steps in, in the father's absence, to create substitutes and scenarios to force the production of the necessary transformation from child to mature subject. The worlds of the Mu and earth were bifurcated by the character of a single mother raising a male child. She both prevents and assists in the process of maturity: her own agenda requires the unification of the two worlds through which, in order to be put right, Ayato must truly merge with the RahXephon and "re-tune the world," that is, he must identify with the world of the father, conjoin with a female and thus free himself finally from an endless adolescence.

In the final scene of the anime after the climactic, long, and celestial battle between RahXephon, the Dolems, and Quon's RahXephon, the world of the anime is abruptly altered to a contemporary and mimetic reality. The long history of invasion and war and the labyrinthine layers of interrelationships are obliterated as if they had never existed. In this first "new world" scene, Ayato is not evident: he is only implied by the suggestion in a phone call between Haruka, now Ayato's wife, and Kisaragi Itsuki, Ayato's brother from

the world of the father, who had died in the spectacular final battle between the Mu and earth but who is now in fact still alive and on the other end of the phone call. Ayato is now, we understand from Haruka's comments, an ordinary academic, just getting his assistant professorship. In other words, instead of a transformation into a fantastical godlike being as the ending to a fairy tale, Ayato's transformation has brought normality to a world that was out of phase and out of time, and has secured the life of a normal but fully adult male for himself. His representation no longer requires a physical presence but can be inferred through his position as father to Kisaragi Quon (an alternate romanization of the name Kuon), the mysterious animus and overcoded feminine double to Ayato, who in this new world has become his own daughter. More remarkably, in this transformed world, the bizarre and fantasy world events of the past have been utterly obliterated from world history, and all knowledge of the events are relegated to the personal and psychical evolution of Ayato's maturity. Just as in the lives of all human beings, the raging wars of childhood are relegated to memory and dreams.

The resemblance of this anime to the classic and most-recognized mecha story, *Neon Genesis Evangelion,* as well as other such anime, is found not simply in the preponderance of the stunning and massive masculine icons but in the poignant plight of subjectivity of the childlike pilot. Though female pilots exist in these anime, as do Kisaragi Quon in *RahXephon* and Rei in *Neon Genesis Evangelion,* they tend to be anima formations of the young male protagonist. I would suggest, then, that mecha anime are generally narratives of male identity formation and subjectivity that are secured through the relationship and eventual unifying transcendence of the boy-child pilot with the mature image of masculine power and agency of the mecha. The story emerges not from their *difference* but from emergence of narrative incitement brought about in the deep gap between pilot and mecha, between lack and desire, between culturally constructed male images and the psychic male position. Mecha anime narratives are the flowers that bloom in the "no man's land" that exists within this gap. The conditions of these narratives describe the process of a distinctively male individuation through the displays of physical combat and a narrative of *protection* against invasion and war against an alien "other," either feminized as in the *RahXephon* or as mechanized technology as in *Evangelion.* The frequency of the mecha anime in this culture suggests a profound condensation of a need for this sort of masculine narrative. These stories have always dominated cultures and proscribed histories, and whether male or female, we as audiences are the beneficiaries of this form.

Notes

1. Anne Balsamo, *Technology of the Gendered Body: Reading Cyborg Women* (Durham, N.C.: Duke University Press, 1996), 144.

2. Jacques Lacan, *Ecrits: A Selection,* trans. Alan Sheridan (New York: Norton, 1977), 65.

3. Lacan, *Ecrits.*

4. Philip R. Banks, *RahXephon Timeline,* khantazi.org/Rec/Anime/Rah7Speculation.html.

5. Ibid.

6. Lacan, quoted in Madan Sarup, *Identity, Culture, and the Postmodern World* (Atlanta: University of Georgia Press, 1996), 35.

7. Terry Eagleton, *Literary Theory: An Introduction* (Minneapolis: University of Minnesota Press, 1983), 164.

8. Lacan, *Ecrits,* 1.

9. Ibid., 2.

10. Ibid.

11. Sarup, *Identity, Culture, and the Postmodern World,* 175.

12. Ibid., 38.

13. *Oxford English Dictionary*, s.v. "imago."

14. Lacan, *Ecrits,* 3.

15. Frenchy Lunning, "Comic Books: Sex and Death at the Edge of Modernity" (PhD diss., University of Minnesota, 2000), 36–37.

16. Ibid., 37.

17. Ibid., 38.

18. Ibid.

19. Eagleton, *Literary Theory,* 185.

20. Lucie Armitt, *Theorising the Fantastic* (London: Arnold, 1996), 5.

21. Lacan, *Ecrits,* 4.

22. Ibid., 67.

23. Eagleton, *Literary Theory,* 165.

Godzilla's Children: Murakami Takes Manhattan

WILLIAM L. BENZON

Murakami Takashi, curator. *Little Boy: The Arts of Japan's Exploding Subculture.* Exhibition at Japan Society Gallery, New York, April 9–July 24, 2005.

Murakami Takashi, editor. *Little Boy: The Arts of Japan's Exploding Subculture.* New Haven, Conn.: Yale University Press, 2005. ISBN 0-300-10285-2 (hardback). New York: Japan Society, 2005. ISBN 0-913304-57-3 (paperback).

"Little Boy" is the nickname of the atomic bomb dropped on Hiroshima at the end of World War II. In Murakami's formulation, Little Boy is also Japan in relation to the United States and the passive consumer of capitalist excess, but also the wide-eyed child of manga and anime. In this exhibition, Murakami presents a wide range of art, artifacts, and imagery and thereby stakes a claim on the artistic consciousness and conscience of the twenty-first century.

For some time I have believed that manga and anime will do for visual culture in this century what African American music did for music in the last century: provide the peoples of the world with a common expressive medium. The work Murakami has assembled supports that conjecture, though only time will tell if it is correct. Japan's visual arts work at a fundamental level that demands our fullest attention and respect. I disagree, however, with Murakami's arguments—and those of other contributors to the exhibition catalog—about the driving force behind those arts. But let us put that aside for now and consider the work, and the argument, as Murakami arranges it in the handsome bilingual catalog (English and Japanese).

The catalog's presentation is well considered and seductive. First Murakami gives us a two-page spread of Okamoto Tarō standing, arms outspread, in front of his large avant-primitive sculpture, the iconic *Tower of the Sun,* created for Expo '70 in Osaka, Asia's first world's fair. (The sculpture was represented in the exhibition by a shoulder-high maquette and a ceiling-high photograph.) Okamoto was the son of a manga artist and a writer, studied in Europe at the University of Paris, and became a household name for uttering "Art is explosion" in a TV commercial. Then Murakami shows us the opening animation for *Daicon IV,* an eight-minute anime film made by amateurs—who play a significant role in manga and anime culture—and shown at the Twenty-Second Japan Science Fiction Convention in 1983. The film is a collage of cultural references: Godzilla, an atomic explosion, a magic sword, Darth Vader, a cute girl in a bunny costume (who surfs the sky standing on the sword), space stations and satellites, Batman and Robin, ray weaponry, cherry blossoms, Mt. Fuji, robots cute and not, and a happy ending.

Having given us a monument and a visual encyclopedia, Murakami turns to broadcast TV, presenting a sci-fi slapstick anime series from 1975–76 called *Time Bokan.* Each week the good guys fight the bad guys and vanquish them in a mecha battle, only to have the bad guys reappear intact the following week. Each episode ends with the highly stylized image of a mushroom cloud resembling a sepulchral skull. It is this image that Murakami has appropriated for his own *Time Bokan—Pink.* Here, the image has become even more stylized and is now completely "flattened" (all shading gone), appearing in white on a hot pink background and balanced beneath a smaller black version of itself that has been turned upside down, with

wreaths of colorful flowers in the eye sockets. A pretty picture.

Thus ends Murakami's overture. As the catalog continues, he moves us from art to reality, presenting a two-page photograph of a mushroom cloud created by a hydrogen bomb detonated at Bikini Atoll in 1954 (16–17). In brilliant reds, oranges, and yellows, the image is gorgeous. On the heels of that image comes a black-and-white image of a bombed Hiroshima: "The two atomic bombs have left a permanent scar on Japanese history: they have touched the national nerve beyond the effects of the catastrophic physical destruction" (19). Then Murakami yanks us back into fantasy with a two-page spread of a rampaging Godzilla: "Some ten years after the end of the war, the flame-spewing Godzilla . . . inevitably reminded every single moviegoer of the massive fire-bombings that struck Tokyo in March 1945" (20). Godzilla was present at the Japan Society exhibition in a series of figurines sculpted by Sakai Yūji. The largest was adult-sized; a row of smaller figurines was arranged in front of a black wall with very abstract performative prose inscribed in white in Japanese and English. Article 9 of the Japanese constitution requires that Japan renounce war. Murakami wryly observes that, with the current situation in Iraq, this article has been "reinterpreted opportunistically to allow Japan . . . to participate in warfare" (22) and that such reinterpretation compromises the Japanese constitution and thus "begs a fundamental reassessment of the document" (22).

Fundamental reassessment—that is what Murakami asks of us. Is the juxtaposition of real images of atomic destruction with fantasy images from a B-movie an offense against human dignity? Or is *that* attitude a reflection of a traditional European humanism that died in Sarajevo in 1914?

At this point, we are twenty-three pages into a presentation that continues for seventy-two more, all as cleverly staged as these pages have been. The other two hundred pages contain supporting essays by Murakami and others and an interview between Murakami and two experts on *otaku* culture, Okada Toshio and Morikawa Kaichirō. Rather than even attempt to cover the rest of the exhibition in this level of detail, I wish to step aside and think about Murakami's argument that the Japanese psyche has been so deeply traumatized by the atomic bombs dropped on Hiroshima and Nagasaki, and so dominated by the United States both politically and economically, that Japan has retreated in an infantilism expressed in passive consumerism and an epidemic of cuteness (*kawaii*) in popular culture. I don't buy it.

Without for a moment questioning the horrors of those two bombs or the horrors of the firebombing of Tokyo and Kobe, I find it difficult to believe that those events have been more deeply scarring to the Japanese than the general shame and humiliation of having lost a war that they initiated. I do not believe that the persistence of atomic bombings as a motif in Japanese culture can be attributed solely to those two brutal events. Nor do I even believe that this persistence can be entirely attributed to losing the war and being occupied by the Americans. *Partially*, sure. *Entirely*, no.

The problem is that apocalyptic art and fantasy are in no way unique to Japan. For example, apocalypse has been a persistent theme in postwar American culture, from the novels of Kurt Vonnegut and Thomas Pynchon to any number of movies: disaster films, sci-fi alien-invasion flicks, and monster movies—including, of course, all those Godzilla movies imported from Japan. As mainland America was not bombed by anyone during World War II, that kind of trauma cannot account for America's very deep scars, the scars that drove the arms race with the Soviet Union and the current war against an Iraq totally lacking in weapons of mass destruction. Apocalyptic culture is not a nightmare from a horrible past; it is a nightmare about an unpredictable future.

Similarly, America is as afflicted with passive

consumerism as is Japan. But America has not been dominated by anyone, though back in the early 1980s there was some fear that America would be economically clobbered by Japan. Passive consumerism is more likely attributable to a high level of prosperity than to external domination.

Whatever his genius as an artist, curator, and cultural entrepreneur, Murakami is not a cultural theorist. He is surely right in asserting that Japan's postwar creativity needs an explanation, but American-inflicted angst and infantilism won't do. Nor do I have a ready-made explanation to offer. But I will hazard a guess.

I suggest that we consider an analogy with the concept of an evolutionary bottleneck. When, for example, a meteor came crashing to earth some 65 million years ago and kicked ash and debris into the atmosphere, that created a bottleneck. Large animals such as the dinosaurs could not find enough food, and so they perished. At the same time, small scampering mammals now had more food and living space, and so they began to thrive.

I am suggesting that the loss of the war and the subsequent American occupation had a similar effect on Japanese culture: certain beliefs and attitudes were placed in doubt while others, consequently, had more room to grow. During the previous century Japan had transformed itself from an isolated feudal nation into an industrial state and world power. With the crushing defeat in World War II, the imperialistic belief structure that had sustained that rise to power was discredited. Something was deeply wrong in the heart and soul of the Japanese nation. Something had to change. And the American occupation was there to force changes in the political system while, as a side effect, bringing American popular culture to Japan.

One of the main cultural beneficiaries of the new dispensation was a lowly form of narrative originally intended mostly for children: manga. Because it was a popular form and a lowly one at that, the arbiters of culture—both the Japanese and their American custodians— didn't pay much attention to it. Manga was able to thrive and explore a wide and wild range of new cultural possibilities, including flattened hierarchies and new gender roles. In the 1960s, anime made its appearance on TV and in turn began to thrive. As Murakami's exhibition and catalog make clear, these were not the only vehicles of new culture, but they were and remain among the most important. These new forms coalesced into the *otaku* subculture discussed in *Little Boy.*

What Murakami does brilliantly in the exhibit is to bring a wide range of material together in one space so we can see the manifold interactions, relations, repercussions, and crossbreeding. One wall is covered in original hand-drawn *Doraemon* panels; another wall displays Hello Kitty art and merchandise; *Mobile Suit Gundam* is represented by a giant robotic head; a large drawing details Gamera's internal anatomy. An *Ultraman* episode plays on one screen, the *Daicon IV* animation on another; Katō Izumi's sculptures evoke chthonic agony, while Aoshima Chiho's polychromatic fantasies cross traditional scroll paintings with manga and 1960s psychedelia. There it is, not *all* of it, but examples of many kinds of *it:* undifferentiated polymorphic cultural proto-stuff.

Ban Chinatsu, Kunikata Mahomi, and Nara Yoshitomo play against cuteness in various ways. Ban puts cute panties on cute elephants with cute eyelashes. Kunikata's *Wakame-chan with Fish Towel* has her body riddled with open eyes like Swiss cheese is riddled with holes. Nara's minimalist figures are more head than anything else, but they are variously pained, determined, entranced, or defiant. Not cute. Kawashima Hideaki's elegantly executed acrylics evokes a soul through intense eyes and lips set in faces that seem sculpted of writhing light.

This play on cuteness, in particular the emphasis on large heads with large eyes, evokes the stylistic feature that is most remarked by newcomers to *otaku* culture. Males as well as

females, adults and young adults as well as infants and children, all are depicted with these *kawaii* overtones in a large range of manga and anime titles, many with large adult audiences. Is this an assertion of the infantile nature of the Japanese psyche?

I do not think so. This stylization reminds me of what the ethologist Konrad Lorenz called the infant schema.[1] Lorenz observed that, in a wide variety of animal species (reptile, bird, mammal), infants have rounder faces than adults, with less prominent noses, relatively larger eyes, and rounder cheeks. This morphology has a *signal function;* it is meant to elicit certain kinds of behavior from conspecifics. There is, one infers, some circuit in the brain that is sensitive to this morphology and that biases behavior in emotionally positive ways.

Taking this at face value we can ask: why is much manga and anime designed to activate these particular circuits? Whatever the artists think they are doing, the effect is to license, to legitimize, nonstandard behavior enacted by these characters. The infant schema evokes *caregiving* attitudes in the audience. In reality, infants are given license to do all sorts of things forbidden to older children, much less to adults. In manga and anime, teens and even adults are given such license; those high foreheads, diminished noses, and big eyes signal the readers and audience: "Cut me some slack, I'm experimenting, trying new things. Care *for* me. Care *about* me." This is most obvious in the case of those magical girls who utter a magic phrase and, in a dazzle of pixie dust, don magical garb and wield superpowers.

This brings us to the major weakness of Murakami's exhibition, the paucity of women in his pantheon of Japanese pop culture. Yes, *Akira, Space Battleship Yamato, Mobile Suit Gundam,* and *Neon Genesis Evangelion* are important landmarks. But so are *The Rose of Versailles, Maison Ikkoku, Sailor Moon, Cardcaptor Sakura,* and *Revolutionary Girl Utena,* all by women and about women. Just why Murakami neglects this

body of work is not obvious, though it may simply be that the work does not fit his "scarred by atom bombs" template. These girls and young women exhibit too much control over their lives to fall victim to externally driven apocalypse.

That self-sufficiency is what is most striking about the paintings of Takano Aya. In her catalog essay, "Beyond the Pleasure Room to a Chaotic Street," Midori Matsui remarks of Takano's art:

> The interpenetration of the future and the past, the outer and inner space is captured dreamily in Takano's paintings, inhabited by supple, nude teenagers and half-human creatures drawn with tentative lines and painted in a vapory spread of acrylic. . . . Her retro-futuristic vision is inspired by the science-fiction novels of Brian B. Aldis, Cordwainer Smith, James Tiptree, Jr., and the comics of Osamu Tezuka, the father of postwar Japanese narrative manga. The mixture of hippie hallucination and space-age fantasy gives Takano's erotic nudes a mythical flavor. Coyly taunting the "Lolita complex" of an *otaku* erotic comic, she conveys a different sort of eroticism derived from the androgyny of the adolescent body. (232)

Takano's work is delicate but substantial. You can see the brushstrokes, but the paint is thin, and Matsui's phrase "vapory spread" is apt. The heads are rounded, as are the large, heavily lined eyes. These wiry and delicate creatures are not cuddly cute. They are haunting. They are not juvenile females from our world; they are self-sufficient beings from another world.

Is this the new world that Tezuka prophesied at the end of *Lost World*? Despite his apocalyptic obsessions, Murakami remarks, "And yet, amidst it all, people awaken and evolve toward a new humanity" (148). Murakami-san has indeed gifted Manhattan, home of the atomic bomb.

1. I'm taking this from chapter 31 of Wolfgang Wickler, *The Sexual Code: The Social Behavior of Animals and Men* (New York: Anchor/Doubleday, 1973).

Anime: Comparing Macro and Micro Analyses

BRENT ALLISON

Patrick Drazen. *Anime Explosion! The What? Why? and Wow! of Japanese Animation.* Berkeley, Calif.: Stone Bridge Press, 2003. ISBN 1-880-656-72-8.

Brian Ruh. *Stray Dog of Anime: The Films of Mamoru Oshii.* New York: Palgrave Macmillan, 2004. ISBN 1-4039-6334-7.

Though *Anime Explosion* and *Stray Dog of Anime* both describe and analyze anime, they have very different purposes. Drazen means to cover the wider medium of anime; Ruh is concerned with one anime film director, Oshii Mamoru. Yet, while the topics differ, the books share enough similar concerns with anime as an artistic medium to make some fruitful comparisons.

Similarities

Both Drazen and Ruh find scholarly value in studying anime not just as a cultural artifact but primarily as literature that can speak to an assumed coherent "human condition" transcending national boundaries. They base much of their confidence on the artistic strength of their favored directors to use anime to tell a compelling story. For Drazen, Tezuka Osamu virtually founded manga's cinematic, as opposed to merely unique, style that later allowed anime to engage audiences more deeply than animation had done previously. Drazen praises Tezuka's directorial skill in conveying animated characters' struggles in ways that live-action cannot.

Ruh, on his part, discusses Oshii's work with anime as itself partly the message of his oeuvre. Critics questioned making *Jin-Roh*—for which Oshii wrote the screenplay, but did not direct—as animation rather than as live action, a notion that Ruh disputes as unfairly dismissing anime out of hand and as missing a larger point. Since *Jin-Roh* takes place in an alternative late-1950s Japan, it had to be animated, because many of the structures of older Japan needed for a live-action film had been torn down. Ruh acclaims Oshii's implicit critique of Japan's neglect of historic preservation through his necessitated use of anime: he could not have made that exact point using live action.

Much of Drazen and Ruh's praise for anime is well deserved. However, their assessments of certain anime titles as representing benchmarks of achievement lack compelling external evidence. Ruh refers to Oshii's second *Patlabor* film as such a benchmark. The film critic Tony Rayns and the director himself both recognize it as a major career achievement, which helps us determine its importance for Oshii. Ruh's analysis of *Patlabor 2*'s messages on technology, mythology, and hierarchy also shed light on why this film matters for Oshii's role as a director who illustrates a complex philosophy. But Ruh does not go into how *Patlabor 2* is an influential film for the medium itself, except perhaps indirectly as foreshadowing Oshii's more prominent *Ghost in the Shell*. Drazen believes that *Nausicaä of the Valley of the Wind* deserves to be called a "groundbreaking masterpiece" (259), but that conclusion is based only on *Nausicaä*'s top ranking status in an *Animage* magazine poll, albeit for ten years in a row. Discussing certain films as benchmarks is a useful even if hardly scientific process. However, more care should be taken either to provide more evidence for their influence, as Ruh does with *Ghost in the Shell* and Drazen with *Princess Knight,* or to resist making such sweeping claims.

Drazen and Ruh share a concern for the roles of women in anime and analyze them within the context of wider Japanese cultural expectations for how women should (not)

behave. Both allude to this topic throughout and devote specific sections to in-depth examinations of how Japanese femininity in anime is constructed and (re)interpreted. However, neither author explicitly looks toward Japanese *masculinity* except in ways that help promote its invisibility, an ongoing problem for many scholars in gender studies. For example, Ruh examines Major Kusanagi Motoko's evolving role as a female cyborg in relation to a masculine world of violence and cybernetics in *Ghost in the Shell*. However, her partner Batou as a large and muscular cyborg is not examined as a masculine being. Likewise, Ruh associates the egg-carrying young girl role in Oshii's *Angel's Egg* with liminality between innocence and awareness—a position constructed as female in other anime Ruh cites—but the masculinity of the egg-smashing soldier escapes scrutiny. Drazen, in his chapter on pornography, neglects the inherent male privilege that historical stories and tales of sexual relations in Japan implicitly construct. While he devotes three chapters to women in anime, including one on pop idols who are almost always female, and another on (homo)sexual (un)ambiguity, including the social pitfalls marginalized characters face, the masculinity that makes their hetero-masculine world possible is allowed to disappear into the social ether.

Differences

Drazen's work is rife with numerous references to history and legend that help put the anime he reviews into a Japanese-specific cultural context. The stories of past struggles and current traditions are often informative and entertaining, though sometimes unrelated to the main analysis. Ruh, on the other hand, sometimes does not go into enough detail when he raises an interesting issue. Examples include hinting at a nonexistent line between dreams and reality, discussing what Oshii meant by calling the philosophical *Patlabor* "a proper pop entertainment movie" (92), and debating whether the *Patlabor* films and *Jin-Roh* argue for complete pacifism or for full-scale (as opposed to half-hearted) military intervention from Japan. However, Ruh's more complete philosophical probing into Oshii's themes of religion, technology, and the self overshadows these shortcomings. Perhaps by virtue of Ruh's specific research topic, his synopses and helpful character descriptions are much more detailed than most of Drazen's.

A continual theme in Drazen's work is anime's inherent conservatism as a facet of Japanese popular culture. Drazen cites *giri* versus *ninjo*, or the conflict between traditional obligations versus personal desire, as a classic struggle wherein the characters' negative response to *giri* most often portends a negative fate. Even in stories that feature strong heroines and positive (potential) same-sex relationships, such as *Please Save My Earth*, *Revolutionary Girl Utena*, and *The Sword of Paros*, traditional gender roles manage to find their way into anime's narrative framework to disrupt the happiness or power of those who would violate those norms.

On the other hand, Ruh portrays Oshii as continually working to break Japanese viewers out of their conventional sensibilities to reexamine their identities and their society. For Ruh, this includes Oshii's critiques of the emptiness of urban capitalist society in *Urusei Yatsura—Beautiful Dreamer*, and the alienation of workers from their Labor (literally) in the *Patlabor* films. Unlike Drazen's analysis of anime narratives as contests of values with hegemony victorious, Ruh attempts to make sense of Oshii's synthesis of those conflicts. This includes his highlighting the necessity of both religion and doubt in *Angel's Egg* and *Patlabor*, the interplay of dreams and reality as full consciousness in *Twilight Q 2*, the merger of Kusanagi and the Puppet Master to create a transcendent identity in *Ghost in the Shell*, and the similarities in destructive violence employed by both the opposing rebels and the Special Unit of the Capital Police in *Jin-Roh*.

Ruh deciphers Oshii's use of Judeo-Christian symbols and themes as representing Oshii's questioning the nature of truth and consciousness (*Angel's Egg*) and his problematizing technology and messianic faith (in the *Patlabor* films). It is precisely Judeo-Christianity's status as a religion alien to Japan that allows Oshii to approach these issues from this fresh vantage point and jar his audience from complacency. Drazen also emphasizes the marginality of Christianity in Japan, but its marginalization allows for narrative flexibility not possible in Western societies, rather than being philosophical probing. This includes scenes of crucifixion in *Sailor Moon* and *Video Girl Ai* as well as Tezuka's influential use of the cross as symbolizing death, transition, or the prevalence of justice in *Twin Nights* and *Astro Boy*.

Drazen acknowledges the influence of Hollywood on anime's postwar embryonic development. Nevertheless, he firmly entrenches anime within the historical cultural context of Japan. If it is a global medium, then its power to transcend boundaries lies in its use of broad universal experiences of sex, family, struggle, and death so that almost anyone from any culture cares about the characters. Ruh makes us care about the work of one real-life character, a stray dog of a director who speaks not just to Japan but to a postindustrial technological state of being inhabited across continents. Oshii encourages us to stray from the pack, if only for a while, forcing us to take responsibility for how we make meaningful action of our dreams, our tools, and ourselves.

Crazy Rabbit Man: Why I Rewrite Manga

TRINA ROBBINS

At the 2004 San Diego comic convention, the largest of its kind in America, the Korea Culture and Content Agency had a huge, attractive, and expensive booth. Their purpose: to present Korean comics (*manhwa*) to an American audience. They gave away free collections of *manhwa* to show American readers what a great job they were doing with comics in Korea. At 242 pages, with glossy, full-color covers, the free books must have set the publishers back a bundle.

The interior art in the giveaway books was for the most part beautiful, but the publishers made one serious mistake: they neglected to get an American rewriter. The result was page after page of unintentionally hilarious copy, such as:

> You did let me in trouble even though you've been watching me over???

> I've been committed crime since the World War ll. Today, I've done by myself to expiate myself. . . . I'll be in calm to die.

> Don't be so sympathy on her!! You never going to say anything after you realize what are going on family in inner room.

> We all understand you must be deeply painful after your wife has been passed away.

> Why do we catch ghost stuffs until dawn?

Here's where I come in. Hello, my name is Trina, and I rewrite manga. Along with a goodly number of other writers, I'm an English-language rewriter. There's a very good reason why we're needed.

Here's the way it works. American manga publishers buy the rights to publish a certain manga, usually a series, in English for an American audience. They give the original Japanese manga to a literal translator, usually a Japanese person living in America. The literal translator translates the manga—literally. This can result in sentences that read like abstract poetry, or like something George W. Bush might have said. You need somebody to turn this into a script that is readable by an English-speaking audience.

FIGURE 1. *Godchild,* volume 2, 2006. Viz Comics.

When I take on the job of English-language rewriter on a manga series, my editor sends me the entire series in its original Japanese form. I can't read Japanese, so each month I look forward to receiving the next issue's literal translation so that I'll finally know what happens next. When I receive the literal translation, I read the script and follow along with the art in the Japanese version. Before I set to work rewriting, I print up the literal translation so that I'll have something to refer to in case I make a mistake, or in case (don't even think about it!) my computer crashes.

I try not to depart from the original plot, so for the most part any changes I make serve to make the script a better read in English. I try to simplify and clarify and make sentences more concise. Thus, I took this (from *Godchild*):

> OSCAR: So this is where it was. I thought I'd lost it!

> OSCAR: The watch that I got as a present from Arina that works at the bar.

and changed it to:

> OSCAR: So here it is. I thought I'd lost it!

> OSCAR: The watch that Arina gave me.

Here's a more complicated dialogue:

> CAIN: According to what I found out, the reason behind your father's death is related to an incident of theft which occurred a few years ago. So I think that this is some sort of revenge scenario carried out by you to get back at the 4 people who blamed the crime entirely on your father.

> CAIN: But that man isn't the prince on a white horse that you think he is, who'll make your wish come true.

> CAIN: He is a god of death who drags people to their death under orders from a large organization. . . . He's using your hatred in order to accomplish "something"!

I simplified while keeping the meaning:

> CAIN: The reason behind your father's death is a theft which occurred some years ago. And this is the revenge scenario carried out by you to get back at the 4 people who blamed the crime on your father.

> CAIN: But that man isn't the knight on a white horse that you think he is.

> CAIN: He's a god of death who works under orders from a large organization he's using your hatred to accomplish something else!

When I first started rewriting manga, my biggest problem was the sound effects. The Japanese

have a sound for everything, even "silent sounds" like grabbing someone's sleeve, touching a piece of paper, or grinning. Sound effects like *gatan*, *gacha*, *jyaki*, *zawu*, *garagaragara* and *doku doku* just don't work in English. I had to decide just what was the sound of someone landing quietly on their toes, and I decided it was *ptt*. Another silent sound I decided on was *kchk*.

Sometimes instead of a sound I used the word itself, so the sound of someone grinning became *grrrinn*. "Noisy sounds" were easier. The sound of a crash became *kerash!* The sound of a slam was *slamm!* A click was *klikk!* As I grew bolder, I even started using my favorite, *kraka-dooom!*

The decorative, visual look of the sound effects is an integral part of the manga page. Volume 1 of *From Far Away* featured thirteen pages with no speech balloons at all, only sound effects. Some publishers leave in the original Japanese lettering while adding the English sound

effects. I think leaving in the Japanese is a bit pretentious, and I'm glad that the publisher I work for, Viz, doesn't do that. Instead, they have very talented letterers re-creating the look of the original sound effects in English.

Sometimes I Americanize certain words to make the script more accessible to a young American reading public (forgive me, hard-core *otaku!*). So a girl eating her *bento* becomes a girl eating her lunch.

Sometimes the names haven't been converted very well into English. Another issue of *Godchild* featured a girl named Lukia. Only after I had already rewritten more than half the story did I come across a note from the writer, Kaori Yuki, explaining her inspiration for the character. When she described the saint she had read about who tore out her own eyes, I realized that she was referring to one of my favorite saints, Saint Lucy, and I had to go back through the script and change the spelling of the girl's name to Lucia. It's a good thing I'm fascinated by quirky saints!

And sometimes I puzzle over a word until I finally figure out what the translator meant. One script in volume 3 of *The Cain Saga* kept referring to "prom roses." Was this something our female protagonist would wear to a prom? I finally realized that the translator meant primroses!

Only rarely have I completely rewritten something. For *BB Explosion,* I wrote two complete songs for the young idol singer-heroine, Airi, keeping the original meaning as best I could. Naturally, the literal translation for her songs didn't work at all—it was disjointed words without rhyme or rhythm, concerning an earring, the moon, love. I'm sorry to say that I somehow erased that particular literal translation, so I can't show you any comparisons, but here's one of my finished songs. Anyone is welcome to set it to music:

The earring that you gave me,
It shines like the moon.

FIGURE 2. *From Far Away,* volume 10, 2006. Viz Comics.

FIGURE 3. *B.B. Explosion,* volume 5, 2004. Viz Comics.

I couldn't say I love you,
But I know I'll say it soon.
Because I've always loved you, but tonight
I know it's all right.
My heart is beating loudly,
I want you to be mine.
I can't help being selfish
'Cuz I want you all the time
Like the moon . . .
Moonlight
Shining on my love
Moonshine
Shining from above,
I'll tell you soon
My lovin' moon.

It's not Cole Porter, but I had a good time writing it.

I'm happy to say that no literal translator I've worked with has ever sent me scripts as hysterically funny as those I found in the Korean *manhwa,* but they have occasionally come close, due to no fault of theirs but to the sometimes bizarre differences between Japanese and English. The words that brought me closest to rolling on the floor and holding my sides were in the gothic manga *Godchild.* In *Godchild,* Yuki Kaori has created a dark, Victorian world made all the darker by references to fairy tales, Mother Goose rhymes, and in this case, *Alice in Wonderland.* In this particular episode, London was being terrorized by a Jack-the-Ripper-type maniac in a white rabbit mask who was beheading beautiful young women. What did Yuki Kaori name this gruesome killer? The Crazy Rabbit Man! It may work in the original Japanese, but in English it definitely didn't strike terror into anybody's heart. I changed his name to The White Rabbit.

So, how have the original Japanese creators felt about my rewriting their scripts? The only one I've heard from has been Yasue Imai, creator of *BB Explosion,* who sent me a manila envelope stuffed with goodies: other manga she wrote, cards, photos of herself, and pictures of the real Airi, who really was an idol singer. We exchanged Christmas cards and photos of our pets. I think she liked what I had done with *BB Explosion,* but she never said a thing about my writing new songs for her heroine.

But as of the writing of this essay I am, at least for now, an ex-manga rewriter. Viz comics has decided to get rid of their literal translator/rewriter teams in favor of one person who can do both—translate and rewrite the Japanese into English. My kind editor, Eric Searlman, has asked me to finish the rewriting on volume 9 of my favorite manga, *From Far Away,* and then I'm off the book.

This move is obviously a cost-cutting measure, but not, in my opinion, a wise one. My experience tells me it will produce an inferior product at best. (A worst-case scenario would have Viz turning out manga that read like those unfortunate Korean comics, but I don't think that's likely to happen.) Even the best literal translator I have worked with has needed rewriting to make the scripts readable.

When Viz realizes their change was not for the better, I'll be here at my computer, surrounded by manga, awaiting their e-mail.

Brain-Diving Batou

BRIAN RUH

Yamada Masaki. *Ghost in the Shell 2: Innocence: After the Long Goodbye*. Translated by Yuji Oniki with Carl Gustav Horn. San Francisco: Viz Media, 2005. ISBN 1-4215-0156-2. Original Japanese publication, 2004.

If the world were a just place, the director Oshii Mamoru would be hailed as the next great cinematic visionary for his latest feature film, *Ghost in the Shell 2: Innocence* (2004). A sequel to the original *Ghost in the Shell* film, which was in turn based on the manga by Shirow Masamune (an alternative romanization of the Japanese name Shirō Masamune), *Ghost in the Shell 2* dispensed with much of the action and characterization of the first film in favor of visual ruminations on the nature of humanity, love, and technology. Despite the film's breathtaking visuals, some reviewers have argued that the film falls short in terms of the story, which consists mainly of a murder investigation very loosely held together by a few narrative threads. However, a film like *Ghost in the Shell 2* should not be viewed for such mundane details as plot or dialogue: it is through the visual elements of the film that Oshii tries to communicate his meaning.

How then should one approach Yamada Masaki's novel *Ghost in the Shell 2: Innocence: After the Long Goodbye?* Although Oshii's film is a wonder of visual style over plotting and narrative, on the printed page Yamada does not have such artistic recourse. *After the Long Goodbye* is a prequel to Oshii's second *Ghost in the Shell* film and takes place immediately before the events depicted in the film. The novel follows the adventures of Batou, a cop with the elite Section 9 police force who is also the film's main character, and the mysterious events that surround him.

After the Long Goodbye occupies a unique position in relation to Oshii's film. The novel was originally serialized in the Japanese animation magazine *Animage*, which has a long-standing relationship with Oshii—it is where *Serafimu~2-oku 6661-man 3336 no tsubasa* (1994-95, *Seraphim: 266,613,336 wings*), his manga collaboration with Kon Satoshi, was serialized, as was his monthly film column "Mamoru Oshii's Visual Diary" (*Oshii Mamoru no eizō nikki*). Yamada's novel began its serialization in *Animage* before *Ghost in the Shell 2* was released in Japan, serving as both a lead-in to the story as well as an advertisement for the film's impending release. This means that some fans of the *Ghost in the Shell* universe in Japan would have gone into screenings of *Innocence* already aware of the events that transpired in *After the Long Goodbye*. In this way, the novel serves as a building block for an understanding of the film—of course, one can be enjoyed and understood without the other, but taking the two works in conjunction creates a well-rounded pairing of the printed word and the visual image.

The novel begins with Batou having dreams of a son, an impossibility since he is a cyborg and incapable of biological reproduction. His life is relatively well contained—since Major Kusagani left for parts unknown in the first *Ghost in the Shell* film, Batou has turned inward, occupying his time with his job and taking care of his dog Gabu (short for Gabriel). One evening on his way home from a shopping trip to pick up dog food, Batou gets into a mysterious car accident that could have killed him many times over. He escapes relatively unscathed, but during the accident his e-brain was forced to reformat itself so he could keep functioning. When Batou gets back home, Gabu behaves oddly toward him; a little bit later when a postman comes to the door to deliver a package, Gabu slips out of the apartment while Batou is distracted.

Batou goes off to look for her, but she seems to have disappeared completely. Although seemingly a personal crisis for Batou, Gabu's disappearance begins to merge with events taking place in Batou's working life. As he investigates

more deeply, Batou begins to discover clues linking his dog's disappearance to an international terrorist known only as the Breeder, a gangster named Cherry Lin, and the transnational fast food conglomerate Mao Mantou. Even Batou's seemingly inexplicable car accident ties into the mystery of Gabu's vanishing.

Although there is a lot that transpires in *After the Long Goodbye,* as in the two *Ghost in the Shell* films, the narrative allows the reader to eavesdrop on Batou's search for some sort of interior awakening. In Batou's case, he is trying to figure out the nature of his own soul and how he relates to Gabu, the only other being to whom he is close. The search for Batou's soul is depicted through Yamada's use of the first person—the reader is presented with nothing but Batou's point of view. Surprisingly, and perhaps a conceit to make the novel more readable, Batou maintains a witty and hard-boiled inner monologue. The result is a very different portrait of the cyborg cop than one sees in the *Ghost in the Shell* films. Rather than being a stony-faced loner (an effect heightened by his eye implants, which betray few traces of emotion), the Batou of *After the Long Goodbye* is a caustic pragmatist who actually has a sense of humor of sorts.

Communicating Batou's interior workings is made vivid through Yamada's crackling prose. At fewer than two hundred pages, *After the Long Goodbye* can be rather dense at times, and it a testament to Yamada's writing that he manages to condense so much material into so few pages without overwhelming the reader. Whenever I read a novel in translation, I am always wary about ascribing any claims of style to an author for fear that it is really the translator's words that are coming though. *After the Long Goodbye* was translated by Yuji Oniki with Carl Gustav Horn, both with a long history in bringing Japanese popular culture into English while making their own efforts as transparent as possible. To see an example, one need only look at the book *Battle Royale* by Takami Kōshun, which was translated by Oniki and released by Viz in 2003.

Although the book was the source material for a riveting film by Fukasaku Kinji, in the English version of the novel Oniki is a savvy enough translator to step back and let Takami's graceless prose tell the often-brutal story.

Thankfully, Oniki and Horn have better source material to work with in *After the Long Goodbye.* Even on the first page, the reader is treated to this description of Batou driving to the convenience store: "The visible light of the headlamps blurred to impotence in airy water. Red plasma writhed against white fluorescent ache, as rows of Chinese *hanzi* marched straight on the windshield, leapt, and then were gone in the rearview. . . . It was like a dream—if such a dream wasn't another cliché." In this short passage, Yamada manages to evoke a real mood and sense of place while acknowledging that he is at times working with well-worn material. Throughout the novel, Yamada paints the *Ghost in the Shell* world in tones that evoke a real place without relying at all on the visual depiction of this world seen in Oshii Mamoru's films. Such crisp writing is to be expected from Yamada—he has won multiple awards for his science fiction work. (Unfortunately for English speakers, Yamada's award-winning work is not available in translation. The only other work of his currently in English is the novel *Aphrodite* published by Kurodahan Press.) The main problem with the writing is Yamada's repeated use of the word "innocence," which crops up so frequently at the end of the book that the concept begins to lose all meaning. It seems almost as if the producers of the *Ghost in the Shell 2: Innocence* film kept pressuring him to remind the readers of *Animage* of the name of the upcoming film (which was known simply as *Innocence* in Japan).

Although the main appeal of any book should be its writing, I would be remiss if I did not comment on the book's design. *After The Long Goodbye* is published in hardcover with an evocative monochrome drawing on the dust jacket of Batou carrying Gabu. Although far from being a graphic novel, there are a few

illustrations, mostly at the beginning and between chapters. These drawings by Shinma Daigo and Saeki Keita serve as small reminders of the novel's relationship to the visual worlds of Shirow Masamune's manga and Oshii's films. For Oshii fans and scholars (of which I am both), there is a short afterword in which Oshii and Yamada discuss how the novel came into being and the themes it develops.

By going into Batou's psychology immediately prior to *Ghost in the Shell 2*, the novel *After the Long Goodbye* in a sense completes Oshii's film. Without knowing what has been happening to Batou, the viewer of *Ghost in the Shell 2* is unable to fill in some of the interior complexity missing from Oshii's cinematic vision. Similarly, Yamada's novel would make for an interesting enough read if one were not familiar with the *Ghost in the Shell* universe. But with knowledge of the manga and the films (and, to a certain extent, the derivative television series *Stand Alone Complex*), the reader is more fully able to understand the relations between the characters. For those trying to figure out the intersecting natures of human, animal, and machine in the *Ghost in the Shell* world (and, by proxy, in their own lives), Yamada's novel provides an essential piece of the puzzle.

Lurkers at the Threshold: Saya and the Nature of Evil

TIMOTHY PERPER AND MARTHA CORNOG

Oshii Mamoru. *Blood the Last Vampire: Night of the Beasts.* Translated by Camellia Nieh. Milwaukie, Ore.: DH Press (a division of Dark Horse Comics), 2005. ISBN 1-59582-029-9. Original Japanese publication, 2000.

Oshii's *Night of the Beasts* is a novel—not a film—centering on a bloody war involving demons *(oni)*, their human prey, and Saya, a mysterious young Japanese woman who works with American authorities to hunt down and kill *oni.*

The story is set in Tokyo in 1969 amid student uprisings and police riots, three years after the events of the film *Blood the Last Vampire.* The film was directed by Kitakubo Hiroyuki in 2000, and Oshii is listed as its original creator. The novel represents Oshii's continuing imprimatur on a certain vision of Saya and her world—dark, profoundly visual, and above all ethical.

The novel opens with a prolonged reference to the first scenes of the film *Jin-Roh,* which also credits Oshii as the original creator: a riot with stone-throwing students, heavily armed police, and dark reflections of flames in water-doused streets. But instead of entering the catacombs of Tokyo (and the mind), *Night of the Beasts* follows a disaffected young high school activist, Miwa Rei, as he flees tear gas and mayhem and encounters a beautiful young woman standing in front of a blood-soaked wall with a samurai sword in her hand. Dead at her feet is a monster—a demon, a horror, a being that should not exist. In the next weeks of suspension from school and virtual house arrest by his drunken father and crazed mother, Rei tries to deny his vision. But he can no longer retreat from his memory of a threshold between this world of police, riot, and injustice, and a world of demons who lurk in darkness, one lying dead in front of a beautiful young woman. . . .

Oshii situates Rei not as looking into an illuminated world familiar from Japanese or world folklore and reduced to mechanism by psychoanalysis and technology but as seeing darkly (as through a glass, as Oshii put it in *Ghost in the Shell*) into something far more ancient and more resonant with humanity than modern mental or physical technique can reveal. As the story progresses, Rei and his fellow activists become caught up in a search for Saya and her companions and therefore for an explanation of the monster. Slowly, timidly, they cross the threshold into darkness—from chaos to madness, so to speak, because they have nothing to lose in *this* world. They encounter Gotōda Hajime, a bedraggled, cigarette-mooching police sergeant who leads them on with opaque clues

and the threat that a friend of theirs is being hunted—either by Saya and her companions, or by the monsters, or by somebody. Gotōda bribes them into collaborating with him—child's play, this—by buying them a huge Korean barbecue, which they gobble happily while listening wide-eyed to his stories of international intrigue. But the image of the dead monster and the beautiful girl with the sword haunts Rei, and he is drawn into the dark world, pulled by the allure of what he has barely glimpsed.

If *Night of the Beasts* were Western, it could easily move toward an epiphany of grace, where Saya is "really" an angel, the monsters "really" devils, and the resolution a religious stereotype of heroic young women defeating the vampires. But beings who dwell beyond the threshold in darkness are not so easy to see or understand—or defeat. Instead of a westernized vision of light conquering all, Oshii moves the story into further darkness: into those places where liminal twilight reigns, where corpses cannot be destroyed, where vast international conspiracies lurk in collaboration with ecclesiastical factions, governments, geneticists, and *oni*. Once again, the darkness is itself alluring.

But here we need a digression. The original film was only forty-eight minutes long, and its brevity triggered displeased criticism by American commentators (courtesy requires that we not cite examples). In their view, the film is irretrievably flawed despite its superlative animation and cinematographic technique, because it is "too short" to tell the viewer who Saya is. This, we suggest, is a *style* of watching films: the viewer sits waiting to be told what is happening, who the characters are, and what it all means. Such viewing demands that the filmmakers tell us everything while we munch popcorn. But this style of watching a film fails when it comes to anime.

Above all, anime and manga are participatory art forms, which leave to the viewer a good deal to consider, analyze, and think about—what Iwamoto calls "unexpressed expression"

and Shigematsu calls "fantasy dimension 2."[1] Anime and manga are therefore (in one view) much more interesting than a television show or a movie that spells out everything about the story. But it is a view not to the liking of some American filmgoers. The Kitakubo film has suffered its share of this kind of "tell me everything because I don't want to think" film viewing.

But that way of viewing falsifies Saya and her story and its characters. They do not dwell in such illumination. Instead, they are Lovecraftian, wherein the story requires that we never quite clearly see the lurkers. If vampires cannot abide the sunlight, then their heliophobia is a metaphor: in sunlight, a vampire is merely a species of erythophilic mammal that needs hemoglobin or some other biochemically defined component of blood. The vampire becomes a biomedical specimen newly and gruesomely sharing a laboratory home with gleaming spectrophotometers and ultracentrifuges. No longer is this specimen a soul-devouring monster; such things vanish in the light of scrutiny. The moment we see Saya in the full light, we know who the monsters are: mere protoplasm, and the raw material for a technical paper in the *Archives of Medical Biochemistry*. Well, so much for evil.

So, to fault the portrayal of Saya is to miss a crucial point that Lovecraft, Poe, Robert Louis Stevenson, Joseph Conrad, and the author of *Beowulf* knew very well. One crosses the threshold to *these* kinds of darkness only at very great risk. With the emergence of psychoanalysis at the start of the twentieth century, certain kinds of horror story (like Bram Stoker's *Dracula*) became implausible. Poor Dracula suffers only from oedipal neurotic anxiety about virgins, nothing that a few hours of psychotherapy or pop psych wouldn't cure.

There is a very telling comparison to be made in the film. David and Lewis, Saya's human companions, are driving around Yokota Air Force base looking for the chiropterans. Even the name is revealing in its westernized taxonomic impulse: Saya calls them *oni*—demons. David

and Lewis are using an oscilloscope device to locate the chiropterans. It is technological to the fingertips and so very American. But when Saya explores the nurse's clinic looking for the *oni,* she stands absolutely still, and we see only her face as she sniffs the air. Then she touches the floor tiles and traces the path of blood spilled when the *oni* were feeding. She *smells* her prey, her hereditary enemies.

In the film and novel, Saya is liminal: she can cross over between realms. So we cannot ever really see her too completely, and Oshii never explains her. The reason is that to see or explain her is to see and explain what she is hunting down. Neither Kitakubo nor Oshii falsify what is at stake in Saya's story: the nature of evil itself.

As *Night of the Beasts* moves on, we follow Rei and Gotōda as they are kidnapped by Saya's companions—David and Lewis, presumably, although they are not named. If we now expect an action-packed confrontation, we will be disappointed. Instead, Rei and Gotōda meet a nameless old man, who presents some fifty pages of careful scholarly exegesis about human evolution, the hunting model for the origin of *Homo sapiens,* and the morality of hunting and killing animals (201–55).

Oshii did not invent this long scholarly interlude. *Night of the Beasts* has a research bibliography that lists Matt Cartmill's thoroughly scholarly book about hunting and human evolution, published in 1993. The old man's anthropological exegesis is a serious intellectual disquisition about Raymond Dart, Robert Ardrey, and a number of other scholars. In it, the old man says:

> Other critics denounce every aspect of the theory [of the hunting model], claiming that the story of the killer ape-men is a mixture of biological fact and evolutionary theory, mired in a logic of Western myth, that simply rehashes the Biblical story of Adam and Eve's expulsion from Eden. The claim

that the appeal of the hunting hypothesis has nothing to do with scientific evidence is probably right on the mark. (217)

By an odd coincidence, one of the authors of the present review can take credit for that view (and we thank Oshii-*sensei* for his kind words). The quote is an excellent summary of a critique of the hunting model written by Timothy Perper and Carmel Schrire.[2] So we can attest that the old man's disquisition is based on first-rate scholarship.

And it creates a startling break in the novel's continuity. The nameless old man who tells Rei and Gotōda about the hunting model is setting down an *ethical* basis for our beliefs in vampires and monsters, one that emerges not from theological concern about devils and demons but from Darwinian evolution and its moralizing underpinnings. The chiropterans, the old man asserts, are a sister species to our own, which coevolved in hidden, blood-drinking parasitism with humans. But we are not innocent either: instead, in killing and eating animals, we are similar to—and as monstrous as—the vampiric chiropterans. The old man asks Rei about the chiropteran dead at Saya's feet:

> "It looked like a human being, didn't it?"
> Rei drew a sharp gasp and looked up.
> What had it looked like? It had unquestionably looked like a human being. Its form had been at once human and inhuman. But, even above that, the impression Rei had gotten was one of a human being turned evil. No.
> Of the evil of humanity itself. (251)

The risk of looking too clearly into the darkness is that we see *ourselves.* But, as Rei has learned, we also see someone else—a supremely beautiful young woman holding a sword, standing in front of her dead prey.

Who is she? The old man believes that Saya is a hybrid between *oni* and human, a geneticist's

nightmare. Gotōda, the police sergeant, believes that she is a result of profound religious sin. Rei listens in bewilderment, unable to decide what he believes or feels. But Oshii himself remains silent: *he* does not speak for Saya. The old man may assert that she is a hybrid, but he does not know her at all—certainly not the way David knows her when he speaks the film's most famous line, that Saya is the "only remaining original." To be an "original" is surely incompatible with being a hybrid, and so Oshii plunges us once again into darkness, uncertainty, and opacity.

Like the nurse in the film, neither we nor Rei ever learn who Saya is. The novel ends thirty years later in 1999, with Rei an overweight middle-aged man, divorced, remarried, a writer about films, as he sits down in a Tokyo subway car. It is the opening scene of the film, recapitulated some thirty years later. A young woman sits next to him. As Rei exits the train, he remembers and recognizes her with a deep pang of loss and grief. It is Saya—beautiful, ageless, and supremely powerful—and she is still hunting down the *oni*.

In the last analysis, Oshii and Kitakubo build parallel visions of Saya. We humans do *not* know everything, and the ways of technology only partly illuminate the dark. Saya remains unknown, standing between this world and that, on a threshold where we encounter ourselves lurking in darkness.[3]

Notes

1. Kenji Iwamoto, "The Aesthetics of Japanese Cinema," *Asian Film Connections*, http://www.asianfilms.org/japan/iwamoto5.html (accessed December 3, 2005); Setsu Shigematsu, "Dimensions of Desire: Sex, Fantasy, and Fetish in Japanese Comics," in *Themes and Issues in Asian Cartooning: Cute, Cheap, Mad, and Sexy*, ed. John A. Lent (Bowling Green, Ohio: Bowling Green State University Popular Press), 93–125.

2. Timothy Perper and Carmel Schrire, "The Nimrod Connection: Myth and Science in the

Hunting Model," in *The Chemical Senses and Nutrition*, ed. Morley Kare and Owen Maller (New York: Academic, 1977), 447–59; cited by Matt Cartmill, *A View to Death in the Morning: Hunting and Nature through History* (Cambridge, Mass.: Harvard University Press, 1993), 19, 26.

3. Saya's story is continued in a sharply different direction in Tamaoki Benkyō's sexually explicit manga, *Blood the Last Vampire 2002*. But Saya remains mysterious and a figure dwelling in the half-lit, violent darkness of *oni*-infested street gangs of Yokohama. Tamaoki Benkyō, *Blood the Last Vampire 2002*, trans. Carl Gustav Horn (San Francisco: Viz Communications, 2002).

トレンド
Torendo
UAAAAA! Trashkultur!
An Interview with MAK's
Johannes Wieninger

CHRISTOPHER BOLTON

Vienna's Museum of Applied and Contemporary Arts (Museum für Angewandte Kunst, or MAK) is known for its eclectic collection and innovative shows. (Some of its exhibits are housed in a cavernous World War II–era flak gun tower that the museum annexed in the mid-1990s.) In fall 2005, MAK sponsored the first show by a major Viennese museum dedicated to manga. We spoke with Johannes Wieninger, the museum's curator of Far Eastern and Islamic art and the creator of the show.

CHRISTOPHER BOLTON: The exhibit has the eye- or ear-catching title *UAAAAA! MANGA*, and a provocative subtitle: *On the Aesthetics of a Trash Culture*. Can you tell us how you conceive trash culture?

JOHANNES WIENINGER: Indeed, people were confused by the subtitle, and manga fan clubs

protested it. But I understand *Trashkultur* in two senses:

First, trash as it is: you use something and discard it afterward. Many things in our everyday life are made for temporary use only and become useless after a short time. But they have a certain aesthetic in their design and content. Weekly manga are trashed after reading. Nobody keeps them. Even the big editors don't keep them. Not everything in our life is made for eternity!

Second, Quentin Tarantino impresses me when he says his work is *Trashkultur*. That means that the producer, creator, or artist may know that his or her work is only of temporary use. They don't create for eternity. And they know that we cannot consume so-called high culture all day long.

This level of everyday culture may have more influence on our lives, thinking, and behavior than any opera production or other art praised by critics. In that sense, we—the museums—must deal with this *Trashkultur* and not ignore it, to understand what is going on. And very often, after a certain period, subculture/trashculture changes into high culture, as we all know.

CB: MAK's collection ranges from applied arts and industrial design to contemporary installation art, with a large teaching collection of Asian art as well. Where does manga fit into this artistic universe?

JW: Although MAK has old and important collections from all the cultures of the world, we see our museum also as a kind of laboratory in which we can try new things. Sometimes we succeed, sometimes we fail. The manga exhibition was a low-budget show, but it worked. We are experimenting also in other fields like fashion, advertising, poster design, etc.

CB: Could you tell us a little bit about the process of conceiving and organizing the exhibit?

JW: During the past few years, several exhibitions on manga were offered to our museum,

but they all tried to show a historic evolution, with samples of work by well-known manga artists. But I believe if you are creating a show on something uncommon, you must use an uncommon language.

For a long time I was not sure how to manage this problem, but during a flight from Tokyo to Vienna I had the idea to work with blowups of the manga and to use only original comic books—not to translate, because the exhibition itself is a translation. Organizing it was not so difficult. After getting in contact with Kōdansha and the manga artists, I knew that less would be more and decided to have only two titles featured in the show.

I chose *Derby Jockey* (1999–2005), a sports manga by Ishiki Tokihiko, and *Mars* (1996–2000), a shojo manga by Sōryō Fuyumi. Sōryō is a star. She is well known in Europe, and *Mars* has been translated into many Western languages. Ishiki is an up-and-coming figure on the Japanese manga scene.

I chose these works because they are contemporary, and both show very dynamic design. Sōryō's style has had a big influence on Japanese graphic design; Ishiki has a fast, individual, and very realistic pencil style.

CB: The exhibition is in the "works on paper" room of the museum, a wonderful space that is the former reading room of the building's nineteenth-century library. That room displays text and graphic art in a series of glass frames suspended from tracks in the ceiling, and for this exhibit you have enlarged the manga pages ten times or more and placed them in these frames. The spectator walks down this track of images—in and around them—almost as if he or she were a character walking through a life-sized manga him- or herself. As you said earlier, an exhibit like this inevitably recontextualizes something from pop culture and Japanese culture as a part of Western museum culture, and one thing that struck me about the exhibit's design is the way that it foregrounds

that transformation. Even for those of us who read a lot of manga, it presented these works in a fresh way, as a different kind of art. But the exhibit also includes a long shelf of actual manga that ran almost the whole length of the exhibit room. I liked that juxtaposition of material objects with their artistic transformation. How did you decide on this display or arrangement?

JW: "Walking through a life-sized manga." Thanks for that wonderful interpretation! This was not my intention, but Ishiki too had that feeling. At first he was afraid blowing up the pages might not work, and he was very surprised to see this alienation of his work. The pages were 170 cm by 100 cm, and some of the characters were bigger than life size! But as I said: I wanted to deal with manga through a medium other than manga. I wanted to tell a story about manga and not just repeat a manga story. The table—it is 10 meters long with more than four hundred books and magazines—should give a broader view of the different types of Japanese comics. These were selected by Kōdansha, by Ishiki himself, and also by manga fans in Japan.

CB: The exhibit is also organized as a kind of tutorial on manga's visual tropes for Western viewers. Different things like sound effects, motion effects, and so forth are explained and illustrated. Is this part of what manga has to teach Western audiences?

JW: No, it was meant to teach the Western audience the characteristics of manga. And my "tutorial" followed Siegfried Kracauer's theories about early black-and-white film, because I understand Japanese comics as a kind of black-and-white film. The relations between Western cartoons, animated films, manga, and anime are well known. Therefore I thought it would be interesting to analyze manga as a film medium.

CB: Are you planning any similar exhibits in the future?

JW: Yes. But the next show should be produced collaboratively with manga artists. We want to use video footage to show the world of the artists and the making of manga today. Our working title is *MANGA II: The Other Point of View.*

CONTRIBUTORS

BRENT ALLISON is a PhD student in the Program in Social Foundations of Education at the University of Georgia. He manages the Web site www.animefandom.org.

WILLIAM L. BENZON has published extensively on literature and cultural evolution. He is author of *Beethoven's Anvil: Music in Mind and Culture*.

CHRISTOPHER BOLTON teaches Japanese literature and comparative literature at Williams College and is coeditor of *Robot Ghosts and Wired Dreams: Japanese Science Fiction from Origins to Anime* (Minnesota, 2007).

MARTHA CORNOG has written articles on manga for the sexology literature and, with Timothy Perper, is editing a book on graphic novels in libraries. She writes the graphic novel column for *Library Journal*.

PATRICK DRAZEN is author of *Anime Explosion! The What? Why? and Wow! of Japanese Animation*.

YURIKO FURUHATA is a PhD student in comparative literature at Brown University.

MEREDITH SUZANNE HAHN AQUILA is a recent graduate of the Master of Communication program at Cornell University.

MARC HAIRSTON is a professional space physicist at the University of Texas at Dallas. He wrote for *Animerica* and is a regular speaker at the Schoolgirls and Mobilesuits workshops at the Minneapolis College of Art and Design.

AZUMA HIROKI is a Japanese cultural critic and author of numerous books, including *Sonzaironteki, Yubinteki: Jacques Derrida nitsuite* and the best-selling *Dobutsukasuru Postmodern*.

MARI KOTANI is a science fiction film critic and author of *Techno-gynesis: The Political Unconscious of Feminist Science Fiction*.

SHU KUGE is an illustrator who works in San Francisco and Tokyo.

THOMAS LAMARRE is a professor at McGill University and author of *Shadows on the Screen: Tanizaki Juni'ichirō on Cinema and Oriental Aesthetics* and *Uncovering Heian Japan: An Archaeology of Sensation and Inscription*.

MARGHERITA LONG is assistant professor of comparative literature and foreign languages at the University of California, Riverside.

FRENCHY LUNNING is a professor at the Minneapolis College of Art and Design and codirector of SGMS: Schoolgirls and Mobilesuits, a weekend workshop there.

DAISUKE MIYAO is assistant professor of Japanese film at the University of Oregon and author of *Sessue Hayakawa: Silent Cinema and Transnational Stardom*.

HIROMI MIZUNO is assistant professor of history at the University of Minnesota.

MARIANA ORTEGA is a translator and illustrator.

TIMOTHY PERPER has written articles on manga for the sexology literature and, with Martha Cornog, is editing a book on graphic novels in libraries.

ERON RAUCH is an artist based in Los Angeles.

TRINA ROBBINS is an award-winning writer who has been writing comics and books for more than thirty years.

BRIAN RUH is author of *Stray Dog of Anime: The Films of Mamoru Oshii*. He is currently a PhD candidate in communication and culture at Indiana University.

DEBORAH SHAMOON is assistant professor of Japanese literature and popular culture at the University of Notre Dame.

MARC STEINBERG is a PhD student of modern culture and media at Brown University.

MASAMI TOKU is associate professor of art education at the California State University, Chico.

KEITH VINCENT is assistant professor of Japanese and comparative literature at Boston University.

CALL FOR PAPERS

The goal of *Mechademia* is to promote critical thinking, writing, and creative activity to bridge the current gap between professional, academic, and fan communities and discourses. This series recognizes the increasing and enriching merger in the artistic and cultural exchange between Asian and Western cultures. We seek contributions to *Mechademia* by artists and authors from a wide range of backgrounds. Contributors endeavor to write across disciplinary boundaries, presenting unique knowledge in all its sophistication but with a broad audience in mind.

The focus of *Mechademia* is manga and anime, but we do not see these just as objects. Rather, their production, distribution, and reception continue to generate connective networks manifest in an expanding spiral of art, aesthetics, history, culture, and society. Our subject area extends from anime and manga into game design, fan/subcultural/conspicuous fashion, graphic design, commercial packaging, and character design as well as fan-based global practices influenced by and influencing contemporary Asian popular cultures. This list in no way exhausts the potential subjects for this series.

Manga and anime are catalysts for the emergence of networks, fan groups, and communities of knowledge fascinated by and extending the depth and influence of these works. This series intends to create new links between these different communities, to challenge the hegemonic flows of information, and to acknowledge the broader range of professional, academic, and fan communities of knowledge rather than accept their current isolation.

Our most essential goal is to produce and promote new possibilities for critical thinking: forms of writing and graphic design inside as well as outside the anime and manga communities of knowledge. We encourage authors not only to write across disciplinary boundaries but also to address readers in allied communities of knowledge. All writers must present cogent and rigorous work to a broader audience, which will allow *Mechademia* to connect wider interdisciplinary interests and reinforce them with stronger theoretical grounding.

To reveal the connections between various communities of knowledge, each issue of *Mechademia* will have a theme yet keep the opportunity available for new or unique analysis. The inaugural issue, *Emerging Worlds of Anime and Manga*, featured essays that show how manga and anime are at the center of a nexus of connections, creating and constructing networks, groups, practices, communities, knowledges, and even worlds. We publish essays that connect these particular aesthetics, now referred to as "Art Mecho," to broader practices as well as social and cultural considerations.

January 1, 2008 "War/Time"

January 1, 2009 "Fanthropologies"

Each essay should be no longer than five thousand words and may include up to five black-and-white images. Color illustrations may be possible but require special permission from the publisher. Use the documentation style of *The Chicago Manual of Style*, fifteenth edition. Copyright permissions will be sought by the individual authors of *Mechademia*.

Submissions should be in the form of a Word document attached to an e-mail message sent to submissions editor of *Mechademia*, at submissions@mechademia.org. *Mechademia* is published annually in the fall.